FAILURE

Documents of Contemporary Art

Co-published by Whitechapel Gallery
and The MIT Press

First published 2010
© 2010 Whitechapel Gallery Ventures Limited
All texts © the authors or the estates of the authors,
unless otherwise stated

Whitechapel Gallery is the imprint of Whitechapel
Gallery Ventures Limited

ISBN 978-0-85488-182-6 (Whitechapel Gallery)
ISBN 978-0-262-51477-4 (The MIT Press)

A catalogue record for this book is available from
the British Library

Library of Congress Cataloging-in-Publication Data

Failure / edited by Lisa Le Feuvre
 p. cm. — (Whitechapel, documents of
contemporary art)
 Includes bibliographical references and index.
 ISBN 978-0-262-51477-4 (pbk. : alk. paper)
1. Failure (Psychology) in art. 2. Arts, Modern—
20th century. 3. Arts, Modern—21st century.
I. Le Feuvre, Lisa.
 NX650.F33F35 2010
 709.04—dc22
 2010006956

10 9 8 7 6 5 4 3 2 1

Series Editor: Iwona Blazwick
Executive Director: Tom Wilcox
Commissioning Editor: Ian Farr
Project Editor: Hannah Vaughan
Design by SMITH
Printed and bound in China

Cover, Still from the film *Steamboat Bill Jnr.* (1928)
starring Buster Keaton. © United Artists.
Photograph courtesy of The Cinema Museum
www.cinemamuseum.org.uk

Whitechapel Gallery Ventures Limited
77–82 Whitechapel High Street
London E1 7QX
www.whitechapelgallery.org
To order (UK and Europe) call +44 (0)207 522 7888
or email MailOrder@whitechapelgallery.org
Distributed to the book trade (UK and Europe only)
by Central Books
www.centralbooks.com

The MIT Press
55 Hayward Street
Cambridge, MA 02142
MIT Press books may be purchased at special
quantity discounts for business or sales promotional
use. For information, please email special_sales@
mitpress.mit.edu or write to Special Sales
Department, The MIT Press, 55 Hayward Street,
Cambridge, MA 02142

Documents of Contemporary Art

In recent decades artists have progressively expanded the boundaries of art as they have sought to engage with an increasingly pluralistic environment. Teaching, curating and understanding of art and visual cultur;e are likewise no longer grounded in traditional aesthetics but centred on significant ideas, topics and themes ranging from the everyday to the uncanny, the psychoanalytical to the political.

The Documents of Contemporary Art series emerges from this context. Each volume focuses on a specific subject or body of writing that has been of key influence in contemporary art internationally. Edited and introduced by a scholar, artist, critic or curator, each of these source books provides access to a plurality of voices and perspectives defining a significant theme or tendency.

For over a century the Whitechapel Gallery has offered a public platform for art and ideas. In the same spirit, each guest editor represents a distinct yet diverse approach – rather than one institutional position or school of thought – and has conceived each volume to address not only a professional audience but all interested readers.

Series Editor: Iwona Blazwick; Commissioning Editor: Ian Farr; Project Editor: Hannah Vaughan; Executive Director: Tom Wilcox; Editorial Advisory Board: Achim Borchardt-Hume, Roger Conover, Neil Cummings, Mark Francis, David Jenkins, Kirsty Ogg, Gilane Tawadros

TO BE AN ARTIST IS TO FAIL AS NO OTHER DARE FAIL

Samuel Beckett, 'Three Dialogues with Georges Duthuit', 1949

EXPERIMENT AND PROGRESS

I WOULD LIKE TO REMAIN ON THE CYNICAL AND SARCASTIC SIDE AND SAY TRUTH IS AN EMBARRASSMENT. BUT IT HAS BEEN SAID THAT LYING IS MORAL, WHICH I CAN UNDERSTAND. SO THAT LEAVES US WITH A QUESTION OF RESPONSIBILITY TO THE AUDIENCE. PEOPLE FREQUENTLY READ MUCH OF MY TEXT AS AUTOBIOGRAPHICAL. PERHAPS THEY ARE RIGHT, BUT IT WASN'T MY INTENTION. I'M EVEN SUSPICIOUS OF MY OWN INTENTIONS

Matthew Brannon, Interview with Rosa Vanina Pavone, *Uovo* (April 2006)

Lisa Le Feuvre
Introduction//Strive to Fail

Uncertainty and instability characterize these times. Nonetheless, success and progress endure as a condition to strive for, even though there is little faith in either. All individuals and societies know failure better than they might care to admit – failed romance, failed careers, failed politics, failed humanity, failed failures. Even if one sets out to fail, the possibility of success is never eradicated, and failure once again is ushered in.

In the realm of art, though, failure has a different currency. Failure, by definition, takes us beyond assumptions and what we think we know. Artists have long turned their attention to the unrealizability of the quest for perfection, or the open-endedness of experiment, using both dissatisfaction and error as means to rethink how we understand our place in the world. The inevitable gap between the intention and realization of an artwork makes failure impossible to avoid. This very condition of art-making makes failure central to the complexities of artistic practice and its resonance with the surrounding world. Through failure one has the potential to stumble on the unexpected – a strategy also, of course, used to different ends in the practice of scientists or business entrepreneurs. To *strive to fail* is to go against the socially normalized drive towards ever increasing success. In Samuel Beckett's words: 'To be an artist is to fail as no other dare fail.'[1]

This collection of writings investigates the ways that artists have used and abused the idea of failure across a number of definitions and modes of address, taking a journey through four imperatives: dissatisfaction and rejection; idealism and doubt; error and incompetence; experiment and progress.

The first section, *Dissatisfaction and Rejection*, addresses claims on failure that arise through discontentment with and refusal of the way things are, whether in the artwork or the surrounding world. Failure is ever concerned with the artwork's place in the world and is tied to its twin, achievement – a relationship fed by distinctions, fears and opportunities.[2] The paradox of failure is that one cannot set out to fail, because the evaluation process of success – as measured by failure – becomes irrelevant. For Beckett, embracing failure offered the possibility of refusing the primary drive of successful art in his time, expression – the concept of which he viewed as a misconstruction at the core of our reception of art.

Although this book focuses on failure in recent art, it has been the source of a productive and generative drive since at least the first stirrings of the modernist era. The Parisian Salon des Refusés of 1863, for example, was an exhibition of failures. At the time, the Salon was an ultimate site of artists' validation; in 1863

the Academicians rejected around 3,000 works that they felt challenged the criteria and authority of the Academy of Fine Arts. The outcry at these exclusions, which included works by Whistler and Manet, led to an alternative exhibition of rejects alongside the official selection.[3] Émile Zola included the event in his 1886 novel *The Masterpiece*, describing artists desperate to be removed from the official selection to the Salon des Refusés, as the 'failures' were far more relevant to their work than those approved by the academicians.[4] For an artist to place a work into the world is to lose control. What does refusal mean? Who are the arbiters of taste? Failure here becomes a pivotal term, rejected by one group, embraced by another.

When failure is released from being a judgemental term, and success deemed overrated, the embrace of failure can become an act of bravery, of daring to go beyond normal practices and enter a realm of not-knowing. In 1953 Robert Rauschenberg proposed to Willem de Kooning his *Erased de Kooning Drawing*. Confronted with the younger artist's request de Kooning agreed, but he chose a work he considered the most difficult to perform the act of erasure on. It took around a month, and around fifteen different erasers, for the drawing to be pared back to almost-white in a gesture of removal that broke with conventional art-making. Dieter Roth's experimental pushing of failure to its limits too enabled him to view the work of preceding artists from a new perspective. In the late 1950s he began to take the view 'that even Malevich's black square resulted from a feeling of failure. One always arrives at something one can no longer depict.'[5] When the conventions of representation are no longer fit for purpose failure can open new possibilities.

As the texts on works by artists such as David Critchley in the 1970s and Dominique Gonzalez-Foerster in the present make clear, one of the most crucial areas where we can identify the endemic presence of failure in art-making activity is in the gap between intention and realization.[6] In the video work *De Novo* (2009), Gonzalez-Foerster ruminates on the ways in which any possible proposal, artistic or otherwise, is informed by the history and failures of all those that might have gone before. She describes her past ideas as 'black holes' that always seem unsatisfactory when realized. Critchley's work *Pieces I Never Did* likewise shows the artist talking to camera, where he describes eighteen propositions for artworks, taking in performance, film, video, installation and sculpture, each one never moving beyond notes in a sketchbook. Such is the process of wrestling with ideas: self-censorship often defines a creative act as a failure before it has been released into the unpredictable realm of the public.

In 2010 the artist Michael Landy filled the South London Gallery with a dumpster-shaped vitrine measuring 600 cubic metres, forming out of polycarbonate and steel a waste container for artworks. Anyone rightfully owning

a work of art could apply to use the disposal facility, with successful applicants approved by Landy in a process that validated self-declared failures. On acceptance, works were logged into an inventory, with provenance and details noted, and then either immediately thrown in by their owners or carefully stored by white-gloved art handlers to be disposed of later. Landy declared this sculpture a 'monument to creative failure'. In his autobiographical memoir *Hand to Mouth: A Chronicle of Early Failures* (1997), the writer Paul Auster recalls one of the ruses he devised to avoid deciding what to write: he dreamt up a literary prize for self-nominated failures. He then reflects on the way this compulsion to sanctify failure was an attempt to hide his own abject fear of what it might be.[7] The judgement involved in naming something a success or a failure is symptomatic of the time and place, and contingent on the critical apparatus one uses to define it.[8]

To achieve resolution is to achieve a masterpiece – a work, in the classic modernist formulation, where nothing can be improved, nothing added.[9] Yet this enterprise, in which the artist is creator of the 'perfect' artwork, is doomed to fail from the start. Zola's novel of 1886 followed from an earlier short story by Honoré de Balzac, *The Unknown Masterpiece* (1831), which narrates a failure of belief, reputation and — that very crux of artistic practice — the failure of the artist's realization to meet an intention.[10] Balzac describes an ageing painter working tirelessly on a portrait of a past lover. The work is hidden from all until it will be complete and perfect. Ever dissatisfied, the artist meticulously strives to make his painting so realistic that it is indistinguishable from a living body. However, when revealed, the pursuit of perfection has undone the representation, leaving a 'wall of paint', with a single, perfect foot just visible amongst the mass of colour. The master tries to justify the painting as an atmosphere rather than a depiction, but ultimately, in this era of representational painting, he believes it to be a failure, evidence of his lost mastery. Balzac's account is of the gaps between intention, expectation and realization.

John Baldessari advises his students: 'Art comes out of failure. You have to try things out. You can't sit around, terrified of being incorrect, saying 'I won't do anything until I do a masterpiece.'[11] In Baldessari's *Wrong* (1967–68) — a technically 'wrong' photographic composition, in which the artist stands in front of a palm tree so it appears to sprout from his head — the aura of the compositionally 'right' image is disrupted so that – even though the new image perhaps replaces this merely with an alternative aesthetic – with the break in representative conventions, a pleasure in failure is introduced.[12] Who has the right to claim the wrongness of an image? What does it matter if a tree sprouts out of a head? This is a turning away from the authority of what is deemed to be right. Assumptions are where attention starts to waver: we can sometimes only become truly attentive when something is indeed wrong.

While speculative thought strives for ever-deepening levels of understanding in the search for content, irony asks questions, not to receive an answer but to draw out of content and form yet more questions. The philosopher Søren Kierkegaard's writings are suffused with paradox, choosing a series of endlessly unfurling contradictions over definitive truth. The ironist deals with the *how* of something being said rather than the *what*, paying a distanced attention to the surface of statements so as to identify gaps in knowledge and productive miscommunication. Where we embrace the irony of bad taste like the artist Martin Kippenberger, deliberately turning away from technical skill, we distance ourselves from the assumed natural order of things.

Kippenberger always seemed to push too hard or the wrong way, resulting in a space of failure where he seemed more than happy to cast himself. His *Metro-Net* project (1993–97), for example, set out to install a series of subway entrances around the world that would lead to nowhere. The first was built on the Greek island of Syros; another was designed as a mobile structure that was crushed on the occasion of its exhibition at Metro Pictures in New York, simply so it could fit through the door.[13] As Ann Goldstein has written, Kippenberger 'mastered the act of failing not through his own incompetence, or even that of others, but through a savvy and strategic application of the oppositional and incongruous.'[14] Indeed, in the face of failure, is there any point in striving for success, when there can be an immersive warmth in being simply pathetic, in not trying. As Ralph Rugoff claimed in his landmark group show 'Just Pathetic' (Los Angeles and New York, 1990), to turn away from ambition is a position: 'To be pathetic I stop being a loser, haplessly falling short of the idealized norm', seeking no place in history, turning instead to a desultory and indifferent claim on the present.[15]

The second section, *Idealism and Doubt*, considers how in the field of art these polarities operate as productive engagements. If failure is endemic in the context of creative acts, this opens the question not whether something *is* a failure, but rather *how* that failure is harnessed. Indifference can offer a position of resistance akin to the attitude of Herman Melville's scribe in *Bartleby, the Scrivener: A Story of Wall Street* (1853), analysed in different ways by Gilles Deleuze and Giorgio Agamben. Melville's narrator, an elderly lawyer, describes his encounter with Bartleby, a man who he chose to employ in his chambers on the basis of his apparent constancy, which he believed would even out the inconsistencies of his existing employees, one of whom was irascible in the morning, the other in the afternoon, both moods adjusted by lunchtime drinking. However fast and committed the scrivener is at his chores at the start of his employment, he very quickly adopts a particular attitude of indifference, responding to questions and requests with the simple phrase 'I would prefer not to', in an incessant passive resistance to required and prescribed behaviours.

To take such a position is to be beyond redemption, to refuse either success of failure, a position Lotte Møller discerns in the work of Annika Ström, and Jennifer Higgie in the work of Matthew Brannon. As Leo Bersani and Ullyse Dutoit state in *Arts of Impoverishment*, their study of Beckett, Mark Rothko and Alain Resnais: 'Surely nothing can be more dangerous for an artist or for a critic than to be obsessed with failure. "Dangerous" because the obsession we are speaking of is not the coming anxiety about failing, but rather an anxiety about not failing.'[16] Paradoxes are at the heart of all dealings with failure – it is a position to take, yet one that cannot be striven for; it can be investigated, yet is too vague to be defined. It is related but not analogous to error, doubt and irony.

Idealism, with its travelling companion doubt, is driven by a misplaced belief in perfection – a concept setting an inaccurate route to what-might-have-been, to the past, and even to perfection itself. Is there a method more pertinent than perfection to the ways we understand our place in the world, and in which art can complicate what we think we know? Think of Felix Gonzalez-Torres' *Untitled (Perfect Lovers)* (1987–90), an identical pair of battery-operated wall clocks, placed side by side, which inevitably will fail to keep the same time. The 'perfection' here lies in the failure of accuracy; anything else would be romantic fiction. Like these out-of-sync clocks, human beings are all fallible; perhaps this is most explicitly revealed to us in the ways that we understand the past through memory and imagination. Here failure abounds. As Gonzalez-Torres demonstrated in much of his work, photographic, or indexical, recollection will never be the most truthful. In 1929 Walter Benjamin reflected on Marcel Proust's unravelling of perceptions through an engagement with the power of forgetting that is driven by an endless methodological dissatisfaction: Proust's typesetters record his constant changing of texts, not to correct mistakes but rather to introduce marginal notes, as if in a desperate attempt to remember everything.[17] It is near impossible to record every single thing and event in our lives – the task would be as overwhelming as in Borges' *Funes the Memorious* (1942).

The thinker Paul Ricoeur considered in detail the processes of memory and recollection, noting that perfect memory, like Gonzalez-Torres' *Perfect Lovers*, is replete with both error and perfection. Ricoeur describes memory as always being at the mercy of the powerful forces of distraction and influence from other experiences held in the mind. 'Pure' memory is simply the act of recollection; memory influenced by imagination is an engagement.[18] This is demonstrated in Renée Green's return to the site of Robert Smithson's work *Partially Buried Woodshed* (1970): Green's *Partially Buried in Three Parts* (1996–99) directly addresses remembered and forgotten history. Her multipart installation interweaves interviews with local residents, activists, her family members and artists, about their imagined and actual memories of America in the 1970s. The charge in Green's

work is in the power of the failure to remember and in the failure of the facts of events, specifically the anti-Vietnam protests at Kent State University, to be written into history. As with Gonzalez-Foerster's recollections, the references build, to draw attention to the moments of forgetting and to the ways in which recollection is a process clouded by mistake, misrepresentation, failures of verisimilitude.

If perfection and idealism are satisfying, failure and doubt are engaging, driving us into the unknown. When divorced from a defeatist, disappointed or unsuccessful position, failure can be shifted away from being merely a category of judgement. Section 3, *Error and Incompetence*, examines these two aspects of failure as positions that can be taken up positively. Julian Schnabel, for example, describes in this section his work as a 'bouquet of mistakes'.[19] Rather than producing a space of mediocrity, failure becomes intrinsic to creating open systems and raising searching questions: without the doubt that failure invites, any situation becomes closed and in danger of becoming dogmatic. Art-making can be characterized as an activity where doubt lies in wait at every turn and where failing is not always unacceptable conduct. As the artists Fischli and Weiss note of their video *The Way Things Go* (*Der Lauf der Dinge*, 1987), in which an assembly of mundane everyday objects and pieces of garbage perform a hilarious set of chain reactions: 'For us, while we were making the piece, it was funnier when it failed, when it didn't work. When it worked, that was more about satisfaction.'[20] After all, if an artist were to make the perfect work there would be no need to make another. Emma Cocker describes in her text 'Over and Over. Again and Again' that to try again is to repeat, to enter into a series of rehearsals with no end point, no conclusions.[21] Beckett's advice in *Worstward Ho* (1983) is to keep on trying, even if the hope of success is dashed again and again by failure: 'Ever tried. Ever failed. No matter. Try again. Fail again. Fail better.'[22]

These refusals to accept incompetence as an obstruction often employ repetitive strategies, just in case a single error was an aberration. In the work of artists such as Marcel Broodthaers, Bruce Nauman and Bas Jan Ader, Sisyphean tasks are driven by a performed disbelief in error as a negative. In an art context such repetition has the potential to pass through the threshold of tedium and even slip into slapstick. To set out to succeed at failing, or to fail at failing, is to step aside from the orthodox order. Slapstick, as described by Jörg Heiser in this section, fills narrative with illogical possibilities that evoke embarrassment and laughter.[23] Embarrassment is a natural response to failure: you want to disappear when it happens, when the world looks at you and judges you for your failing. What though, if being embarrassed is not so bad after all? We all embarrass ourselves frequently, yet it is fear of the judgement of our failures that endures.

Chris Burden's practice acts out the simple question 'what happens if you…?', making the risk of failure a space of opportunity as he pushes the limits of

possibilities and courts incompetence. Burden proposes questions that are manifested through actions and events, interrogating structures of power and assumptions, introducing doubt, and never fully eliminating the unknown. He offers a series of impossible proposals that are then acted out: integral to each is the possibility and frustration of failure. This can be seen most explicitly in *When Robots Rule: The Two Minute Airplane Factory* that took the form of an assembly line manufacturing model airplanes to be launched into the cavernous space of Tate Britain's Duveen Galleries in 1999. Although on paper the machine was capable of the task, in practice only a single plane made the flight, with visitors instead confronted with technicians carrying out tests and adjustments. Technology has no intuition, reflexivity or ability to know if something 'looks right', yet the purpose of machines is to increase efficiency beyond the ability of the human hand. At Tate the apparent failure made the work all the more poignant; the inability of the machine to replicate human endeavour became a poetic philosophy of failure. The once-success, though, raises the question 'what if it was tried again?'. With an adjustment could countless model airplanes be manufactured in a day? He has observed that 'some of my favourite sculptures were the ones that were total disasters. You fantasize a way they are going to be, you try to do everything in your power, and then they are total flops. It's really interesting to examine how you could be so wrong.'[24]

Failure, by definition, takes us beyond assumptions and what we think we know and can be represented. Section 4, *Experiment and Progress*, examines failure's potential for experimentation beyond what is known, while questioning the imperatives of progress. The act of testing takes on a different register when considered as a process rather than a result-oriented search for progress. When testing is an end in itself, non-completion, and therefore non-perfection, becomes a valid option. There is a pleasure in testing through failure. The artist Roman Signer, for example, courts failure just in case success unexpectedly turns up. If not, though, it really doesn't matter. His 'accident sculptures' ironically mimic experiments and their documentation. Paul Ramírez-Jonas addresses the hierarchies of failure through an exploration of the spaces between desire for progress and actual experience.[25] His video *Ghost of Progress*, 2002, is shot from a camera mounted on his bicycle handlebars as he traverses an unnamed city in the developing world. At the opposite end of the handlebars is a scale model of Concorde – once a symbol of optimistic progress, now a failed experiment. Utopian hopes and ultimate commercial realities embodied by Concorde are juxtaposed against a background of survival street commerce, new and old cars, public transport, noise, decaying historic and modern buildings, smog, dirt, and people going about their daily lives.

This speculative experimentation or testing is tied up with the modernist project, where the idea of the inventor (be it the artist, scientist, philosopher or

explorer) is embedded in the desire for a progress-driven radical break in understanding. When one's expectations are dashed there can be an opportunity for a new register of thinking. As Robert Smithson states in his conversation with Dennis Wheeler (1969–70), by isolating the failures one can 'investigate one's incapabilities as well as one's capabilities', opening up possibilities for questioning how structures and limits shape the world.[26]

The philosopher of science Karl Popper popularized the process in logic known as *falsifiability*: the probability that an assertion can be demonstrated as false by an experiment or observation. For example 'all people are immortal' is an easily falsifiable statement, demonstrated by the evidence of even one person having died. For Popper, the essence of scientific experiment is the investigation of more complex falsifiable propositions, or hypotheses. What characterizes creative thinking within an experiment is the ability to 'break through the limits of the range', that is to apply a critical mode of thinking rather than working with the sets of assumptions at hand. In order to do so one must engage with failure and embrace the unanticipated.[27] In art, failure can also be a component of speculative experiment, which arrives at something unrecognizable as art according to the current criteria of knowledge or judgement.

In this uncertain and beguiling space, between the two subjective poles of success and failure, where paradox rules, where transgressive activities can refuse dogma and surety, it is here, surely, that failure can be celebrated. Such facets of failure operate not only in the production but also equally in the reception and distribution of artworks, inscribing certain practices into the histories of art. As we know, these histories are constantly tested and challenged and are themselves implicated in artists' roles as active agents, seeking new forms of rupture, new delineations of space within contemporary experience, in order to place something at stake within the realm of art.[28] The impossibility of language, as explored in Liam Gillick and Will Bradley's inclusions in this section, forces a stretching of this structure of understanding beyond its limits, in order to pull on thought rather than words: this opens moments of un-understanding which in time can be elucidating. To paraphrase the section from Wittgenstein's *Tractatus Logico-Philosophicus* that closes this collection: often it is worth considering that the deepest failures are in fact not failures at all.

1 Samuel Beckett, from 'Three Dialogues with Georges Duthuit', *transition*, no. 48 (1949); reprinted in Samuel Beckett, *Proust & Three Dialogues with Georges Duthuit* (London: John Calder, 1965) 119–26.

2 See Daniel A. Siedell, 'Art and Failure', *The Journal of Aesthetic Education*, vol. 40, no. 2 (Urbana-Champaign: University of Illinois Press, Summer 2006) 105–17.

3 See Bruce Altshuler, ed., *Salon to Biennial: Exhibitions that Made Art History. Volume 1: 1863–1959* (London and New York: Phaidon Press, 2009) 23–30.

4 Émile Zola, *L'Oeuvre* (Paris, 1886); trans. Ernest Vizetelly, *His Masterpiece* (New York: Macmillan, 1896); reissued as *The Masterpiece* (Oxford: Clarendon Press, 2008).

5 Dieter Roth, interview with Felicitas Thun (Basel, February 1998), in *Dieter Roth: Gedrucktes Gespresstes Gebundenes 1949–1979* (Cologne: Oktagon Verlag, 1998); reprinted in *Flash Art International* (May–June 2004) 104–5.

6 See Clive Gillman's text on David Critchley in this volume, 42; and Daniel Birnbaum's text on Dominique Gonzalez-Foerster, 65.

7 See Paul Auster, *Hand to Mouth: A Chronicle of Early Failures* (London: Faber & Faber, 1997) 35–7.

8 See Tom Holert, 'Surviving Surveillance? Failure as Technology', *Printed Project*, no. 6 (Dublin, 2007).

9 See for example Russell Ferguson's citation of Virginia Woolf and Michael Fried, in *Francis Alÿs: Politics of Rehearsal* (Los Angeles: Armand Hammer Museum of Art/Göttingen: Steidl, 2007) 11.

10 Honoré de Balzac, *Le Chef d'oeuvre inconnu* (Paris, 1831); trans. Richard Howard, *The Unknown Masterpiece* (New York: New York Review of Books, 2001).

11 John Baldessari in Sarah Thornton, *Seven Days in the Art World* (New York: Norton, 2008) 52.

12 See Abigail Solomon-Godeau, 'The Rightness of Wrong', in *John Baldessari: National City* (San Diego: Museum of Contemporary Art/New York: D.A.P., 1986) 33–5; reprinted in this volume, 33.

13 See Marcus Verhagen, 'Trash Talking', *Modern Painters* (February 2006) 67–9; reprinted [retitled by the author as 'There's No Success Like Failure': Martin Kippenberger] in this volume, 43.

14 Ann Goldstein, 'The Problem Perspective', in Ann Goldstein, ed., *Martin Kippenberger: The Problem Perspective* (Los Angeles: The Museum of Contemporary Art, 2008) 39–44.

15 Ralph Rugoff, from catalogue essay for 'Just Pathetic' (Los Angeles: Rosamund Felsen Gallery/ New York: American Fine Arts, 1990), cited in Michael Wilson, 'Just Pathetic', *Artforum* (October 2004).

16 Leo Bersani and Ulysse Dutoit, *Arts of Impoverishment: Beckett, Rothko, Resnais* (Cambridge, Massachusetts: Harvard University Press, 1993) 1–9.

17 Walter Benjamin, 'The Image of Proust' (1929), in Walter Benjamin, *Illuminations*, ed. Hannah Arendt (New York: Schocken Books, 1968) 201–16.

18 See Paul Ricoeur, *La Mémoire, l'histoire, l'oubli* (Paris: Éditions du Seuil, 2000); trans. Kathleen Blamey and David Pellauer, *Memory, History, Forgetting* (Chicago: University of Chicago Press, 2004) 7–10.

19 Julian Schnabel, Statements (1978) in *Theories and Documents of Contemporary Art* (Berkley: University of California Press, 1996) 266.

20 Peter Fischli, David Weiss and Jörg Heiser, 'The Odd Couple: An Interview with Peter Fischli and David Weiss', *frieze*, no. 102 (October 2006) 202–5.

21 See Emma Cocker's essay in this volume, 154.

22 Samuel Beckett, *Worstward Ho* (London: John Calder, 1984); see also Brian Dillon, 'Eternal Return', *frieze*, no. 77 (September 2003) 76–7; reprinted in this volume, 122.

23 Jörg Heiser, 'Pathos versus Ridiculousness: Art with Slapstick', in *All of a Sudden* (New York and Berlin: Sternberg Press, 2008).

24 Chris Burden, interview with Jon Bewley (1990), in *Talking Art*, ed. Adrian Searle (London: Institute of Contemporary Arts, 1993) 26–7.

25 See Inés Katzenstein, 'A Leap Backwards into the Future', in *Paul Ramírez Jonas* (Birmingham: Ikon Gallery, 2004) 108–12; reprinted in this volume, 184.

26 Robert Smithson, from 'Interviews with Dennis Wheeler' (1969–70), section II, in *Robert Smithson: The Collected Writings*, ed. Jack Flam (Berkeley and Los Angeles: University of California Press, 1996) 208–9; reprinted in this volume, 171.

27 See Karl Popper, *Endless Quest* (London and New York: Routledge, 1992); and Bazon Brock, 'Cheerful and Heroic Failure', in Harald Szeemann, ed., *The Beauty of Failure/The Failure of Beauty* (Barcelona: Fundació Joan Miró, 2004) 30–33.

28 See Joseph Kosuth, 'Exemplar', in *Felix Gonzalez Torres* (Los Angeles: The Museum of Contemporary Art, 1994) 51–9; reprinted in this volume, 90.

smearing

and destroying are

my failure to achieve what I want

the result of

Dieter Roth, Interview with Felicitas Thun, 1998

DISSATISFACTION AND REJECTION

Paul Barolsky
The Fable of Failure in Modern Art//1997

'We should not forget that 99 per cent of all art-making attempts are failures.' Thus declares Phillip Lopate the essayist in his recent book, *Portrait of My Body*. Although the phrase 'art-making attempts' offends one's sense of prose style, Lopate's statement seems reasonable enough, and we accede to its apparent truthfulness – even if we do not have the faintest notion how many works of art are in fact failures. We think of art and failure together, however, precisely because their conjunction is one of the deep themes in the history of modernism, one of its commanding plots, especially in the writings of artists themselves, authors of imaginative literature who anxiously but tellingly return time and time again to the theme of the failed artist. Born of the historical circumstances in which it is written, inevitably given form by them, fiction is true to these circumstances and thus helps to shape and define our understanding of history. Balzac's 'The Unknown Masterpiece', a central fable in this larger story, is the tale of the aged, deluded, indeed quixotic, painter Frenhofer who laboured for ten years on a portrait of a courtesan which, when it was finally revealed, emerged as a confused mass of colour and jumble of lines, a work the artist burned when he came to see that, in the end, it was 'nothing'. Filled with 'doubt', as Balzac said, Frenhofer aspired to the absolute, to the realization of what was 'unknown' to painters, to what was beyond their ability to achieve, an artistic perfection impossible to realize in the modern world. Associated by Balzac with both Satan and Prometheus, Frenhofer is no less a transgressor, himself a Faust among painters, seeking to fathom the very secrets of his art.

Balzac's tale was rewritten by Émile Zola in his novel *The Masterpiece*, the pathetic story of the rejected painter Claude Lantier who hanged himself in front of his modern 'masterpiece'. Zola embellishes Balzac's bitter theme, for whereas Frenhofer had destroyed his painting, along with his other works, Lantier destroys his own life. Zola's painter was not only modelled on Balzac's; he was also inspired in part by his boyhood friend Cézanne, who identified himself intensely and bitterly with Frenhofer, his much discussed 'doubt' rooted in the latter's anxiety. Picasso, who also saw himself as a type of Frenhofer, spoke of Cézanne's 'anxiety', employing the very word adapted by Balzac to characterize his imaginary painter. Cézanne's 'anxiety', Picasso observed, was his legacy to all artists.

The theme of the artist's 'doubt' and 'anxiety' is nowhere more conspicuous than in the work of Henry James, which validates Oscar Wilde's claim that Balzac invented the nineteenth century. Taking the French master's lesson to heart,

James rewrites Balzac (to cite just one example) in his short story 'The Middle Years', the tale of an aged, dying writer, Dencombe, who, having 'done all he should ever do', nevertheless did not 'do what he wanted'. What the dying Dencombe dreaded was that 'his reputation should stand on the unfinished', adding, finally, 'our doubt is our passion'. The purest form of James' homage to Balzac, however, is 'The Madonna of the Future', the story of the quixotic, Frenhofer-like painter Theobald who worked for years on a picture of the Madonna, seen by no one. When it is finally revealed, the painting is even more radically unfinished than Frenhofer's, for it is an empty canvas, the ultimate symbol of the failure of art. The unfinished canvas would come to be the very sign of art's failure and would appear again later in Alberto Moravia's novel *The Empty Canvas*, the existential story of an artist unable to fill the void in his life which was epitomized by the canvas, the very 'void of unessential night', empty, silent, indifferent.

Frenhofer's 'doubt' hovers over Russian literature as well. In a haunting tale, 'The Portrait', saturated with the Hoffmannesque fantasy of Balzac, Nikolai Gogol writes of a mad painter, Chartkov, possessed by the devil, who is driven to the ultimate perilously modern question: 'Did I ever really have any talent?' Before Frenhofer this is not a question we will find in the story of the artist, from Apelles and Zeuxis to Raphael, Rubens, Poussin and Rembrandt. When Gogol's painter asks, 'Didn't I deceive myself?', does he not come to Frenhofer's ultimate understanding that, in the end, he has been a failure? His response to such self-knowledge opens up a new possibility of violence. Instead of annihilating his own works, Gogol's painter, spending huge sums of money, buys up all the finest works of art he can find in order to destroy them. Bringing these rival works of art home, he tears them into little pieces and stamps on them as he laughs with fiendish glee – a sign of the ultimate, frenzied insanity that consumes him. Over a century later Robert Rauschenberg would famously erase a drawing by his friend Willem de Kooning. The devil's work had become neo-Dada farce.

Sometimes writers project the anxieties of the modern artist, of his sense of failure, into the past. In his monumental *The Death of Virgil*, Hermann Broch embellishes the historical account of how the Roman poet wished to have his great epic destroyed if he did not return from a journey. Only now, in Broch's pages, this story is turned into an 'imaginary conversation' between Virgil and Augustus, in which the poet inveighs against the inadequacies of his poem, insisting that its 'imperfections' go deeper than anyone can imagine. Caesar's response is to indict Virgil, as if the writer were an ancient Frenhofer. 'The doubts that every artist harbours about the success of his work, in your case,' Augustus tells Virgil, 'have degenerated into a mania'. In a large historical irony, Virgil, whose work gives definition to the very idea of the canonical 'masterpiece', is now seen in the modern period as himself afflicted with the malaise of modernism,

overwhelmed by artistic inadequacy, ironically unable to achieve the very epic work that shapes our concept of what a masterpiece is or, should we say, was.

The sense of artistic failure echoes through the chambers of modernist fiction. In a famous passage of his great novel, Proust has the fictional novelist Bergotte ponder his entire oeuvre with a negative judgement on himself when he looks at Vermeer's *View of Delft*. 'That is how I ought to have written ... last books are too dry, I ought to have gone over them with a few layers of colour, made my language precious in itself, like this little patch of yellow wall.' As in Balzac and James, the painter's art is the mirror in which the writer sees the reflection of his own flawed work. The painter clarifies the writer's self-doubt, his sense of imperfection, his inability to create a masterpiece.

It does not surprise us that Frenhofer, who haunts modern fiction as he informs the consciousness of modern artists, is still very much with us. Witness the recent film of Jacques Rivette, *La Belle Noiseuse* (1991), which freely reworks Balzac's story, giving to Frenhofer a distinctly and not inappropriately Picassoid persona. Picasso's own anxious identification with Frenhofer has recently resurfaced in the pages of the *New Yorker*, where the critic Adam Gopnik describes Picasso as 'the great master who never was'. Unwittingly echoing Balzac and Picasso's own intense identification with Balzac's character, the critic says of modern painting in general that what makes it 'interesting is its inability to offer polished meanings, secure achievements, and neat Old Masterish careers'. In Gopnik's indictment, Frenhofer's failure casts its shadow over our age, the age of artistic anxiety, as Auden might well have said. [...]

[This repeated] story is truly dreadful but it cannot be ignored, for it is told over and over again by Balzac, Zola, James, Gogol, Schwob, Richepin, Proust, Beerbohm, Leo Stein, Broch, Moravia, Willeford and Barnes, in fables English, French, Russian, German, Italian and American, in stories that are a significant part of the global history of modern art and literature, of modernism, as it is called. Many of these writers are minor figures, some have been forgotten, others can be dismissed, but it does not escape notice that among our writers, Balzac, Proust, James and Broch, we encounter figures who are themselves central participants in the story of modernism that they help to define. Their achievement is part of the very irony of modernism, an art that aspires to great heights but that is ultimately doomed, like that of Kafka's 'hunger artist', whose grotesque self-deprivation is the acme of artistic abjection, abnegation, annihilation. This story can be expanded seemingly ad infinitum by countless other recent examples: Peter Ackroyd's *The Last Testament of Oscar Wilde* (1983), in which the protagonist pathetically proclaims his ultimate failure, concluding 'I have betrayed my own gifts'; Thomas Bernhard's *The Loser* (1983), in which a pianist named Wertheimer, unable to achieve the excellence of his fellow student Glenn

Gould, abandons his art by committing suicide; or Antonio Tabucchi's fable of Ovid in his *Dreams of Dreams* (1992), a fantasy of the ancient poet who dreams he has become a gigantic butterfly, with consequences horrendous and pathetic. Reciting his poetry to Augustus, Ovid emits the incomprehensible sounds of an insect, only to be brutally rejected by the emperor – as if in a monstrous inversion of Broch's story of Virgil's relations to Augustus. As Kafka had rewritten Ovid in his metamorphosis of Gregor Samsa into an insect, Tabucchi rewrites Kafka. For whereas Samsa still had the power of speech, Ovid the butterfly cannot speak at all. Like many of Ovid's own most poignant characters, Tabucchi's Ovid has lost the gift of language: the ultimate privation of the poet, his very medium, the word. 'Don't you hear my poetry, Ovid cried ... but his voice was a faint whistle.' More than a dream, Ovid's dream in Tabucchi is a nightmare, a nightmare of the artist's ultimate failure – a nightmare from which the story of modernism, despite the irony, jests, parody, drollery and blagues of James and Proust, Picasso and Duchamp, Richepin and Barnes, has not yet awakened.

Paul Barolsky, extracts from 'The Fable of Failure in Modern Art', *The Virginia Quarterly Review*, Summer 1997 (Charlottesville: University of Virginia, 1997) 395–404.

John Berger
The Success and Failure of Picasso//1965

The gifts of an imaginative artist are often the outriders of the gifts of his period. Frequently the new abilities and attitudes become recognizable in art and are given a name before their existence in life has been appreciated. This is why a love of art which accompanies a fear or rejection of life is so inadequate. It is also why ideally there should always be a road open to art even for those to whom the medium, the talent, the activity involved mean nothing. Art is the nearest to an oracle that our position as modern scientific men can allow us.

What happens to an artist's gifts may well reveal, in a coded or cyphered way, what is happening to his contemporaries. The fate of Van Gogh was the partial fate of millions. Rembrandt's constant sense of isolation represented a new intimation of loneliness experienced, at least momentarily, by hundreds in seventeenth-century Holland. And so it is with Picasso. The waste of his genius, or the frustration of his gifts, should be a fact of great significance for us. Our debt to him and to his failures, if we understand them properly, should be enormous.

Picasso has remained a *living* example, and this involves far more than not dying. He has not stopped working. He has not lied. He has not allowed his personal desperation to destroy his vitality or his delight in energy. He has not become politically – and therefore humanly – cynical. He has never, in any field, become a renegade. We cannot write him off. He has achieved enough to show us what he might have achieved. Because he is undefeated, he remains a living reproach. But a reproach against what?

Picasso is *the* typical artist of the middle of the twentieth century because his is the success story *par excellence*. Other artists have courted success, adapted themselves to society, betrayed their beginnings. Picasso has done none of these things. He has invited success as little as Van Gogh invited failure. (Neither was averse to his fate, but this was the limit of their 'invitations'.) Success has been Picasso's destiny, and that is what makes him the typical artist of our time, as Van Gogh was of his.

There have been – and are – many fine contemporary artists who have not achieved success, or, as we say, the success they deserve. But nevertheless they are the exceptions – sometimes because, courageously and intelligently, they have wanted to be so.

Consider how in the last twenty years the rebels and iconoclasts of the years before have been honoured! Not to mention traditionalists like Bonnard and Matisse. Or consider the phenomenon from the consumers' rather than the producers' point of view. Art, and especially 'experimental' art, has now become a prestige symbol, taking the place, in the mythology of advertising, of limousine cars and ancestral homes. Art is now the *proof* of success.

It would be too far outside the scope of this essay to explain why this has happened or to discuss the accompany¬ing bitter contrast between the fortunate and unfortunate among artists. In a competitive society rewards such as are now offered for art are bound to mean an immense and uneconomic number of underprivileged hoping against hope for their chance.

The fact remains that since the French Revolution art has never enjoyed among the bourgeoisie the privileged position it does today. Once the bourgeoisie had their own artists and treated them as professionals: like tutors or solicitors. During the second half of the nineteenth century there was also an art of revolt and its artists were neglected or condemned until they were dead and their works could be separated from their creators' intentions and treated as impersonal commodities. But today the living artist, however iconoclastic, has the chance of being treated like a king; only, since he is a king who is treated rather than who treats, he is a king who has lost his throne.

All this is reflected in the way artists talk amongst themselves and judge one another. Success is simultaneously desired and feared. On one hand it promises

the means to survive and go on working; on the other it threatens corruption. The most frequently heard criticism is that, since his success, X is repeating himself, is merely picture-making. But the problem is often seen too narrowly as one of personal integrity. With enough integrity, it is suggested, one should be able to steer an honest course between success and corruption. A few extremists react so violently that they actually believe in failure. Yet failure is always a waste.

The importance of Picasso's example is that it shows us how this fundamental problem of our epoch is an historical and not a moral one. Because Picasso does not belong to Western Europe we can appreciate how unnatural his success has been to him. We can even imagine the kind of *natural* success which his genius needed. Furthermore we can see very precisely how the success which he has suffered has harmed him. It would be quite wrong to say that Picasso has lost his personal integrity, that he has been corrupted; on the contrary, he has remained obstinately true to his original self. The harm done is that he has been prevented from developing. And this has happened because he has been deprived of contact with modern reality.

To be successful is to be assimilated into society, just as being a failure means being rejected. Picasso has been assimilated into European bourgeois society – and this society is now essentially unreal.

The unreality, although it affects and distorts manners, fashions, thoughts, is at base economic. The prosperity of capitalism today depends, through investment, on the raw materials and labour of the underprivileged countries. But they are far away and unseen – so that at home most people are protected from the contradictions of their own system: those very contradictions from which all development must come. One could well talk of a drugged society.

The degree of torpor is particularly startling in Britain which, not so long ago, was known as the 'workshop of the world'; but with variations the same trend governs all capitalist countries. In the *Financial Times* in 1963 the twenty largest British monopolies were listed. Their total net profits were £414 million. Of this figure *two-thirds* came from enterprises involved in overseas exploitation (oil, tobacco, rubber, copper, etc.) whilst profits from heavy industry in Britain were no more than £18.7 million and from light industry only £43 million.

The ideological effects of such stagnation are so immediate and pronounced because of the stage of knowledge which we have now achieved. Once it was perfectly possible to live off the loot of the world, to ignore the fact, and still to make progress. Now it is impossible *because the indivisibility of man and his interests and the unity of the world are essential points of departure in every field of thought and planning,* from physics to art. That is why the average level of cultural and philosophic exchange in the West is so trivial. It is also why such progress as is being made is made in pure science, where the discipline of the method forces

researchers to jettison, at least whilst working, the habitual prejudices of the society they find themselves in.

The young, those who are still anonymous in a society which imprisons with names and categories, sense the truth of all this, even if they do not explain it. They suspect that the rich are now neurotic and daily getting worse. They look round at the faces in an expensive street and know that they are ignoble. They laugh at the hollowness of formal, official ceremonies. They realize that their democratic choice exists only in theory. They call life the rat-race. They regret that they haven't had time to find an alternative.

The example of Picasso is not only relevant to artists. It is because he is an artist that we can observe his experience more easily. His experience proves that success and honour, as offered by bourgeois society, should no longer tempt anyone. It is no longer a question of refusing on principle, but of refusing for the sake of self-preservation. The time when the bourgeoisie could offer true privileges has passed. What they offer now is not worth having.

The example of Picasso is also an example of a failure of revolutionary nerve – on his part in 1917, on the part of the French Communist Party in 1945. To sustain such nerve one must be convinced that there will be another kind of success: a success which will operate in a field connecting, for the first time ever, the most complex imaginative constructions of the human mind and the liberation of all those peoples of the world who until now have been forced to be simple, and of whom Picasso has always wished to be the representative. [...]

John Berger, extract from *The Success and Failure of Picasso* (Harmondsworth: Penguin Books, 1965); reprinted edition (London: Writers and Readers Publishing Cooperative, 1980) 202–6.

Dieter Roth
Interview with Felicitas Thun//1998

Felicitas Thun Can one say that your entire oeuvre is inseparable from your literary work?

Dieter Roth I always really wanted to be a poet. I couldn't stand school as a child. I went to Switzerland at seventeen for career counselling, where they advised me to become a graphic designer. I became an apprentice and then a graphic designer, though I always wanted to be a poet and had always written poetry. We founded the magazine *Spirale* in 1963. I showed the others my poems, but they found them to be too sentimental. So I simply destroyed them all and threw myself into art. I didn't write anything till 1966. The poems are now all gone. I arranged them on a board, piled them up and then nailed them down. I finally sent them down the River Aare one day, in the hope that someone would find them.

Thun Your work reveals an intense preoccupation with your Swiss environment from 1953 onwards, marked by an orientation to concrete art. Your characteristic spontaneity or unorthodox way of dealing with materials seems to be suppressed, while a self-imposed dictate from without makes itself apparent.

Roth Rolf Iseli, Peter Meier, Walter Vögeli and I ran Galerie 33 in Berne and showed our paintings there. The Op-art paintings – they don't exist anymore – were done then, red and green contrasts, which flickered crazily. I etched aluminium plates to achieve shiny and matte contrasts. This went on till I settled down in Iceland. I couldn't do any constructivist work there. One didn't get any clean colours, only rather dull, locally produced ones. So I had to work with materials available to me. I was in a rather desperate state. There were quarrels at home. I was broke, and the work was uninteresting. I saw a Tinguely exhibition in 1960 in Basel, all those self-destroying machines that slung stuff around. I was consumed with envy and became even unhappier. Tinguely had made something that seemed right to me. I said to myself – stop all that constructivist stuff! That's when the first diaries were made, as a reaction to Tinguely. The first conscious change I made – from constructivism to smearings – came in 1960.

Thun You went to America regularly from 1958 onwards and also taught there. How do you see the works of Robert Rauschenberg or Jasper Johns in the context of graphic art after 1960?

Roth American artists became famous immediately, as compared to their European counterparts. They had the strong support of galleries and worked ostentatiously. There was nothing experimental about their work. No plowing one's way through smearing around – the arduous in the life of an artist was no longer there. It's a lot more obvious to the European artist that art goes back to a time when important persons such as old kings, generals, or God were the subject matter of painting. Once that became uninteresting, because the kings abdicated, one pretended to feel called upon to paint something equally worthy, the opposite of kings – simply sows and oxen. A consciousness emerged that the exalted in art had to be forgotten and one even had to resist it.

The Americans, in my view, saw what had been made as a reaction to the deserving and exalted in our part of the world as worthy. Let's say that Malevich painted a black square, painting (so to speak) the museum shut – away with it! Rothko, on the other hand, tried to pry open this surface in an attempt to create an exalted object. This, of course, is futile. The American artists failed to comprehend that European art was on a realistic search for truth. Its path was away from the lofty and beautiful. Even Expressionism was an attempt at painting unworthy stuff. Rauschenberg and also Jasper Johns started off in desperation. I saw the American flag [painting by Johns] in New York when it had just been painted, but it all just ended in an extravagant gesture which had nothing to do with reality.

I went through something in 1950, something I had often experienced as a child, I'm sure you know it. One draws something and then begins to smudge it till one is in a frenzy. One can't stop and paints on till it is all totally destroyed. If you've experienced that you'll probably understand what I did during my smearing phases.

Smearing and destroying are the result of my failure to achieve what I want. That's why it became my method of work for years. It's the same with writing. I tried to ruin the first *Scheisse Gedichte* (Shit Poems). The feeling that I couldn't do it led me to get the students in America to ruin even the typographic work. I suddenly realized that perhaps even Malevich's black square resulted from a feeling of failure. One always arrives at something one can no longer depict. At any rate, I always regressed to naturalistic activity, like the description of day-to-day life, or of my joys and fears. One doesn't need to be skilled at that. Speech and a little bit of drawing suffice. It becomes increasingly simple. I avoid the difficult. My work has taken the course of the description of the everyday and what lies beneath it.

Thun The recurrent break in your work can, in that case, be described as a repeated linking to your emotional and subjective concept of art?

Roth Each change in my work, I think, brought it a step closer to a factual account, more unconscious initially, but it became increasingly conscious. I shouldn't and I don't think I even want to invent anything that would contribute to entertainment, to be simply hung on the wall. Till I was about fifty I oriented myself almost exclusively to what I observed in literature and art. I wanted to be part of it in order to triumph. Bad luck, excessive boozing and divorce gradually pushed me out of it. I stopped being party to the production of pictures, and my subject matter comes from my own reservoir of experience. My store of images consists of the Polaroid. I photograph all that is out there and write about all that happens. That's how I get the literature I love to produce and find the images I can use. That allows me to improvise while making the paintings, using only those images that interest me, those that have not yet become exalted. A distance is thus achieved to all those museums, to all the allures, and to the masterpieces. […]

Dieter Roth and Felicitas Thun, extract from interview (Basel, February 1998), in *Dieter Roth: Gedrucktes Gepresstes Gebundenes 1949–1979* (Cologne: Oktagon Verlag, 1998); reprinted in *Flash Art International* Vol 37, no 236 (May–June 2004) 101–5.

Abigail Solomon-Godeau
The Rightness of Wrong//1997

That certain of John Baldessari's National City paintings, recently encountered in two important group exhibitions, seem to have acquired a museological aura, a subtle patina of art-historical importance, even – improbable as it seems – a kind of authority, was probably inevitable. The perverse phenomenon by which initially transgressive cultural productions acquire an 'auratified' second life has a history at least as long as Duchamp's *Fountain*. Consequently, there is no good reason to have expected Baldessari's landmark works of 1966–68 to have resisted those complex processes that in the fullness of time transform the outrageous into the canonical. Having said that, it is no less significant that each time I have re-encountered *Wrong* (1967–68) in museum settings in the past several years, I burst out laughing. And because *Wrong* continues to have its effect upon each viewing, it obviously surpasses the realm of the one-liner. This suggests that if Baldessari's deadpan if deceptively casual expulsion of centuries of aesthetic precepts still carries its punch, it can only be because aestheticism, notwithstanding its aggregate onslaughts from Dada through various postmodernisms, is still

alive and kicking, whether in the form of guides to amateur photography (which is, in any case, only the most obvious target of *Wrong*) or more generally, in the still-potent belief that art objects, by definition, occupy a special and rarefied domain that differentiates aesthetic experience and reception from all other forms of perception and cognition. If we still laugh at *Wrong*, it is because almost everyone outside the highly specialized world of elite culture believes, *deeply* believes, that art remains integrally linked to something called 'Beauty' – an assumption which Baldessari has also addressed, no less famously, in his *Pure Beauty* of 1967–68. That the once-sovereign aesthetic concept of beauty – ends and means of all classical art styles – should have become, even before the end of the nineteenth century, the redoubt of philistines and reactionaries, may be regrettable, but its historical eclipse has been demonstrably the precondition for all that has been most vital, dynamic and culturally significant in modern and contemporary art.

Nevertheless, and despite the repudiation of aestheticism (in effect, the ideology of the beautiful) by numerous avant-gardes, it retains a residual and persistent life in cultural discourse. Although *Wrong* makes specific reference to the protocols of amateur photography, which advises the photographer on rules of composition, its frame of reference is clearly far more inclusive. The 'wrongness' of the palm tree springing so infelicitously from the head of the subject necessarily implies an art of 'rightness' and indeed, for centuries of Western art, theory, pedagogy and production were jointly shaped by academic rules, prescriptions and proscriptions governing all aspects of art-making. While this juridical aspect of elite visual culture was more or less a dead letter by the early nineteenth century, contemporary elite culture has yet retained, albeit in vestigial forms, many of its former rationales. This in turn suggests that what were once academic precepts are now deeply lodged in what might be called the collective cultural preconscious: if most peoples' snapshots do not in fact feature trees sprouting from their subjects' heads, it is because they obey, unthinkingly, the laws of 'right', rather than 'wrong' composition. Another residual trace of academic authority survives in the categorical belief in art's capacity to render the beautiful, however defined. Beauty, or, as generations of French art critics tirelessly propounded it, *le beau*, was in fact one of the totemic concepts in classical art theory: each element of a work of art was supposed to be a perfect representation of its type (e.g. a perfect leg, a perfect tree) and the art of composition a hierarchical and harmonious ensemble of its parts. This was, in effect, the recipe for beauty and its concomitant yield of pleasure, a recipe which modern art, beginning with Courbet, willfully jettisoned.

Nevertheless, while no one has ever disputed the notion that art's pleasures take many forms (including its cognitive ones), it goes without saying that most people prefer to take their pleasures in work that can still be described in terms

of beauty. The pilgrims to the recent Vermeer exhibition, like their ancestors who made their homages to the Apollo Belvedere, are akin in their desire to experience 'pure' beauty, and at first hand. Hence, the problem for those of us who identify the ideology of aestheticism with cultural as well as political conservatism is not just that [the conservative US politician] William Bennett thinks art should be beautiful, but that our relatives think it, our colleagues think it, our students think it, and – in the broadest sense – our culture thinks it. Indeed, it may be the case that the further we move from the historical moment that enshrined *le beau* as the means and ends of art, the stronger the nostalgia for its once sovereign status. Like the parallel investment in an auratic art, and despite Walter Benjamin's prognostications, the lost ideal of beauty would seem to shimmer more brightly in the astral glow of cyberspace, digital imaging and virtual reality.

Wrong, however, is certainly as anti-auratic a work as one could find; its mechanical processes and low-rent facture (photo on canvas, lettering by a local sign painter) no less than its stunningly banal photograph offhandedly declare its mongrel status within the elite precincts of easel painting, which like a royal menagerie, is characterized by its concern with lineage, breeding and ancestry. The negation of the artist's touch (both photo and lettering are the work of other hands), uncompromisingly rejects the fetishism of authorship as much as it does the fetishism of the beautiful object. Instead, *Wrong* offers a different range of pleasures: the jouissance of anarchic subversion, the libertarian joy of upsetting rules, hierarchies and conventions. Like a number of other artists whose work is actually funny rather than merely witty (one thinks here of Claes Oldenburg, William Wegman and Vito Acconci in the former context), Baldessari's National City paintings appear, more so than ever, a kind of utopian practice, transforming the banality of the quotidian with the critical energy that has long characterized the most invigorating aspects of modern and contemporary art. For it is not the ideology of aestheticism that has the capacity to resist either the threat of the 'totally administered society', or the commodification of all aspects of human life that distinguishes our bleak *fin-de-siècle,* but rather, the anti-authoritarian, democratic and ludic impulses exemplified in Baldessari's *Wrong.*

Abigail Solomon-Godeau, 'The Rightness of Wrong', in *John Baldessari: National City* (San Diego: Museum of Contemporary Art/New York: D.A.P., 1997) 33–5.

Sarah Thornton
On John Baldessari//2008

Baldessari has mentored countless artists, and although he now teaches at UCLA, he is still seen to embody the think-tank model that has spread all over the United States, although it exists in one of its purest forms at CalArts. One of his mottos is 'Art comes out of failure', and he tells students, 'You have to try things out. You can't sit around, terrified of being incorrect, saying, "I won't do anything until I do a masterpiece".' When I asked how he knows when he's conducted a great crit class, he leaned back and eventually shook his head. 'You don't know', he said. 'Quite often when I thought I was brilliant, I wasn't. Then when I was really teaching, I wasn't aware of it. You never know what students will pick up on.' Baldessari believes that the most important function of art education is to demystify artists: 'Students need to see that art is made by human beings just like them.' […]

Sarah Thornton, extract from *Seven Days in the Art World* (London: Granta Books/New York: W.W. Norton, 2008) 52.

Stuart Morgan
The Man Who Couldn't Get Up: Paul Thek//1995

There are artists who grit their teeth, plot their strategy, make their work and become successful. And there are artists like Paul Thek. Fugitive, unworldly, Thek collaborated with others for much of his life and died in 1988, a disillusioned man. Now a retrospective exhibition, originating at Rotterdam's Witte de With, re-examines his career with the help of photographs, film, diaries, sculptures, installations and paintings.

As a project, it is fraught with difficulties. Not that Thek's initial success and eventual failure were part of a period that is lost. It is the meaning of that life at that time which is lost: a life of travel, communes and festivals, of drugs and promiscuity, but above all, perhaps, of expectations of the future. Now we feel we know better; the high hopes of the 1960s were unfounded. Worse still, with the passage of time, what Thek called 'the wonderful world that almost was' became a joke, a dream, a hieroglyph without a key.

The year is 1963. In the catacombs at Palermo a good-looking young man is standing, arms folded, with skeletons ranged behind him. As a portrait, the snapshot seems far from successful: the subject seems out of place because his mind is elsewhere. The second attempt by the same photographer, a head and shoulders shot taken eleven years later, shows the subject, still handsome in his way but baggy-eyed, with thinning hair and a lined forehead. Only one clue reveals that it is the same person. For by now the loss of focus that had previously seemed charming has become an inevitability; he looks straight through us because he cannot escape his own mind. Perhaps he is still in Palermo, among the catacombs. 'There are about 8,000 corpses', he wrote, 'not skeletons, corpses decorating the walls, and the corridors are filled with windowed coffins. I opened one and picked up what I thought was a piece of paper; it was a piece of dried thigh.' As always his reaction was unusual … 'I felt strangely relieved and free', he wrote. 'It delighted me that bodies could be used to decorate a room, like flowers.'

By the late sixties everyone knew the work of Paul Thek. Pictures of his work appeared in art magazines. Critics interviewed him. In 1966 Susan Sontag even dedicated her greatest book, *Against Interpretation*, to him. But then what? 'He fell wounded', reads one of his notebook entries from 1979. 'Some tried to help him up, but he was wounded to the core, they tried – then, one by one – they left him, drifted away into their own lives, their own hoped for successes, and failures, but he had fallen, they (some of them) urged him on, urged him UP, tried even to SEDUCE him once again into living, and Life as always knew what she was doing; the Pleroma lit up in his brain, like a vaginal dentifrice.' Half farce, half pathos, the tone recalls the sick humour of the sixties: the tone of Joseph Heller or Terry Southern, with Nathanael West lurking in the distance. It is also the work of a self-dramatizing figure, someone carried away by the sheer theatre of it all. Yet despite the fact that the strain and self-pity seem calculated, no amount of artifice can conceal the truth: this is a cry for help.

Signs of strangled emotion were evident from the first, with decorative paintings in bilious colours reminiscent of early, fairytale Kandinsky. They reappeared in chastened form in a series of paintings called *Television Analyzations*, begun in 1963. One image is of a society woman – all mouth, bosom and necklace – leading what looks like a growing procession of clones, all, like her, giving cheesy grins and making cathedrals with their long fingernails. Everything is grey except for her vivid, red necklace, only part of which is visible. In another 'analyzation', again of only part of a woman's face, her open mouth and fleshy tongue are featured, while another shows a hand cradling a fruit bat. His notebooks leave readers in no doubt of Thek's attitude to women; a mistrust so deep it verged on loathing. Regard the paintings as glimpses of the vagina, and the distancing effects – the sense of protection offered by the regressus in

infinitum, the painted equivalent of interference on a television screen, the sense of flesh tightly furled or gaping, like an open mouth – all become explicable. So do the bared fangs, as if the viewer (or the painter himself) is confronting some animal force. The preliminary to eating is baring one's teeth, after all, or smiling. Thek used eating as a way of understanding consumption and society in general with an attack so audacious that it ranks as a masterstroke.

A container lies on its side, bearing the same lettering as all the others. 'New', it tells us, '24 Giant Size Pkings / Brillo Soap Pads with Rust Resister / Brillo Mfg. Co. Inc. NY / Made in USA'. Gazing into the Plexiglas bottom of the case, we are appalled. The motifs of the mouth with tongue and the television as framing device have shifted to three dimensions in order to mount a full-scale attack on consumer culture. 'No ideas but in things', Warhol implied. 'No ideas but in flesh', Thek countered. In the *Technological Reliquaries* series, to which this piece belongs, elaborate containers, often of coloured plastic, house lumps of what resembles raw meat. The choice of the Brillo box was deliberate. Yet though Thek had visited the Factory and met Warhol, there can be little doubt that he meant this as a reproach, not only on Warhol himself but also on his particular interpretation of Pop, a reading which would become conceptual art.

Another ritual which underlay Thek's work was that of the funeral service. ('My work is about time', he wrote in a notebook, 'an inevitable impurity from which we all suffer.') *The Tomb* (1967), one of the best known installations of the sixties, featured a ziggurat-shaped room in which a life-sized model of the artist himself was presented like a corpse lying in state, surrounded by relics of his life. The work was personal to a degree. (Thek's bedroom as a child had been ziggurat-shaped and as a grown-up he had even made cases for his work which contained transparent, upturned ziggurats to be looked through like a framing device.) Interpreted as a farewell to sixties culture, or even a monument to the Vietnam War, it was wrongly subtitled *Death of a Hippie* by the Whitney Museum when included in a group exhibition. To Thek's annoyance the name stuck. It marked the climax of a period of casting body parts – a wax arm and hand in armour, for example, decorated with butterfly wings. *The Tomb*'s beeswax cast of the artist's own body, with plaited hair, gold adornments, personal letters and a bowl was succeeded by another Thek surrogate: *Fishman* (1968), a religious icon cast from his own body, of a flying or prone male covered with fish. ('And I shall make you fishers of men', Jesus told his disciples on the shores of Lake Galilee.) *Fishman* was shown a second time face down on the underside of a table high above the viewer's head. By then Thek's supporters were beginning to realize that their interpretations and the artist's own were poles apart, or that some other, larger significance was intended. There was another problem: now that the relation between Thek and his work was becoming clearer, viewers were rejecting his insistence on the first-person singular.

But another artistic confrontation helped strengthen Thek's resolve. In 1968, he had been invited to show at the Galerie M.E. Thelen in Essen, but his work had been damaged in transit. Even so, he decided to open the gallery and sit day after day, mending the pieces. *A Procession in Honour of Aesthetic Progress: Objects to Theoretically Wear, Carry, Pull or Wave* marked the beginning of his interest in process and the word 'procession', which he used to describe subsequent group activities. The sheer oddness of the Essen presentation is hard to convey. Chairs were adapted to be worn so that the wearer's head protruded through the seat, and, for the first time, newspapers littered the ground. (These would enter his artistic vocabulary on a permanent basis.) Thek had recently seen Beuys' work for the first time, and, as in the case of Warhol, had reacted strongly, less with the artist's mind than with his untethered sexuality: 'It seemed to me that all it needed was glamour and worth and charm and a woman's touch', he commented. Yet there was less separating them than he imagined. Beuys was striving to make a visual language. So was Thek, though his way of doing so seemed more like adopting a family. Removed from the Tomb, the figure of the hippie became a main protagonist. So did Fishman, and so did a giant latex dwarf called 'Assurbanipal' because of his Assyrian beard … In the same way Thek was adopting people, living and making work with them by constantly adapting and re-adapting existing elements and aiming for fullness of meaning using a Jungian approach to world myth.

Only photographs remain of the Processions. Influenced by the films of Jack Smith and the theatre of Robert Wilson, Thek pushed improvisation to its limits. The word 'procession' – a stabilization of the term 'process' – and the journey taken through his installations referred to the liturgical and celebratory in equal measure. (Led by Assurbanipal, *The Procession/The Artist's Co-op* (1969) consisted of a line of chairs, a table with bottles and serviettes and the remains of a night's drinking, while *The Procession/Easter in a Pear Tree* (1969) even included a large cross.) Thek, who enjoyed the fiesta mentality and the way Italian homes were decorated for holidays, refused to recognize any dichotomy between worship and celebration, religious and secular. *Another Pyramid* (1971) followed, this time life-size, with trees and washing hanging out to dry; a table and chairs; more newspapers; another procession led by Assurbanipal; the Fishman hanging from the ceiling, a fountain, a pink volcano … There seemed to be no boundaries.

Biographers might argue that Thek's distressing early life led to a need for family, security, comfort, faith, above all a stable domestic environment, that he found these in the company of the changing members of his co-operative, but moreover, that the kind of stability he craved seemed almost mediaeval, with a calendar that was cyclical rather than linear. This approach might possibly have led to an antiquated, even static attitude to art. On the one hand, the Processions

offered a permanent opportunity for the team to recycle its own works. On the other, they might have provided chances for the employment of principles of repetition akin to those of (say) Indian ragas. In addition, like pre-twentieth century artists, Thek and his team seem to have made decisions according to a shared theory of beauty, though, in contrast to those of pre-twentieth century artists, their aesthetic was their own invention.

The urge to solve the problem of vocation seems to have troubled Thek for years. 'Thicker. Deeper', he wrote in a letter to his longtime collaborator Franz Deckwitz early in 1972. 'I want to make a real place to rest and worship in, not just art.' Indeed, at stages in his life a powerful tension existed between his career as an artist and his urge to retire from the world. By this time his faith was being buttressed by periods of meditation in a Benedictine monastery in Vermont. Despite his failure to make a living and letters from museums saying they could no longer manage to keep his installations in permanent storage, it still seemed to him that with his large-scale retrospective organized by Suzanne Delahanty at the ICA in Philadelphia the tide might have turned. He was wrong. Around 1975–76, his luck gave out. By 1978 he was working in a New York supermarket, then cleaning in a hospital. After that, his hopes of entering a monastery were dashed by a doctor's confirmation of his status; he was HIV Positive.

By this time Thek had been reasserting his dedication to the naïve, as a means of making art as well as leading one's life, with the series of bronze sculptures called *The Personal Effects of the Pied Piper*, regarded as a lay saint who allowed the rats to devour his possessions. As usual, his hyperactive mind refused to settle on a single theme for very long, and the Piper became confused with Mr Bojangles (from the song by Jerry Jeff Walker) and *Uncle Tom's Cabin*. Somehow the Tar Baby (from *Uncle Remus*) also became part of the mix. By this time the newspapers which had been a permanent feature of the installations were being used as a paint surface. Sometimes religious, usually satirical, frequently apocalyptic, permanently disillusioned in its vision of a New York that featured the half-built World Trade Center towers he called Sodom and Gomorrah, Thek's approach was that of a man at the end of his tether. (Ten years later he presented his own completely unrealistic Richard Serra's *Tilted Arc* project, retitled *Tilted Ark*, with holes bored through it in the shape of stars, a small zoo and a park with flowers.) Yet the uneven standard of the paintings should not blind us to the genuineness of the vision: *Uncle Tom's Cabin in Flames* and *Bo Jangles in Flames* (1979) are premonitions of an American apocalypse; by 1980, Thek was making paintings with titles like *Turquoise Potato Peelings in a Sea of Piss and Shit*. (His titles are a delight. Who could forget *Church of the Holy Molar, Fascist Grapes* or *Neolithic Porno*?)

But there is no point in pretending that the last years of Thek's life gave rise to his finest art. Forget the last years of bitterness and disillusion and illness and return to his retrospective in Philadelphia in 1977. Imagine the camp and tacky raised to the point of intellectuality and far beyond: to a state of childlike belief, as viewers encountered a sea of sand – 'It's water you can walk on; it's time', Thek explained unhelpfully – a barge with kitsch forests and stuffed animals, the wooden model for Tatlin's tower, King Kong, a homage to Picasso, the Warhol Brillo Box again, a bathroom and a shanty and a stuffed bird and … If people had told him to stop, Thek would have taken no notice. For, as his paintings show, he already felt that time was running out. He was right. He never retired to a monastery as he had planned, nor did he make peace with those who had hurt or ignored him. (Like Dr Johnson, he was 'a good hater'.) Did he ever relax into the situation as it was, or did he continue to look straight through it to something else, somewhere else, as he seemed to have done for the whole of his strange, confused, cryptic, inspiring life?

Stuart Morgan, 'The Man Who Couldn't Get Up', *frieze*, no. 24 (September–October 1995) 47–50. Reprinted by permission of the Estate of Stuart Morgan and *frieze* (www.frieze.com).

Ray Johnson
On *Another Throwaway Gesture Performance* (1979)//1984

I did one of my most bizarre lectures up at the Rhode Island School of Design. It consisted of my trying to move a piano across a stage, and people kept coming up to ask if they could help, and I said, 'Certainly not! I mean the point is that I *can't* move this piano, and I'm struggling to move it, and it's obviously not going to get moved across the stage, and I'm putting out a great exertion of energy, and I'm on a public platform, and you are all viewing me, which is the whole point of this thing.' I said. 'You figure it out.'

Ray Johnson, statement recorded in Henry Martin, 'Should an Eyelash Last Forever: An Interview with Ray Johnson' (February 1984); in *Ray Johnson: Correspondences* (New York: Whitney Museum of American Art/Columbus, Ohio: Wexner Center for the Arts/Paris: Flammarion, 1999) 183.

Clive Gillman
David Critchley: *Pieces I Never Did* (1979)//2005

[…] David Critchley's most well known work, *Pieces I Never Did* (1979), was originally conceived as a three-channel installation, using the new resource of U-Matic colour video editing that was accessible at the Royal College of Art. Developed over a lengthy period in 1978, it remains a complex and engaging work, allowing readings on many levels, but is perhaps dominated by the artist's own perception that it was made 'as a testament to my involvement with performance, with film and with video from a principled perspective which I no longer maintain in relation to these media'. In the piece the artist talks directly to camera about a whole series of works that he has conceived but never made, while on the other monitors these works are played out for the camera. The piece is exceptionally entertaining and even daring for a video work of this era, but at its heart there remains a compelling glimpse into the mind of an artist wrestling with the core of his practice. In the single-channel version of the piece – the one that most viewers will experience today – the monologue is intercut with repeated elements of one of the pieces he never did – the artist stripped to the waist screaming the words 'shut up' until he is hoarse and unable to emit more than a squeak. As the work evolves, this voice returns again and again as a manifestation of the challenge he is presenting to himself to find meaning in the reflexive, structural analysis of his form. The presentation of so many actions, each of which could so easily have formed individual works, as non-actions, lays open the predicament of an artist who has discovered little value in the domain of his success and seeks to find another corner to turn. The 16 individual pieces – which include shouting, throwing oneself against a wall until it crumbles, running away from a camera that keeps catching up, onanism, standing in corners – each individually speak of a challenge to find the 'principle' inherent in a formal interrogation but collectively portray an artist in command of his medium, yet approaching a conclusion of rejection.

That the rejection came shortly after this work's completion is now a matter of personal and anecdotal histories. Critchley admits to having burnt in 1983 all his paper and documentary photographic work and placed all his own copies of his videotapes (including master tapes in his possession) in plastic sacks outside the London Video Arts building in Soho, for the garbage collectors to take away. […]

Clive Gillman, extract from 'David Critchley', commissioned essay for LUX online (London: LUX, 2005).

Marcus Verhagen
There's No Success Like Failure:
Martin Kippenberger//2006

Martin Kippenberger liked to overplay his hand. He did it on principle, turning comedy into farce and grand drama into *opéra bouffe*. Ever the Oedipal rebel, he treated artists of the past as parental figures who had to be provoked. And he gave his work a throwaway quality; even his biggest projects come across as doodles, as disposable pieces, put together on a whim. One of the common refrains in the literature on Kippenberger is that, for all his humour, he was a deeply serious artist. That misses the point; it is precisely because he viewed seriousness as a vandal views private property that his work retains a trashy, carnivalesque power. On the rare occasions when he tried to strike a more solemn note, he made strangely tepid pieces.

When confronted with exalted reputations or principled positions, Kippenberger responded like a person with Tourette's Syndrome. In 1984 he painted a mock-Cubist piece, a swirling mass of red and grey beams against a black background, and called it *With the Best Will in the World I Can't See a Swastika*. For no discernible reason, he represented the Nazi emblem in dislocated form and then, in the title, feigned the incomprehension of the untutored viewer who couldn't, 'with the best will in the world', make sense of a difficult canvas. At a time when many in Germany, including of course Anselm Kiefer, were trying to find responsible ways of remembering the atrocities of the Third Reich, Kippenberger treated the subject in flippant, deliberately mystifying terms, while using the title to snub a certain class of gallery-goer and to disown, or pretend to disown, his own provocations. In fact, the painting was so turgid, its aping of Cubist devices so crude and laboured, that the viewer was bound to wonder whether it wasn't just a pretext for its title.

Many of his taunts were aimed at other artists. For his seminal 1987 show, 'Peter', he crammed Max Hetzler's gallery in Cologne with customized furniture, jerry-built sculptures and assorted other knick-knacks. Among the pieces was *Wittgenstein*, a lacquered wood construction that looked like a modular piece by Donald Judd but also, and more clearly, like a slightly flimsy closet – it even had a clothes rail. While the title inflated the intellectual span of Judd's work, the sculpture itself effectively likened the artist to a maker of cheap furniture. And in another, still more brazen piece of Oedipal sabotage, Kippenberger acquired one of Richter's grey paintings and used it as a table top; that too was in the show in Cologne.

At least Kippenberger was even-handed. He offended progressive, liberal and conservative sensibilities, he scoffed at artists and curators, and most of all he

made fun of himself – his appearance, his lifestyle and his artistic pretensions. He was his own favourite model, playing a variety of roles from the tragic hero to the drunken oaf and hamming them all up. When he was beaten up for raising the price of beer at S.O.36, the Berlin nightclub he ran between 1978 and 1979, he commemorated the event in a series of paintings and photos of his swollen, bandaged face. Surely remembering Vincent van Gogh's images of his own injured head, Kippenberger recycled the old figure of the artist-martyr only to undercut its pathos by suggesting that even then he was playing to the galleries. For the early series *Dear Painter, Paint for Me* (1981), he collected snapshots of himself in various locations and commissioned a billboard painter to recreate the images on large canvases. In one, he spread himself out on a discarded sofa amid piles of rubbish on a New York pavement, looking every bit the cut-price *flâneur*. He had a talent for pratfalls and schmaltz, for playing puffed-up parts in a trivializing key.

Whether he painted himself chained to a beer can or dropping his trousers, he gave his outward persona an aura of boozy inanity and hinted at the pleasure he took in his own ridicule. Inspired by a photo of a proud, ageing Pablo Picasso standing in his briefs next to his greyhound, Kippenberger took to painting himself in oversized underwear. Exposing his growing beer gut, he adopted bold, defiant postures, but the effect was burlesque: he presented himself not as another naturally imposing figure but as a poseur for whom Picasso's confident masculinity was a pipe dream. That was the point of the constant Oedipal jibes – he played them for laughs. They were never meant as effective slurs; rather, they were designed to reflect back on the artist himself, to show him up as an infantile character whose jeering only exposed his own failings.

Kippenberger was always on the move, working for periods in Italy, Brazil, Greece, Spain and Austria, and the same restlessness is apparent in his work; he never settled on a given manner or medium. Looking over his career, you get the sense that he worked not to build on an idea but to exhaust it and move on to another. All the same, he developed over the years a repertoire of preferred motifs, including the frog, the fried egg and the lamp post, and some of them plainly served as self-images. In fact, he made relatively few pieces that weren't in some sense self-portraits. Certainly, the crucified frog with a beer mug was a stand-in for the artist; so were the 'drunken street lamps' that merged the perennial comic duo of the drunk and the lamp post into a single, wavy fixture. That preoccupation with his own projected persona, whether it was clearly identifiable or displaced onto another figure or object, lasted throughout his career.

Kippenberger was not just a frantic iconoclast and *Selbstdarsteller* (self-performer/promoter) as the critic Diedrich Diedrichsen called him, he was also a viciously funny observer of the social rituals of post-war Germany, and more particularly of the outlook and aspirations of the German lower middle class. The

Dear Painter... series included a huge close-up of pens clipped to the outside pocket of a suit; that was Kippenberger's shorthand for the application and competence of the clerk or middle manager. But the suit was a cheap one (the kind the artist himself affected to wear), suggesting that the clerk's work was poorly paid and that his pocket display of efficiency was the expression of a tenuous standing and a leery, defensive pride. And Kippenberger returned again and again to the Ford Capri, the quintessential budget coupé of the 1970s, which appeared in drawings and photos, even in an installation (*Capri by Night*, 1982), standing for movement and escape and, by extension, for the dream of upward mobility. Yet no one who could afford a classier model would ever have dreamt of buying a Capri. It was to the expensive sports car what Kippenberger-in-underwear was to the old Picasso – an image of aspiration that had failure written all over it.

Failure, of course, was an obsessive concern for Kippenberger, who cast himself as a failed artist and his work as failed objects and images. Here was a man who could paint with fluency but revelled in the grossly ham-fisted brushwork of pieces like *With the Best Will in the World...* He presumably agreed with the critics who saw him as a hack and a dauber. In 1982 he made *Orgone Box by Night*, a large container that was filled with discarded paintings and named after a contraption, invented in 1940 by the wayward psychiatrist Wilhelm Reich, which was designed to effect healing through the concentration of primal energies. (What, you have to wonder, would have pushed Kippenberger to bin a painting?) This was failure squared, his rejection of the paintings hilariously compounded by the failure of the box to redeem them and by the artist's identification with a discredited thinker. But you only have to remember what success meant for Kippenberger – the crimped, delusional visions of social advancement and material comfort, of one day owning a Capri – to see why failure had such appeal.

His most sustained essay in dysfunction was the inspired *Metro-Net* project (1993–97), a series of subway entrances and ventilation shafts. One entrance was built in a field on the Greek island of Syros, another in the small Canadian town of Dawson City; both were made using local techniques and architectural forms. They were stopping-off points in a hare-brained system of global integration, their vernacular details offering a witty gloss on their very remoteness from the true hubs of global transport and communications. Adding another absurd twist, the artist then created *Transportable Subway Entrance* (1997), a fragmentary transport node that was designed to be ferried around by another means of transport. And, in a luminous final gesture, he crushed the transportable structure so that it could fit through the entrance to Metro Pictures in New York, where it was to be shown. The puns here – the entrance that didn't fit into an entrance, the subway station at Metro Pictures – surely appealed to Kippenberger. But the

crowning joke was this: having created a grandly dysfunctional variation on a wholly functional theme, he all-but-destroyed it in an effort to squeeze it into an art gallery, that is, into the one place that could accommodate its uselessness.

Kippenberger was a little like Alfred Jarry's Père Ubu: a vastly restive and energetic figure who tipped everything he touched into a bilge of crude sentiment and doubtful humour, never missing a chance to rubbish a lofty view and always preferring the infantile to the measured and the pointless to the productive. He had chutzpah even in his self-doubt, in his endless parade of comically abject self-images. His work was a counterpoint to the Neo-Expressionist grandstanding of older German artists like Kiefer and Georg Baselitz, its trashy quality serving as a way of recognizing that various artistic projects, including painting and self-portraiture, had reached a point of possibly terminal crisis while still using them as vehicles for passages of hammy, delinquent brilliance.

Marcus Verhagen, revised and retitled text originally published as 'Trash Talking: How Martin Kippenberger Found Success in Failure', *Modern Painters* (February 2006) 67–9.

Emma Dexter
Authenticity and Forgery: Luc Tuymans//2004

Luc Tuymans demands a certain coolness, a detachment in his work, which is also found in the work of historical artists he admires such as El Greco, Velázquez, Léon Spilliaert and even Magritte. Tuymans describes this quality as 'indifference'[1] and achieves this bloodlessness through a variety of means, most obviously through a reliance on photography as a constructive tool in the creation of an image, but also by rigorously limiting the time spent painting each image to a single day. Tuymans paints from photographs rather than from the actual object (thereby overcoming the modernist injunction against depiction by only depicting representation). This indirectness is continued through the representation of incidentals rather than the main subject, and through the use of substitutes and stand-ins such as models, dolls, mannequins or other people's drawings for the real thing. Even the enormous *Still-life* is a form of stand-in, a picture of absolute vacancy created in response to the events of 9/11, yet refusing to represent them at all. Tuymans relishes the ambiguity that only painting can offer: are we looking at a painting of a real person or a painting of a photograph or a painting of a model of a person? Is the painting to be believed in, or is it part

of some elaborate and self-referencing sham? Paintings of stills taken from television or films, such as *Animation* (2002) or *Blessing* (1996), which are blurred, indistinct and ambiguous, ensure we never know what we are looking at. The inadequacy of Tuymans' painting becomes its strength at this point, for in its weakness and ineptitude it can shift effortlessly between the roles of icon, index or symbol. Critic and curator Stephen Berg has described Tuymans' practice as having a profoundly boneless semiotic character.[2] Clearly it is this quality of deviousness which allows Tuymans' practice to withstand the critical buffets of any post-structuralist critiques of painting.

At the very beginning of his career as a painter Tuymans realized that nothing new was possible in painting, and as a result he created the oxymoronic notion of 'authentic forgery'.[3] This cleverly encapsulates Tuymans' dual role: to engage with the practice of painting, but at the same time to signal his understanding of its redundancy or 'belated' quality. The term simultaneously suggests a distancing from the act of painting and a self-conscious association with the formal and anecdotal language of the amateur and the bourgeois. Critics have even noted that technically and stylistically Tuymans creates 'forged' paintings through works that have a distinctly faded palette, denoting paintings prematurely aged, as if they had been painted with a stain rather than paint (for example, *Gaskamer*) or distinctive craquelure as in *Body* (1990). Tuymans has said that as his practice is a painting of memory, he wants the paintings to 'look old from the start'.[4] In addition, other works, notably *Petrus & Paulus* (1998), and the works from the *Passion* series discussed below, were executed in the style of the notorious Dutch forger Hans Van Meegeren (1899–1947), and therefore in this case we are even looking at 'forgeries' of 'forgeries', While Richter's own 'second order representational strategy'[5] Involves a knowing oscillation between Photo-Realism, abstraction and gesture, Tuymans' version is much more multi-layered and elusive. According to critic and curator Ulrich Loock, Tuymans' alibi for painting rests not just on the representation of representation (the index), but also on other less distinct or conceptually beneficial qualities such as clumsiness, lack of commitment, amateurishness and deliberate inconsequentiality.[6] Embedded in the notion of 'authentic forgery' is the idea of memory and its failure.[7] Authentic forgery becomes a correlative, a form of allegory for failure of memory, for memory is always partial, and can indeed be deceptive, creating a kind of forged or false version of experience to replace actuality. But a false memory is very different from the act of forgetting and then remembering. What Tuymans does is create paintings that recreate the act of remembering. An important early painting, *La Correspondance* (1985), depicts remembrance both on a literal and metaphorical level. *La Correspondance* is a painting of a postcard which is one of numerous examples sent by the Dutch author J. van Oudshoorn

(1876–1951) to his wife, to record the lunch table at which he sat in the same restaurant day after day when he was away from home for a long period of time.[8] The image is an enactment of remembering, of homesickness, while the addition of the overlaid screen of decorative motifs acts symbolically as a veil between the present and the past. The series of paintings which depict Christ's Passion – for example *Christ* (1999), *Petrus & Paulus* and *Judas* (1999) – are another re-enactment of remembrance, for they are really paintings of the performances of the Passion Plays at Oberammergau in Germany, described in a stylistic language borrowed from a notorious forger. The performances are themselves an elaborate and ritualized enactment of memory, but they are also tainted by their association with anti-Semitism and the Nazis. Not only did these religious productions continue without interruption during the era of National Socialism (ironically not far from Dachau concentration camp), but they were also visited by Hitler in 1934 and praised for their demonstration of vile Jewry and Roman superiority. Tuymans' use of imagery from Oberammergau specifically raises the spectre of Christian apathy/responsibility in relation to the Holocaust and references the centuries-old myth of Jewish guilt which has been the excuse for anti-Semitism since the Middle Ages, and which the Nazis were happy to exploit. In these paintings, the image itself starts to dissolve and all we are left with is the thin veil of history: a palimpsest created from propaganda, myth and forgery. Tuymans has layered these images with so many bluffs and double-bluffs that the true subject of the paintings has become invisible.

Loock has pointed out that Tuymans' paintings are allegories for a memory that has lost its object forever: Tuymans' gaze is melancholic, contemplating empty rooms and isolated objects; a lack of connection is clearly delineated.[9] Loock goes on to point out the way in which Tuymans destabilizes the whole question of representation: the artist uses cinematic contingency, aesthetic disguise, writing and metonymic failure to undermine painting and create an allegory of its insufficiency. So painting as reproduction fails continually in his work, and this failure, this disguise, allows him to depict the unrepresentable, for example, the Holocaust.

We need to view Tuymans' entire oeuvre as an act of remembrance, flitting as it does in its subject matter from the significant and collective to the incidental and absurd. And somehow because of this heterodox, over-arching schema, each painting becomes a space for remembering, while the space outside the painting, the empty gap between the canvases, represents all the stuff of the world that Tuymans does not depict, so becoming the space of forgetting or oblivion. Another analogy with Kafka seems apposite here: Walter Benjamin points to the question of memory and forgetting in *The Trial* (1925). K is told things by other characters no matter how surprising or astonishing they are, as if he should know

them already: 'It is as though nothing new were being imparted, as though the hero were just being subtly invited to recall to mind something he had forgotten.'[10] Perhaps this description fits the character of what we experience when presented with a selection of Tuymans' paintings. For, as in Kafka, strange and absurd details stand out against a deceptive normalcy of narrative, narration and description, and there is always the sense of something being uncovered and remembered which had been known, but was lost and needs to be recovered again. This is the function of the history painting: the Holocaust, the Passion of Christ, the barbarism of colonialism; these are all embedded in Tuymans' vision of the everyday, and come back to haunt us. What Kafka predicts, Tuymans records. The two meet in the unreflective surface of the dark glasses that Tuymans has painted onto Reinhard Heydrich in *Die Zeit*. Benjamin adds: 'Oblivion is the container from which the inexhaustible, intermediate world in Kafka's stories presses towards the light.'[11] The phrase 'inexhaustible world' expresses the cumulative quality of Tuymans' vision. [...]

1 [footnote 14 in source] 'Juan Vincente Aliaga in Conversation with Luc Tuymans', in Ulrich Loock, Juan Vincente Aliaga, Nancy Spector, Hans Rudolf Reust, *Luc Tuymans* (London and New York: Phaidon Press, 2003) 15.

2 [15] Stephan Berg, 'Twilight of the Images', *The Arena* (Kunstverein Hannover, 2003) 11.

3 [16] 'Juan Vincente Aliaga in Conversation with Luc Tuymans', in Loock, et al., *Luc Tuymans*, op. cit., 8.

4 [17] Ibid.

5 [18] David Green, 'From History Painting to the History of Painting and Back Again: Reflections on the work of Gerhard Richter', in David Green and Peter Seddon, eds, *History Painting Reassessed: The Representation of History in Contemporary Art* (Manchester: Manchester University Press, 2000) 33.

6 [19] Loock, et al., *Luc Tuymans*, op. cit., 37–8.

7 [20] Ibid., 44.

8 [21] Luc Tuymans, 'Disenchantment' (1991), in ibid., 118.

9 [22] Loock, 'On Layers of Sign-relations, in the Light of Mechanically Reproduced Pictures, from Ten Years of Exhibitions', in Loock, et al., *Luc Tuymans*, op. cit., 56–7.

10 [23] Walter Benjamin, 'Franz Kafka' (1934), in *Walter Benjamin: Selected Writings. Volume 2: 1927–1934* (Cambridge, Massachusetts: Belknap Press of Harvard University Press, 1999) 809.

11 [24] Ibid., 810.

Emma Dexter, extract from 'The Interconnectedness of All Things: Between History, Still Life and the Uncanny', in Emma Dexter and Julian Heynen, *Luc Tuymans* (London: Tate Publishing, 2004). Reproduced by permission of Tate Trustees.

Michael Wilson
Just Pathetic//2004

In the 1990s stretch of a time line featured in the handy primer *Art Since 1960*, the steady march of mini-movements – 'Young British Artists', 'art post-medium', 'live art', 'context art' – is rudely interrupted by an upstart newcomer, 'abject/ slacker art'. As the volume's author, Michael Archer, plots it, the tendency first showed up at the butt end of the 1980s and burned out by about 1996, though the influence of its lax affect is felt still. Centred stylistically on a shabby-chic variant of Pop, abject art marked a transition (at least in the art world) from the 1980s careerism of *American Psycho* (Bret Easton Ellis' book hit stores in 1991) to the jaded slackerdom of Kevin Smith's 1994 movie *Clerks*.

The label 'abject art' suggests a fittingly belated use/abuse of Julia Kristeva's book on the scatological impulse, *Powers of Horror: An Essay on Abjection* (first translated into English in 1982), and curator/movement-maker Ralph Rugoff confirms that Kristeva was indeed 'very important for critics and curators interested in the abject'. Of his own exhibition 'Just Pathetic', he offers, 'Georges Maine was closer to the pathetic spirit; that also comes from a history of philosophical thought that deals with the roots of comedy, including Baudelaire's notion of "satanic laughter".' Nevertheless, to the academic mandarins such theoretical borrowings felt promiscuous. Denis Hollier bristled in the pages of *October*; in response to 'Abject Art', a 1993 exhibition at the Whitney Museum of American Art organized by Independent Study Program fellows Craig Houser, Leslie C. Jones and Simon Taylor, he complained, 'What is abject about it? Everything was very neat; the objects were clearly art works. They were on the side of the victor.'

At the cusp of the decade, three exhibitions mapped out abject art's overlapping territories: Rugoff's 'Just Pathetic' at Rosamund Felsen, Los Angeles, along with 'Work in Progress? Work?' at Andrea Rosen and Vik Muniz's 'Stuttering' at Stux, New York. All three opened in 1990, and between them they introduced a handful of artists who would become this anti-movement's major players. Mike Kelley and Cady Noland were Rugoff's key protagonists, while Karen Kilimnik and Cary Leibowitz were the divas of Muniz's drama. And at Rosen, the then twenty-eight year-old Sean Landers launched a rigorous programme of self-deprecation with which he has persisted, Morrissey-like, well into his middle years. 'True Stories', at the ICA, London, in 1992, and 'Abject Art' at the Whitney were arguably more definitive surveys, but it was this first odd trio that set the (low) tone.

In 'The Loser Thing', an early survey of the tendency (*Artforum*, September 1992), Rhonda Lieberman defines abjection as being 'cast off, existing in or

resigned to a low state – dumped by yourself, as you psychotically misrecognize yourself in ideals'. Citing Marcel Proust (who embarked on the translation of Ruskin's art-historical writings despite being insufficiently fluent in spoken English 'to order chops in a pub') and Samuel Beckett (who bought the same size shoes as James Joyce, literally walking 'in the master's footsteps' until his feet got too sore), she characterizes these acts of high-end homage as 'constitutionally abject', attitudinal precursors to their pathetic descendants. Leibowitz, Landers and the rest are marked by their ability to translate inadequacy into art, throwing the previous decade's slick critiques of modern mastery into harsh relief.

Introducing his show, Rugoff writes that to be 'pathetic' is to be 'a loser, haplessly falling short of the idealized norm', and that the art he identifies as belonging to this degraded taxonomy 'makes failure its medium'. It does so, he argues, in several ways. First, it exhibits a preference for lowbrow aesthetics and threadbare materials but pointedly avoids dignifying either one as metaphoric or poetic. Second, it veers away from established modes of art production toward a strain of base comedy more often experienced at the back of a school bus. Finally, it makes little or no attempt to align itself with art history, preferring an ephemeral and defensive association with the present, however lacklustre that might be.

The clutch of works by Mike Kelley that appeared in 'Just Pathetic' filled the bill. Kelley had already staked out the thrift store and the yard sale as his domain. The pitiful assortments of mangled soft toys, grubby socks, limp baby blankets, and tarnished pet dishes that he contributed to Rugoff's show suggested that there was nowhere to go but down. In a tripartite memorial to a pair of dead cats (*Storehouse*, *Mooner* and *Ougi*, all 1990), Kelley articulated (but barely) a commentary on emotional displacement and cultural inadequacy that in the immediately preceding era of cold steel and hard cash would have been laughed out of the gallery. Where Jeff Koons' *Rabbit* (1986) is glamorous and erotic despite its kitsch origins, Kelley's mice look used and abused, utterly beyond redemption.

Michael Wilson, 'Just Pathetic', *Artforum* (October 2004).

Mark Prince
Feint Art: Martin Creed, Ceal Floyer, Sergej Jensen, Michael Krebber, Paul Pfeiffer//2004

In 1976, Jasper Johns and Samuel Beckett collaborated on an artist's book, Beckett suggesting the cross-hatching designs go at the front of the book and the flagstone etchings at the end: 'Here you try all these different directions but no matter which way you turn you always come up against a stone wall'.[1]

Generous by Beckett's standards, this recalls an earlier piece of criticism, from 1949, in which he ranges impatiently from one contemporary painter to another, all of whom 'strain to enlarge the statement of a compromise', before arriving at the ideal profile of an artist as being one 'whose hands have not been tied by the certitude that expression is an impossible act', dismissing the evasion of this remit as 'desertion, art and craft, good housekeeping, living'.[2]

In retrospect Johns fits the bill, and the connection with Beckett seems propitious if not inevitable. Here was an artist who spoke of keeping painting in a state of 'shunning statement'. The match extends to Johns' relation to the Abstract Expressionists who preceded him, a progression from gregariousness and a confidence in modernist linearity to systematic negation and correction. This is a reversal which probably repeats itself periodically. In a recent *Guardian* article, Philip Dodd, director of the ICA in London, disparaged the opening of the new Saatchi Gallery as a display of 'theatrical' art, which the passing of the nineties has left looking 'dated'. He spoke of the demise of an era of artists with 'six assistants' and high production values, heralding a new dawn of DIY art-making, supposedly rooted in suburban bedrooms.

If Jeff Koons, with his mantra, 'Art is communication', can be seen as precursor to the nineties 'confidence' artists Dodd was referring to, who are the followers of Johns' diffidence? The proliferation of the international art market, and the institutions which serve it, make Beckett's ethos seem quaintly impractical. Among so many competing voices one has to shout loud and clearly to be heard. Who has time for uncertainty when there is so much networking to be done? If careers only begin to seem viable when they are vehicles for an aesthetic niche honed to the visibility of a product, what room is there for art which constantly qualifies and retracts itself, defined by its lack of self-assertion? The question suggests a distinction between, on the one hand, a literal courting of failure along with all its attendant chaos – the 'helpless statement' towards which Johns claimed to strive – and on the other, a crystallization of the gestures of uncertainty within a coherent, even marketable, form. It is the latter which Beckett shrinks from in mock horror but which is most relevant here: 'to make of this submission, this admission, this fidelity

to failure, a new occasion, a new term of relation, and of the act which, unable to act, obliged to act, he makes, an expressive act, even if only of itself, of its impossibility'.[3]

Johns' early paintings resolve themselves in a struggle between a rigid structure and a terror of too many coexisting options. Freed from the restraining armature of the flag's layout (*Flag*, 1955), it seems the brushstrokes would spread into aleatoric chaos. For Michael Krebber, this crisis appears to reach a debilitating stage before brush has touched canvas, and the combative structure is the overweening weight of painting's precedence, as opposed to the hard edges of standard signs. The results are a last gasp of effort, as much as the fearful relinquishing of a tentative attempt at action. But there is a theatrical edge which belies this appearance of crisis, and a strain of black humour which threatens the seriousness of the existentialist knitted brow. Is the paralysis of doubt an exquisite performance and, to adapt Dodd's term, can 'theatricality' be hijacked as a tool of self-deprecation rather than a sign of brash self-aggrandisement? This hinges on an apparent incompatibility between crisis and presentation, between the lack of space for self-consciousness in a genuine state of helplessness, and the composure required to prepare a face. Why should confidence have a monopoly on inauthenticity; why does it tend to shade into a confidence trick?

Krebber's show at Christian Nagel in Berlin earlier this year took his own cover design for a pop album as a seed for a delicate circuit of cross-referencing objects, hinting at the outline of a narrative. A patch of fifties wallpaper, an airmail sticker, a newspaper cutting, a yellowing record cover: second-hand fragments hung from miniature bulldog clips with an air of slightly apologetic reluctance. The CD cover's contrast of squared paper as a ground for Twomblyish scribbles was a trigger for a series of variations on the clash of received pattern and imposed disruption, the past as an inherited, inflexible and somehow obligating presence, as against the tremulousness of Krebber's organizing hand. A dot screen patchily sprayed on the printed grid is an act of graffiti and of memory, defacing and mimicking the ground, nodding to authorities of the past, such as Sigmar Polke, and mocking them with an offhand lack of conviction.

The paucity of Krebber's gestures, like Martin Creed's minimal interventions, is double-edged in relation to the gallery it occupies: these artists play the *flâneur*, barely deigning to engage with the economic function of the space, while depending on its sanction and focus to give visibility to actions which hardly resolve themselves into a stable form. The institution is a solid manifestation of Beckett's 'new occasion', buttressing and enshrining the dissolving artwork and transforming a fear of commitment into the controlled withholding of a performance. Indications of a collapse of purpose are adopted as a transparent performative skin stretched tight over a loss of meaningful content, as protection from it, and as a window though which to study it at a remove.

Creed has said, 'In a lot of work I try to make it and unmake it at the same time … which sort of adds up to nothing but at the same time is something too.' Johns' numbers, stencilled repeatedly over each other, objectify the successive addition/erasure of painting as a pattern of self-negation. The superimposition retains the after-image of its separate strata, like the flickering fractions of a second on a digital stopwatch. The brushstrokes that compose his flags, exaggerated by fatty encaustic, only partly disable them as functional signifiers: you still get the image. Krebber's pink monochrome paintings, however, are highly aestheticized traces of pure erasure. His skinny stretchers and flat absorbent primers emphasize the pallet-knifed ridges of acrylic paint, an act of retraction effetely self-regarding, divulging nothing of what it erases. But the paintings' reticence and disregard for object presence somehow make this erasure entirely the point. The image is wiped away but there is no gathering formalistic agenda to compensate, which is the fatuousness of the paintings and also the risks involved. As concentrated doses of uncertainty they omit to supply the narrative behind the withdrawal into silence, while refusing to wallow in the silence itself.

This reads as a sinking graph line of abstraction's capacity to retain formalistic expressive meaning alongside a rising line illustrating the conversion of that failure into aesthetic capital. Johns' superimposed corrections depend on abstraction's force being adequate to counterbalance the flag's image. Gerhard Richter's grey paintings from the 1970s, in their scale and accreted deliberation, partially connect with the formalist standards of reductive minimalist abstraction. Krebber's monochromes helplessly succumb to the more pressing reality of an image's erasure. Sergej Jensen's painting applies bleach and a variety of fashion offcuts to coloured fabrics. His skeletal constructivist designs are play, fully positive alongside Krebber's negations, but it is the optimism of an abstraction which has already scaled itself back from expansiveness to an ephemeral patterning. The significant step is from Krebber's dwindling grasp of painting's capacity to reveal, through to Jensen's surface doodlings, for which design is ironically replete and presents no shortfall from either representation or formalism. The tooth of the fabric, to which material can be attached or colour removed, is an unchallenged limit.

The axis here is between solipsism and communication, between self-embroiled process and an effective image. Jensen's patterns are a corrupted formalism, colour field vistas curtailed by a cramped set of moves circling back on themselves. But this uncontested insularity is utilized as a form in itself, 'a new occasion'. The taxonomic trappings of Creed's 'works' constitute an ironic edifice of communication, with several bricks thrown in, which supports and transports the solipsism of his actions. His cubes of compacted masking tape in their smug cardboard containers (*Work #74*, 1992) make a fetish of pointless but precise construction within a joke on the labour of form for a non-existent content. When

the cubes are distributed across a gallery's walls (*Work #81*, 1993), these negligible encapsulations of futile labour activate the interior as a site of non-activity, a negatively defined space. Creed has evolved a polished theatrical expression of a failure to express. There is an emotional naïvety in the multi-coloured balloons half-filling a gallery (*Work #201. Half the air in a given space*, 1998) and the reassuring neon messages displayed on public façades (*Work #203. Everything is going to be alright*, 1999). It is a glimpse of a forthright and heartfelt communication, which the didactic underside of the gestures (the mathematic materialism of air ratios, the deadpan font format of the white neon) deliberately takes back.

Does a display of solipsism reveal the self or a lack of self, in Beckett's sense of a frantic stream of self-involved monologue being the only available fuel to maintain the absence behind the voice, and prevent psychological implosion? Creed's project is a personalized comedy of manners designed to accommodate an absence, to dress it up and present it formally. His conceptual frames implicate the absurdity of the institutional context as much as the weakness of an expressive self. The balloons are like a *trompe l'oeil* device that turns out, on closer inspection, to advertise rather than disguise its own empty illusionism. Their gradual deflation during the exhibition's duration lays this state increasingly bare. It is a tautological loop which returns us to the empty room: a state of saying nothing as well as a foregrounding of the naked conditions of institutional presentation, in themselves complex enough.

Tautology, both repetition and retraction, is Ceal Floyer's main device. It destabilizes the material truisms she constructs. In the series of works based on light and sound, the intangibility of these media becomes a sign for an illusion's weightlessness. The hefty presence of the slide carousels and projectors contrasts with the relatively slight image they are there to produce. *Door* (1995) casts a band of light from a carousel onto the bottom edge of a closed door, as though the light were emanating from the room beyond. Like a cartoon, the effect exaggerates the recognition of a common phenomenon. The means to create the image simultaneously punctures it, a cyclical process of establishing and short-circuiting a fiction ad infinitum. This futility is its own self-justifying spectacle; like Jensen's myopic plodding, it somehow detaches itself from the 'helplessness' which these self-defeating manoeuvres would logically signify, and rounds off each work with a complacent finish.

The *Nail Biting Performance* (2001) in which Floyer stands alone on the soloist's podium of a large concert hall and bites her nails beside a microphone, is the quintessential collision of inadequacy with its reinvention as presentation. Does the spectacle retroactively nullify the crisis by casting it as artifice, formalized by the grand setting? And how is this artificiality to be distinguished from the unambiguous fiction of, say, a woman weeping in a film drama? Film's narrative absorbs the crisis into the brackets of the drama, whereas Floyer places her action

in opposition to the surrounding assumptions: a concert hall's ordered recital. She falls short of her foil, framing the performance as recalcitrant reality which breaks the mould of achieved artifice the environment expects. The context is exposed as conventional while being used to promote the nail biting to a literalness which its status as performance mocks.

Like Creed's balloons, Floyer's empty, inflated and tied *Garbage Bag* (1996) denigrates its apparent pretensions to a minimalist aesthetic, while its nihilistic role as gallery accessory rubbishes the white-walled institutional backdrop: the piece is graphically all surface and no content. An ideal of materiality unadulterated by illusion is given and then taken away. For Creed and Floyer, Minimalism's disillusioned phenomenology is a smug asceticism which they subvert using the representational projections which that aesthetic prided itself on putting aside. In this respect, it has the same role as formalist abstraction for Krebber and Jensen: a forsaken hierarchy that haunts their strategies like a lost innocence.

Deployed as a dysfunctional tool, the empowerment of digital technology can reverse these terms. Manipulation injects a thread of abstraction to undermine the narrative image: facility facilitates its own deconstruction. This tail-chasing is applied to the hysteria of media multiplication like a moral corrective. The images in Paul Pfeiffer's series *Four Horsemen of the Apocalypse* (2000) are erasures of the figure of Marilyn Monroe from a photo session of her frolicking on a beach. Fields of scarcely fluctuating static turn on an ambivalence between painterly formalism (itself a lost quantity) and the eerie shadows of an image. An illusion of stillness reinvents abstraction as a depleted state: time's negation. The pictures fail to the extent that the narrative which produces them remains contextual, but the dissolution of the original is a process of renewal, restoring a primitive intensity to its jaded history. What had been cluttered with familiar associations is cleansed back to an emptiness for which there are no automatic responses. The inability to maintain an image is subsumed by the performance that masks it, wipes the slate clean, and suggests a new beginning. We have come full circle: minimal abstraction, having given way to erasure, is reconstituted as a ground of potentiality. Maybe it's time to bring on the gestures of confidence to fill that tantalizingly vacated space.

1 Cited in Jasper Johns, *Writings, Sketchbook Notes, Interviews* (New York: MoMA, 1996) 153.

2 Samuel Beckett, *Proust & Three Dialogues with Georges Duthuit* (London: John Calder, 1965) 125.

3 Ibid.

Mark Prince, 'Feint Art', *Art Monthly*, no. 267 (June 2003) 1–5.

Johanna Burton
Rites of Silence: Wade Guyton//2008

Just who does he think he is? Poised in front of Wade Guyton's work, admirers and detractors alike often find themselves asking the same question. It's not so much a query regarding the artist's character – though of course it's partially that, too – but rather the expression of a genuine quandary, one that can feel so basic that it's hard to find the way to frame it. *Where is he coming from?* is another way to put it, and it may be a little closer to the mark. But the real question is rather, and perhaps simply: How are we to understand Guyton's relationship to what he makes? And following from that: Why do the oblique contours of this relationship seem to announce themselves as the very content of the work?

Consider two of Guyton's one-person shows mounted in the past six months, the first at Friedrich Petzel Gallery in New York, the second at Galerie Chantal Crousel in Paris. While a group of multiple works was produced for each, Guyton would seem at first glance to have presented nearly carbon-copy exhibitions. In both instances, the artist laid down a false floor made of plywood sheets painted a dense black, the kind of black that seems at once to reflect and suck up light. On the walls were hung large-scale paintings, described in the respective – also nearly identical – press releases as 'ostensibly black monochromes'. *Ostensible* is a fantastic word, and it goes some way in addressing Guyton's work. Etymologically, it derives from the Latin *ostensus*, 'to show', but this connotation of transparency is joined by one of scepticism. There's something being shown, but there's also something that is *not* being shown, that's being blocked from view. Synonymous with *allegedly*, *ostensibly* also implies that a claim has been made, that a statement has been drafted, but that there is simply no verifiable proof to back it. That which is ostensible looks like, sounds like, even feels like what it purports to be, but it flashes doubt like a striptease, asking that we believe *and* interrogate simultaneously.

Such operations, though seemingly discovered afresh every decade, have long been the purview of certain practices of painting. Indeed, the past forty years of critical discourse have taken as foundational the idea that it is perhaps *only* its ostensible nature that keeps contemporary painting from relinquishing all relevance. This doesn't mean that a deeply held, intuitively argued belief in painting qua painting is not still in effect. (These days, a phrase like 'the function of painting' has a fifty-fifty chance of being met with an eye roll – one more eerie similarity between this era and the 1980s.) What it means, rather, is simply that those who can't quite accept the notion of painting's radical authenticity have

long looked for its first principles outside the frame. Take, for instance, the following passage, which would seem to address Guyton's ostensible monochromes astutely enough:

> It is fundamental to X's work that it functions in complicity with those very institutions it seeks to make visible as the necessary condition of the artwork's intelligibility. This is the reason his work not only appears in museums and galleries but also poses as painting. It is only thereby possible for his work to ask, What makes it possible to see a painting? What makes it possible to see a painting *as a painting*? And, under such conditions of its presentation, to what end painting?

My tell-tale substitution of the generic placeholder 'X' for a proper name is likely clue enough that this is borrowed text and that it doesn't describe Guyton's paintings at all. As it happens, these are Douglas Crimp's words, from his 1981 essay 'The End of Painting', with the subject of his analysis being, perhaps unsurprisingly, one Daniel Buren.[1] Who better to exemplify the contextual turn born of the 1960s and 1970s – a shift that allowed for the very conditions of artistic production and reception to become content? And how useful might it prove to think through the implications of one of the original purveyors of institutional critique for an artist, in this case Guyton, whose practice would seem, if not exactly aligned with, nonetheless clearly indebted to the older figure? Buren had his factory-produced textile stripes, Guyton has his equally terse black squares spit out of an ink-jet printer; surely this is a neat transposition of strategies from an industrial to a post-industrial context. In the end, though, while the comparison is indeed quite useful, what turns out to be most illuminating are the differences, not the correspondences, that it reveals.

For however uncannily germane to Guyton's practice Crimp's language might initially seem, the critic's analysis ultimately proves wholly inapplicable to the younger artist's work, and the very disjunction in fact sheds some light on greater shifts in the terms of artmaking during the past forty years. If in 1981 Buren continued to hold out promise for critical practice, it was precisely because his work did *not* read legibly within the language of painting it alluded to. As Crimp put it in his essay's closing gambit, while Buren's work was of course literally visible, it was at odds with any historicist account of painting and therefore did not register within painting's terms. Crimp's projection for the future was clear: 'At the moment when Buren's work becomes visible, the code of painting will have been abolished and Buren's repetitions can stop: the end of painting will have been finally acknowledged.' Buren was just as confident about the deep ramifications of his own ideas. Quoted in Crimp's essay is a passage from the artist's 1977 volume *Reboundings*, wherein Buren claims the highest stakes for

his work: 'It is no longer a matter even of challenging the artistic system. Neither is it a matter of taking delight in one's interminable analysis. The ambition of this work is quite different. It aims at nothing less than abolishing the code that has until now made art what it is, in its production and in its institutions.'[2] Whether Buren succeeded or failed in these aspirations and whether his subsequent anointment by the very 'art history' against which he chafed signals an abolishment or an expansion of said code are questions for another time (and I am certainly not the first to raise them). But the fact that Buren is today so much acknowledged by art-historical discourse – such that the tenets of institutional critique are now readily accepted by institutions themselves – presents a conundrum of sorts for any artist who would seek to make 'critical' art. Pointing to the context for painting, or for artmaking more generally, as Guyton does, is inevitably attended by the peril of merely mimicking gestures of the past that, in this changed historical situation, are reduced to motif. We therefore need to ask how artists might best extrapolate from the discursive tussles of Buren's time, pondering how and to what end an artist such as Guyton might be keeping the 'end of painting' at bay or, perhaps more aptly, keeping the death of painting alive.

Looking closely at the works in question, one notes that if Guyton is himself working toward the dismantling of codes (or, perhaps more realistically, the rerouting of them), he is not founding his project on the nullification of painting or on its transformation into an illegible cipher: If his are 'ostensibly' black monochromes, in other words, it's not due to any confusion whatsoever about the status of these objects as paintings. That is to say that what is 'ostensible' here really is the denomination 'black monochrome' and not painting itself. Though obviously following a formal, Guyton's monochromes have none of the built-in regularity of, say, Buren's stubborn 8.7 centimetre wide alternating cloth stripes which have in their way taken on über-aesthetic status despite their original somewhat anti-aesthetic premise). In fact, the opposite is true. Despite being produced by way of a set of predetermined, extremely limited rules and without a drop of paint or a single brushstroke, they bear all the obvious residues of spontaneous (and therefore 'immediate') mark making. Having folded lengths of factory-primed linen so that each half equals the width of his Epson Ultra Chrome large format printer (44 inches), Guyton runs them through the machine, which deploys hundreds of individual ink jet heads. Together, these tiny, dumb mechanical soldiers labour at Guyton's behest to produce just as dumb an 'image': A black rectangle, drawn and then 'filled' by Guyton in Photoshop, is printed twice, once on each side of his folded linen, doubling, in essence, the image of the rectangle (at the same time as trying to unite its parts on one field). Depending on the effects of the initial printing process, Guyton opts to run one side or the other (or sometimes both) through the machine a second and sometimes third

time (or more), smoothing and filling prior snags and drags on the one hand and on the other, providing an even denser surface on which new anomalies can occur. To the extent that Guyton's enterprise could be seen as one invested in the technics of image production, it figures technology's tendency to complicate, rather than simplify – that is, to make its own kind of mess. And truth be told, Guyton aids and abets the glitches, gagging his printer with material not meant for it and asking it to lay uniform sheets of ink over an expanse twice its size – feats hardly enumerated in the user's manual. In fact, if Guyton has a technical skill per se, it might be defined as encouraging malfunctions.

Once the canvas has been fed through the printer, it drops unceremoniously to the floor and accordingly picks up evidence of its time there in scratches, dings and dust. The resulting two sides of the rectangle – given the imprecise procedure of simply folding the canvas in half and temporarily taping its edges together – are rarely if ever perfectly aligned; rather, one side typically is slightly higher or lower than the other. And one side, or both, may register the marks of having wandered diagonally off track during printing before being pulled back into alignment; this sometimes produces a kind of shuttered effect, almost photographic in its unintended illusion of light (the primed canvas) peeking out from between regimented lines that no longer match up to form an uninterrupted solid. The ink, trying to fix itself to a ground that is designed to hold thicker pigment, also occasionally pools, smudges and drips. And of course, every piece of linen, once unfolded, bears the mark of the central seam, not so much a 'zip' as a kind of vertical navel.[3] Each painting thus bears proof of its process – the one real constant in every iteration of the series. (Or at least, the only readily apparent one: There is also the single digital 'source' that is the foundation of all the monochromes – an image file on Guyton's computer with the hard-core-sounding name 'big-black. tif', which, when opened, reveals a comically unassuming little black rectangle).

The urge to act the connoisseur and genealogize in the face of these works is palpable as, somewhat counter-intuitively, all these procedures result in unadulterated visual pleasure of the kind often associated with abstraction in its more luscious manifestations. Hung sparingly on white walls, the paintings take on the stark elegance we attribute to a whole lineage of morphologically similar items. Names, from Rothko to Reinhardt and Stella to Marden, are apt to fly. But let's not forget that these are ostensible monochromes only. They are, none of them, fully resolved, not *really* monochromes, because the measure of their success rests largely on their gesturing to monochromeness without ever really getting there. Indeed, a few of the most beautiful canvases – which register thread-thin lines spread nearly an inch apart from one another – are also the most minimal. They were not, however, produced because the cartridge was running dry, as one might think – the problem is not too little ink but, in a sense,

too *much*, as the machine overloads itself in an attempt to carry out Guyton's bidding over and over again. With nearly all its jet heads clogged by ink that has built up and coagulated, the printer barely sputters out a trace of the image it is asked to compulsively repeat. The delicate, visually complex composition that accrues is nothing more than evidence that the Epson 'self-clean' function has not kicked in when it ought to.

So what are we to make of all this? Guyton's process is steeped in embarrassingly elementary moves: Preselecting basic parameters such as whether to print 'draft' or 'economy', at 'speed' or 'quality' rate, and according to 'normal', 'fine', or 'photo' standards – and then simply pushing 'print' – comprises most of the artist's control over the work he produces. (The critic inevitably wonders whether it is, after all, worth spilling this much ink on, well, the vicissitudes of spilled ink.) And yet he pairs this embarrassment with another one: that of making undeniably aesthetic products. (Here Guyton's works would seem to perform themselves as decoys inciting the urge for art-historical roll-calling – a kind of bald 'ostensibility' that might appear all too well attuned to the current vogue for generic 'appropriative' gestures.) Taken together, however, these qualities imply an awareness that a work of art's motioning toward another that came before it does not necessarily bear out much meaning; and an assumption that the binary poles of pining homage and violent erasure are the only two ways to read such allusions is just another mode of marketing. Guyton's recent series of black paintings nods, if mutely, toward this crossroads, in which engagements with discursive history and profiteering usurpations of it look more and more similar. For if today it is impossible not to recognize the lessons handed down by Buren and others, it is likewise impossible not to see how those lessons themselves have been incorporated as a kind of affirmative content. If the language of 'abolishing the code' has itself become code, what can one say in retort or even in response?[4]

FINALLY, A PERSONAL INCIDENT, which will nicely introduce the figures to come: Thursday, March 9, fine afternoon, I go out to buy some paints (Sennelier inks) – bottles of pigment: following my taste for the names (golden yellow, sky blue, brilliant green, purple, sun yellow, cartham pink – a rather intense pink), I buy sixteen bottles. In putting them away, I knock one over: in sponging up, I make a new mess: little domestic complications, ... And now, I am going to give you the official name of the spilled colour, a name printed on the small bottle (as on the others vermilion, turquoise, etc.): it was the colour called Neutral (obviously I had opened this bottle first to see what kind of colour was this Neutral about which I am going to be speaking for thirteen weeks). Well, I was both punished and disappointed: punished because Neutral spatters and stains (it's a type of dull

grey-black); disappointed because Neutral is a colour like the others, and for sale (therefore, Neutral is not unmarketable): the unclassifiable is classified – all the more reason for us to go back to discourse, which, at least, cannot say what the Neutral is.[5]

The spring of 1978 found Roland Barthes doing his own ruminating on the vicissitudes of spilled ink and giving his second lecture series at the College de France. Over several months, he introduced and expounded on a term that, nonetheless, he had no intention of ever fully pinning down: 'the Neutral'.[6] Summing the course up for the school's compulsory annual report, Barthes wrote of his topic that 'one studies what one desires or what one fears; within this perspective, the authentic title of the course could have been: *The Desire for Neutral.*' He continues, 'The argument of the course has been the following: we have defined as pertaining to the Neutral every inflection that, dodging or baffling the paradigmatic, oppositional structure of meaning, aims at the suspension of the conflictual basis of discourse.' Presented not as a progressively building argument but instead as an offering of twenty-three figures or 'twinklings', Barthes' exploration of the Neutral includes an argument for silence as one of the incarnations of his fugitive concept. The word – *silence* – should perhaps be treated with some circumspection here; as Barthes points out, he is himself speaking about it. Indeed, silence as defined by Barthes, like many of the figures he presents, does not conform to our likely expectations. Silence – like the Neutral itself – is not a passive condition but rather one voluptuously active, so active in fact that it refuses to settle into or onto a singularly readable position. If this sounds dangerously close to a kind of willy-nilly, fleeting lack of commitment, it of course risks being so (but only when it is not *actually* Neutral); for an active silence, as Barthes puts it, is what lies at the heart of all rigorous discourse. It opposes dogmatic speech *and* dogmatic silence alike.

As the foregoing may hint, an obvious tension regarding politics is characteristic of much of Barthes' late work.[7] His suggestion that endlessly articulated battles between opposing opinions might be less potentially subversive than what remains unstated ('the implicit is a crime, because the implicit is a thought that escapes power') is understandably met with frustration by those in circumstances demanding nothing less than out-and-out activism. But Barthes' was, again, not a dictum to be consumed and applied. It was a methodological manifestation of *desire* – full if unfulfilled, and quite analogous to his (disappointed) dream of a truly neutral ink, without colour or body; a desire that had all manner of political implications, not the least being that, as one commentator put it, Barthes's writing marked a lifelong project with 'no motor other than desire'.[8]

Guyton, too, seems, if not programmatically, to put forward a kind of Neutral deportment, one that, per Barthes, 'postulates a right to be silent'. That does not, of course, keep his commentators from ascribing, almost compulsively (and often aggressively), content and intent. (Indeed, Barthes' worry about silence is that while it begins as a 'weapon assumed to outplay the paradigms', it too 'congeals itself into a sign'.) It's hard to imagine a more overdetermined space than the site of the monochrome – the *black* monochrome no less, that tried-and-true image that now virtually screams out its simultaneous status as *tabula rasa* and *tabula finitum*. But if it seems that Guyton, at thirty-six years old, has reached this point much too early – what avenues has he left open for himself, one wonders while looking at so many iterations of the high-culture sign for 'That's all, folks' – it is worth considering the ways in which his career has proceeded by way of such impasses, with such seeming foreclosures levied to hold open future possibilities. [...]

1 Douglas Crimp, 'The End of Painting', *October*, no. 16 (Spring 1981). Reprinted in Crimp, *On the Museum's Ruins* (Cambridge, Massachusetts: The MIT Press, 1993) 84–105. Crimp's essay addresses Barbara Rose's review of 'Eight Contemporary Artists' (The Museum of Modern Art, New York, 1974), which included Buren. For Rose, Buren stood as emblematic of a group whose overly political spirations bred 'disenchanted, demoralized artists' producing mediocre work. In 1979, Rose curated an exhibition at the Grey Art Gallery in New York, titled 'American Painting: The Eighties'. Crimp argues that the show was meant as retaliation against conceptual practices such as Buren's and aimed to reinscribe traditional ideas about the legacies of painting.

2 From Daniel Buren, *Rebondisages: An Essay*, trans. Philippe Hunt (Brussels: Daled & Gevaert, 1977). Cited in Crimp, *On the Museum's Ruins*, op. cit., 103.

3 This folding of canvas, with the result that painting can double in size, began well before Guyton's monochromes, manifesting in paintings that include X's, flames, etc., so the 'navel' is itself not unique to this most recent series. However, while the X's and flames resulted from one large file being split in half (thus printed in two sections, one on each side of the canvas), the monochromes are in fact the result of two iterations of the same bigblack-tif file printed one after the other.

4 See on this topic, for instance, Benjamin H.D. Buchloh, who has long written on Buren and Buren's reception: 'The Group That Was (Not) One: Daniel Buren and BMPT', in *Artforum* (May 2008) 310–13. He writes succinctly there on the question 'why the spaces and practices of contestation and critique that Buren (and Hans Haacke, Michael Asher, Marcel Broodthaers, et al.) opened at the end of the 1960s were – or so it seems now, at least – iredeemably hijacked ...'

5 From Roland Barthes, *The Neutral*, trans. Rosalind F. Krauss and Denis Hollier (New York: Columbia University Press. 2005) 48–9.

6 *Le Neutre* was not published in France until 2002; it was translated into English in 2005.

7　Questions regarding the relationship between one's politics and one's practice have long been asked. An interesting article appeared in *Artforum* (November 1977: 46–53) by Moira Roth, whose 'The Aesthetic of Indifference' looked closely at 'cool' practices by Duchamp, Cage, Cunningham, Rauschenberg and Johns. Roth argues that though their practices do not comment directly on the cold war during which they thrived, they, like 'others of a more liberal and self-critical persuasion, found themselves paralysed when called upon to act on their convictions, and this paralysis frequently appeared as indifference.' I am arguing not for a paralysing indifference but instead for a kind of personal, even amorous politics, but it is interesting that there is similarity when it comes to how and even whether signs of the political are perceived.

8　This is Thomas Clerc's phrase, in his preface to *The Neutral*, xxiii. Clerc is referring explicitly to the way in which Barthes uses such a wide array of sources from all areas of culture. He similarly discusses the wide net of Barthes' enquiries and citations as proceeding by way of a kind of 'second-hand erudition' and a 'joyous dilettantism', neither of which undermines Barthes' rigour as a thinker but both of which do highlight the unconventional nature of his method.

Johanna Burton, extract from 'Rites of Silence', *Artforum* (Summer 2008) 365–70.

Daniel Birnbaum
Dominique Gonzalez-Foerster: *De Novo*//2009

A starting point: an abandoned garden at the end of Venice's Arsenale. Behind the gate, amid the wild plants, one gets a glimpse of a fragment of a tennis court. Is this perhaps the tennis court from Vittorio De Sica's 1970 film *The Garden of the Finzi-Continis*, based on a novel by Giorgio Bassani? Dominique Gonzalez-Foerster's *De Novo* (2009) tells the story of how a young artist makes five attempts to participate in the Venice Biennale. The film acts as a time machine. It begins with a work in a dark gothic space, involves an invisible piece on a vaporetto (a sea ritual; a ring is thrown into the water), an unfinished video installation invaded by the audience in the Palazzo delle Esposizioni, a 'scribbling proposal' for 'Utopia Station' (almost nothing, a black hole), and, finally, in the summer of 2009, the gate and the abandoned garden.

A possible proposal cannot be a totally new idea, as if nothing has happened before; rather, it must include the story of all previous proposals and the sense of failure and impossible dialogue with the city that these generated. On learning the list of ingredients in an installation by Gonzalez-Foerster, one often senses that it is less an autonomous work exploring its medium than an atmospheric space that draws out the melancholy inherent in its constituent pieces. Although strangely vacuous, and not displaying works of art in any traditional sense, her exhibitions convey an unmistakable atmosphere – a kind of lightness. It's a special form of weightless ambience, sometimes melancholic, sometimes joyous.

Daniel Birnbaum, 'Dominique Gonzalez-Foerster', in *Making Worlds/Fare Mondi* (Venice: 53rd Venice Biennale/Marsilio, 2009) 64.

MEANINGLESS WORK IS
POTENTIALLY THE MOST
ABSTRACT, CONCRETE,
INDIVIDUAL, FOOLISH,
INDETERMINATE, EXACTLY
DETERMINED, VARIED,
IMPORTANT ART—ACTION—
EXPERIENCE ONE CAN
UNDERTAKE TODAY

Walter De Maria, On *Boxes for Meaningless Work*, 1961

IDEALISM AND DOUBT

Paul Ricoeur
Memory and Imagination//2000

The Greek Heritage

The problem posed by the entanglement of memory and imagination is as old as Western philosophy. Socratic philosophy bequeathed to us two rival and complementary *topoi* on this subject, one Platonic, the other Aristotelian. The first, centred on the *eikon*, speaks of the present representation of an absent thing; it argues implicitly for enclosing the problematic of memory within that of imagination. The second, centred on the theme of the representation of a thing formerly perceived, acquired or learned, argues for including the problematic of the image within that of remembering. These are the two versions of the aporia of imagination and memory from which we can never completely extricate ourselves.

Plato: The Present Representation of an Absent Thing

It is important to note from the start that it is within the framework of the dialogues on the sophist and, through this person, on sophistry itself and the properly ontological possibility of error, that the notion of the *eikon* is encountered, either alone or paired with that of the *phantasma*. In this way, from the very outset, the image but also by implication memory are cast under a cloud of suspicion due to the philosophical environment in which they are examined. How, asks Socrates, is the sophist possible and, with him, the false-speaking and, finally, the non-being implied by the non-true? It is within this framework that the two dialogues bearing the titles *Theaetetus* and *Sophist* pose the problem. To complicate matters further, the problematic of the *eikon* is, in addition, from the outset associated with the imprint, the *tupos*, through the metaphor of the slab of wax, error being assimilated either to an erasing of marks, *semeia*, or to a mistake akin to that of someone placing his feet in the wrong footprints. We see by this how from the beginning the problem of forgetting is posed, and even twice posed, as the effacement of traces and as a defect in the adjustment of the present image to the imprint left as if by a seal in wax. It is noteworthy that memory and imagination already share the same fate in these founding texts. This initial formulation of the problem makes all the more remarkable Aristotle's statement that 'all memory is of the past'.

Let us reread the *Theaetetus*, beginning at 163d.[1] We are at the heart of a discussion centred on the possibility of false judgement, which concludes with a reference to the thesis that 'knowledge is simply perception' (151e–187b).[2]

Socrates proposes the following 'attack': 'Supposing you were asked, "If a man has once come to know a certain thing, and continues to preserve the memory of it, is it possible that, at the moment when he remembers it, he doesn't know this thing that he is remembering?" But I am being long-winded, I'm afraid. What I am trying to ask is, "Can a man who has learned something not know it when he is remembering it?"' (163d). The strong tie of the entire problematic to eristic [disputatious argument] is immediately obvious. Indeed, it is only after having crossed through the lengthy apology of Protagoras, and his open pleading in favour of the measure of man, that a solution begins to dawn, but, before that, an even more pointed question is raised: 'Now, to begin, do you expect someone to grant you that a man's present memory of something which he has experienced in the past but is no longer experiencing is the same sort of experience as he then had? This is very far from being true' (166b). An insidious question, which leads the entire problematic into what will appear to us to be a trap, namely, resorting to the category of similarity to resolve the enigma of the presence of the absent, an enigma common to imagination and memory. Protagoras tried to enclose the authentic aporia of memories, namely, the presence of the absent, in the eristic of the (present) non-knowledge of (past) knowledge. Armed with a new confidence in thinking, likened to a dialogue of the soul with itself, Socrates develops a sort of phenomenology of mistakes, where one thing is taken for another. To resolve this paradox he proposes the metaphor of the block of wax: 'Now I want you to suppose, for the sake of the argument, that we have in our souls a block of wax, larger in one person, smaller in another, and of pure wax in one case, dirtier in another; in some men rather hard, in others rather soft, while in some it is of just the proper consistency.' Theaetetus: 'All right, I'm supposing that.' Socrates: 'We may look upon it, then, as a gift of Memory [Mnemosyne], the mother of the Muses. We make impressions upon this of everything we wish to remember [mneoneusai] among the things we have seen or heard or thought of ourselves; we hold the wax under our perceptions and thoughts and take a stamp from them, in the way in which we take the imprints [marks, semia] of signet rings. Whatever is impressed upon the wax we remember and know so long as the image [eidon] remains in the wax; whatever is obliterated or cannot be impressed, we forget [epilelethai] and do not know' (191d). Let us note that the metaphor of the wax conjoins the problematics of memory and forgetting. There follows a subtle typology of all the possible combinations between the moment of knowledge and the moment of the acquisition of the imprint. Among these, let us note the following pairs: 'that a thing which you both know and are perceiving, and the record of which you are keeping in its true line [ekho to mnemeion ortho] is another thing which you know ... that a thing you both know and are perceiving and of which you have the record correctly in line as before, is another thing you

are perceiving' (192b–c). It is in an effort to identify this veridical characteristic of faithfulness that we will later reorient the entire discussion. Pursuing the analogy of the imprint, Socrates assimilates true opinion to an exact fit and false opinion to a bad match: 'Now, when perception is *present* to one of the imprints but not to the other; when (in other words) the mind applies the *imprint* of the absent perception to the perception that is *present*; the mind is deceived in every such instance' (194a).[3] We need not linger over the enumeration of the different kinds of wax, intended as a guide to the typology of good or bad memories. But let me not fail to mention, however, for our reading pleasure, the ironic reference (194e–195a) to 'those whose wax is shaggy' (*Iliad* III) and 'soft'. Let us retain the more substantive idea that false opinion resides 'not in the relatons of perceptions to one another, or of the thoughts to one another, but in the connecting [*sunapsis*] of perception with thought' (195c–d). The reference to time we might expect from the use of the verb 'to preserve in memory' is not relevant in the framework of an epistemic theory that is concerned with the status of false opinion, hence with judgement and not with memory as such. Its strength is to embrace in full, from the perspective of a phenomenology of mistakes, the aporia of the presence of absence.[4]

With regard to its impact on the theory of imagination and of memory, it is the same overarching problematic that is responsible for the shift in metaphor with the allegory of the dovecote.[5] Following this new model ('the model of the aviary' in the words of Burnyeat), we are asked to accept the identification between possessing knowledge and actively using it, in the manner in which holding a bird in the hand differs from keeping it in a cage. In this way, we have moved from the apparently passive metaphor of the imprint left by a seal to a metaphor that stresses power or capacity in the definition of knowledge. The epistemic question is this: does the distinction between a capacity and its exercise make it conceivable that one can judge that something one has learned and whose knowledge one possesses (the birds that someone keeps) is something that one knows (the bird that one grabs in the cage) (197b–c)? The question touches our discussion inasmuch as a faulty memorization of the rules leads to an error in counting. At first glance, we are far from the instances of errors of fit corresponding to the model of the block of wax. Were these not, nevertheless, comparable to the erroneous use of a capacity and, by this, to a mistake? Had not the imprints to be memorized in order to enter into use in the case of acquired knowledge? In this way the problem of memory is indirectly concerned by what could be considered a phenomenology of mistakes. The failed fit and the faulty grasp are two figures of mistakes. The 'model of the aviary' is especially well-suited to our investigation in as much as grasping is in every case comparable to possession (*hexis* or *ktesis*), and above all to hunting, and in which every memory

search is also a hunt. Let us again follow Socrates, when, as a true sophist, he surpasses himself in subtleties, mixing ring doves with doves but also non-doves with real doves. Confusion is rampant not only at the moment of capture but also with respect to the state of possession.[6]

By these unexpected divisions and duplications, the analogy of the dovecote (or the model of the aviary) reveals a richness comparable to that of the foot mistakenly placed in the wrong print. To the mis-fit is added the erroneous grasp, the mis-take. However, the fate of the *eikon* has been lost from sight. The *Sophist* will lead us back to it.

The problematic of the *eikon* developed in the *Sophist* comes directly to the aid of the enigma of the presence of absence concentrated in the passage in *Theaetetus* (194) related above.[7] What is at stake is the status of the moment of recollection, treated as the recognition of an imprint. The possibility of falsehood is inscribed in this paradox.[8] [...]

1 [footnote 2 in source] Plato, *Theaetetus*, trans. M.J. Levett, revised by Myles F. Burnyeat, in *Plato: Complete Works*, ed. John M. Cooper (Indianapolis: Hackett, 1997) 191.

2 [3] On all of this, see David Farrell Krell, *Of Memory, Reminiscence and Writing: On the Verge* (Bloomington, Indiana: Indiana University Press, 1990). [...]

3 [4] This passage is Krell's alternative translation (with his emphases, 27).

4 [5] A careful discussion in the tradition of analytic philosophy of the strictly epistemic argumentation can be found in Myles Burnyeat, *The Theaetetus of Plato* (Indianapolis: Hackett, 1990). [...]

5 [6] The model of the block of wax had failed in the case of the faulty identification of a number by means of the sum of two numbers; abstract errors like this defy an explanation in terms of a misfit between perceptions.

6 [7] One will note in passing the unexploited allegory of the archer who misses his mark (194a) and recall that *hamartanein* (to be mistaken and, later, to sin) is to miss the target.

7 [8] We are leaving the *Theaetetus* just at the moment when the discussion, which up to now has been centred on false judgement, tightens around the strictly epistemic problem of the relation among these three themes, namely, knowledge, perception and true judgement (201e). From a strictly epistemic viewpoint, one passes from the error of identification and description in the *Theaetetus* to pure errors of description in the *Sophist* (Burnyeat, *The Theaetetus of Plato*, 90).

8 [9] In this regard, I would say, in opposition to Krell, that there is no reason to turn the discovery of this paradox against Plato and to discern in it a foretaste of the ontology of presence; the paradox seems to me to constitute the very enigma of memory. It is rather the very nature of the problem that this paradox brings to light.

Paul Ricoeur, extract from *La Mémoire, l'histoire, l'oubli* (Paris: Éditions du Seuil, 2000); trans. Kathleen Blamey and David Pellauer, *Memory, History, Forgetting* (Chicago: University of Chicago Press, 2004) 7-10.

Søren Kierkegaard
The Concept of Irony//1841

[...] Looking at irony in relation to the uninitiated, in relation to those against whom the polemic is directed, in relation to the existence it ironically interprets, we see that ordinarily it has two modes of expression. Either the ironist identifies himself with the odious practice he wants to attack, or he takes a hostile stance to it, but always, of course, in such a way that he himself is aware that his appearance is in contrast to what he himself embraces and that he thoroughly enjoys this discrepancy.

When it comes to a silly, inflated, know-it-all knowledge, it is ironically proper to go along, to be enraptured by all this wisdom, to spur it on with jubilating applause to ever greater lunacy, although the ironist is aware that the whole thing underneath is empty and void of substance. Over against an insipid and inept enthusiasm, it is ironically proper to outdo this with scandalous praise and plaudits, although the ironist is himself aware that this enthusiasm is the most ludicrous thing in the world. Indeed, the more succesful the ironist is in beguiling, the further his fakery proceeds, the more joy he has in it. But he relishes this joy in private, and the source of his joy is that no one realizes his deception. This is a form of irony that appears only rarely, although it is just as profound as the irony that appears under the form of opposition and is easier to carry through. On a small scale, it is sometimes seen used against a person about to be afflicted with one or another fixed idea, or against someone who imagines himself to be a handsome fellow or has especially beautiful sideburns or fancies himself to be witty or at least has said something so witty it cannot be repeated enough, or against someone whose life is wrapped up in a single event, to which he comes back again and again, and which he can be prompted to tell at any time merely by pressing the right button, etc.

In all these cases, it is the ironist's joy to seem to be caught in the same noose in which the other person is trapped. It is one of the ironist's chief joys to find weak sides such as this everywhere, and the more distinguished the person in whom it is found,, the more joy he has in being able to take him in, to have him in his power, although that person himself is unaware of it. Thus at times even a distinguished person is like a puppet on a string for the ironist, a jumping-jack he can get to make the motions he wants it to make by pulling the string. Strangely enough, it is the weaker sides of the human being more than the good sides that come close to being Chladni figures[1] that continually become visible when made to vibrate properly; they seem to have an intrinsic, natural necessity, whereas the good sides, to our dismay, so often suffer from inconsistencies.

But on the other hand, it is just as characteristic of irony to emerge in an antithetical situation. Faced with a superfluity of wisdom and then to be so ignorant, so stupid, such a complete Simple Simon as is possible, and yet always so good-natured and teachable that the tenant farmers of wisdom are really happy to let someone slip into their luxuriant pastures; faced with a sentimental, soulful enthusiasm, and then to be too dull to grasp the sublime that inspires others, yet always manifesting an eager willingness to grasp and understand what up until now was a riddle – these are altogether normal expressions of irony. And the more naïve the ironist's stupidity appears to be, the more genuine his honest and upright striving seems, the greater his joy. Thus we perceive that it can be just as ironic to pretend to know when one knows that one does not know as to pretend not to know when one knows that one knows. Indeed, irony can manifest itself in a more indirect way through an antithetical situation if the irony chooses the simplest and dullest of persons, not in order to mock them but in order to mock the wise. [...]

It seems best to orient ourselves in the conceptual milieu to which irony belongs. To that end we must distinguish between what could be called executive irony and contemplative irony.

We shall first contemplate what we ventured to call executive irony. In so far as irony asserts contradistinction in all its various nuances, it might seem that irony would be identical with dissimulation. For the sake of conciseness, the word 'irony' is customarily translated as 'dissimulation'. But dissimulation denotes more the objective act that carries out the discrepancy between essence and phenomenon; irony also denotes the subjective pleasure as the subject frees himself by means of irony from the restraint in which the continuity of life's conditions holds him – thus the ironist literally can be said to kick over the traces. Add to this the fact that dissimulation, in so far as it is brought into relation with the subject, has a purpose, but this purpose is an external objective foreign to the dissimulation itself. Irony, however, has no purpose; its purpose is immanent in itself and is a metaphysical purpose. The purpose is nothing other than the irony itself. If, for example, the ironist appears as someone other than he actually is, his purpose might indeed seem to be to get others to believe this; but his actual purpose still is to feel free, but this he is precisely by means of irony – consequently irony has no other purpose but is self-motivated. We readily perceive, therefore, that irony differs from Jesuitism, in which the subject is, to be sure, free to choose the means to fulfil his purpose but is not at all free in the same sense as in irony, in which the subject has no purpose.

In so far as it is essential for irony to have an external side that is opposite to the internal, it might seem that it would be identical with hypocrisy. Indeed, irony is sometimes translated in Danish as *Skalkagtighed* [roguishness], and a

hypocrite is usually called an *Øienskalk* [eye-rogue]. But hypocrisy actually belongs to the sphere of morality. The hypocrite is always trying to appear good, although he is evil. Irony, on the other hand, lies in the metaphysical sphere, and the ironist is always only making himself seem to be other than he actually is; thus, just as the ironist hides his jest in earnestness, his earnestness in jest (somewhat like the sounds of nature in Ceylon), so it may also occur to him to pretend to be evil, although he is good. Only remember that the moral categories are actually too concrete for irony.

But irony also has a theoretical or contemplative side. If we regard irony as a minor element, then irony, of course, is the unerring eye for what is crooked, wrong, and vain in existence. Regarded in this way, irony might seem to be identical with mockery, satire, persiflage, etc. There is, of course, a resemblance in so far as irony sees the vanity, but it diverges in making its observation, because it does not destroy the vanity; it is not what punitive justice is in relation to vice, does not have the redeeming feature of the comic but instead reinforces vanity in its vanity and makes what is lunatic even more lunatic. This is what could be called irony's attempt to mediate the discrete elements – not into a higher unity but into a higher lunacy.

If we consider irony as it turns against all existence, here again it maintains the contradiction between essence and phenomenon, between the internal and the external. It might seem now that as the absolute negativity it would be identical with doubt. But one must bear two things in mind – first, that doubt is a conceptual qualification, and irony is subjectivity's being-for-itself; second, that irony is essentially practical, that it is theoretical only in order to become practical again – in other words, it has to do with the irony of itself and not with the irony of the situation. Therefore, if irony gets an inkling that there is something more behind the phenomenon than meets the eye, then precisely what irony has always insisted upon is this, that the subject feel free, so that the phenomenon never acquires any reality [*Realitet*] for the subject. Therefore, the movement is continually in the opposite direction. In doubt, the subject continually wants to enter into the object, and his unhappiness is that the object continually eludes him. In irony, the subject continually wants to get outside the object, and he achieves this by realizing at every moment that the object has no reality. In doubt, the subject is an eyewitness to a war of conquest in which every phenomenon is destroyed, because the essence must continually lie behind it. In irony, the subject is continually retreating, taking every phenomenon out of its reality in order to save itself in negative independence of everything.

Finally, in so far as irony, when it realizes that existence has no reality [*Realitet*], pronounces the same thesis as the pious mentality, irony might seem to be a kind of religious devotion. If I might put it this way, in religious devotion

the lower actuality [*Virkelighed*], that is, the relationship with the world, loses its validity, but this occurs only in so far as the relationships with God simultaneously affirm their absolute reality. The devout mind also declares that all is vanity, but this is only in so far as through this negation all disturbing factors are set aside and the eternally existing order comes into view. Add to this the fact that if the devout mind finds everything to be vanity, it makes no exception of its own person, makes no commotion about it; on the contrary, it must also be set aside so that the divine will not be thrust back by its opposition but will pour itself into the mind opened by devotion. Indeed, in the deeper devotional literature, we see that the pious mind regards its own finite personality as the most wretched of all.

In irony, however, since everything is shown to be vanity, the subject becomes free. The more vain everything becomes, all the lighter, emptier, and volatilized the subject becomes. And while everything is in the process of becoming vanity, the ironic subject does not become vain in his own eyes but rescues his own vanity. For irony, everything becomes nothing, but nothing can be taken in several ways. The speculative nothing is the vanishing at every moment with regard to the concretion, since it is itself the craving of the concrete, its *nisus formativus* [formative impulse]; the mystic nothing is a nothing with regard to the representation, a nothing that nevertheless is just as full of content as the silence of the night is full of sounds for someone who has ears to hear. Finally, the ironic nothing is the dead silence in which irony walks again and haunts (the latter word taken altogether ambiguously).

1 [A reference to the calculations and experimental devices of the German physicist and musician Ernst Chladni (1756–1827), who developed methods for measuring such phenomena as the oscillations of plates and other bodies].

Søren Kierkegaard, extracts from *The Concept of Irony* (1841); trans. Howard and Edna Hong (Princeton, New Jersey: Princeton University Press, 1989) 249–51; 254–8.

Gilles Deleuze
Bartleby, or The Formula//1989

[Herman Melville's] 'Bartleby' is neither a metaphor for the writer nor the symbol of anything whatsoever. It is a violently comical text, and the comical is always literal. It is like the novellas of Kleist, Dostoyevsky, Kafka or Beckett, with which it forms a subterranean and prestigious lineage. It means only what it says, literally. And what it says and repeats is *I would prefer not to*. This is the formula of its glory, which every loving reader repeats in turn. A gaunt and pallid man has uttered the formula that drives everyone crazy. But in what does the literality of the formula consist?

We immediately notice a certain mannerism, a certain solemnity: *prefer* is rarely employed in this sense, and neither Bartleby's boss, the attorney, nor his clerks normally use it ('queer word, I never use it myself'). The usual formula would instead be *I had rather not*. But the strangeness of the formula goes beyond the word itself. Certainly it is grammatically correct, syntactically correct, but its abrupt termination, *not to*, which leaves what it rejects undetermined, confers upon it the character of a radical, a kind of limit-function. Its repetition and its insistence render it all the more unusual, entirely so. Murmured in a soft, flat and patient voice, it attains to the irremissible, by forming an inarticulate block, a single breath. In all these respects, it has the same force, the same role as an *agrammatical* formula.

Linguists have rigorously analysed what is called 'agrammaticality'. A number of very intense examples can be found in the work of the American poet E.E. Cummings – for instance, 'he danced his did', as if one said in French *il dansa son mit* ('he danced his began') instead of *il se mit à danser* ('he began to dance'). Nicolas Ruwet explains that this presupposes a series of ordinary grammatical variables, which would have an agrammatical formula as their limit: *he danced his did* would be a limit of the normal expressions *he did his dance, he danced his dance, he danced what he did...* This would no longer be a portmanteau word, like those found in Lewis Carroll, but a 'portmanteau-construction', a breath-construction, a limit or tensor. Perhaps it would be better to take an example from the French, in a practical situation: someone who wants to hang something on a wall and holds a certain number of nails in his hand exclaims, *J'en ai un de pas assez* ('I have one not enough'). This is an aggramatical formula that stands as the limit of a series of correct expressions: *J'en ai de trop, Je n'en ai pas assez, Il m'en manque un...* ('I have too many', 'I don't have enough', 'I am one short'...). Would not Bartleby's formula be of this type, at once a stereotype of Bartleby's

and a highly poetic expression of Melville's, the limit of a series such as 'I would prefer this. I would prefer not to do that. That is not what I would prefer…'? Despite its quite normal construction, it has an anomalous ring to it.

I would prefer not to. The formula has several variants. Sometimes it abandons the conditional and becomes more curt: *I prefer not to.* Sometimes, as in its final occurences, it seems to lose its mystery be being completed by an infinitive, and coupled with *to*: 'I prefer to give no answer', 'I would prefer not to be a little reasonable', 'I would prefer not to take a clerkship', 'I would prefer to be doing something else'… But even in these cases we sense the muted presence of the strange form that continues to haunt Bartleby's languge. He himself adds, 'but I am not a particular case', 'there is nothing particular about me', *I am not particular*, in order to indicate that whatever else might be suggested to him would be yet another particularity falling under the ban of the great indeterminate formula, *I prefer not to*, which subsists once and for all and in all cases.

The formula occurs in ten principal circumstances, and in each case it may appear several times, whether it is repeated verbatim or with minor variations. Bartleby is a copyist in the attorney's office; he copies ceaselessly, 'silently, palely, mechanically'. The first instance takes place when the attorney tells him to proof read and collate the two clerks' copies: *I would prefer not to*. The second, when the attorney tells Bartleby to come and re-read his own copies. The third, when the attorney invites Bartleby to re-read with him personally, *tête à tête*. The fourth, when the attorney wants to send him on an errand. The fifth, when he asks him to go into the next room. The sixth, when the attorney enters his study one Sunday afternoon and discovers that Bartleby had been sleeping there. The seventh, when the attorney satisfies himself by asking questions. The eighth, when Bartleby has stopped copying, has renounced all copying and the attorney asks him to leave. The ninth, when the attorney makes a second attempt to get rid of him. The tenth when Bartleby is forced out of the office, sits on the banister of the landing while the panic-stricken attorney proposes other, unexpected conditions to him (a clerkship in a dry goods store, bartender, bill collector, travelling companion to a young gentleman…). The formula burgeons and proliferates. At each occurrence, there is a stupor surrounding Bartleby, as if one had heard the Unspeakable or the Unstoppable. And there is Bartleby's silence, as if he had said everything and exhausted language at the same time. With each instance, one has the impression that the madness is growing: not Bartleby's madness in 'particular', but the madness around him, notably that of the attorney, who launches into strange propositions and even stranger behaviours.

Without a doubt, the formula is ravaging, devastating, and leaves nothing standing in its wake. Its contagious character is immediately evident: Bartleby 'ties the tongues' of others. The queer words, *I would prefer*, steal their way into

the language of the clerks and of the attorney himself ('So you have got the word, too'). But this contamination is not the essential point; the essential point is its effect on Bartleby: from the moment he says *I would prefer not to* (collate), he is no longer *able* to copy either. And yet he will never say that he prefers not to (copy): he has simply passed beyond this stage. And doubtless he does not realize this immediately, since he continues copying until after the sixth instance. But when he does notice it, it seems obvious, like the delayed reaction that was already implied in the first statement of the formula: 'Do you not see the reason for yourself?' he says to the attorney. The effect of the formula-block is not only to impugn what Bartleby prefers not to do, but also to render what he was doing as impossible, what he was supposed to prefer to continue doing.

It has been noted that the formula, *I prefer not to*, is neither an affirmation nor a negation. Bartleby does not refuse, but neither does he accept, he advances and then withdraws into this advance, barely exposing himself in a nimble retreat from speech. The attorney would be relieved if Bartleby did not want to, but Bartleby does not refuse, he simply rejects a non-preferred (the proof reading, the errands…). And he doesn't not accept either, he does not affirm a preference that would consist in continuing to copy, he simply posits its impossibility. In short, the formula that successively refuses every other act has already engulfed the act of copying, which it no longer even needs to refuse. The formula is devastating because it eliminates the preferable just as mercilessly as any non-preferred. It not only abolishes the term it refers to, and that it rejects, but also abolishes the other term it seemed to preserve, and that becomes impossible. In fact, it renders them indistinct: it hollows out an ever expanding zone of indiscernability or indetermination between some non-preferred activities and a preferable activity. All particularity, all reference is abolished. The formula annihilates 'copying', the only reference in relation to which something might or might not be preferred. I would prefer nothing rather than something: not a will to nothingness, but the growth of a nothingness of the will. Bartleby has won the right to survive, that is to remain immobile and upright before a blind wall. Pure patient passivity, as Blanchot would say. Being as being, and nothing more. He is urged to say yes or no. But if he said no (to collating, running errands…), or if he said yes (to copying), he would quickly be defeated and judged useless and would not survive. He can survive only by whirling in a suspense that keeps everyone at a distance. His means of survival is to prefer *not* to collate, but thereby also not to prefer copying. He had to refuse the former in order to render the latter impossible. The formula has two phases and continually recharges itself by passing again and again through the same states. This is why the attorney has the vertiginous impression, each time, that everything is starting over again from zero. […]

What then is the biggest problem haunting Melville's oeuvre? To recover the already-sensed identity? No doubt, it lies in reconciling the two originals *but thereby also in reconciling the original with secondary humanity*, the inhuman with the human. Now what Captain Vere [in *Billy Budd*] and the attorney demonstrate is that there are no good fathers. There are only monstrous, devouring fathers, and petrified, fatherless sons. If humanity can be saved, and the originals reconciled, it will only be through the dissolution or decomposition of the paternal function. So it is a great moment when Ahab [in *Moby Dick*], invoking Saint Elmo's fire, discovers that the father is himself a lost son, an orphan, whereas the son is the son of nothing, or of everyone, a brother. [...]

Melville's bachelor, Bartleby, like Kafka's, must 'find the place where he can take his walks'... America. The American is one who is freed from the English paternal function, the son of a crumbled father, the son of all nations. Even before their independence, Americans were thinking about the combination of States, the State-form most compatible with their vocation. But their vocation was not to reconstitute an 'old State secret', a nation, a family, a heritage, or a father. It was above all to constitute a universe, a society of brothers, a federation of men and goods, a community of anarchist individuals, inspired by Jefferson, by Thoreau, by Melville. [...]

Pragmatism is misunderstood when it is seen as a summary philosophical theory fabricated by Americans. On the other hand, we understand the novelty of American thought when we see pragmatism attempt to transform the world, to think a new world or a new man in so far as they *create themselves*. Western philosophy was the skull, or the paternal Spirit that realized itself in the world as totality, and in a knowing subject as proprietor. Is it against Western philosophy that Melville directs his insult, 'metaphysical villain'? A contemporary of American transcendentalism (Emerson, Thoreau), Melville is already sketching out the traits of the pragmatism that will be its continuation. It is first of all the affirmation of a world in *process*, an *archipelago*. Not even a puzzle, whose pieces when fitted together would constitute a whole, but rather a wall of loose, uncemented stones, where every element has a value in itself, but also in relation to others: isolated and floating relations, islands and straits, immobile points and sinuous lines – for Truth always has 'jagged edges'. [...]

Pragmatism is this double principle of archipelago and hope. And what must the community of men consist of in order for truth to be possible? *Truth* and *trust*. Like Melville before it, pragmatism will fight ceaselessly on two fronts: against the particularities that pit man against man and nourish an irremediable mistrust; but also against the Universal or the Whole, the fusion of souls in the name of great love or charity. Yet, what remains of souls once they are no longer attached to particularities, what keeps them from melting into a whole? What

remains is precisely their 'originality', that is, a sound that each one *produces*, like a *ritornello* at the limit of language, but that it produces only when it takes to the open road (or to the open sea) with its body, when it leads its life without seeking salvation, when it embarks upon an incarnate voyage, without any particular aim, and then encounters other voyagers, whom it recognizes by sound. This is how D.H. Lawrence described the new messianism, or the *democratic* contribution of American literature: against the European morality of salvation and charity, a morality of life in which the soul is fulfilled only by taking to the road, with no other aim, open to all contacts, never trying to save other souls, turning away from those that produce an overly authoritarian or groaning sound, forming even fleeting and unresolved chords and accords with its equals, with freedom as its sole accomplishment, always ready to free itself so as to complete itself. According to Melville or Lawrence, brotherhood is a matter for original souls: perhaps it begins only with the death of the father or God, but it does not derive from this death, it is a whole other matter – 'all the subtle sympathizings of the incalculable soul, from the bitterest hate to passionate love'. [...]

The dangers of a 'society without fathers' have often been pointed out, but the only real danger is the return of the father. In this respect, it is difficult to separate the failure of the two revolutions, the American and the Soviet, the pragmatic and the dialectical. Universal emigration was no more successful that universal proletariatization. The Civil War already sounded the knell, as would the liquidation of the Soviets later on. The birth of a nation, the restoration of the nation state – and the monstrous fathers come galloping back in, while the sons without fathers start dying off again. Paper images – this is the fate of the American as well as the Proletarian. But just as many Bolsheviks could hear the diabolical powers knocking at the door in 1917, the pragmatists, like Melville before them, could see the masquerade that the society of brothers would lead to. Long before Lawrence, Melville and Thoreau were diagnosing the American evil, the new cement that would rebuild the wall: paternal authority and filthy charity. [...]

For even in the midst of its failure, the American Revolution continues to send out its fragments, always making something take flight on the horizon, even sending itself to the moon, always trying to break through the wall, to take up the experiment once again, to find a brotherhood in this enterprise, a sister in this becoming, a music in its stuttering language, a pure sound and unknown chords in language itself. What Kafka would say about 'small nations' is what Melville had already said about the great American nation: it must become a patchwork of all small nations. What Kafka would say about minor literatures is what Melville had already said about the American literature of his time: because there are so few authors in America, and because its people are so indifferent, the writer is not in a position to succeed as a recognized master. Even in his failure,

the writer remains all the more the bearer of a collective enunciation, which no longer forms part of literary history and preserves the rights of a people to come, or of a human becoming. A schizophrenic vocation: even in his catatonic or anorexic state, Bartleby is not the patient, but the doctor of a sick America, the Medicine-Man, the new Christ or the brother to us all. [...]

Gilles Deleuze, extracts from 'Bartleby, ou la formule' (1989), *Critique et Clinique* (Paris: Éditions de Minuit, 1993); trans. Daniel W. Smith and Michael A. Greco, *Essays Critical and Clinical* (Minneapolis: University of Minnesota Press, 1997) 68–71; 84; 85; 86; 87; 88; 89–90 [footnotes not included].

Giorgio Agamben
Bartleby, or On Contingency//1993

The Scribe, or On Creation

As a scrivener, Melville's Bartleby belongs to a literary constellation. Its polar star is Gogol's character Akaky Akakievich ('for him, the whole world was in some sense contained in his copies... he had his favourite letters, and when he got to them he truly lost his wits'); its centre is formed by the twin stars, Flaubert's Bouvard and Pécuchet ('the good idea that both secretly nourished – copying'); and its other extremity is lit by the white lights of Walser's Simon Tanner ('I am a scribe' is the only identity he claims for himself) and Dostoevsky's Prince Myshkin, who can effortlessly reproduce any handwriting. A little further on lies the asteroid belt of Kafka's court room clerks. But Bartleby also belongs to a philosophical constellation, and it may be that it alone contains the figure merely traced by the literary constellation to which Bartleby belongs. [...]

The Formula, or On Potentiality

As a scribe who has stopped writing, Bartleby is the extreme figure of the Nothing from which all creation derives; and at the same time, he constitutes the most implacable vindication of this Nothing as pure, absolute potentiality. The scrivener has become the writing tablet; he is now nothing other than his white sheet. It is not surprising, therefore, that he dwells so obstinately in the abyss of potentiality and does not seem to have the slightest intention of leaving it. Our ethical tradition has often sought to avoid the problem of potentiality by reducing it to the terms of will and necessity. Not what you *can* do, but what you *want* to do or *must* do is its dominant theme. This is what the man of the law repeats to Bartleby. When he

asks him to go to the post office ('just step around to the Post Office, won't you?'), and Bartleby opposes him with his usual 'I would prefer not to', the man of the law hastily translates Bartleby's answer into 'You *will* not?' But Bartleby, with his soft but firm voice, specifies 'I *prefer* not' ('I *prefer* not', which appears three times, is the only variation of Bartleby's usual phrase; and if Bartleby then renounces the conditional, this is only because doing so allows him to eliminate all traces of the verb 'will', even in its modal use). When the man of the law honestly tries, in his own way, to understand the scrivener, the readings to which he dedicates himself leave no doubts as to the categories he intends to use: 'Edwards on the Will', and 'Priestly on Necessity'. But potentiality is not will, and impotentiality is not necessity; despite the salutary impression that the books give him, the categories of the man of the law have no power over Bartleby. To believe that will has power over potentiality, that the passage to actuality is the result of a decision that puts an end to the ambiguity of potentiality (which is always potentiality to do and not to do) – this is the perpetual illusion of morality.

Mediaeval theologians distinguish between *potentia absoluta*, an 'absolute potentiality' by which God can do anything (according to some, even evil, even acting such that the world never existed, or restoring a girl's lost virginity), and *potentia ordinata*, an 'ordered potentiality', by which God can do only what is in accord with his will. Will is the principle that makes it possible to order the undifferentiated chaos of potentiality. If it is true that God could have lied, broken his oaths, incarnated himself in a woman or an animal instead of in the Son, he thus did not want to do so and he could not have wanted to do so; and a potentiality without will is altogether unrealizable and cannot pass into actuality.

Bartleby calls into question precisely this supremacy of the will over potentiality. If God (at least *de potentia ordinata*) is truly capable only of what he wants, Bartleby is capable only without wanting; he is capable only *de potentia absoluta*. But his potentiality is not, therefore, unrealized; it does not remain unactualized on account of a lack of will. On the contrary, it exceeds will (his own and that of others) at every point. Inverting Karl Valentin's witticism 'I wanted to want it, but I didn't feel able to want it', one could say of Bartleby that he succeeds in being able (and not being able) absolutely without wanting it. Hence the irreducibility of his 'I would prefer not to'. It is not that he does not *want* to copy or that he does not *want* to leave the office; he simply would prefer not to. The formula that he so obstinately repeats destroys all possibility of constructing a relation between being able and willing, between *potentia absoluta* and *potentia ordinata*. It is the formula of potentiality. [...]

The Experiment, or On De-Creation
In a work on Robert Walser, Walter Lüssi invented the concept of an experiment

without truth, that is, an experience characterized by the disappearance of all relation to truth. Walser's writing is 'pure poetry' (*reine Dichtung*) because it 'refuses, in the widest sense, to recognize the Being of something as something'. This concept should be transformed into a paradigm for literary writing. Not only science but also poetry and thinking conduct experiments. These experiments do not simply concern the truth or falsity of hypotheses, the occurrence or non-occurrence of something, as in scientific experiments; rather, they call into question Being itself, before or beyond its determination as true or false. These experiments are without truth, for truth is what is at issue in them.

When Avicenna, proposing the experience of the flying man, imagines a dismembered and disorganized human body, showing that, thus fragmented and suspended in the air, man can still say 'I am', and that the pure entity is the experience of a body without either parts or organs; when Cavalcanti describes the poetic experience as the transformation of the living body into a mechanical automaton ('I walk like a man outside of life / who seems, to those who see him, a man / made of branches or rocks or wood / who is led along by artifice'); when Condillac introduces his marble statue to the sense of smell, such that the statue 'is no more than the scent of a rose'; when Dante desubjectifies the 'I' of the poet into a third person (*I' mi son un*), a generic, homonymous being who functions only as a scribe in the dictation of love; when Rimbaud says 'I is another'; when Kleist evokes the perfect body of the marionette as a paradigm of the absolute; and when Heidegger replaces the physical 'I' with an empty and inessential being that is only its own ways of Being and has possibility only in the impossible – each time we must consider these 'experiments without truth' with the greatest seriousness. Whoever submits himself to these experiments jeopardizes not so much the truth of his own statements as the very mode of his existence; he undergoes an anthropological change that is just as decisive in the context of the individual's natural history as the liberation of the hand by the erect position was for the primate or as was, for the reptile, the transformation of limbs that changed it into a bird.

The experiment that Melville entrusts to Bartleby is of this kind. If what is at issue in a scientific experiment can be defined by the question 'Under what conditions can something occur or not occur, be true or be false?' what is at issue in Melville's story can instead be formulated in a question of the following form: 'Under what conditions can something occur *and* (that is, at the same time) not occur, be true *no more than not be true*?' Only inside an experience that has thus retreated from all relation to truth, to the subsistence or non-subsistence of things, does Bartleby's 'I would prefer not to' acquire its full sense (or, alternatively, its nonsense). The formula cannot but bring to mind the propositions with which Wittgenstein, in his lecture on ethics, expresses his ethical experience *par*

excellence: 'I marvel at the sky because it exists', and 'I am safe, whatever happens'. The experience of a tautology – that is, a proposition that is impenetrable to truth conditions on account of always being true ('The sky is blue or the sky is not blue') – has its correlate in Bartleby in the experience of a thing's *capacity* to be true and, at the same time, not true. If no one dreams of verifying the scrivener's formula, this is because experiments without truth concern not the actual existence or non-existence of a thing but exclusively its potentiality. And potentiality, in so far as it can be or not be, is by definition withdrawn from both truth conditions and, prior to the action of 'the strongest of all principles', the principle of contradiction.

In first philosophy, a being that can both be and not be is said to be contingent. The experiment with which Bartleby threatens us is an experiment *de contingentia absoluta*. [...]

Giorgio Agamben, extract from 'Bartleby, o della contingenza', in Giorgio Agamben and Gilles Deleuze, *Bartleby: La formula della creazione* (Macerata, Italy: Quodlibet, 1993); trans. Daniel Heller-Roazen, in Giorgio Agamben, *Potentialities: Collected Essays in Philosophy* (Stanford: Stanford University Press, 1999) 243; 253–5; 259–61 [footnotes not included].

Paul Watzlawick
On the Nonsense of Sense and the Sense of Nonsense//1995

[...] That we do not discover reality but rather invent it is quite shocking for many people. And the shocking part about it – according to to the concept of radical constructivism – is that the only thing we can ever know about the real reality (if it even exists) is what it is not. It is only with the collapse of our constructions of reality that we first discover that the world is not the way we imagine.

Ernst von Glasersfeld writes in his introduction to *Radical Constructivism*:

Knowledge is assembled by living organisms in order to organize the actual shapeless flow of experience as far as possible into reproducible experiences with relatively reliable connections between them. This means that the 'real' world only manifests itself when our constructions fail. But as we can always only describe and explain the failure in those terms, which we have used to build the failed structures, a picture of the world, which we could make responsible for the failure, could never be conveyed to us.

Somewhat more metaphorical would be the following analogy: the captain of a

ship has to cross straits he does not know and does not have a chart for nor navigational help such as a beacon, etc. on a stormy, dark night. In the circumstances only two things are possible: Either he sails into a cliff and loses his ship and his life; in the last moment of his life he realizes that the reality of the straits was not as he imagined and his course did not correspond with the actuality of the straits. Or he reaches the open sea; then he knows only that his course was accurate but no more. He does not know whether there could have been easier, shorter crossings than the one he blindly chose. And he does not know what the real condition of the straits was.[1] [...]

1 Ernst von Glasersfeld, *Radical Constructivism: A Way of Knowing and Learning* (London: Falmer Press, 1995).

Paul Watzlawick, extract from *Vom Unsinn des Sinns oder vom Sinn des Unsinns* [On the Nonsense of Sense or the Sense of Nonsense] (Cologne: Taschen, 1995); translated in *Markus Vater* (Solingen, Germany: Museum Baden, 2007) 76.

Scott A. Sandage
The Invention of Failure: Interview with Sina Najafi and David Serlin//2002

Sina Najafi and David Serlin Can you start by telling us the scope of your forthcoming book [*Born Losers: A History of Failure in America*, 2005]?

Scott Sandage The book is a cultural history of the idea of failure in American life from roughly Benjamin Franklin to Bob Dylan. [...] It is a book about ordinary people who throughout American history fell short of whatever the prevailing mark was in the period in which they lived.

One of the problems I had was answering the question, 'Why had nobody written a book about failure before?', at least not a book about real people who failed, rather than what sermons or short stories or novels or advice manuals say about failure. There had been an assumption that there is no source material, that, by definition, someone who failed miserably throughout his life would not have left a paper trail. This turned out to be a false assumption. One of the reasons is that failure has been such a ubiquitous part of the American experience that archives are full of people who have failed. For example, one of the best sources I have found was a cache of about 5,000 letters that ordinary people wrote to

John D. Rockefeller, Sr., in the 1870s, saying 'Dear rich and famous man, here is my long, sad story. Please help me by (a) giving me a job (b) sending me some money (c) giving me advice on how to succeed, etc.'

Najafi and Serlin Does the quantity of material remain consistent throughout the period that you analyse?

Sandage Yes and no. Yes, because I have been able to find enough information throughout the period. No, because part of the analysis in the book is the role that has been played by evolving narrative genres in describing the identity of failure. For example, prior to 1820 you didn't have things like credit reports, police reports, school grades, personnel files, constituent mail, letters to millionaires, and so on. All of these are narrative genres that are invented at particular points in our history and each of them contributes something new to the ability of a person to describe his or her own identity.

A phrase that occurs repeatedly throughout the essays and novels of an author like Mark Twain is 'the average man'. There is a scene in *Huckleberry Finn* where Twain says 'the average man is a coward'. The idea of the average man can't exist until the science of statistices becomes sufficiently well known to a cross section of the general public. The science of statistics dates back to the 1830s and 1840s, but it is the advent of sociology in the late nineteenth century – as well as ideas like credit reporting and movements like Social Darwinism – that represent the beginning of systems being invented to meet perceived needs to rank and classify people.

Credit reporting, for instance, is something that figures largely in the book. You know how you get offers in the mail to show you your credit report? Consumers get rated by TRW, and businesses by Dun & Bradstreet and other companies. This all starts in 1841, with a New York City business called the Mercantile Agency, which later turns into Dun & Bradstreet. The country is at that time still reeling from one of the first national economic crises – the Panic of 1837 – and the Mercantile Agency offers a service to meet a need that did not previously exist. It helps you decide who is trustworthy in a situation in which you are now doing business with people you will never meet. The telegraph, the railroad, the steamboat – all these developments make it possible to transact business across great distances, and so the handshake and looking a man directly in the eyes and sizing him up is no longer possible.

The Agency comes into existence to meet the need to systemize trust. But for the first 40 or 50 years, credit ratings are largely verbal. They are little stories. Only gradually do they begin to develop numerical, encrypted or coded rating systems. So, if I'm a silk wholesaler in New York City and receive an order for five bolts of

silk from a storekeeper in Ohio, I want to know if he's good for the money. I would go to the Mercantile Agency and they would have on file a little story about this person that had been provided by a covert operative in that person's town. [...]

Much of the language that people use today to describe themselves or others as a failure derives from the language of business in general, and the language of credit reporting in particular. I think that is part of the puzzle of failure in America. Why have we as a culture embraced modes of identity where we measure our souls using business models? For example, the term 'A Number 1' used to describe a person comes from credit rating. It means that this person's financial assets, A, and moral character, 1, qualify him for the best rate of interest when he borrows money. Or if you call somebody second-rate or third-rate, that's another way of describing what type of credit rating he has. If he's first-rate, that is because he gets the first rate of credit, etc. If you've ever heard someone called 'of no account', or 'good for nothing', these are from the language of credit rating. Is he good for a thousand dollars to borrow or good for nothing? But in our culture, the phrase 'good for nothing' has moved from a very specific, purportedly objective financial and numerical assessment to something that is much more encompassing in terms of what it says about a person's identity.

Najafi and Serlin How do ordinary people evaluate failure before the creation of these standards of failure?

Sandage In debate with public ways of measuring failure. My goal in a lot of the cases is to get as many competing narratives about the same person as I can find. I will have the credit report which is narrative, a diary if I can find one, a letter from that person's wife or relative describing the person. There are various ways in which these historically specific narratives I mention start to multiply in the nineteenth century so that your identity is a competition amongst the various people who claim the right to describe you. Your identity is in some way a distillation of these narratives, and at various times one may win out. These narratives that we use to construct our identity come increasingly with rewards and punishments. If you are the sort of person who can tell this type of story about your life, you get this reward. If you are the sort of person who can tell another story, you get that punishment. Your life story can help or hurt you.

So in terms of how ordinary people respond, they become aware of the fact they are not the only one telling their story. A lot of times they contest them. The major part of what I do when I deal with the credit reporting is to look at libel cases filed by people who felt that they had been maligned by various credit agencies, which had reported that they were failures or were going to become failures.

Credit rating was invented by a man named Lewis Tappan, who was also an abolitionist centrally involved in the Amistad case (1841). Tappan was a silk wholesaler with his brother in New York City. They went bankrupt spectacularly in the Panic of 1837, and Lewis decided to get out of that business and do something else. It is ironic that an abolitionist created a new way of putting a price on a human head.

The two major drivers of changing American attitudes toward failure in the long term have been, obviously, the growth of capitalism and, much less obviously, the emancipation of slaves. Prior to the Civil War, there were two categories of identity in American life: slaves and free people. After the Civil War, there are two categories of identity in American life: successes and failures. Obviously success and failure is much more of a continuum than slave or free. On the other hand, because it is a continuum and explained within the idea of meritocracy, it is much easier to blame or to make moral judgments about the deficiencies of someone who fails than it was to blame someone for being a slave.

Najafi and Serlin What did failure mean before these changes?

Sandage Basically nothing, because the concept of failure as something that defines your whole identity is a new thing. In terms of language, it doesn't exist at all before the Civil War: you will not find a sentence like 'I feel like a failure' in American writing before 1860. And it is, strangely enough, the usual literary suspects who recognize the metaphoric value of business failure and begin to use it in ways that describe what the culture is doing with that metaphor, meaning that they begin to use it as a metaphor for personal failure – not because they agree with the metaphor but because they recognized that the culture is moving toward taking business success or failure as being the thing that defines your soul. [...]

The first major American financial crisis was the Panic of 1819 and that was the first event that showed ordinary people in diverse geographic areas that some incomprehensible thing that happened on Wall Street could make a major change in their life. Now, of course, there had been hard times before that, but generally in relation to wars, crop failures, droughts and other phenomena that were visible and could be understood. But in 1819 when the economy went belly up, it was invisible and incomprehensible. It was a sea change for Americans to begin to construct their identities in a society that was secularizing, on the one hand, and experiencing cyclical booms and busts that were of uncertain origin, on the other. So about 1820, you begin to get that kind of literature about bankruptcy and failure. But there's a 180-degree shift in the way the word *failure* is used: from 1820 through the Civil War, or thereabouts, *failure* was used to describe people who met economic catastrophe, but the construction was, 'I

made a failure', rather than, 'I *am* a failure'. It was an event that could be discrete, without touching upon one's moral and existential being.

So the first meaning of *failure* before the Civil War is *bankruptcy*. If you say, 'He made a failure', it means he's a bankrupt businessman and, more specifically, it means somebody was too ambitious. He ran his credit up too far, he tried to expand their business too quickly, or he moved into a sideline business that was not the thing he knew the most about. If you ask an ordinary American today to describe a person who is a failure, they would say, 'An underachiever who sort of ambles through life without a real plan and is stagnant.' And that's a 180-degree shift from failure as a person who is an over-reacher and too ambitious to someone who is an underachiever, not ambitious enough.

Scott A. Sandage, Sina Najafi and David Serlin, extracts from 'The Invention of Failure: An Interview with Scott A. Sandage', *Cabinet*, no. 7 (Summer 2002).

John Cage
Anarchy, Poem I//1988

<pre>
 s Pirit of
him for on E
 corpora Tions
 ar E
 failu Re
 Know-how of
 a Re
 id Ols will
 free re Public
 each thr Ough
 Them in
 ma Ke
 I to me
 a Narchism
</pre>

John Cage, Poem I from *Anarchy* cycle of poems (1988); reprinted in *John Cage: Anarchy* (Middletown, Connecticut: Wesleyan University Press, 2001).

Joseph Kosuth
Exemplar: Felix Gonzalez-Torres//1994

> The eye of the intellect sees in all objects what it brought with it the means of seeing.
> – Thomas Carlyle

Whatever one would want to say about that project called Conceptual art, begun nearly thirty years ago, it is clear now that what we wanted was based on a contradiction, even if a sublime one. We wanted the *act* of art to have integrity (I discussed it in terms of 'tautology' at the time) and we wanted it untethered to a prescriptive formal self-conception. Paul Engelman, a close friend of Ludwig Wittgenstein and the collaborator with him on the house for Wittgenstein's sister, has commented about tautologies that they are not 'a meaningful proposition (i.e. one with a content): yet it can be an indispensable intellectual device, an instrument that can help us – if used correctly in grasping reality, that is in grasping facts – to arrive at insights difficult or impossible to attain by other means.'[1] What such questioning directed us toward, of course, was not the construction of a theory of art with a static depiction (a map of an internal world which *illustrates*) but, rather, one that presumed the artist as an active agent concerned with meaning; that is, the work of art as a *test*. It is this concept of art as a test, rather than an *illustration*, which remains. What, then, is the contradiction?

It is as follows. How can art remain a 'test' and still maintain an *identity* as art, that is, continue a relationship with the history of the activity without which it is severed from the community of 'believers' that gives it human meaning? It is this difficulty of the project (referred to now as Conceptual art) that constituted both its 'failure' – about which Terry Atkinson has written so well – as well as its continuing relevance to ongoing art production.[2] It would be difficult to deny that out of the 'failure' of Conceptual art emerged a redefined practice of art. Whatever hermeneutic we employ in our approach to the tests of art, the early ones as well as the recent ones, that alteration in terms of how we make meaning of those 'tests' is itself the description of a different practice of art than that which preceded it. That is not to say that the project did not proceed without paradox. Can one initiate a practice (of anything) without implying, particularly if it sticks, a teleology? Even at the end of modernism a continuum is suggested. This is one of the ways in which its success constituted its failure. What it had to say, even as a 'failure,' still continued to be art. The paradox, of course, is that the ongoing cultural life, of this art consisted of two parts which both constituted its

origins and remained – even to this day – antagonistic toward each other. The 'success' of this project (it was, in fact, believed as art) was obliged to transform it in equal proportion to its 'success' within precisely those terms in which it had disassociated itself from the practice of art as previously constituted. Within this contradiction one is able to see, not unlike a silhouette, the defining characteristic of the project itself: its 'positive' programme remains manifest there within its 'failure', as a usable potential. One test simply awaits the next test, since a test cannot attempt to be a masterpiece that depicts the totality of the world; indeed, it is only over the course of time that the process of a practice can make the claim of describing more than the specific integrity of its agenda. It is such work, like any work, located within a community, that gives it meaning as it limits that meaning.

What is the character of such 'tests'? As Wittgenstein put it: 'In mathematics and logic, process and result are equivalent.' The same, I would maintain, can be said of art. I have written elsewhere that the work of art is essentially a *play* within the meaning system of art. As that 'play' receives its meaning from the system, that system is – potentially – altered by the difference of that particular play. Since really *anything* can be nominated as the element in such a play (and appear, then, as the 'material' of the work) the actual location of the work must be seen as elsewhere, as the point or gap where the production of meaning takes place. In art the how and why collapse into each other as the same sphere of production: the realm of meaning.

As for the project of Conceptual art, we know that what is 'different' doesn't stay different for long if it succeeds, which is perhaps another description of the terms of its 'failure'. Thus the relative effectiveness of this practice of art was dependent on those practices of individuals capable of maintaining a sufficiently transformatory process within which 'difference' could be maintained. Unfortunately practices begun in the past are subject to an over-determined view of art history whose presumptions are exclusive to the practice of art outlined here. The traditional scope of art historicizing – that is, the definition of a style attributed to specific individuals – is most comfortable limiting itself to perceived early moments which are then dated and finalized. While such 'credits' make sense emotionally for the individuals concerned, we've seen where it stops the conversation just where it should begin. In actual fact, the continued 'tests' of the original practitioners should be considered on their own merit along with the 'tests' of other generations, in so far as all are relevant to and comprise their own part of the *present* social moment.

Finally, that which proves to be useful now from this project is one and the same as that which immunized this particular practice from the ravages of a concept of progress. It is the accessibility of its theoretically open 'methodology'

(if only loosely meant as an approach) that has remained viable to a culturally nomadic (even within late capitalism) set of practitioners. Enter here Felix Gonzalez-Torres, stage left.

That monographic tradition referred to above will, undoubtedly, have somewhat other things to do with the work of Gonzalez-Torres. This text has another purpose. I am writing as an older artist who was there at the beginning of a particular process, yet one who is sharing a present context with younger artists. There can be indices on a variety of levels, some superficial and some not, which connect such diverse practices within a cluster of shared concerns, but occasionally the work of a particular individual is exemplary, and such is the case with Felix Gonzalez-Torres.

If one looks through the writing on his work over these past five years, the references most often cited have been to Minimal and Conceptual art. Unfortunately, because of the level of understanding of much of the writing on these topics, the use of these terms tends to block the light rather than enlighten. My interest here is to initiate an attempt to describe the intellectual tradition within which Felix Gonzalez-Torres works as an artist, and his importance now to that tradition as a difference.

Minimalism, still functioning (even if in protest) as an art conceived of in terms of form, offered to my generation the possibility of a tabula rasa, cleansed of the prior meanings collected by modernism. Formed in negation as a signifying activity (before it was made into sculpture by the market), Minimalism had much to say about what was no longer believable in art. To this end, Minimal art was a stoppage and clearing out; it cleaned the wall of other marks to make way there for the handwriting that was to follow. All that was a long time ago. The recycling now of the Minimalist glossary by Gonzalez-Torres constitutes its re-erasure of prior meaning in yet another way. If anyone doubts that artists work with meaning and not form, consider the literature on Minimalism at the time, with its criticism of this work as being simply a replication of Constructivism. Constructivism, Minimalism, Gonzalez-Torres: it goes a long way to show the role of context in the perception and meaning of a work of art. The conceptual 'virus' (as Gonzalez-Torres has described his role) that inhibits the corporal presence of his Minimal forms is, of course, that of supplanted meaning. The corpus of his work is beyond the form his 'host' takes. The basis of a conceptual practice is not what you see but what you understand. It is this process of coming into understanding that links the viewer/reader with the work and concretizes that experience as part of the same event that formed the work, as meaning. The viewer/reader then becomes part of the meaning-making process, rather than being put in the role of passive consumer.

The image-referent of Minimalism succeeds in denying its 'objecthood' and here is where Gonzalez-Torres' work leaves behind Minimalism: he contains it as

parody. The meaning made is Felix's. This is ensured by maintaining an instability in the work as object, goods or material. The illusion of an image or object is the illusion of static representation, since what is seen is a frozen moment of its fragmentation and dissemination (they're often there for the taking). The dynamic of that particular movement is as much the material condition of the work as is whatever formal properties the work shares with what preceded it. Where it comes from (ordered from commercial sources), how long it stays (it sits there, and temporarily behaves as an artwork is expected to), and where it goes (questions arise about the cultural meaning of a fragment, unsigned, which could – perhaps – consign it back to its commercial origins ... yet only almost, since it retains a trace of Felix's subjectivity and political life).

What is the cultural life that Gonzalez-Torres has added to his 'host?' We can see, in another context, that expression institutionalized into Expressionism created a paradox of impersonal generalized marks intended to celebrate the personal. The signifying role of auratic relicry which we inherited from Christian ritual found another cultural life in the market, but ritual without religion is simply a stage for authority, albeit in the guise of 'quality'. Of course art is a form of expression, what else could it be? Such a truth is truistic, however, and we can thank Expressionism for how 'expressive' all the work now looks that was once called anything but. We know now what Expressionism was expressing: Expressionism. What can really be said about expression itself, as a generalization, once it is in the work?

If it is not a generalization, but specific, then it has a kind of functional 'content' which is part of the work's play, with no role as 'expression' per se. The institutionalized expression celebrated in earlier forms of painting seems to pale in relation to this artist's use of personal experience to ground works made with 'impersonal' materials. But it is even wrong to put it that way. This work, like all of the best work in this century, is about meaning, and the value of the work doesn't reside in the props employed to construct that meaning but in the authenticity of that manifestation which the integrity of one individual can assert. Perhaps the most eloquent demonstration of a difference between Gonzalez-Torres and Minimalism might be to consider – for a moment – the same wrong move twice. In the first wrong move we look to the fluorescent light of Dan Flavin – to the object, with a bulb, bought in a hardware store – and try to find the meaning of this work in its materials. We then look to one of Gonzalez-Torres' stacks of paper, also trying to find meaning there, in that stack. We know that both have something to say about an activity called art. Is not the important difference between these artists how they arrive at the condition of art: what we learn from that passage of impersonal materials into products of subjective responsibility? What is the meaning that stands in the gap between a pile of

Gonzalez-Torres candies and a stack of paper that shapes what we see and organizes our thoughts? What, now, does a fluorescent light by Flavin tell us?

One asks these questions to get beyond the object. In a world of objects, we need to know what separates the 'objects of art' from the rest. What the work of Felix Gonzalez-Torres suggests to us is that one can have much to say within the context of art without sacrificing the personal connection to one's work which keeps it within a real social space, and which, as well, gives work a political grounding. Politics, in the case of Gonzalez-Torres, is not an abstract message that reduces work to a passive purveyor of 'content' – as illustration – but, on the contrary, is a socially-based activity which makes the viewer/reader part of the cultural act of completing the work.

1 Paul Engelmann, *Letters from Wittgenstein, with a Memoir* (Oxford: Basil Blackwell, 1967) 105.

2 Increasingly, after 1970, the intrusion of 'the philosophically interrogative subject into the construction of artistic identity/subjectivity' – as Atkinson has put it – began to wind down as a concern. From the point of view of Atkinson and myself (in marked contrast to what now goes under the name Art & Language) the 'return to painting' of the eighties was in the main a failure of historical nerve in art practice, a fatigue in the face of the complex legacy of Conceptualism which buckled under the market's pressure for 'quality defined' traditional forms of art. For more on Terry Atkinson's point of view, see his 'The Indexing', in *The World War I Works and the Ruins of Conceptualism* (Belfast: Circa/Dublin: Irish Museum of Modern Art/Manchester: Cornerhouse, 1992); *The Bridging Works 1974* (London: Mute Publications, 1994); 'The Rites of Passage', in *Symptoms of Interference, Conditions of Possibilities: Ad Reinhardt, Joseph Kosuth and Felix Gonzalez-Torres* (London: Camden Arts Centre, 1994); and 'Curated by the Cat', presented as a lecture at the Camden Arts Centre, 8 January 1994.

Joseph Kosuth, 'Exemplar', in Felix Gonzalez-Torres (Los Angeles: The Museum of Contemporary Art, 1994) 51–9.

Renée Green
Partially Buried. Version B: Reading Script//1999

Black screen
 Music begins: *Apocalypse*, The Mahavishnu Orchestra, 1970
 Titles roll up
 (Footage of R. driving World's Fair globe, childhood association images – zoo,

children playing, museum, parks carousel, etc. – alternate between black screens with blue running text)

Running text (to translate as a simultaneous voice-over in German)

How does one return? To a country, to a place of birth? To a location which reeks of remembered sensations? But what are these sensations? Is is possible to trace how they are triggered and why they are accompanied with as much dread as anticipation?

Apocalypse continues, but shifts from orchestral to seventies jazz fusion.

Running text

Returning to a once familiar place can remind one of childhood, especially if one was just ending childhood upon departure. Although there have been many departures and returns since those earlier years this return, perhaps for reasons since those earlier years this return, perhaps for reasons of age and uncertainty, induced the artist to examine her relationship to the genealogy of American artists as well as an attempt to imagine the currents which affected her before she was consciously aware of their capacity to shape.

(Footage of models of New York, a German toy train passing through a model city, desk with Smithson sculpture book and laptop screen, image of *Partially Buried Woodshed*, map of Kent, Ohio, 1970 *New York Times Encyclopaedic Almanac*, still photo of Robert Smithson and Robert Morris climbing chainlink fence, students in Berlin protesting against the Axel Springer Verlag – is intercut with the running text at intervals)

Music: *Changes*, Jimi Hendrix and Buddy Miles at the Fillmore, 1970

Running text

Everywhere she goes she encounters echoes of the 1970s. The 1970s are in vogue now. Were they in vogue then? What could that mean? Are the 1990s in vogue now? This is the decade we are in and we are contemporary. It does seem popular to be contemporary, in step with the times. But hasn't that always been the case when one is contemporary.

(Images from *Performance* with Mick Jagger, from the year 1970, and of records from the 1970s are intercut with the running text at intervals)

Rolling text: Background colours change continuously

Contemporary: 1. existing, occuring, or living at the same time; belonging to the same time: Newton's discovery of the calculus was contemporary with that of Leibniz; 2. of the same age or date: a Georgian table with a contemporary wig stand; 3. of the present time: a lecture on a contemporary novel; 4. one belonging to the same time or period with another or others; 5. a person of the same age as another.

Music stops

(Sound of projector and voice-over of still text in English over footage of earth being dug up and dropped by machinery, fingers pressing down and moving over piano keys [close up]. Super 8 footage of light and shadows on green grass, a children's swing set, Kent State campus in the summer of 1996, views of bridges and industrial wasteland in Cleveland, feet walking up a hill [close up], photo of William Carlos Williams)

Still text on separate screens: Intercut with above stated images

Screen A: He was born in 1936. Her mother was born in 1934. Often when you read about his work you can't escape the importance of his death:

Screen B: 'Robert Smithson, who dies in a plane crash in 1973, remains as compelling a presence among artists today as he was then.'

(The first sentence in Robert Smithson: The Collected Writings, edited by Jack Flam, 1996)

or

Screen C: 'The greatest tragedy of Smithson's early death is not merely that there will be less "good art" in the world, but that he was virtually the only important artist in his aesthetic generation to be vitally concerned with the fate of the earth and fully aware of the artist's political responsibility to it.'

(The closing sentence of Lucy Lippard's Breaking Circles: The Politics of Prehistory)

or

Screen D: 'Before his fatal accident in 1973 Robert Smithson was a leading vanguard artist, but after it he became an even more significant figure, especially for those who viewed him as the equal of such innovators as Jackson Pollock.'

(The first sentence of Robert Hobbs' Introduction to Robert Smithson: Sculpture)

Black screen

A ticking sound begins

Ticking sound continues over footage of demonstrations of entropy: an egg falling to the ground and shattering, fingers 'running' in a circle inside a bowl in which salt and pepper are equally divided. Footage intercut with the running text.

Running text

Deaths and lives are what myths are made of and their residue is what we can read about or watch in a movie.

The artist is now 36

'Nel mezzo del cammin di nostra vita / mi ritrovai per una selva oscura, / che la dirritta via era smarrita.'

'At midpoint of the journey of our life / I woke to find me astray in a dark wood, / perplexed by paths with the straight way at strife.'

Often she thinks of these words and remembers having read that when Samuel Beckett died the only book he had with him was Dante's *The Divine Comedy*.

(Sound of music experiments and music by Arnold Schoenberg. Footage of John Cage with students, musical contraptions installed in museums)

Running text with German voice-over

She thinks of her mother's training as a classical vocalist, of her study of twentieth-century music, of how she'd been impressed to find John Cage on the cover of the art magazine in which her daughter was interviewed, strangely enough on 'sites of genealogy'. The artist remembers how she and her little brother assisted their mother in her experimental music exercises for a workshop at Kent State. Making noise with kitchen utensils at specified intervals. The year was 1970.

She has been described as an international artist who works 'in installations' and who at times makes 'site-specific' work. For several years the meanings of these definitions have seemed more and more hollow. This year one of the 'site-specific' works was lost. To re-examine these terms she returns to Smithson's writings of the 1960s and early 1970s. What was this dialectics of site/nonsite? Could the 'nonsite' be a place of production? Must it be dead compared to the site? Was the site also dead?

(Footage of Kent State campus 1996, memorial plaque)

Still text

These were the seemingly binary distinctions:

(appears in yellow type over the image of this list)

Site	Non-site
1. Open Limits	Closed Limits
2. A Series of Points	An Array of Matter
3. Outer Coordinates	Inner Coordinates
4. Subtraction	Addition
5. Indeterminate Certainty	Determinate Uncertainty
6. Scattered Information	Contained Information
7. Reflection	Mirror
8. Edge	Centre
9. Some Place (physical)	No Place (abstract)
10. Many	One

Running text with English voice-over out of sync with rapid titles intercut with footage:

As she reads her mind wanders to thoughts of her mother.

(Sound of motors humming)

(Footage images alternate between motorized kitchen appliances and footage of the Kent State campus in 1996, map of Kent State, *New York Times Almanac* dated 1970, turned pages of James A. Michener's book on Kent State, archival footage from 1970)

They occupied the same time and location briefly. Is that important? Not necessarily, but she ponders the conjecture. Kent State, 1970. When her mother was in an experimental music workshop could Smithson have been organizing for dirt to be dumped on a woodshed? Maybe the memory of scraping graters, whirring egg beaters and pounding pans while spoken words were rhythmically uttered evokes images of dirt dug and dumped, of those coined 'beatniks', even of her uncle, who went to Kent State, jamming or did they say 'groovin'? But Smithson was no boho cat and her mother was certainly not a boho chick.

Did people have more fun then? Burying buildings with dirt, pouring glue down hills, making islands out of broken glass. Allan Kaprow gave students dollar bills to pin on trees at Kent State then. But, what a question? She was alive then. Contemporary. A ten-year old contemporary.

The girl watched the news and waited anxiously, often. That's part of what she recollects of childhood. Waiting. Seeing the running text of the news reporting students shot at Kent State moving across the bottom of the TV screen. Waiting. TV programmes were interrupted and her mother was late returning home from there. Across the street kids played Jackson Five 45s and Sly Stone. The girl smoothed her bedspread and checked for order. Finally her mother did arrive but she can't now remember what either said. It was 4 May 1970.

(Footage of Kent State and the town of Kent, Ohio in 1996. R. walking around the campus, moving footage and still photographs.)

They drive around the campus, July 1996. 'Is that the notorious door to the Music and Speech building?', she says pointing at one of the box-like buildings. This she read about in James A. Michener's non-fiction book, *Kent State: What Happened and Why*. Her mother doesn't remember. Her father points to 'The Hill', which he remembers.

(Footage of 'The Hill' in colour Super 8, handheld camera moving rapidly through the trees)

Interview insert: Dorothy Shinn, art critic, *Akron Beacon Journal*, describing the red plants on the slope in front of the *Partially Buried Woodshed* site (see *Partially Buried Transcripts*).

Running text: intercut with footage of Dorothy moving into the woods and with her voice still describing the site:

'Whenever there was an unusually violent incident, or a scatological one, or something "excessive", one finds the writer taking refuge in the literary conventions of the day. "I was left in a state of distraction not to be described"' (Equiano).
(Toni Morrison, *The Site of Memory*)

No sound

Rolling text

'The rustic, ramshackle woodshed stood in sharp contrast to the other buildings in the area, which were for the most part modern concrete structures. It was a makeshift storage for dirt, gravel and firewood. Smithson decided to leave some firewood in the building and on 2 January had earth moved to the area from a construction site elsewhere on campus. Operating a back hoe under Smithson's direction, Rich Helmling, a building contractor piled twenty loads of earth onto the shed until its central beam cracked. The breaking of the beam was crucial to the piece: To Smithson it symbolized entropy, like the falling of Humpty Dumpty, 'a closed system which eventually deteriorates and starts to break apart and there's no way that you can really piece it back together again'.

(From *Robert Smithson: Sculpture*, edited by Robert Hobbs)

Interview insert: Brinsley Terrell, artist and former sculpture professor, Kent State University.

He wanted to do a mudslide and it was January. Mud doesn't slide in January, at least not in Ohio. So he sort of said, alright, so he'd go back to New York and everybody sat around one evening and said, 'we don't want to go back to New York. Isn't there something you've always wanted to do?' And he said well, he'd always wanted to bury a house or a building. So everyone sort of ran off like little sort of rats and somebody found a building, somebody found a place on campus where they were excavating earth and got somebody to agree to divert some of the earth to bury the building. The building was over here (he points) and it didn't look like this, the university's been expanding down this end.

(Footage of the artist R. entering the woods walking to the *Partially Buried Woodshed* site, entering the woods, walking on the remaining foundation of the shed)

There used to be a farmhouse sort of over here, and in the backyard of the farmhouse was this wooden shed that was full of logs. And the university in its naïvety said sure we're going to demolish this, you can use this building.

So we spent all week hauling the logs out of the shed because Smithson didn't want them in there. I think there were a few that got left, but most of them got hauled out. He got ill with flu, and we hauled all of the logs out. It's a nice sunny

day, but it was snowing hard most of the that week. At the end of the week the bulldozer came around and the trucks of earth came around and we piled earth on the corner of the building until the main beam cracked, which was a precondition which Smithson had decided, that was the point at which to finish. So he piled the earth.

The drawings always indicated that there would be more earth on top of the building. I guess it cracked rather early. So that sort of stopped. Then we had a sort of last day and I was sort of saying how do we keep this thing, what do we want to happen to it? Well, he didn't want it to be cleared away just for the sake of clearing it away, he wanted it to pick up some history. And I sort of thought, 'Well, how do I go to the university and argue that this earth piled on a building is something that they should keep?' And I asked him to put a monetary value on it, which started off at $10,000, he got his gallery to write a letter with $10,000 on it. Not that you could ever sell it or move it, but it's easier to talk to people about a monetary sum than it is to argue that something that doesn't look like art to them is worth keeping.

(Footage from the pages of *Robert Smithson: Sculpture*: 'I, Robert Smithson, hereby donate the following work of art to Kent U. ...')

So the university wouldn't accept it, but said that it wouldn't bulldoze it for the sake of it, which was pretty safe because they thought they were going to build a great big building on the site. And they thought that was sort of safe. But the problem was that the shootings happened. He put the piece up in January and all hell broke loose on the campus in May. And the students were shot and Kent lost all its political clout, and all its funds to build any buildings. So the site sort of sat there. And then, every now and then, someone would want to clear it away and someone would rally round and try to prevent them. And this was a sort of reoccuring theme.

The building was burned at one point and we all sat there and argued about every beam and whether it was safe, and part of the building was cleared away and part of it was kept. And finally one winter when nobody was looking, the main beam that had cracked initially, collapsed. At some point in there the grounds crew came in and tidied up and got rid of the building.

The site is sort of still there, the earth is sort of still there. I guess I always liked the fact that the university never really understood that it got an important piece. Actually nobody building the piece understood that it was going to be an important piece. I don't think Smithson thought it would be an important piece.

Voice-over (continues over footage of overgrown remains of *Woodshed*)

'The *Partially Buried Woodshed* has been regarded as a prescient and revolutionary work of art. Only four months after its creation, four students were

killed and nine others wounded by National Guardsmen during a campus protest against America's invasion of Cambodia. This subsequent tragedy has for many people eminently politicized the creation and significance of the *Woodshed*. Art critic Phil Leider told Nancy Holt he felt it to be the single most political work of art since Picasso's *Guernica*. Nancy Holt has referred to the piece as 'intrinsically political' and indicated that Smithson himself believed it to be 'prophetic'. All we can say definitely, however, about the politics of the work is that the *Woodshed* is implicitly anti-'Establishment' through its reference to "muddy thinking".'

(From *Robert Smithson: Sculpture*, edited by Robert Hobbs)

(Recording of the reading of an excerpt of *The Establishment*, by Robert Smithson, simultaneous with music – Hendrix)

(Footage of Metropolitan Museum of Art and Central Park)

(Footage of departing shot of woodshed after Dorothy Shinn interview, view from distance, fade to black)

Voice-over: Lumumba Turner, freedom fighter, interview excerpt:

'The times have been buried...' (see *Partially Buried Transcript 2* and *Partially Buried CD track*)

Voice-over: Laura Owens, artist, born in 1970, describing a high school teacher in Ohio who had been a National Guardsman (*Partially Buried* CD track)

(Footage: slow motion out of sync with voice-over)

Running text Intercut while Laura's voice continues

'When I hear someone say, "Truth is stranger than fiction", I think that old chestnut is truer than we know, because it doesn't say that truth is truer than fiction; just that it's stranger, meaning that it's odd.'

('Toni Morrison, *The Site of Memory*)

Laura's voice stops and the sound of a child speaking in German in sync with the jellyfish footage continues ('Haben die augen?', translated as 'Do they have eyes?'). Sound of projector begins with footage of road at night.

Cut to black

End

Renée Green, *Partially Buried. Version B: Reading Script* (1999) (adapted from *Partially Buried. Version A: Reading Script*, 1996); in *Renée Green: Shadows and Signals* (Barcelona: Fundació Antoni Tàpies, 2000) 65–72; reprinted in *October*, no. 80 (Spring 1997) 39–56.

Lotte Møller
Failures: Annika Ström//2008

Failing as an artist and failing as a human being are recurrent themes in Annika Ström's work. Her songs, text pieces and films all touch on the question of inadequacy – if not miserable failure. The content and aesthetics repeatedly play with the notion of imperfection. Ström's text pieces are clearly hand painted, the videos include shaky, blurred images, and her rhythm-box compositions flirt with an amateurish Eurovision aesthetic.

Take for instance the sequence in the music film *16 minutes* (2003), in which a male ice dancer fails at a jump. The close-up of the ice skate losing its grip on the ice is cut onto a series of less dramatic clips from everyday life. Scenes of fish trapped in a container, carpets being washed in a lake, the artist working alone in her studio, a Swedish accordion orchestra, a sunset, or a wastebasket rolling on the floor, are presented together with short sequences of friends and family showing their photos of other friends and family members. The images are accompanied by sad love songs with lyrics such as *It's either me or you* or *This is a song for you, but you will never hear it*. The sadness of the songs heavily underscores the melancholy nature of the images, which are then transformed into metaphors for lost expectations and failed relationships. Nearly every image is either a close-up or in detail. The viewer is deprived of the context, and this is made conspicuous by its very absence. *16 minutes* describes the sensation of the world closing in on you. It stages the feelings of loneliness and isolation that make it impossible to see life from a greater perspective.

Everyone knows it is very human to fail, but that does not make it socially acceptable. Many of Ström's text pieces deliberately label the speaker as a general failure with self-effacing statements such as, *I love to live but not with me* or *Excuse me I am sorry*. Or they refer specifically to the artist's profession: *I have no theory about this text* or *Everything in this show could be used against me*. The sarcasm comes to the fore in the phrases that mock the inherent pretentiousness and myth-building mechanisms of the art world. The 'misspelled' text piece *This work refers to Joseph Kosutt*, was initially intended as a little joke about so-called 'referentialism' in contemporary art, but someone took the statement seriously and it ironically ended up serving as its own target. Seen from that perspective, one could say that it failed at its purpose – but it did prove a point.

The videos, *The missed concert* (2005), and *After film* (working title, 2008),[1] ironically play with notions of failure and incompetence as well. *The missed concert* is based on a true story. Ström has a truly bad memory when it comes to

song lyrics, and this means that her songs have to be very short. This, of course, affects the lengths of the concerts. They are very easily missed. In fact, it happened to this writer several times, for very banal reasons that should not be mentioned here. *The missed concert* presents the kind of stories Ström always hears from people when they attempt to explain why they missed her concert, how embarrassed and sorry they are and so on.

After film – which only exists as a neatly written manuscript for a video piece – documents Ström's incompetence even before the failure has become a fact. The video predicts the artist's first feature will be a total flop. Upon the film's release in 2009, friends from Ström's neighbourhood in southern England are questioned about the sudden disappearance of the filmmaker and her son. Some speculate that she has quit her career as an artist to join an aid programme for children in Argentina – or was it Indonesia? All in all, *After film* is not only about failing. It plays with the romantic notion of secretly leaving your old life behind to begin anew.

Although Annika Ström presents her failures – or fear of failures – it is in the ironic frame of their presentation that Ström's 'failures' become poetic. Her works touch on basic human anxieties, such as the fear of being judged by others or the feeling of not being good enough. Constantly insisting on revealing her own irrational fears and supposed insufficiencies, her work questions the predominant values of a success-oriented society.

1 [This work evolved to *After film trailer* (2008).]

Lotte Møller, 'Failures', in *Annika Ström Live: Works from 1995 to 2008*, ed. Christophe Boutin (Paris, onestar press/Värnamo, Sweden: Fälth & Hässler 2008) 101.

Jennifer Higgie
The Embarrassing Truth: Matthew Brannon//1995

Art is the triumph over chaos.
– John Cheever

You know how it is. You see a show you really like. You spend time with it as you're thinking and walking around and looking, you jot down some words in your notebook. Then you go on your own way, and the images stay with you and

you recall them with accurate, complex pleasure; but after a while life takes over, and those once crisp lines begin to blur. And then when the days and weeks and months pass, and all you have left of those tangled, illuminating ideas that you so enjoyed when you looked so hard at those pictures and objects are the few words you hastily scribbled in your notebook, because you said to yourself: I don't need to write the details of my thinking down, because these thoughts are so good they will never be forgotten.

Oh, but they will. So much interpretation (read: art, life) is clouded and driven by the fallacies of memory, about the slippage between actuality and recollection. Trying to mine slivers of meaning from the residue of an experience that has, inevitably, cracked and crumbled with time can complicate or cool your initial engagement with something or someone (not necessarily a bad thing). Case study: a couple of months ago I spent a good while looking at Matthew Brannon's pictures and sculptures, and I liked them *a lot*, with a rare, dizzy shot of recognition – as though they were things I wanted to know about before I realized they existed, if you know what I mean. Like Surrealist tableaux dreamt up by advertising executives in the 1950s, they were at once the freshest and most old-fashioned things I had seen in a very long time. (I must also add that they prompted, although no alcohol had passed my lips, a Martini-soaked daydream, which endeared them to me *immediately*.) I loved the work's brittle originality (weird how that word has become so old-fashioned), its wit and restraint and the way its good-looking friendliness belied its tricky aspirations. I also enjoyed how the spectre of Andy Warhol's youthful, advertorial self seemed to haunt the younger artist's creations like a genial great-uncle.

More recently, revisiting the results of Brannon's toil, I still liked them a lot, but for reasons that were more difficult to articulate. Why this was so was initially unclear to me. Perhaps it was because: a) like they always do, things change, even the static ones; or b) I was now forced to write down my thoughts, an activity that tends to cast an anxious pall over subjects once heartily enjoyed; or c) it had been raining for longer than it ever had before in the history of rain; or d) I was older. But whatever, in a short space of time I had shifted from thinking about Brannon's work in an ice-clinking-in-a-tumbler-on-a-balmy-evening sort of way and had started associating it with the words of a writer whose name I can't remember, who said that living in the modern world was like having fun at a picnic while keeping your ear cocked for the distant rumble of thunder.

The thing is, Brannon's prolific output lends itself to easy readings, despite its complexity, because it's simply so enjoyable – hence my confusion. However, if you choose to spend some time with its charmingly superficial qualities, hidden depths gradually reveal themselves (but depths, I hasten to add, that cling fondly to their immaculate wrappings). Often displayed in cabinets that recall museums

circa 1952, the work can swing, in the blink of an eye, from a sort of Ernest Hemingwayish macho will-to-truth to a mood of urbane malaise *à la* Truman Capote, to a discreet Minimalism or a wilful absurdism. Another sly level of confusion is, of course, the work's twisted relationship to nostalgia, about which Brannon declares: 'The current art world participates in a conservative version of radical. I am more interested in a radical version of conservative.'[1] It's no coincidence that the artist has chosen both to pay homage to and undermine the look of advertisements from the 1950s – the most confident decade in the history of the USA and the one in which everyone seemed to smoke, when alcoholism was the norm and disappointment was admitted to only in novels. It was, in other words, the last decade before the cracks began to show on a grand scale.

Brannon's disorienting strategies are apparent in his approach both to individual works and to his exhibition designs: he often sets his type so tiny that you have to lean in close to read it, and combines unexpected, almost invisible, objects and inaccessible sculptures with more apparently conventional elements (for example, he has placed minute poems in the spine of *Artforum* and told me about wanting to bury a screenplay in a wall). At his recent exhibition at the Friedrich Petzel Gallery in New York, it would have been easy to overlook two handmade wooden lightbulbs, a fake light switch and a pile of 25 black books and a wooden cup on a shelf so high up it was impossible to read them (*Rat*, 2008). The books were misleadingly described as 'novels' but are, according to the artist, 'more like 64-page prose poems'[2] (he has also written *Hyena* and *Mosquito*, 2007, and *Poodle*, 2008). Their inaccessibility is intentional. Brannon told me that: 'No one so far has read them aside from my wife and an editor although maybe the collectors who bought them have snuck a peek. I've been pretty careful to make sure the dealers don't.'[3] He also placed a 'sleep-sounds cancelling device' in the gallery with the stated purpose of creating a peaceful ambience, although I suspect it was included because anything as predictable as not including a 'sleep-sounds cancelling device' would make Brannon fret about the possibility of closure. It's as if he likes to seduce everyone with the sunny charm of his work and then, *whammo*, allow scenarios to spiral into something that Patricia Highsmith (who liked to keep snails in her bra, by the way) might have dreamt up in the Ripley books. (It makes sense that a few years ago he reworked posters for horror movies.)

The dislocation Brannon mines so well mirrors the problems not only of interpretation but also, obviously, of life itself (no one is flawless). This is apparent in the gulf between what the work looks like (anachronistic, chic, insane) and what the, if not brutal, then at least acerbic (and often hilarious) texts that often accompany the images declare. (That Sigmund Freud's *Jokes and Their Relationship to the Unconscious*, from 1905, is one of the artist's favourite

books should come as no surprise.) Brannon describes his rationale thus: 'I seek a play with words that is both specific in meaning and conversely teetering with inappropriate reception'.[4] It's a strategy that both mirrors the schizophrenic relationship of advertising to reality and functions as a form of resistence to a culture nurtured on quick-fix sound bites. Accordingly, words (the original ready-made) are often the most free-associated and abstract element of the pictures. They can be terse, deadpan and literal – as in 'Finish your drink, we're leaving', written beneath an image of a smouldering cigarette and a soda siphon – or deranged micro-stories or concrete poems. Almost all of them, however, deal with, on some level, failure – of words to communicate, of alcohol to animate, of critics to criticize, of relationships to offer solace or of representation to represent. Below a picture of scattered coins, for instance, is written: 'He's telling me he didn't like the show. It's nothing more than graphic design. The writing is trite and full of gimmicks. The work is embarrassingly self-conscious, boring, over-rated, and in the end, totally unnecessary. I look away, set down my espresso and mutter *who asked you?*' Brannon also mines non sequiturs within an inch of their baffling lives: for example, the words 'Steak dinner' underline an image of bananas, while another picture of what appears to be a pot of fish is captioned 'Compliance & Resentment'. A silhouette of a blackbird, some pencils, an iPod, paper clips and a coffee stain is accompanied by the words 'Pigs Like Us', beneath which, in tiny type, is written: 'They had to pump her stomach. Amazing what they found. Among the arugula, watercress, blue-fin tuna, age-dried steak. There it is. Your heart. And Look... a bunch of razor blades. Little light bulbs. Cocaine. Little travel bottles. Anti-depressants. Your old untouched job application.'

Getting absorbed in these textual mini-dramas can overwhelm the sheer range of nuance and visual reference in Brannon's work. In response to his show at Petzel I noted down things and themes that leapt out: 'ennui, language as material, sincerity (?), a 1950s palette, women's shoes and Warhol, self-deprecation, knives (double-edged), laughter (high-pitched), drinking (as in alcohol), heels (all types), typewriters, cigarettes and cities, vodka and wine, jazz (generally), John Updike, getting tight, Richard Prince, suburbs, East Coast, Pae White, *Revolutionary Road* (as in the novel), Stan Getz? Bill Evans? Vignettes, bitter glances, the joy of surfaces (and superficiality?), dislocation, flatness, light bulbs, linoleum, being literal, allusive and vague (i.e. human), the embarrassment of art and sex and combinations thereof, disillusion, poems, America and hyenas.' (There's a lot more of the same, including 'the future?', 'melancholy' and 'the smell of tweed after rain', but I think you've got the idea.) Re-reading this, the only thing that stumped me, apart from the amount of question marks, was hyenas. What did they have to do with anything?

I had no idea. So I lay in cool dark, room and tried to remember every moment of my visit to Brannon's show and then studio where I recalled he had greeted me in friendly fashion, in vivid green loafers. He was articulate and self-deprecating and showed me lots of things and talked about them well. He was at once very interested in the craft of his pictures (letterpress is a somewhat antiquated printmaking technique that is undergoing a revival) and in the way words can simultaneously reflect, misrepresent and complicate a situation. (Non sequiturs are a case in point: eavesdrop on a bus or a dinner party, and they're all you hear – it's a form of communication more common than you might assume.) Then I remembered something else: just when Brannon was showing me one of his exquisite prints (most of which are made in an edition of one, like paintings), without warning he asked me if I wanted to listen to a recording he had made in Berlin of a hyena. I said yes, we sat on his couch and listened to a wild caged animal howl, but then, as far as I remember, we changed the subject. How could I have forgotten that this happened? It was like buying tickets for a flute concerto and finding yourself at a shooting range.

(While we're on the topic of wild animals, I'd like to make a slight detour for a moment. Few people have observed – and punctured – the complacencies of polite society with as much wit as the Edwardian writer Saki, who is like a pre-war British literary equivalent of Brannon. The two seem to share the belief that civilization is protected by a veneer so thin it struggles to keep the beasts – the metaphorical and literal ones – at bay. Take this exchange from Saki's short story 'The She-Wolf' (1914): "'I wish you would turn me into a wolf, Mr Bilsiter", said his hostess at luncheon the day after his arrival. "My dear Mary", said Colonel Hampton, "I never knew you had a craving in that direction." "A she-wolf, of course", continued Mrs Hampton, "it would be too confusing to change one's sex as well as one's species at a moment's notice."')[5]

Anyway, thinking about all of the above, I read every interview Brannon has given, and in one of them the hyena once again makes a sudden entrance. 'Did you know', he asks his interrogator, who in terms of animals has so far mentioned only ostriches, 'that hyenas are the only predators of lions outside of man? They are portrayed as frightened scavengers, but in reality a hyena eats and hunts about the same as the lion. When a hyena eats another animal, it eats everything, cracking huge bones and swallowing it all. Its faeces are often white from bone.'[6] Then Brannon's gritty conversational gambit suddenly changes gear. 'Truth', he says, 'is also another loaded term. I would like to remain on the cynical and sarcastic side and say truth is an embarrassment. But it has been said that lying is moral, which I can understand. So that leaves us with a question of responsibility to the audience. People frequently read much of my text as autobiographical. Perhaps they are right, but it wasn't my intention. I'm even suspicious of my own

intentions.'[7] In other words, Brannon's work may not be literally autobiographical, but the core of it – its simultaneous distrust of, and flirtation with, absolutes – is. This makes sense to me. Why, he seems to ask, would you trust a picture in the first place? After all, even the smartest of them are simply *pictures*, not sentient beings. He makes clear that our (and by 'our' I mean people who live in big, Western cities) seemingly watertight understanding of the world is, in fact, as leaky as hell – which, though a pretty sad state of affairs, doesn't, thankfully, mean we can't have fun getting wet.

1 Rosa Vanina Pavone, 'Innocent Accidental Unintentional Indulgent. Never: An Interview with Matthew Brannon', *Uovo* (April 2006) 154.

2 Email from Matthew Brannon to the author, 30 September 2008.

3 Ibid.

4 Pavone, op. cit., 150.

5 Saki, 'The She-Wolf', from *Beasts and Super-Beasts* (London, 1914).

6 Pavone, op. cit., 148.

7 Ibid, 148.

Jennifer Higgie, 'The Embarrassing Truth', *frieze*, no. 119 (November–December 2008) 166–71.

International Necronautical Society
Tate Declaration on Inauthenticity//2009

We start by thanking Tate Triennial curator Nicolas Bourriaud – firstly for his provision of a platform for the delivery of this joint statement of inauthenticity for the first time in the UK; and, equally importantly, for placing at our disposal this piece of conceptual hardware, 'the altermodern'. As a notion, it resonates loudly with the INS's own concerns. As an organization, we have always resisted the catch-all term 'postmodernism' – and particularly when it is used to designate a historical or cultural period that follows 'modernism'. This is a misuse, plain and simple. Jean-François Lyotard himself, the term's first proponent, was at pains to point out that, far from naming an epoch, the postmodern describes a rupture and eruption within the modern, and an attitude of incredulity towards grand narratives, be these aesthetic, ideological or metaphysical. *This* definition we celebrate, while recognizing that the nomenclature in which it originally came wrapped is beyond recycling.

But we want to go further, interrogating even the term 'modern'. For us, all forms of periodization suck. We have no idea when modernity is meant to have started and no clue when it might end. Sometimes we think that maybe it never happened. And if the postmodern is defined in terms of incredulity towards meta-narratives, then when does that begin? In Aeschylus' *Agamemnon*? In Socrates' endless irony? In Paul's rejection of the Old Law? With Averroes' implicit separation of rationality from the authority of faith? With Copernicus' rejection of the Ptolemaic universe? This list could be extended. The point is that the possibilities are infinite. There have always been cracks in the historical stories any social group tells itself. What the INS is interested in are the breaks, fissures and shadows that the modern has always had within it; we are interested in the way that the modern has always, and very self-consciously, been devoted to failure, to its failure and the failure of any attempt to circumvent it in an idea of the postmodern. To put it in the outdated Heideggerese of the deconstruction business, the modern has always already been altermodern.

Bourriaud's altermodern chimes with the INS's own projects further still. In his vision, the artist becomes a 'homo viator' who travels and trans-passes, drawing lines in space and time, materializing trajectories. The words could be taken from the INS's own First Manifesto, which, behind the signifier 'death', envisaged space: a space of transit and transition, marks and traces, a provocation to cartography. Beneath the manifesto's talk of 'craft' laboured allusions not only to technologies and vehicles of transport – and, by extension, to technology itself – but also to 'craft' in its wider sense of practice, know-how, skill; and, through this, to the philosophical notion of *techné* as revealing or unfolding. The General Secretary's First Report to the First Committee, *Navigation Was Always a Difficult Art* (delivered in the Map Room of the Royal Geographical Society in London in 2001), took as its symbolic protagonist, the figure of Melville's Queequeg: epitome of homo viator, a displaced third-world labourer endlessly transported along the vectors of the global enterprise of whaling. The vehicle on which he finds himself, the Pequod, is given over to a grand project: Captain Ahab's revenge. But Queequeg has his own *petit projet* that mimics and unsettles this one. Readers of *Moby Dick* among you will recall that the tatooed Polynesian harpoonist, fully expecting to die after contracting a fever, has the Pequod's skilled carpenter knock him up a coffin; when he unexpectedly recovers, he adorns the redundant coffin with the lines and traces covering his body, copying them from the living organic surface to the dead one. These tattoos, you might further recall, represent the layout of the earth and heavens, and the transit between these, according to the Queequeg's people's belief, and thus form 'a mystical treatise on the art of attaining truth'. Yet, as they cover his whole body, Queequeg cannot see them, and so needs to copy them – that is, himself – onto another surface, projecting space in the manner of a cartographer.

For the INS, it is no coincidence that the surface he projects onto is that of death, or at least its synecdoche, the coffin: marker of a death imperfectly experienced, deferred. That Captain Ahab, watching the 'rude' Queequeg, shakes his fist at heaven is no less telling: Ahab, too, is projecting himself narcissistically towards the whale, hoping to etch himself out across its skin, to behold himself on that white screen as whole, complete, an avenging hero, even if – or perhaps because – that trajectory can only resolve itself at the point of death. Ahab thus embodies an eminently Western fantasy of subjectivity as heroic authenticity. For all its 'rude' primitiveness, Queequeg's little art project, in its futility, both mirrors and parodies Ahab's own, and that of Western man in general. This, ultimately, is what the Great American Novel has to tell us: space, in the end, will not lie flat and form a passive surface for our narcissism, our self-projections, the realizations of our grand and aggrandising narratives. A book that devotes so many of its pages to the sheer materiality of what lurks on the horizon and beneath the surface – their fat, sperm, bones, bile, liver and so on – can only have one winner. The whale's materiality, its excessive weight, shatters the Pequod, rendering all self-projections void – or, to put it another way, the screen becomes blubber.

Today, we want to advance a set of proposals, of numbered theses, that will state categorically – catechistically even – some core elements of INS doctrine. These statements, like all INS propaganda, should be repeated, modified, distorted and disseminated as the listener sees fit.

1 We begin with the experience of failed transcendence, a failure that is at the core of the General Secretary's novels and the Chief Philosopher's tomes. Being is not full transcendence, the plenitude of the One or cosmic abundance, but rather an ellipsis, an absence, an incomprehensibly vast lack scattered with debris and detritus. Philosophy as the thinking of Being has to begin from the experience of disappointment that is at once religious (God is dead, the One is gone), epistemic (we know very little, almost nothing; all knowledge claims have to begin from the experience of limitation) and political (blood is being spilt in the streets as though it were champagne).

2 For us, art is the consequence and experience of failed transcendence. We could even say, borrowing defunct religious terminology, that it produces icons of that failure. An icon is not an original, but a copy, the copy of another icon. Art is not about originality, but about the repetition of the copy. We'll be coming back to this point repeatedly.

3 In order to grasp its place within INS doctrine, the experience of failed transcendence must be elucidated with reference to the classical philosophical opposition of form and matter. For Plato and Aristotle, nothing was more real than form. Knowledge of a thing, for Plato, is knowledge of the form of that

thing, which is what makes that thing the thing it is, what Plato called *eidos*. For Aristotle, it is the essence or *form* of a thing that makes it the thing it is, what he called *ousia*. For Plato, higher than the material world and more real than the material world stands the world of forms, the world of ideas. For Aristotle, essence stands higher than existence.

4 Christianity imbibes, divinizes and somatizes this thought. If, for Plato, the highest knowledge was knowledge of the form of the Good, then for Christianity, the highest knowledge is of God. God is the most real thing there is, and if knowledge of God is impossible because of our fallen state, then our soul should strive to love God and love God alone and above all else.

5 If form is perfect, if it is perfection itself, then how does one explain the obvious imperfection of the world, for the world is not perfect *n'est-ce pas*? This is where matter – our undoing – enters into the picture. For the Greeks, the principle of imperfection was matter, *hyle*. Matter was the source of corruption of form, of the corruption of the visible world. In Christianity, the imperfection of matter is made much sexier as the imperfection of the material world after the Fall and most of all the imperfection of the Flesh, which drove St Paul into such ecstasies of self-denigration or mortification (we like that), as when he speaks of 'the body of this death', of the law of sin that rages in the body's members.

6 For us – necronauts, modern lovers of debris, radio and jetstreams – things are *precisely* the other way round: what is the most real for us is not form, or God, but matter, the brute materiality of the external world. We celebrate the imperfection of matter and somatize that imperfection on a daily basis.

7 How do we let matter matter? How is the mattering of matter to be muttered and uttered? How is it to be formed? Following one of our heroes, Maurice Blanchot, we can isolate two tendencies, two temptations, two sloping *pistes* of possibility:

7.1 One temptation is to try and ingest all of reality into a system of thought, to eat it all up, to penetrate and possess it. This is what Hegel and the Marquis de Sade have in common: the desire to assimilate all reality to the subject through the power and the Concept. This is the idealistic rage of the belly turned mind where matter is soaked up into concepts that function like blotting paper. This is what Deleuze had in mind when he said that philosophy was one long ass-fuck. On this view, language is a sort of murder and Adam was the first serial killer when he wandered around the Garden of Eden giving names to material things.

7.2 The other option is to let things thing, to let matter matter, to let the orange orange and the flower flower. On ths second slope, we take the side of things and try and evoke their nocturnal, mineral quality. This is, for us, the essence

of poetry as it is expressed in Francis Ponge, the late Wallace Stevens, Rilke's *Duino Elegies* and some of the personae of Pessoa, of trying (and failing) to speak about the thing itself and not just ideas about the thing, of saying 'jug, bridge, cigarette, oyster, fruitbat, windowsill, sponge'.

7.3 Sponge

7.4 Sponge

8 In a sense, and this is the point that Blanchot makes so powerfully, all art and literature is divided between these two temptations: either to extinguish matter and elevate it into form or to let matter matter by making form as formless as possible. The INS delivers itself solidly to the second temptation: to let matter matter, to let form touch absence, ellipsis and debris. Like Flaubert at the end of *The Temptation of St Antony*, who says he wants to '... flow like water, vibrate like sound, gleam like light, to curl myself up into every shape, to penetrate each atom, to get down to the depth of matter – *to be matter*'. But instead of seeing the radiant face of Christ like the tortured saint, Flaubert disintegrates into the void like Madame Bovary on her back in the woods, rifled by a man's organ, her eyes burnt by the fire of a star.

9 Thus our other heroes: not the Dorian Gray who projects such a perfect figure out into the world, but the rotting flesh-assemblage hanging in his attic; not the Frankenstein who would, through his creation, see himself in the likeness of God, who stands like Caspar David Friedrich on high mountaintops to contemplate the sublime – but his morbid double who confronts him there with the reality of industry, the stench of meat-packing factories; not the imperial dreams in the head of the polar explorer Ernest Shackleton but rather his blackened, frostbitten toes, which, after the white space into which he'd ventured and on which he hoped to write his name solidified and crushed his boat, he and his crew were forced to chop from their own feet, cook on their stove and eat. Necronauts are poets of the antipodes of poetry, artists of art's polar opposite, its Antarctica.

10 In short, against idealism in philosophy and idealist or transcendent conceptions of art, of art as pure and perfect form, we set a doctrine of poetic or necronautical materialism akin to Bataille's notion of *l'informe* or 'the formless': a universe that 'resembles nothing' and 'gets itself squashed everywhere, like a spider or earthworm'. This is the universe that must be navigated. And, as *Moby Dick*'s narrator Ishmael knows all too well as he floats on the decorated coffin that has become his life raft, navigation is a difficult art. [...]

International Necronautical Society, 'Tate Declaration on Inauthenticity', in Nicolas Bourriaud, ed., *Altermodern* (London: Tate Publishing, 2009) 1–5. Reprinted by permission of Tate Trustees.

Turquoise potato peelings in a sea of piss and shit

this
work
refers
to
joseph
kosutt

ERROR AND INCOMPETENCE

Joel Fisher
Judgement and Purpose//1987

Anaprokopology = N o $\mathcal{J}ucce ss$

For the ancient Greeks the idea of success was intrinsically linked to the idea of perfection. In such a world view, no idea could have been more foreign than that expressed by those dangerous new religions that glorified the potential of the child or the imperfections of a repentant sinner. The shift in values was profound when, suddenly, it was not the 'finished' man who was 'chosen', but the imperfect disciple – when the sick, the afflicted and children were no longer despised. For us, thousands of years later, the conflicting ideas of the ancient Greeks and the early Christians operate within us simultaneously rather than sequentially. This should not be possible, but it is. The result is that sometimes we view success as finished perfection – at other times as the perfectibility of growth.

Since failure only exists in contrast to success, it, too, mirrors this contradiction: it can be considered as a kind of incompleteness, or as existence without grace. Paying attention to the way we seem to hold two opinions simultaneously, and to the resultant judgements we make, gives us an opportunity to explore some general attitudes toward human achievement. Given such radical ambivalence, what are the means we use to steer or guide our efforts?

In this essay I propose a new field of study to explore attitudes toward human judgement, a study of the science of failure in which anthropologists or philosophers might usefully engage. It is surprising to me, in fact, that philosophers have not attended to the concept of failure. The more I think about it, the more I believe that the consideration of failure should exist as a distinct area of study. With some good humour, then (and appropriate Greek roots), I've coined a neologism to encompass a theoretical concept of failure, an analysis of its mechanism, and its consequences in guilt or shame. I propose *anaprokopology*, from *ano*, not, and *prokopi*, success, as a general term to designate that area of existence in which success is not achieved or is irrelevant. This particular study, however, lies within the general literature of connoisseurship and concerns the process of making distinctions. Perhaps it can also be expanded to a broader relevance.

Location

Why are we surrounded by the potential of failure? To what extent is failure imaginary or real? Although we haven't yet any larger systematic study of failure, there is a modest literary genre in which many forms of failure are contrasted to a single instance of success. Probably the best known example is the New

Testament parable of planting seeds. The seeds (by implication either us, or the word of God) are destined to failure if, instead of landing on fertile ground, they fall either in the path, on rocky ground, or among the thorns. There are dangers in each of these places. The seeds might be eaten by birds, trampled under foot, choked by brambles, or succumb to drought. There are many ways to fail, it seems, but success is singular.

The structure of the parable is not uncommon. I found a similar pattern in an obstetrics textbook which I bought in London shortly before my son was born. It provided a frightening inventory of all the ways a birth could go wrong. There were dozens of chances for disaster in contrast to the essentially unmentioned possibility of a living, healthy baby. Success takes up a very small part of the story. It is easier to consider failure, almost as if the method might be determining the form. There is a hint here, perhaps, that analysis itself is more comfortable with failure.

Such examples would lead us to believe that failure is more common than it is. Manifest failure, however, is relatively uncommon. Often one anticipates failure as the logical end of the path one is following and, when such a situation is sensed or recognized, the path can be abandoned. Perhaps that is why unfinished work used to be seen as a form of failure. In such a resonant example as the story of the Tower of Babel, the unfinished becomes a metaphor for failure itself.

Now, unfinished work is more often accepted as worthy of serious consideration. This shift in values is one on which artists and art historians have had some effect. The metaphor absorbs process in some of Michelangelo's later sculpture (St Matthew, the Rondanini Pietà, the Dying Slave); we see the figures as bound and imprisoned in the rock. Today the unfinished is considered a convention, and there is general agreement that the Michelangelos are masterpieces. We no longer need to face the unfinished with a negative prejudice or a suspended judgement. We have begun to look at a work as somehow complete at every point in its development.

While it is true that many inevitable failures are abandoned, others get 'finished'. Sometimes it takes a long time to recognize a problem. Sometimes flaws only appear in retrospect, not having been obvious during the creative process. In such a case the artist might exhibit a work publicly, even sell it, recognizing too late a serious problem in the work. One needs a special kind of judgement here. How can one expect to recognize failure at a time when one doesn't know or recognize one's goals. Many artists define what they want by observing their own decisions which are often very precise. The sense of 'getting it right' is pre-verbal and instinctive. The clarity in a work is evolutionary, and the history of its evolution maps an artist's development. With some artists, and in some works by all artists, such clarity never appears. Instead, we feel a chronic, nagging suspicion about these works. We are never certain whether they are the

best or the worst things we've ever seen, and we suspend judgement. Most often artists hold back such works for future consideration. Picasso kept *Les Demoiselles d'Avignon* rolled up under his bed for years. The decision to release it may have been prompted by someone else. Sometimes a decision is never made, and the artist never relinquishes the work. I'm sure that it is not unusual for older artists to be more and more surrounded by such questionable failures – their obvious successes long since having left home.

The Frontier

Failure has a curious birth. It comes indirectly, without a trace of cynicism, almost as if it creates itself. Failure is never planned for or organized. It comes from outside intention, and always implies the existence of another separate, more vital concern. A genuine failure cannot be intentional. An intentional failure is no such thing, but an unwholesome, nihilistic form of success.

Once again we are involved with intention. It seems to me that over and over again in different ways it is intention that has marked the way of art in the twentieth century. The recognition of intention implies that, to some extent, an artist is accountable for his images or actions. The existence of intention provides an opportunity for failure, ground on which failure can grow.

Failure itself draws a distinction. Where failure occurs, there is the frontier. It marks the edge of the acceptable or possible, a boundary fraught with possibilities. This edge mixes certainty and insecurity. It taunts us to try again and tells us firmly to stay back. The failure tells us clearly where our limitations – at that moment – are. A few minutes later it might be different. This is why the risks of failure add value to success.

All things fail save only *dreams*. (Ruth Benedict)

The Forms of Failure

The most extreme form of failure occurs when standards are so high, and their satisfaction so unlikely, that the likelihood of success becomes almost fictional. Though such standards guarantee failure, they do not discourage the passionate impulse to strive toward the highest ideals – leading to the realm of almost mystical failure that is akin to the implied and eternal failure of *neti neti* (not this, not that), the ancient Upanishad formula for distinguishing the sacred. The search for the impossible objective is the most profound and pure manifestation of anaprokopological form. Beckett sums it up in his distinctive voice. [...]

Other approaches to work are less ethereal: there are works for which there is a kind of 'rightness', whether it occurs internally as part of the work or externally in its relationship to the world. [Among the artists surveyed in the

US touring exhibition 'The Success of Failure', 1987][1] Keith Sonnier has explained why it was necessary for him to abandon a whole series of works when he saw the conditions in which the children who would be producing them were working. The impulses of his heart and his sense of compassion were greater than his need to follow through on the pieces he had planned. The means of production would have tainted the art. Similarly, an unseen supporting pipe destroys the spirit of Jackie Winsor's piece, because the work itself implies that it stands by itself. Winsor knew that false implications could under¬mine the work. The seriousness with which she considered that factor proves that the successful creation of an artwork relies on more than visual standards.

One artist's good work can be another's failure. Eric Fischl, in talking about failure, points out that the most interesting idea in one of his paintings was actually not his idea. And curiously, an artist's original idea may not have a place in his or her own work.

What is appropriate to a given artwork has multiple dimensions. Integrity (an ultimate unity) prevails when something is both internally and externally appropriate, both true to itself and true to its environment. And the work must also follow through on the promises it makes. It can't soften or dilute its purpose at the last moment.

Some years ago I heard a story about a wealthy collector who decided to put a Picasso painting up for auction. He took it to the auction house and was told by the experts that they would not take it because they thought it was a fake. The man was outraged, and after a few rude comments about the credentials of the auction-house experts he took the painting directly to Picasso himself. He explained the problem to Picasso and asked him to verify it as truly one of his pictures. Picasso looked at the painting carefully, and then came back to the collector.

'I'm sorry', he said. 'They are right. It is a fake.'

'But that can't be!' gasped the man, 'I bought it directly from you fifteen years ago.'

'Well', said Picasso, 'I can make fake Picassos just as well as anyone else.'

What we call a sense of timing also has to do with this multiple dimension of the appropriate. Without timing a work may be unintentionally invisible; one cannot make a proper evaluation. Thirty years ago when Meret Oppenheim painted her picture, she saw it differently than she did when she put it into this exhibition. At that time, instead of seeing the painting in front of her, she saw only what she thought the painting *should* be. Paul Thek's contribution to this show plays with the sense of the inappropriate in contrast to conventions: he proposes a work that reverses sexual stereotypes by changing 'Our Father' to 'Our Mother'. It is a work that probably has more impact now, when sexual inequality

is still obvious, than it will have in the future. It deals with what could be called 'threshold values'. It makes us wonder what distinctions it may be appropriate to make in periods of change.

Corresponding to the different forms of failure are different kinds of obstacles. Except for psychological obstacles, which are mostly a matter of anticipation, obstacles appear unexpectedly or contrast with expectation in the overall plan. Alice Aycock expected good weather when the rains came. If she had expected rain, she could have made a number of adjustments – she could have planned the opening for another time and place, or she could have designed a different sort of work. When an obstacle stops the action completely, all the energy that has existed as expectation is homeless. What one feels is a sense of loss.

More and more we find instances of things that work in photograph or in reproduction but not in reality. When something works photographically but not actually, one thing that might be wrong is scale or proportion. Scale has a specific, narrow margin of error, and is very sensitive to degree or amount. I take these to be larger issues. Sometimes everything in the recipe can be right except the proportion of the ingredients. We need something more than perfect aim. Our arrow must go far enough to reach the target, and not so far that we overshoot it. In many fields, excess is a kind of deficiency. Twice as much is not twice as good. There is a critical threshold beyond which is error.

Often things fail only in amount – too this or too that. Too aggressive, too argumentative, too arrogant, too arty, too big, too coercive, too confused, too cultured, too dangerous, too derivative, too illustrative, too intellectual, too immature, too limited, too self-conscious, too sentimental, too sloppy, too shy, too subtle, too thin, too little. Too much. The excessive is our preferred value judgement. Which extremes do we value? The kinds of extremes we find objectionable are gauges of our attitudes and values.

Just as all vision has its blind spots, all images have a field of eclipse. Creating the image is only part of the problem. Somehow the image must penetrate the viewer's mind. Images as complex structures are subject to a whole range of snares, traps and blockages. And they always carry with them a great deal of additional information.

Failure within the general area of image-making presents its own set of problems and unites a diverse range of artists in this show. Though perhaps not initially obvious, the work of Lawrence Weiner falls under the heading of image-making. How? Weiner's work fails, he says, because 'no one knew what it looked like'. In other words, the image didn't carry at all. The gift remains ungiven.

The best artist is the imperfect artist. (Wyndham Lewis)

Intentional Existence

In what ways are we mindful of our failures? Sometimes, of course, not at all. There are times when pain blocks a conscious recognition, when our failure taints our own abilities and what we and others expect of ourselves. It is generally felt that we 'own' our failures in a different sense than our successes. We share success; failure, no matter what, is more private. Thus, we also conspire to protect our friends from their failures. This illusory protection adds another layer to the pain, sometimes even damaging those it tries to protect. This is the failure in failure; by comparison, the original failure is refreshingly simple and minor. The difficulty we have in containing failure is probably the reason some people view it as contagious. And yet the emphasis is not quite right: a failure when recognized is never so serious as when it isn't recognized. A balance is restored. We could even say that an acknowledged failure does not exist.

Inventors, I suspect, have a very high failure rate, but their attitude of 'try-try-again' protects, within society, the freedom to persevere. Edison once said that he failed his way to success. Nowadays we tend to make collective the kind of individualism that Edison represented. Now we do things in groups. Someone gave me a quote from a Silicon Valley executive: 'We tell our people', he said, 'to make at least ten mistakes a day. If you're not making ten mistakes a day, you're not trying hard enough.' Imagine the change if we valued a list of major failures on a person's resumé. If it is true that only failure or anticipated failure is the author of change, a list of failures would be more revealing than a list of successes.

As a scientific method the ideal experimental sequence is to make predictions based on observations and then to look for the facts to prove the hypothesis wrong. You look for failure and hope you won't find it. This is a middle-ground alternative to looking only for success but it is still several steps away from seeing failure as positive.

We may fall short of our goals but, even in our failures, those things for which we strive somehow endure – precisely because we are striving for them. They have an *intentional existence*. We intend (that is, lean toward) a more perfect state, and the goal of that dream or striving locates itself mysteriously in the work. I'd like to suggest that some great works of art might themselves be failures and, moreover, that their failure contributes to their greatness. I also think it is possible that there is more genuine content in failure than in success. Sometimes the failures of big ideas are more impressive than the successes of little ones. [...]

1 'The Success of Failure' (organized by Independent Curators Incorporated, 1987–88).

Joel Fisher, extracts from 'Judgement and Purpose', in Joel Fisher, ed., *The Success of Failure* (New York: Independent Curators Incorporated, 1987) 8–10; 10–11.

Brian Dillon
Eternal Return//2003

When Wire's Colin Newman introduced the swift svelte stab of '12XU' with these words (on their 1977 début album *Pink Flag*), he doubtless intended a sardonic swipe at the so quickly sublimated, normalized expectations of a Punk audience already willing to hear the shock of the new parlayed into fresh orthodoxy; already favouring the recognizable classic over the fractured innovation that was ostensibly Punk's point. If the song itself, with its faux guttersnipe delivery and mad dash to the 1 minute, 55 seconds mark, was a knowing parody of expected Punk moves, the intro was a neat rejoinder to the audience's hankering for newly canonized favourites: in short, for repetition.

When the band performed *Pink Flag* once more at London's Barbican Centre earlier this year, and Newman duly delivered the pointed preface to '12XU' right on cue, it was doubly difficult to know just what manner of repetition was being canvassed 26 years on. Here it was again. Again: though not quite; now laden with the weight of a nostalgia that threatened to consign the whole performance to the status of mere heritage event; yet also, somehow, in its uncannily accurate reanimation of a dead time, quiveringly and weirdly alive.

Such is the nature of repetition. On the one hand, there is nothing so predictable, so tiresomely unwelcome, as the ideal copy: it is a marker of a merely traditional, conventional desire for consistency, a loyalty to a past that, repetition assures us, has never really gone away. Repetition, as some of our most lingering modern cultural beliefs inform us, is nothing but a serial disorder: a compulsion equally tragic and pathological, so the argument goes, in both its contemporary manifestation as revival or nostalgia and in its classic form as cultural continuity, the way 'we' do things. On one reading, repetition is a sort of endlessly reflected dementia: *echopraxia* (the thoughtless and meaningless repetition of the actions or movements of others) or *echolalia* (imitation of speech).

But repetition is also the indispensable condition for all kinds of cultural values: from a coherent sense of a self that we carry from one moment to another, to the notion of scientific truth. How valid would an experiment be if it could never be repeated? What would a human history look like that was incapable of discerning, in the tumult of events, surprises and cataclysmic upheavals, some strand of repetition? In fact, at precisely those moments when history seems to convulse in the agony of innovation and renewal, repetition is not far away. The very word 'revolution' implies a movement of return, a spectral rehearsal of what has gone before that, so the revolutionary believes, can be made to live again. Yet

the repetition is never quite the perfect restaging of the past that its instigators envisaged: the French Revolution may have imagined itself remaking the ancient history of Rome, but an unpredictable element, an ineluctable difference, intervened. Likewise the coup of 1851, a travesty of Napoleon Bonaparte's 55 years earlier, inspired Karl Marx to write famously: 'all great events and historical personages occur, as it were, twice – the first time as tragedy, the second as farce.'

If Marx was the first great political thinker of the ambiguous energies of repetition, Søren Kierkegaard was its torturedly private, intimate adherent. In *Repetition* (1843) – a bizarre, pseudonymous work in which Kierkegaard's narrating persona, Constantin Constantius (even his name is a repetition), engages in ironic correspondence on the possibility of true repetition with a lovelorn, melancholic young man – he conjures up the possibility of a pure and total repetition. Repetition, says Kierkegaard, is not the same as remembering: where recollection is in thrall to what it has lost (and can only ever experience it as lost), repetition is dedicated to the perfect rehearsal of the past, to experiencing one's whole life as a story that has already been told.

Constantius travels to Berlin, hoping to re-enact an earlier visit. But the repetition fails: his hotel room is subtly different, the coffee in a local restaurant lacks the exact quality it had before, and, even worse, when he returns home his servant has rearranged the furniture, dispelling even the reliable repetition of home. The repeated experience, it turns out, is always something different, and this, in fact, is its very value for Kierkegaard. Repetition, paradoxically, is always new: 'the dialectic or repetition is easy, for that which is repeated has been – otherwise it could not be repeated – but the very fact that it has been makes the repetition into something new.' Even if Constantius' Berlin sojourn had managed to recapture every detail of his earlier stay, from the perspective of Kierkegaard would still have been different.

Here then is repetition's double nature: it names both an endlessly predictable recurrence (the relentless crawl to infinity that is the experience of boredom, for example; or the equally unreachable horizon of obsession) and a ceaselessly renewable starting-point (the repetition that results from forgetting: at its most extreme, a neurological catastrophe that plunges the brain-damaged or demented patient into a lifetime of repetition). Repetition, as Gilles Deleuze wrote, has both its tragic and its comic aspects: nothing is more appalling, and at the same time ludicrous, than the individual condemned to the same action over and over again. But repetition, says Deleuze, is also a kind of freedom: without its regular framing and punctuating insistence we would never be able to experience difference, to relish the new, at all. In the simple repetition of a clock's ticking is already the possibility of movement, of a narrative (we hear the actual and meaningless 'tick, tick' as 'tick, tock': a tiny story). In the repetition of rhyme we hear something

new, experience the words of a poem afresh, just as much as we discern their similarity. Everywhere, supposedly uniform repetition is marked by the instability of difference: 'modern life is such that, confronted with the most mechanical, the most stereotypical repetitions, inside and outside ourselves, we endlessly extract from them little differences, variations and modifications.'

We need to listen, says Deleuze, to these differences (just as we need to attend to the repetitions inherent in apparent chaos): we find in them a new economy of thought, experience and aesthetic expression. The enemy of repetition's difference is the order of mere representation: a mode of thinking that tries to exchange one thing for another, to make one thing mean another, according to an essentially capitalist logic of equivalence and exchange. Repetition undoes representation with the twin weapons of theft and the gift: it's only by stealing, or giving unconditionally, that we enter into the realm of true repetition, where the same and the different overlap without asking anything of each other.

Deleuze imagines an aesthetics of repetition, and twentieth-century art responds with a name: Warhol. But not the Warhol of the arguably belated insight into the inherently commodified, reproducible nature of the work of art (when all is said and done, still a Romantic, if ironized, insight). A Deleuzian Warhol would be something else: the Warhol of a pure repetition that turns out to be a startling difference. The Warhol who wonders, as he wanders repetitively 'from A to B and back again', at a comedian who says the same thing every night: 'but then I realized what's the difference, because you're always repeating your same things anyway'. The serial movie-watching Warhol for whom repetition, not surprise, is the point, and who is then surprised to find that repetition is the surprise: 'what makes a movie fast is when you see it, and then when you see it a second time it goes really fast. If you really want to suffer, go see something and then go see it again. You'll see that your suffering goes by quicker the second time.'

Repetition and difference: this is, after all, precisely the historical problem of the avant-garde (hence decades of endlessly repetitive theorizing: how to be avant-garde again?). For every Modernist evocation of innovation (Ezra Pound: 'make it new') and every Postmodernist embrace of the copy, there have been those who recognized the difference that repetition makes. Gertrude Stein, whose prose 'portraits' of the likes of Picasso and Hemingway were not representations but, she claimed, repetitions, is the missing link between Marx and Warhol: between tragedy turning to farce and finding the tragedy in the comedy of the modern image. She came to the ultimate repetition of her most famous statement – 'a rose is a rose is a rose' – through listening to her aged, half-deaf aunts repeating themselves endlessly, their conversations spiralling into comfortable confusion. 'The succeeding and failing', she wrote repetitively, 'is what makes the repetition, not the moment to moment emphasizing that makes

the repetition.' Somewhere in that statement too are Samuel Beckett's narrators ('Try again. Fail again. Fail better.'), doling out their collections of stones in endless series, or giving up the narrative ghost only to start again, cursed with hope.

For all the avant-garde's fetishization of repetition, there is still something inherently reprehensible about the blank embrace of echo, reflection, the merest multiplication of instances of the same (even if the same comes with lofty philosophical justifications of its own difference). Repetition still scandalizes – with its seamless, frictionless glide into the flat distance – all our notions of originality, innovation and authenticity. How often do connoisseurs of repetition justify apparent monotony by appeal to actual (simply misheard, badly intuited) variety? Especially in music, where one person's dumb, dull, distinction-free repetition is another's endless plane of minutely unfolding, beautiful possibilities. As if the purest repetition would be in the end inseparable from the purest stupidity; as if we can't quite believe anybody could actually find something in what is after all just one damn thing after another. Perhaps we only believe in repetition (as something interesting, engaging, even moving) by claiming that it's not really repetition at all. Which is in turn a way of claiming that our lives – all our habits, routines, obsessions, mistakes unrecognized and patterns unbroken – are really, despite all evidence to the contrary, not repetitive. And so we watch, listen, read and live, all the time intoning the same mantra. There is repetition. There is no repetition. Repeat to fade …

Brian Dillon, 'Eternal Return', *frieze*, no. 77 (September 2003) 76–7.

Larry Bell ✓
Something caused one of the glass panes to crack …
//1997

Something caused one of the glass panels to crack. I replaced it assuming that the panel was defective to begin with. A few months later the same panel cracked again in exactly the same place. I knew that there were forces at work that were not visible, so I hired an engineering firm to look at the problem and tell me what to do.

It was my opinion that the problem came from the way the glass was mounted. Each panel was held in the water with a small concrete pier. On the top of each pier was a piece of aluminium that held the glass on each side. Silicone rubber was used to glue the glass in place.

The engineers could not find a problem with the mounting, and told me the problem was with the glass. When the same panel broke in the same place a *third* time, I decided to change the mounting. The city of Abilene had built the pond and the mounting piers.

A new set of mounts were made and brought to the site. It was January and very cold in this part of Texas. The pond had frozen to a sheet of ice. We were obliged to break the ice up to remove it, and found that there was a layer of duck shit on the bottom of the concrete.

After the pond floor was cleaned, we went about the job of removing the sculpture by cutting apart the silicone rubber that held the triangles together. The plan was to lift the outer corner of each triangle to break it free of the silicone that held it to the aluminium. As we lifted the glass from the corner, the concrete piers that they were mounted on came up from the bottom of the pond attached to the glass. These piers were supposed to be part of the concrete floor of the pond.

All of the piers lifted off the bottom of the pond with the exception of the pier under the panel that kept breaking. In other words the entire sculpture was loose on the pond floor with the exception of the panel mounted to the pier that was not loose. This was the panel that kept breaking.

We found that the pond was more inconsistent in its making than the engineering drawings told us. My new mounts would not work until the pond was constructed again. It took two years to rebuild the pond. When we installed the piece again, someone came along and finished it off with a blast from a shotgun. I never returned to Abilene. *C'est la vie.*

Larry Bell, untitled statement [retitled here], in *Unbuilt Roads: 107 Unrealized Projects*, ed. Hans Ulrich Obrist and Guy Tortosa (Ostfildern-Ruit: Hatje Cantz, 1997) 3.

William Wegman
Bad News//1971

[...] In the first version of *Bad News* a student was cutting a piece of wood on a bandsaw. There was a glass of something behind his elbow, and I noticed the elbow in relation to the glass and the edge. I thought how funny it was to knock things over. It's so predictable. The glass, the edge, the stage is familiar: you've seen this play before. The elbow is blind ... it moves without sensing toward its victim. When? This is its subjectivity and its tension; the cheap torture of

someone about to pop a balloon – he warns you and it becomes worse, real agony if you are me. I think I stepped in at this point, where my anxiety was greatest, and at the same time most familiar. To preserve and extend it, I took a series of six photographs, stopping each time to decrease the amount of liquid in the glass, while continuing the motion of the elbow toward it. To allow the glass to fall empty acquits one phase of the disaster while promoting a sadism akin to removing only half the spider's legs. In *Bad News*, final version, I located the work around a kitchen sink, where the history of glasses is less remote.

William Wegman, 'Bad News', *Avalanche* (Winter 1971) 62.

Chris Burden
TV Hijack (1972)//1973

On 14 January [1972] I was asked to perform a piece on a local television station by Phyllis Lutjeans. My first proposal was to eat the recorded show as it was being taped and simultaneously broadcast. The viewer would have seen me eating the show he was watching. This proved technically impossible, and I was getting little cooperation from the staff of the station. After several other proposals were censored by the station, I agreed to an interview situation. I arrived at the station with my own video crew so that I could have my own tape. While the taping was in progress, I requested that it be transmitted live. Since the station was not broadcasting at the time, they complied. In the course of the interview, Mrs Lutjeans asked me to talk about some of the pieces I had thought of doing. I demonstrated a TV Hijack. Holding a knife at her throat, I threatened her life if the station stopped the live transmission. I told her I had planned to make her perform obscene acts. At the end of the recording I asked for a tape of the show. I walked into the hall, unwound the reel and destroyed the show by dousing the tape with acetone. The station manager was irate, and I offered him my own tape, which included the show and its destruction, but he refused it.

Chris Burden, 'TV HI-JACK, February 2, 1972. Television Studio, Newport Beach, California. Chris Burden and Phyllis Lutjeans', *Avalanche* (Summer/Fall 1973) n.p.

Chris Burden
On *Pearl Harbour* (1971)//1990

Some of my favourite sculptures were the ones that were total disasters. You fantasize a way they're going to be, you try to do everything in your power, and then they're total flops. It's interesting to examine how you could be so wrong.

I remember one, it was called *Pearl Harbour* (1971), and it was a one-night performance, on the anniversary of the Pearl Harbour attack. I was given this huge armory in Santa Barbara to do it in, and I built 40 little wind-up model airplanes. A big searchlight shone through the armory, with its huge vaulted ceiling. I had a crew of about 15 people and the idea was that these planes would be continually in the air, circling in the beam of the searchlight. The idea was that as each plane landed it would be wound back up and relaunched. We had these special little winding mechanisms, we practised for a bit. It was just a disaster. Planes were flying off into the audience, there were whole minutes when no planes were in the air, then there'd be two struggling around. People in the audience were grabbing the planes so they could take them home as souvenirs. My staff would go up and say, 'You'd better give that back – Chris Burden's a pretty mean guy.' A lot of the planes were stuck in the crevices of the ceiling. So, you know, I'm sure the people who organized the event were disappointed, but I was quite elated. I'd been so wrong in my expectations. It was a total unsuccess in that sense, because it was a failure in terms of what I'd imagined it to be. I think it's important to be in touch with your intuition, which is a very difficult thing to do because the whole process of education is really to pound that out of you. You're supposed to have a logical reason for everything. Everything is empirical, and since most of us are the product of years and years of education, the answer that 'Oh, that feels right', or 'That's the way to go', is basically unacceptable to society. To trust your intuition is exactly the opposite of any sort of formal education.

Chris Burden, statement from 'Chris Burden in conversation with Jon Bewley' (1990), in *Talking Art*, ed. Adrian Searle (London: Institute of Contemporary Arts, 1993) 26–7.

Tacita Dean
And He Fell into the Sea//1996

> But the young Icarus, overwhelmed by the thrill of flying, did not heed his father's warning and flew too close to the sun, whereupon the wax in his wings melted and he fell into the sea.

Simon Crowhurst, who was fifteen and at school in 1975, remembers the disappearance of Bas Jan Ader: he remembers it very precisely because it was spoken about in connection to his own father's disappearance six years earlier. How his father had disappeared in the ocean was still a mystery to him. It was incomprehensible; alien even. It was a time when people, whole boats went missing in the Bermuda Triangle without rational explanation: strange algae consuming the oxygen out of the sea and causing a vacuum in the air above. Buoyancy was lost and everything became as lead. This was better than the truth, which he only discovered some months later when he took *The Strange Last Voyage of Donald Crowhurst* out of his school library, and his father's fraudulent journey and agonized death at sea was revealed to him. So Bas Jan Ader's disappearance confirmed only that his father was somehow not alone out there and that one day these unfathomable disappearances would have to be resolved.

With disappearance will always come the hope of reappearance. At the same school was the son of John Stonehouse, the British Labour Member of Parliament who left a pile of his clothes on Miami beach in 1974 to stage his own suicide. A minute's silence was held in the Commons and his obituary was published. Australian detectives, acting on a tip-off that Lord Lucan had at last surfaced in Melbourne, inadvertently came across Stonehouse living under an assumed name. He had reappeared.

The boys, Crowhurst and Stonehouse, were grouped together at school as many believed Donald Crowhurst had also staged his own death and was living another life in a multitude of reported places. When Ader was reported missing, he joined their fathers' group. After all he was an artist, making a work of art. Everyone believed he would reappear.

But Bas Jan Ader was not a man of stunts. He was making a work of art, but his work of art was not to disappear. He wanted to cross the ocean alone, in answer to the journey that had brought him to California in the first place. He had sailed there as a deckhand and wanted to sail back: to arrive and leave by sea – a romantic equation and obvious apotheosis. His audacity lay only in his desire (casual but nonetheless mindful) to also break the world record by making the

trip in the smallest ever boat: 2 feet and 2 inches smaller than the last successful passage. Ocean Wave was probably not even double his body's length.

Ader was a master of gravity. But when he fell, all he would say was that it was because gravity made itself master over him. He understood the necessary surrender and decisiveness of purpose needed to make gravity his companion, unlike the prosaic James Honeycutt in *The Boy Who Fell Over Niagara Falls*, whose misjudgement of the supremacy of water, left him trying desperately to reverse his ineffective outboard motor on the brink of the Niagara Falls. It is a bad sailor who trusts his engine. Bas Jan Ader probably felt closer to the boy whose very lightness would be his protector as he fell the 161 feet to certain death.

Did Ader feel protected because he was making a work of art? Protected in his pursuit of the sublime, which suspends all truth and postpones the realization that we are, in fact, dully mortal? More than anyone, he played with this engagement – laid himself open to the possibility of death. Taunted it. Provoked it. Fell for it. Sadly we can only glimpse at the enormity of Bas Jan Ader's feat because he failed. Had he completed his Part Two, we would never think enough of what it takes to sail alone across the Atlantic in a boat barely bigger than most sailors' dinghies.

It is perhaps the most unsettling fact of all to learn that *The Strange Last Voyage of Donald Crowhurst* was found in Ader's faculty locker in Irvine some time after he had disappeared. We have to suppose he read it. We have to suppose he imagined Crowhurst's anguished journey in the light of his own incipient one, even if it was only to dismiss it. We have to suppose he knew, as he set out, that there were many ways to fail as there were many ways to succeed.

Icarus, blinded by the elation of his ascent, failed and fell: fell to fail. His was a journey up that came down. Crowhurst's was a journey along: flat, doomed and sorrily human. His fall was wretched, unimagined, unannounced and wholly practical. But for Bas Jan Ader to fall was to make a work of art. Whatever we believe or whatever we imagine, on a deep deep level, not to have fallen would have meant failure.

Tacita Dean, 'And He Fell into the Sea', text written to accompany the artist's first in the series of three works collectively titled *Disappearance at Sea* (1996–99).

Julian Schnabel
Statement//1978

I want my life to be embedded in my work, crushed into my painting like a pressed car. If it's not, my work is just some stuff. When I'm away from it, I'm crippled. Without my relationship to what may seem like these inanimate objects, I am just an indulgent misfit. If the spirit of being isn't present in the face of this work, it should be destroyed because it's meaningless. I am not making some things. I am making a synonym for the truth with all its falsehoods, oblique as it is. I am making icons that present life in terms of our death. A bouquet of mistakes.

Julian Schnabel, Statement (1978), in *Julian Schnabel: Paintings 1975–1987* (London: Whitechapel Gallery, 1986) 101–5.

Christy Lange
Bound to Fail//2005

The work is constructed simply of two wooden boxes, easily mistakable for minimalist sculpture. It is inscribed with its own title and instructions: 'Boxes for Meaningless Work. Transfer things from one box to the next box, back and forth, back and forth, etc. Be aware that what you are doing is meaningless' (Walter De Maria, *Boxes for Meaningless Work*, 1961). The artist's directions animate the object; you can almost hear the dull thud of an item being dropped into the bottom of each hollow box, generating the sad echo of something being discarded in an empty bin, or the sound of the first item in a collection rattling to the bottom of its container. The noise becomes a rhythm as the user shuttles the item from one box to the other, over and over again, knowing that the process will serve no purpose other than to exhaust the person performing it. He will eventually have to stop, and therefore fail to complete his task. Nonetheless, this futile process – functionless, repetitive and bound to fail – is a work of art.

The ironic contradiction is not lost on De Maria: 'Meaningless work is potentially the most abstract, concrete, individual, foolish, indeterminate, exactly determined, varied, important art-action-experience one can undertake today ... By meaningless work I simply mean work which does not make money or accomplish a conventional

purpose … Filing letters in a filing cabinet could be considered meaningless work only if one were not considered a secretary, and if one scattered the file on the floor periodically so that one didn't get any feeling of accomplishment.'

The imaginary rhythm emanating from De Maria's boxes signals the steady beat of countless works to follow that took fruitless labour or seemingly purposeless tasks as the subject or medium of the art itself. Echoing inside these hollow vessels are the sounds of Mel Bochner methodically arranging coins on the ground to photograph them (*Axiom of Indifference*, 1971–73), Vito Acconci quickening his pace to follow people down the street in *Following Piece* (1969), or Bruce Nauman bouncing balls against the walls in *Bouncing Two Balls between the Floor and Ceiling with Changing Rhythms* (1967–68).

As the singular, unique art object began to dematerialize in the 1960s, the possibilities for what art could be expanded infinitely, to include a hole carved in a wall, the exact measurements of a room, an unrecorded dialogue, a distance travelled, a closed exhibition, or the simple act of waking up day after day. The process of meaningless work or the execution of worthless tasks became a medium, method, material and metaphor for artwork. Artists adopted systems to organize or expedite these processes, but the systems they chose were often irrational, illogical, absurd, or destined to sabotage themselves.

Conceptual art, despite its associations with objectivity, acknowledged and mined the subjectivity and flaws of its own methods. As Sol LeWitt proclaimed in his germinal 1967 article in *Artforum*, 'Paragraphs on Conceptual Art': 'Conceptual art is not necessarily logical. The logic of a piece or series of pieces is a device that is used at times only to be ruined.' Unscientific or nonsensical experiments were none the less rigorously documented. Ed Ruscha tested the effects of gravity and impact on a typewriter thrown from a speeding Buick (*Royal Road Test*, 1967). Lee Lozano investigated the consequences of smoking excessive amounts of marijuana in *Grass Piece* (1969): 'Make a good score, a lid or more of excellent grass. Smoke it "up" as fast as you can. Stay high all day, every day. See what happens.' Both artists recorded their findings accordingly. Douglas Huebler's Variable Pieces constituted any activity at all, including his own attempt to photograph everyone alive (*Variable Piece No. 70*, 1971–97). Despite their sometimes rigid and formulaic approach and presentation, these methods were impossible to uphold. Such systems short-circuited as they succumbed to their own built-in shortfalls.

Bruce Nauman failed in a visceral, almost aggressive way, setting himself a variety of impossible tasks and sometimes getting visibly angry or frustrated if he could not complete them. In *Failing to Levitate in the Studio* (1966), for example, the artist documented a performance in which he attempted to levitate while lying between two chairs. According to Nauman, the attempt did not fail for lack

of effort: 'I was working on the exercise in the studio for a while and wanted to make a tape of it, a record, to see if you could see what was happening. When I did the things, they made me tired and I felt good when I finished, but they were not relaxing; they took a lot of energy and concentration and paying attention ...'

Clearly, the difficulty of the task had no bearing on the exertion he put forth. The image of the artist – stiff as a plank, arms at his sides and toes pointed upward, intent upon achieving a feat of mental and physical concentration – is superimposed on another one of Nauman: chair pulled out from under him, legs splayed wide on the scrap-laden floor of his studio. Granted, his feet have travelled only from the top of the metal folding chair to the floor, resulting in an awkward, uncomfortable collision between his neck and the edge of the seat, but the sound of his limp body slumping to the ground implies a much harder fall. Despite his best effort, he had not succeeded in accomplishing the kind of metaphysical or transcendent feat that we expect to transpire in the artist's studio.

As opposed to the palpable discomfort Nauman experiences, Bas Jan Ader performs his work from the comfort of a plush leather armchair in *The Artist as Consumer of Extreme Comfort* (1968). In this photograph, the artist gazes forlornly into a dimly lit fireplace, while a lamp beside him yields a comforting yellow glow. An unattended book sits in his lap, and a glass of whiskey is propped in one hand, as his concentration drifts towards the crackling fire. At first glance, it appears that the frustrated artist is too sad to tell us that he has given up – he is out of ideas and no longer even tries to create work. When, in fact, he has forsaken art making for pure leisure. Rather than pace his studio or wander the streets in search of miraculous inspiration, he cozies himself up by the fire.

How can we reconcile this indulgent state of inertia and self assured repose with Ader's other seemingly desperate attempts to be noticed: his wall painting which pleads 'Please don't leave me'; his postcards dispatching the resigned message, 'I'm Too Sad to Tell You' (1971); or his straightforward recording of himself tumbling head first off the roof of his house into a hedge? In most of Ader's work, as in some of Nauman's, failure itself is staged and systematically documented. His repeated pratfalls land somewhere between theatrical melodrama and possible suicide attempts. The sound of Ader continuously splashing into the canal as he falls off his bicycle yet again would eventually foretell his last work, *In Search of the Miraculous* (1975), in which he was lost at sea during an attempt to cross the Atlantic in a small boat.

Taken in earnest, Ader's and Nauman's insistence on trying to perform physical impossibilities and then document their shortcomings seems to have been a test of the impact of their own human and artistic failings on the world. But they attempted their feats knowing that these minor failures bore only minor consequences on the world itself. Why not set themselves a task they could deftly

and triumphantly complete? Perhaps they sensed that if their systems functioned efficiently or successfully, they would be indistinguishable from 'ordinary work', and could no longer be called art.

In contemporary art, the repeated irony of failed work persists, even as Expressionism reconciles itself with Conceptualism, and the dematerialized materializes again. Failure becomes an inner monologue (or dialogue) in the work of artists such as Fischli & Weiss. With the luxury of irony and inefficiency, the pair contemplate their own self-doubt and inability to perform in *Will Happiness Find Me?* (2003). The installation of slide-projected images (and subsequent book) is a series of hand-scribbled questions – a potentially endless and random stream of irrational fears, doubts and postulations. Their questions are posed from the same ironic distance as Gilbert & George's melancholic musings in *To be with art is all we ask*. The queries range from the banal ('Should I make myself some soup?'; 'Should I remove my muffler and drive around the neighbourhood at night?') to the existential ('Should I show more interest in the world?'; 'What drives me?'; 'Where will I end up today?'). As they wait for their inspiration, they transform the wait into art. But the silent undertone emerges in questions such as 'Do I have to get up and go to work?' or 'Should I crawl into my bed and stop producing things all the time?' – is it still okay to fail?

Sean Landers has carried on a similarly indulgent interior dialogue between his ego and his alter ego (the Successful Artist and the Failure) since the early 1990s. He takes the obsessive recording systems of Roman Opalka or Hanne Darboven to a personal and confessional extreme, inflecting them with what he calls the 'sloppy internal'. His prolific disclosures, literally scrawled across his canvases, reflect deep self-doubt, even while they reach new levels of self-aggrandisement, leading us to question the authenticity of his admissions. Pick apart the scrambled logorrhea of *Self Something* (1994), and you can decipher the words: 'I can't seem to finish this painting. I am so profoundly uninspired right now I can't tell you. I just want to eat sugary and salty snack foods and watch TV.' Sift through his abundant scribblings, and a few sentences ring out. 'I am trying hard', he writes. And it seems like he is. But a few inches away, in the same small penmanship, he notes: 'There is no point to this.' Landers writes this even as he is finishing the painting. Although he makes the statement with his tongue planted firmly in his cheek, he confesses the secret of meaningless work: even frustrated art making itself can be successful artwork if it acknowledges its own failings. Better still, if it acknowledges this fact, but also acknowledges the irony of it.

Like Landers, the Swedish artist Annika Ström questions her position in the art world. In many of her works, self-doubt and insecurity reveal themselves – sometimes in a small slip of the camera, other times in bold typeface. In *16 minutes* (2003) she films herself performing a half-hearted pirouette in her studio,

followed by a fuzzy television recording of professional skaters making skilful loops on the ice. For Ström, this precarious performance seems to be as close to perfection as it gets, but just as near to falling down. As she points out: 'The works bring up self-doubts, not necessarily about me as a person, but as a human being and her difficulties in the system in which she operates.' Her text pieces, on white paper with a hand-made coloured-in stencil, make ambivalent declarations about the works themselves, such as *this work refers to no one* (2004), or *i have nothing to say* (2004). While these matter-of-fact statements seem to refer to the wry wit of earlier conceptual text pieces, they also deny this same system of reference.

Ström acknowledges the pitfalls and frustrations of the art world she must function within. In *One week bed and breakfast in Berlin for frustrated and/or uninspired, envious artist* she printed application forms inviting young artists to stay with her. 'Some people thought the work was cynical, but really it was about the fact that artists should stick together.' The influence of earlier works is openly conflicted, especially in the text piece *this refers to all male art*. 'I made the piece as a comment on 'cool guys' referring to other 'cool guys' in the 1960s, as a means of giving their work credibility and getting it into public collections', she explains. 'Ninety per cent of young male artists are referring to the 1960s guys right now. If it makes sense to refer to something, and it produces a new work, then it's fine to me. But it seems rare.' Ström's ambivalence about art's self-reflexivity is none the less expressed.

Jonathan Monk often makes willing and obvious use of conceptual art and its former systems, turning it into the raw material for his work and then altering it to make it decidedly new, but still recognizable. He does not just reverently refer to predecessors such as Jan Dibbets, Douglas Huebler, Lawrence Weiner, Sol LeWitt and Robert Barry, he adapts their works to change their meaning or mutate their objectivity into something humorous, absurd, personal or aesthetic. 'Sometimes people look at my work and think it's just conceptual art with a bit of this, that and the other', he says. 'But works by conceptual artists are just a starting point for me.'

In *Return to Sender* (2004) Monk co-opts On Kawara's series *I Got Up* (1968–79), in which Kawara sent postcards to friends and colleagues systematically reporting his whereabouts. Tearing the pages out of a catalogue that documented the work, Monk dutifully sent the pages back to the original addresses, hoping for responses, yet knowing Kawara had long left the location. 'That's something where the possibility of failure is there before you start', says Monk. Using Kawara's own system as a point of departure, he created another, more illogical system, resuscitating a work from the past.

Though Monk, like other artists from his generation, regularly recycles and regenerates the style and strategies of conceptual art, he concedes that these

methods have aged: 'As a style, conceptual art doesn't really function anymore. At the time, they used typewriters to make pieces, because that's what they had. But if I use a typewriter now, it's because I want to make it look like conceptual art, and then to play with that idea.' In many of his pieces, he deals with the inevitable maturation of conceptual art to show how its rigid systems do not remain fixed, and can even fade or decay. Referring to the older works of art that he sometimes appropriates in his exhibitions, he observes: 'When I see them now I'm surprised by how old they look.'

Monk pinpoints the possibilities for failure hiding underneath the surface of these older systems and brings it out by translating it into aesthetic objects. In *In Search of Perfection* (2003) he offers the viewer a chance to attempt to cut out a perfect circle from a piece of paper and project it on a wall to match one drawn in pencil. Most of the attempts are frustrated by the failure of the scissors to co-operate, or the viewer's inability to imitate the artist's perfect circle. Each viewer can experience the frustration of trying to live up to a pre-existing model or expectation for art. In 2003's *Searching for the Centre of a Sheet of Paper (White on Black/Black on White)* – a reference to Douglas Huebler's *A Point Located in the Exact Centre of an 81/2 x 11 Xerox paper* – Monk animates two separate series of viewers' attempts to put a dot exactly in the middle of a piece of paper (one series is a white dot on black paper, the other is the reverse). As the artist says: 'The piece is done with the understanding that you can't do it.' But his system is designed to cope with this eventuality. When it fails, the dots appear to be dancing; when it succeeds, the dots and the work itself become invisible. Success is possible, but failure is more likely. Either way, a new piece of art is made.

What contemporary artists such as Ström, Landers and Monk tap into is not the cold rationalism of conceptual artworks, but the cracks in their objective systems, or the vague, fleeting appearance of insecurity or doubt. Combined with their own conflicts about the system of the art world, what they allow us to see is not the patent successes of previous works, but their occasional futility and failure. While some conceptual art is rigorous and methodical, intellectual and distanced, it can also be paradoxical or daft, emotional or romantic. There is something fragile and fallible about taking on a project that can't be finished, performing an act that can't succeed, or creating a work that will never be seen. It is the repeated, unsure attempts and predictable small failures that constitute the self-effacing and endearing quality of meaningless work.

Could it be this duality that defines the most successful and enduring works? Why do artists' flawed systems and small failures attract us? Are they more authentic, more honest, more empathetic? Perhaps it is because the work that adopts this strategy is always only an attempt, always incomplete, and must therefore admit its own shortcomings. Or perhaps it gives us hope that

productivity and even success are firmly implanted at the pit of failure. Or maybe it's the reassurance that human error can be performed without consequence or catastrophe, especially when tested in a safe environment. Art is not work precisely because it doesn't have to 'work'. The act of failure or the failed act of art making is promising and productive. Or maybe it is because when systems try and fail to create order, or break down and fail, it evokes our own failings. As Annika Ström suggests: 'I guess it's more interesting because it creates questions instead of just answering a question, a question only made by the artist... and it shows that the artist is fragile. It presents the fragile parts of us all.'

Christy Lange, 'Bound to Fail: Open Systems–1', *TATE ETC*, no. 4 (Summer 2005) 28–35.

Jörg Heiser
All of a Sudden//2008

Crash! Bang! Wallop! – Biff! Bang! Pow!
In his book *Comedy is a Man in Trouble*, Alan Dale defines slapstick as staging a 'collapse of the hero's dignity' – either by attack from outside or of its own accord. A poke in the eye, a boot to the rump, a brick to the head, a banana skin. The tragi-comic boom-bash as fates entwine and bodies collide. Why is this funny, even the thousandth time? One well-known reason is *schadenfreude*. Another is the exact opposite: empathy and a feeling of solidarity in moments of misfortune. Slapstick as a sudden jolt in a smooth sequence, an absurd attack of hiccoughs in everyday life and world events, allowing us to catch glimpses of the truth about ourselves and our relations with others. There's something liberating about this, and something moving.

Thus far, slapstick could be placed within the history of theatre and literature, from Aristophanes to Miguel de Cervantes to Alfred Jarry. But a closer look at slapstick in the medium of *film* reveals qualities that suggest an elective affinity with art – that is, the way it tells funny little stories as a guise through which to render storytelling itself absurd, by repetition of motifs (running gags), chaotic montage, and overindulgence in certain medium-specific effects. 'Crash! Bang! Wallop!' and 'Biff! Bang! Pow!' For a good gag, slapstick will gladly dispense with narrative logic, plot and characterization.

The fast cuts and absurd contrasts of slapstick had their roots in the quick-paced reviews of vaudeville and in the cartoon strips of early twentieth-century

newspapers. In film, from 1910, camera and editing technology reinforced them and gave them a central role. At the time, this prompted critic and slapstick apologist Gilbert Seldes – in his eulogy *The Seven Lively Arts* (1924) – to oppose attempts at explaining slapstick purely in terms of historical precursors. Slapstick, he claimed, is camera angle, technical tricks, editing, projection; without these factors it would forfeit its tempo and rhythm, or become mere acrobatics.

Both slapstick and art, then, have a tendency toward the anti-narrative, and both aim to use the mechanisms of the media in which they are situated to achieve something that would not be possible without them.

Lessing's Bouncing Head: Franz West

What suggested this idea of a link – beyond connections merely in subject matter – between slapstick and art? First: the observation that contemporary sculpture often deliberately sets the scene for an embarrassing event. Charles Baudelaire is supposed to have said that sculpture is something you trip over when you stand back to look at a painting. The quotation is also variously attributed to painters Barnett Newman and Ad Reinhardt, or Pop artist Claes Oldenburg. Whoever originally came up with this bon mot, it vouches for the preferential treatment of painting and its flights of the imagination over the blunt presence and earthly heaviness of sculpture – the type of naked physical presence of which the style-conscious dandy poet and the bourgeois intellectual grappling for composure would rather not be reminded.

But the real irony of such disparaging attitudes to sculpture is that from the early twentieth century – and increasingly right up to the present – art has developed a fondness for the situation comedy of tripping over stuff that gets in the way. Not always literally, of course, but in a certain sense. Let's take an example: a shapeless papier-mâché lump, the size of a bison's head, part of it sprayed pink, sits atop a steel spring. The spring is mounted on a white plinth. This object was made by Viennese artist Franz West. What on earth is it meant to be? Where's the story? It's not written anywhere; we have to tell it ourselves.

A closer look, then, and a little patience. The white plinth is open on one side, so it could also be a lectern. And there's a shelf with a small book. Can I leaf through it? Normally, you're meant to keep your fingers off the art, but since the lectern bears clearly visible traces of use – like printers' ink and grease from the hands of a speaker gripping its edges – I feel authorized to touch.

So I pick up Gotthold Ephraim Lessing's *Laocoön: An Essay on the Limits of Painting and Poetry*, written in 1766. In it, Lessing makes a distinction that was to remain influential until far into the twentieth century: art is a static medium, literature a time-based one. Writing has rhythm and progression, whereas art is a frozen moment. At the Vatican in Rome there is proof of this: the marble

Laocoön fighting two serpents that are after him and his two infant sons. For more than two thousand years, he has been frozen in a moment of imploring the heavens for pity. Right, I think, as I lean forward to put the book back on the shelf, and – ouch! – bang my head on the lump of *papier-mâché*. Thanks to the steel spring, it starts to sway gently back and forth like the head of a nodding dog in the back of a car. Lessing is refuted. Art does move in time and space after all.

When, in 2002, Franz West placed this amorphous object on a white plinth-cum-lectern and called it *Laocoön's Bouncing Head (Lessing Study)*, he might also have had in mind that, together with the lectern, the comical bulbous head becomes a speaker with a reddened face, trying to exude authority and wobbling his head out of sheer nervousness. The object is already a parody in its own right. West has a reputation for helping people loosen up in the face of overblown theatricality. As a young man, he was present in 1968 at the notorious event by the Vienna Actionists that came to be known as the 'university mess'. In front of a packed lecture hall, Actionist spiritual leader Otto Mühl swung his whip and urinated into Günter Brus' mouth, when the latter was not whistling the Austrian national anthem while masturbating and smearing himself with his own excrement. During all this, Oswald Wiener stood at the blackboard and delivered a lecture. As the action neared its close, the audience was asked if anyone wished to comment on the whole ballyhoo, a question answered with stony silence by all three hundred people present. Whereupon Franz West went to the front, politely thanked the performers, and asked for some applause. Silence gave way to mirth as West treated the great, fearless breach of taboo as no more than an edifying lecture event – unlike the state authorities, who handed down prison sentences of several months to the Actionists for denigrating national symbols.

With his *Lessing Study*, too, West feigns a fool-like naïvety, since there is more going on here than just a clumsy oaf refuting Old Lessing by bumping his thick skull against some swaying thing that recalls a flustered lecturer. That really would be no more than a funny story. What makes it really interesting is that contemporary art achieves this effect by laying out books as bait, so that I pick them up although I really should know better. By making plinths that are not plinths but lecterns with grubby fingerprints. By having titles that give me a hint, a punch line, but also a puzzle about the status of the artwork: Is it just a self-sufficient object in space like some extraterrestrial apparition, designed for rapt contemplation? Or is it there to be used, even if only for some potential, imagined purpose? In a word: instead of constantly emphasizing its unity, its inapproach-ability, its autonomy – like the tabernacle of some sacred idea – interesting art does the exact opposite and throws itself without restraint into the arms of my perception. It leaves me with the joyous dirty work of thinking and criticizing. It doesn't tell stories; it generates them.

The true genius of this strategy of self-diffusion – of the 'open work', as Umberto Eco first called it – is the paradoxical way it leaves art's autonomy as a form of expression intact. After all, describing reality, looking good, and, if necessary, being critical are all things other forms of expression can do just as well, often better.

For West, it all began with the *Adaptives* (since 1974). These twisted, limb-like forms made of plaster over a metal core challenged viewers to take them in their hands and to use them as a cross between Uncle Albert's crutch and Aunt Bertha's brassière, to pose with them or to play with them. The only question is: Who adapts to whom here, me to the object or the object to me? We don't want to look too foolish fiddling around with these crooked things, and if no one is watching we only end up chuckling all the more foolishly.

These objects, then, tested the border between 'fine' and 'applied' art – there was certainly some applying going on here, but what was its purpose? West would not be West if he didn't give this testing of borders a mercantile twist. And it was in the 1990s that he became more widely known with his chairs and armchairs. These items, produced by West and his assistants with the diligence of any small-scale furniture manufacturer, proved very popular with museums and collectors who could offer a seat to visitors with a casual 'that's a West.' But those who boast of such ownership too proudly get their come-uppance. The chairs have crudely but precisely built steel frames, upholstered with robust fabrics, but it's hard to make up one's mind whether or not they are actually comfortable. In search of the best sitting position, one ends up switching back and forth between sagging slump and ramrod straight, which raises the suspicion that West imagined a sitter forever alternating between blind drunk and terminally uptight.

When, in exhibitions, West then demonstratively places his chairs in front of sculptures or paintings by himself or other artists, it becomes obvious (if further proof was needed) that all this comfortable-uncomfortable stretching and shifting enacts bourgeois art-viewing and art-collecting as a sketch – at the same time as taking it very seriously: What do people really do with art? How do they live with it, and how does it figure in the irksome, embarrassing, irritating earthly heaviness of their everyday life? As with the *Adaptives*, the notion of 'becoming one' with the cathartic experience of the sublime or artistic beauty turns into a comedy number, and we are the ones acting it out.

The Year 1913 and What Came Before

West's *Laocoön* head, which developed out of his *Adaptives* and chairs, shares a central quality with a famous work by Marcel Duchamp. In 1913, Duchamp mounted the front wheel of a bicycle on a stool; *Bicycle Wheel* is the simplest imaginable collage of two otherwise unaltered objects, and as in West's piece, a

moving object is mounted on a static one. In both works, it is movement which knocks the dignified off balance. Duchamp's bicycle stool was no good for sitting on, and any attempt to do so would have resulted in a pratfall. Apropos of 1913: this was the year Charlie Chaplin signed his contract with Keystone, where, beginning in 1914, he churned out a steady stream of short slapstick films. The year 1913 also saw the successful newspaper cartoon duo Mutt and Jeff – a tall thin guy and short fat guy, both totally crazy – hit American cinema screens as an animated cartoon. And George Herriman's *Krazy Kat* – that peculiar cartoon cat in love with a mouse who keeps hurling bricks at her head, while she spurns the advances of a policeman who tries to protect her from this abuse – was first published in a daily newspaper.

Brick plus cat's head: a slapstick answer to Cubism's concept of collage. In 1912, Braque and Picasso had begun to include pieces of wallpaper, scraps of tablecloth and newspaper clippings in their still lifes. Admittedly, the period immediately preceding World War I was fairly bursting with cultural and technological upheavals, but in spite of this, the simultaneous emergence of modern slapstick à la Chaplin and the modern art object *à la* Duchamp cannot be purely coincidental.

When Gestures Come Unstuck

In 1900, the philosopher Henri Bergson wrote *Laughter: An Essay on the Meaning of the Comic*. So what is comical? For Bergson, laughter is a reaction to 'a certain mechanical inelasticity', when human movements resemble automatic mechanisms. He gives the example of a man running along a street who stumbles and falls, triggering the impulse to laugh in those looking on. Timeless as this may sound – even Neanderthal man fell flat on his face occasionally – this statement is very much of its time, as the turn of the last century bore witness to an historically unprecedented wave of industrialization and mechanical acceleration in all areas of life. Perhaps Bergson had seen the short film made by the Lumière brothers in 1895 entitled *The Gardener, or The Sprinkler Sprinkled*, one of the first ever 'acted' films and a prototypical piece of slapstick: man waters garden, young rascal appears behind him, steps on hose, baffled man examines suddenly dried up nozzle, and – of course! – gets a soaking.

Laughter is an ambivalent reaction: relief at deviation from the norm but also a mocking reprimand to return to it. The norm in question here involved adapting to the new industrial society and using its achievements with confidence (including running water coming out of a garden hose), even if the society in question was still largely mired in a pre-industrial mindset of strict relations of rank and kin. The laugher, Bergson writes, behaves like 'a stern father' who 'at times may forget himself and join in some prank his son is playing, only to check

himself at once in order to correct it.' We see before us the classic image of a late-nineteenth-century bourgeois *paterfamilias* attempting to shore up his dwindling authority with postures of dignity and authoritarian intimidation.

Slapstick and the comic feed on the failure of such attempts, when gestures come unstuck, when unintended movements and mishaps torpedo the bourgeois individual's controlled stasis inspired by the soldierly pathos of the nineteenth century. For Germany, Norbert Elias has fittingly dubbed this fatal tendency the 'Wilhelmine society of satisfaction', where the model for engagement was not the interplay of free expression but the strictly regulated, pitiless duel. The corresponding type of sculpture is meant to demonstrate military might and imperial grandeur, from the *Monument of the Battle of the Nations* in Leipzig (inaugurated in 1913) to the gigantic *Germania* watching over the Rhine near the Lorelei.

For Bergson's France, a comparable phenomenon might be termed 'Napoleonic pseudo-meritocracy.' The bourgeoisie opposed the aristocracy's heredity-based elites by forming its own based on competence and capability. But it was obliged to gloss over its own establishment and perpetuation of privilege over generations by working itself up into the Napoleonic pathos of the Grande Nation as a bulwark against the rising tide of barbarism and weak-mindedness. As far as Victorian Britain is concerned, suffice it to recall that table legs were covered up as a precaution against sexual connotations; the opposite theory, that it was less about sex than status and that a table's legs were covered up above all when the workmanship did not match the class of its owners, makes no fundamental difference – both are expressions of social inhibition.

It was in America that immigrants representing all these backgrounds and attitudes met up with those who had fled from them to the New World. And above all, it was in the America of the 1910s and 1920s that slapstick and art collided directly for the first time. Marcel Duchamp embarked for America in 1915, having come to know France's pseudo-meritocracy only too well. [...]

Jörg Heiser, extract from *All of a Sudden: Things That Matter in Contemporary Art* (Berlin and New York: Sternberg Press, 2008) 17–25.

Fischli & Weiss
The Odd Couple: Interview with Jörg Heiser//2006

The series of staged photographs *Stiller Nachmittag* (*Quiet Afternoon*, 1984–5), or 'Equilibrium' series, employs everyday objects in the most absurd, gravity-defying constellations rivalling Chinese circus acts: for example, an empty wine bottle sits on top of an apple that sits on top of an eggcup, while a plate balances on the cork of the bottle, held in place by a counter-balance of a fish slice and a ladle, the latter holding an onion in a net (*Natürliche Grazie*; *Natural Grace*).

Der Lauf der Dinge (*The Way Things Go*, 1987) takes the issue of tinkering with gravity one step further, setting it in motion. The result is a 30-minute sequence of enduring triumph: car tyres, candles, plastic bottles, fire crackers, suspicious liquids, planks and balloons are all lined up like dominoes (only occasionally bamboozled by way of a well-hidden cut). The sheer amount of Sisyphean work that must have gone into this is astounding, as is the case with which the result sets itself at the head of a comical tradition of wacky, complex machineries fulfilling simple tasks in a convoluted, yet suspenseful way (though Fischli/Weiss remove even the simple task – the domino effect just ends in fog). It's a tradition that leads from the cartoons the American engineer Rube Goldberg thought up in the early twentieth century (his British counterpart was W. Heath Robinson bespectacled types in overalls), through Gyro Gearloose, to Kermit demonstrating the 'What Happens Next machine' to his eager Sesame Street audience.

Jörg Heiser In the 'Equilibrium' series and in *The Way Things Go*, slapstick features not only in methodical terms but also directly – the physical comedy of objects. How did the one lead to the other?

David Weiss First there were the 'Equilibriums'. We were sitting in a bar somewhere and playing around with the things on the table, and we thought to ourselves, this energy of never-ending collapse – because our construction stood for a moment and then collapsed before we built it up again – should be harnessed and channelled in a particular direction. That was also the original idea for *The Way Things Go*; when you see the 'Making of', it becomes clear that the creative process was not funny at all. I've always found that astonishing anyway – the way people always laugh when the next thing falls over. Because for us it was more like a circus act, trained objects. And the ones that didn't do it were badly trained or badly positioned. It required considerable patience.

Peter Fischli Strangely, for us, while we were making the piece, it was funnier when it failed, when it didn't work. When it worked, that was more about satisfaction. And that the film created the impression that the things move on their own, without human help, that they become spirited, living beings.

Heiser These stories of failure and collapse and then not failing after all – that's also the heroic theme of slapstick: the hero who accidentally breaks something, but in so doing brings about a stroke of good fortune and knocks over the villain etc. In *The Way Things Go* you laugh because something that cannot really work actually does work. It's a kind of triumph.

Fischli And there's an element of comedy in your identifying this heroic theme in the pathetic falling-over of objects. I see it too, and I think you're right, but if that is the case, then it has an element of comedy in itself.

Weiss A professor in Germany once asked us whether we were thinking about the French Revolution when we were making that film.

Heiser Why?

Weiss Because of the upheavals that lead to further upheavals. And in China a student asked me if we had been thinking of reincarnation and the transmigration of souls …

Heiser The title *The Way Things Go* suggests the historical, a concatenation of fateful events.

Fischli I don't really like it, that title.

Heiser Why?

Fischli Well, it's somehow …

Heiser … a bit Wim Wenders?

Fischli Yes, and it's not my favourite title, because it's too close to what we see – 'Suddenly This Overview' is a better title, for a series of small clay sculptures. […]

Jörg Heiser, Peter Fischli and David Weiss, extract from interview, 'The Odd Couple', *frieze*, no. 102 (October 2006) 202–5. (www.frieze.com)

Fischli & Weiss
How to Work Better//1991

1 DO ONE THING AT A TIME

2 KNOW THE PROBLEM

3 LEARN TO LISTEN

4 LEARN TO ASK QUESTIONS

5 DISTINGUISH SENSE FROM NONSENSE

6 ACCEPT CHANGE AS INEVITABLE

7 ADMIT MISTAKES

8 SAY IT SIMPLE

9 BE CALM

10 SMILE

Fischli & Weiss, text of the artwork *How to Work Better* (1991/2000), editioned screenprint on paper.

Richard Hylton
The Moving World of Janette Parris//2002

As a storyteller Parris is disposed to narratives that speak about the mundanities of urban life, troubled relationships, frustration and the ever-present fear of failure. That's not to say it's all doom and gloom. For whilst her observations are sometimes bleak, they also come tempered with poignancy and hilarity. It is perhaps then surprising that in these narratives very little happens, usually the bare minimum. Conversely, however, much is said about the human condition.

I first encountered Parris' work in 1996 in a show called 'The Happy Shopper', where she presented a short video piece on a domestic television and video player.[1] This five-minute work, in which an actor performed alongside a small handmade doll was called *SE5. Episode 2: Betrayal.* The basic plot revolved around a boyfriend who comes home to discover his girlfriend, played by a doll, sharing a bed with another man, played by an actor. Distraught, the boyfriend throws the girlfriend out of the flat. It was a strange piece. Possessing all the qualities of low-budget video production, it also used dialogue familiar from soap opera. Parris' narrative was presented as emphatically deadpan. The fact that one of the characters was a doll made it all the more ridiculous. Devoid of climax or spectacle, the scene somehow appeared to be quite extraordinary. This feeling of anti-spectacle was further compounded in subsequent soap opera works where the dynamic between actors and mute dolls remained non-existent. Examples of this include the cries from the clandestine lover in *SE5. Episode 5: The Affair* (1997), the wife's regretful monologue in *8005. Episode 1: The Divorce* (1997) and the man's pregnant pauses in *8005. Episode 2: Blind Date* (1997). While soap opera narratives rely on suspense and dramatic effect, Parris' narratives deliberately lack these qualities. Despite the low-key nature of these episodes, *SE5* and *8005* assumed a quasi-public information role, warning of the pitfalls of relationships.

Parris' attraction to soap opera seems to stem from the fact that it is an instantly recognizable form that offers the viewer an immediate route to identification with characters. Soap opera becomes the proverbial 'blank canvas' on which she stages her narratives. Over the past few years Parris has been busy appropriating further populist art forms and entertainments, be they cartoons, music or musical theatre, to tell her particular stories. Where cartoons like *The Simpsons* are neatly packaged satirical social commentaries, Parris' animations are somewhat inconclusive. Where musicals are ostentatious and bombastic, her musical operas are low-key. The persistence of understatement, coupled with her use of narrative, suggests that Parris' intentions are quite simple. Yet given

the relationship between 'low' and 'high' art, gallery-based art and performance, the spectacular and the unspectacular, there is clearly more to all this than initially meets the eye. Her work raises questions for us about the nature of art and the position of the artist.

If the characters in her video soaps play out the stereotypical situations of human relationships, then the stereotype is further developed in her laconic but poignant animations. Set in a South London cafe, *Fred's* (1999) weaves Parris' stock-in-trade tales of woe into discussions on sex, morals, class and art. More than simply showing the 'funny side of life', *Fred's* is imbued with both melancholy and insightful wit. Writing on *Fred's*, Alison Green has observed:

> ... animation carries with it the expectation of comedy... But *Fred's* is rather sad... It tells the story of a collection of people on the edge of not making it in their respective milieus, who meet over egg sandwiches and receive kind and sage comfort from the restaurant's eponymous owner. At the same time that these characters are stereotypes, they ring true.[2]

Further Education (2000), Parris' second animation, likewise illustrates her deft use of irony. Set in the fictitious Welham College on the first day of term, it centres on the tale of three rather languid tutors whose respective disciplines of audio-visual work, pottery and life drawing appear outdated in a changing world of further education now dominated by IT courses and 'efficiency savings'. Such is the nature of Parris' characterizations, which can be as scornful as they are compassionate, that these competing forces become a prerequisite to capturing the tragedy of 'real' life. From Dan, who proudly announces that the first draft of his 'silent movie for the twenty-first century' is near completion, to Red Den's calculation that he will save £1,000 a year if he brings sandwiches to work, to Joan who can only muster derision for her mature students, all three exude a sense of inertia and resignation.

Locating the genesis of Parris' storytelling in American cartoon imports like the wry *King of the Hill*, or home-grown soaps like *Eastenders* and *Brookside* seems quite appropriate, particularly since she is the first to acknowledge the influence that populist entertainment has on her work. [...] However, we may also consider some other influences. Growing up in the 1960s and 1970s, Parris was brought up on what could now be considered the flotsam and jetsam of television: programmes like *Crossroads*, noted for its wobbly sets and cardboard acting, the tear-jerking morality of *Little House on the Prairie*, the elementary animation of *The Magic Roundabout*, and even the abecedarian *Paint Along with Nancy* could account for the eccentric nature of her work. However, to understand Parris' use of the deadpan we may also consider the 'kitchen sink' drama *Cathy Come Home*

and comedies such as *Whatever Happened To The Likely Lads* and *The Liver Birds*. In their distinctive ways, both genres spoke about the problems faced by a younger generation growing up in Britain, dealing with the pressures of conformity, unemployment, disenfranchisement and relationships. Whilst these particular programmes have undoubtedly been overwritten by paradigm shifts in television, they introduce a certain logic to the way Parris brings together the quite disparate areas of social commentary, observation and comedy.[3] Surprisingly, the 'sampling' of recognizable tropes of populist entertainment with her trademark anti-climactic plots results in an experience which is like watching vignettes of life.

As in her other work, Parris' musicals are quite unspectacular. Everything from plots to props is pared down to the minimum. This rudimentary aesthetic is as much a question of style as it may be a pecuniary necessity. The musical *If You Love Me* (1999) follows a group of friends suffering that familiar syndrome of post-art college malaise, drifting through life waiting for something to happen. *You're the One* (2001) Parris' second musical, observes the disparity between the rather mundane office shenanigans of a style magazine and the chi-chi world it aims to portray. Although the social spaces portrayed in *If You Love Me* and *You're the One* are very different, Parris' treatment of her subjects is much the same in that both pieces focus on individuals who yearn for a sense of fulfilment in work and relationships. However, while both musicals represent a 'slice of life', it is perhaps no surprise that *If You Love Me* is closer to her own experience while *You're the One* comes across as a more distant observation.

The songs performed in the musicals come from pop, soul, rock and most notably rhythm and blues, once again signifying Parris' own eclecticism. Focused ostensibly on the love song, the musical selection embellishes the predicaments of her characters, like Jo, who sings Brownstone's *If You Love Me* to her non-committal boyfriend. As 'cover versions', performed live with the accompaniment of a band, they are appropriated. But in copying songs, some of which are iconic, ubiquitous, or both, these performances are never intended to emulate the 'original'. The lyrics represent a spirited meta-narrative that is both sincere and tragic. As the music that Parris uses is inscribed with cultural, social and geographical significance, is it possible that the performance of rhythm and blues songs by an all-white cast is merely incidental?[4] Is it any more or less significant than, say, a rendition of a Jeff Buckley song? Parris' deployment of actors as backing singers or, more specifically, as singers who illustrate the story unfolding before our eyes, adds both a Brechtian and a comical spin to what are quite melancholic scenarios. What is refreshing is how she is able to marry different genres and styles without burdening herself with the task of over-explanation.

As a collection of acerbic anecdotes, the *Bite Yer Tongue* series (1998) of cartoons laments the failure to confront people in any given situation. Handwritten

as confessions, the frugal production values succinctly mirror the sense of resignation and poignancy of the narratives:

> I once went for a job interview with an employment agency. The interviewer offered me a chair and then proceeded to read through my CV. 'I see you are well qualified and that you have over 10 years clerical experience also your speed on the VDU is exceptional.' She then added that this was an employer's market and proceeded to offer me a job with a well known English bank, the rate being £3.50 per hour which would increase to £4.00 after three months continuous employment. Lunch breaks would last 30 minutes and would be unpaid with two 15 minute breaks also unpaid throughout the eight-hour night shift. You would be expected to process at least 3000 items per hour, failure to reach minimum targets will result in the termination of your contract. I wanted to say 'So the Slave Trade is alive and well in 1997' but I didn't. I said … That sounds fine. When do I start? Went home, opened a packet of Kwik Save No Frills economy beef burgers.

As an ode to the twentieth virtue of diplomacy and tolerance, the plausibility and banality of each scenario is emphasized. In his article 'Comic Art', David Lillington considered the efficacy of the *Bite Yer Tongue* series:

> … by adopting a stand-up comic attitude, the stories may issue from real life but they are also fictions … The effectiveness of this *Bite Yer Tongue* series lies in its extreme simplicity, in Parris' knack with short, frank, exasperated speech, and in the sense that if she wanted to do something more highly skilled she could.[5]

He goes on to discuss a range of artists who, like Parris, tell stories in cartoon form. Lillington also refers to a number of artists, which would include Parris, who share a 'sense of the absurd, of nostalgia, of pathos'.[6]

Although Parris makes no secret of the fact that her stories are garnered from her immediate environment – the art world, friends and acquaintances – as the use of her own postcode in SE5 testifies, the *Bite Yer Tongue* series is the most explicit example of Parris placing herself in the narrative frame. Rather than seeing this as Parris' authentic voice, we may also consider this as a kind of 'acting out'. This is a task Parris commonly reserves for the actors she employs, as in *Small Talk* (2001), a stand-up routine written by Parris and performed verbatim by an actor (Ralf Collie) in an art gallery.[7] This produces a degree of ambivalence as to what constitutes Parris' authentic voice. What might initially be read as simply 'acting' on the part of actors could also be seen as her own acts of displacement, which are both formal and conceptual. The eclecticism of the work suggests that contravening artistic protocol is a way of escaping the fixity of both

the artist and subject. Might we then think of her work as an act of intervention? For, rather than disrupting public space with the altruism of the artist billboard project, does relocating the visual art audience to the world of the theatre seek to disrupt the insularity of the art world and its fixation with the object?

This process of deferral may also be seen in William Wegman's photographic portraits of his dog Man Ray. Wegman undertakes a self-imposed exile from the 'frame', placing his dog centre stage to act out as raccoon, frog and so on. Man Ray becomes the alternative site for the staging of the self. In his essay 'The Rhetoric of the Pose', Henry Sayre says of Wegman's strategy:

> The self in his work is something 'undecidable', a fluid condition of conflict and contradiction that, if it offers no possibility of final definition, does liberate Wegman to explore, even to the limits of the ridiculous, the processes by which we continually (re)constitute our identities.[8]

Parris' acts of displacement may raise questions pertaining not only to her narratives, but equally to questions of authorship, the artist and audience. The question of what constitutes 'the work' becomes more ambivalent. Is it the explicit narratives? Or is it the, relationship between genres? We might then think of her peripatetic practice as a series of alter egos that continually push the boundaries of what constitutes Parris the artist. Is it Parris the video artist, the cartoonist, the comedian or the dramatist? The irony in all this is that while her narratives remain decidedly understated, the itinerancy of her practice represents a spectacularly ambitious project. It is also a risky strategy, if for no other reason than it doesn't always look as if it is anxious to be read as art. This is a risk that she is willing to take. But by now, we shouldn't be surprised by any of this, because with Parris' art there is always work for us to do.

1 'The Happy Shopper', Elephant and Castle Shopping Centre, London, 19 December 1996 – 25 January 1997.

2 Alison Green, 'Ways of Communicating', *Dumbfounded* (London: Battersea Arts Centre, 1999) 37.

3 It is also worth noting that the proliferation of television channels has produced a dramatic change in the nature of television; the distinctions between the 'Soap', the 'Documentary' and 'Comedy' are not as clear as they may have once been. What began as an altruistic genre of 'Video Diaries' has been usurped by the 'Docu-Soaps', where 'real' people cannot help but play up to the camera, quickly assuming the status of celebrity. Television has also become more self-referential in its ability to adopt a satirical position such as in *Drop the Dead Donkey*, a spoof on the workings of an editorial newsroom, or the more recent feigned 'Docu-Soap', *The Office*.

4 An obvious comparison could be seen in the way that hip-hop has produced both irony and 'cross-over' appeal in its appropriation of the familiar. Most notable in this tradition was Run

DMC's collaboration with the rock band Aerosmith to produce *Walk This Way*. But perhaps a more appropriate example could be Jay Z's song *Hard Knock Life*. Using an abrasive sample of the song of the same title from the musical *Annie*, Jay Z overlays the story of his 'struggle' in life to be and 'stay at the top'. Like Parris' selection of songs which embellish her characters predicaments, Jay Z's sample from *Annie* ironically echoes his own personal narrative.

5 David Lillington, 'Comic Art', *Art Monthly*, no. 216 (May 1998) 5–6.

6 Ibid. Lillington's examples include David Shrigley, Georgina Starr, Tim Millar, et al.

7 Janette Parris, *Small Talk*, performance, 21 September, 2001; exhibition, 22 September – 28 October 2001 at 'The International 3', Manchester, commissioned by Work & Leisure International and The Annual Programme.

8 Henry M. Sayre, 'The Rhetoric of the Pose: Photography and the Portrait as Performance', *The Object of Performance: The American Avant-Garde since 1970* (Chicago: University of Chicago Press, 1989) 53–7.

Richard Hylton, 'The Moving World of Janette Parris', from *The Best of Janette Parris* (London: Autograph ABP, 2002) 1–4.

Heike Bollig and Barbara Buchmaier
Holes in Our Pants//2007

In everyday usage errors usually have a negative connotation. They are considered as aberrations from the optimal, standard state or procedure in a system determined in terms of its functions. But, looking at all the factors that affect different areas of our lives, the categorization of errors doesn't necessarily have to be clear and straightforward. In fact, our evaluation of errors very often shifts between the tendency to class them as taboo or to glorify them. Whether for the purpose of increased effectiveness, to ensure that the global economy runs smoothly (ISO Standards), or in an artistic context, error is very often understood as a subversive-provocative element. This might be due to its potential to function as a tool that breaks open the existing aesthetic consensus. In short, neither the damaging nor the beneficial effects of error are predominant. It is clear however, that mistakes are not consciously *examined*. Moreover, standardized mechanisms of evaluation applied to human achievement in education and administration can have devastating effects. Or is school merely a place for 'institutionalizing' the avoidance of errors? While it may be right to consider errors totally unacceptable in fields like medicine and technological production, they count as

a permitted or even necessary element in the creative disciplines and professions that emphasize innovation.

A comparison of the relative importance of errors inside and outside the art context shows that specialized criteria of evaluation are often applied: art may be boring, art is allowed to be ugly, art doesn't have to be understood by everybody, and so on. Absurdities are appreciated and honoured. The artist's possibilities seem limitless, for mistakes and aberrations now play the role of both consciously deployed methods and creative elements. That way it becomes possible in the art field to transform things that do not fit together into things that match. Artists can intentionally seek coincidences and accidents, to rhyme lines that do not otherwise rhyme, or to record videos which do not really communicate anything concrete to the viewer. It seems that almost anything can be strung together in that endless chain of creative options. The first small conflict, however, arises in the case of a lack of consequence: one drop, always dripping? Does the effect of recognition really lead to credibility? Unstable actions performed by artists are increasingly interpreted as negative, inauthentic, untrue or wrong. This is especially true in the artist's immediate professional surroundings. Can an artist still dare to undermine the recipients' expectations? Can he or she risk undermining an engaged curator's often quite idiosyncratic and fixed statements? With their zig-zag leaps all over the field, artists' wayward strikes lead to them being banished to the spectators' stand by a couple of referees.

This is the moment where the actual border between cultural service and what is generally called artistic freedom begins. In the visual arts, it is certain that the main protagonists of the market and the media play a decisive role in judging which conscious mistakes or references to erroneous conditions are allowed in an artist's work, or, in deciding if errors visualized or analysed in a work of art could be 'attractive' enough to be established and commercialized.

Deviation from the standard, in the art business or in daily consumption, will hardly concern a larger public; nor will objects from daily life or luxury goods intentionally produced with errors, or unique art objects which are, according to friendly recommendations from art VIPs, dedicated to the subject of 'error'. All of these will probably only reach the interest of splinter groups: people who are looking for the 'extraordinary' and who acknowledge and appreciate errors or conscious aberrations from the standard as a source of innovation and production, or as a characteristic that can create identity in their own work. Errors can be charming, and dealing with them openly can be perceived as 'sexy' because it attests to self-consciousness and self-reflexivity. Errors are valued as being 'human', for they say something about the individual features, the functioning or the character of a person (What would a world full of self-conscious losers look like?). However, the error's inherent aura of resistance went on the market a long

time ago and has not been an exclusive product since. Capitalism generates product sectors at regular intervals where a precise and calculated trade of speculation with erroneous products takes place. This can be true for rare productions like faultily embossed coins or misprinted stamps that often enter the collectors' market in very limited editions. These items were once mass products and have now become fetish items due to a slight irregularity.

What clearly seems more profitable is the appropriation of 'fucked up', allegedly 'subcultural' or 'leftist' styles, first by avant-garde fashion designers and subsequently by global players who have copied these designers' individual products. A typical example of this is the textiles sector's trend for the diminution and destruction of materials. Think of ripped or bleached jeans or the adoption of washed-out, worn out or frayed fabrics. Working with such traces of abrasion and the authentification of products that is connected to it can also be observed in the production of electric musical instruments. Here, amplifier speakers and electric guitars are produced as so-called 're-issue-models'. The notion that the production powers of big firms are encouraged to produce such erroneous products virtually 'brand new' in shops that are especially equipped for that purpose seems absurd; however, it is common practice.

Not only do the aforementioned examples of 're-issue-models' seem out of place, but often one's self does, too. Foucault's grim conclusion that 'life in the midst of other human beings led to a being who is always somehow out of place and who is destined to commit mistakes and to err' follows a question about categories of knowledge that no longer act on the assumption of 'right' and 'true', but on the gesture of straying and on the absurdities that penetrate social, artistic, political and economic life.

In some areas, reality is closely approaching that state of incongruity. Nevertheless, it remains hard to imagine a social system that doesn't orient itself towards either ethical anchor points or towards the search for truth, but towards displacement, chance and aberration. One possibility would be to assume responsibility for the conscious construction of a state of erring, deluding, lying or deceiving, and to examine one's own choices and impacts from this new perspective. [...]

Heike Bollig and Barbara Buchmaier, extract from 'Holes in Our Pants', in Bollig and Buchmaier, eds, *On Errors* (Frankfurt am Main: Revolver, 2007) 62–9 [footnotes not included].

Emma Cocker
Over and Over, Again and Again//2010

All of old. Nothing else ever. Ever tried. Ever failed. No matter. Try again. Fail again. Fail better.[1]

Endless actions. Irresolvable quests. Repeated tasks that are inevitably doomed to fail or that are recursively performed – over and over, again and again. The myth of Sisyphus can be used as an interpretive frame through which to reflect upon examples of artistic practice that play out according to a model of purposeless reiteration, through a form of non-teleological performativity, or in relentless obligation to a rule or order that seems absurd, arbitrary, or somehow undeclared. According to many accounts within Classical mythology, Sisyphus was punished for his impudence and lack of respect for the gods, and assigned the task of rolling a rock to the top of a mountain only for it to then roll back down again.[2] His interminable sentence was that he would remain locked into the repetition of this forever failing action for all eternity. Though the term *Sisyphean* is often used to describe a sense of indeterminable or purposeless labour, it actually refers to a tripartite structure whereby a task is performed in response to a particular rule or requirement, fails to reach its proposed goal and is then repeated. More than a model of endless or uninterrupted continuation of action, a Sisyphean practice operates according to a cycle of failure and repetition, of non-attainment and replay; it is a punctuated performance. A rule is drawn. An action is required. An attempt is made. Over and over, again and again – a task is set, the task fails, and the task is repeated. *Ad infinitum.*[3]

In diverse examples of conceptual and post-conceptual art practice from the 1960s onwards, an artist appears locked into some hapless or hopeless Sisyphean endeavour – the blind or misguided following of another's footfall, the foolhardy attempt to write in the rain, hide-and-seek games using the most infelicitous form of camouflage, the never-ending pursuit of an impossible or undeclared goal. Rather than an endless reiteration of the myth's logic – where meaning remains somehow constant – the repeated occurrence of the Sisyphean gesture has the potential to be inflected with cultural specificity at particular historical junctures. Within the various practices discussed in this essay, the myth of Sisyphus is invoked in different ways where its meaning can be seen to shift, moving from (and also *between*) a sense of futility and an individual's resignation to the rules or restrictions of a given system or structure, through resistance, towards a playful refusal of the system's authority. Here, the myth's logic becomes

pleasurably adopted as the *rules of a game* or as a way of revealing porosity and flexibility within even the most rigid framework of inhabitation. While an interest in failure and repetition is evident at various historical and cultural moments, I want to focus on specific practices in order to stage and then shift between the possibilities of different readings, moving from a model of resignation or even resistance towards one of critical refusal, in an attempt to move beyond purely absurdist readings of the Sisyphean paradigm.[4] My aim is to work towards an affirmative reading of the myth's logic by drawing attention to selected examples of artistic practice from the 1960s onwards, where the Sisyphean loop of repeated failure is actively performed within the work itself as part of a generative or productive force, where it functions as a device for deferring closure or completion, or can be understood as a mode of resistance through which to challenge or even refuse the pressures of dominant goal-oriented doctrines. [...]

At one level, the model of Sisyphean failure and repetition within artistic practice can be framed in relationship to a literary tradition of existential or, more particularly, absurdist thought. Whilst one could identify innumerable antecedents, a specifically Sisyphean model of absurdity is explored within the writing of Albert Camus. Camus' *The Myth of Sisyphus* (1942) treats the mythological narrative of the Sisyphean tale as the locus for interrogating humankind's futile and exhausted search for meaning or purpose in an unintelligible world, the myth's eponymous protagonist representing nothing other than the futility of human existence locked into a framework of unrelenting and aimless action.[5] Significantly, however, for Camus the repeated action within the Sisyphean myth has the capacity to be articulated as the site of both tragedy *and* resistance, as the location for acknowledging a shared or collective sense of purposeless existence and yet also a mechanism through which to become acutely conscious of one's own agency and individual plight. The moment of failure – as the rock rolls to the bottom of the mountain and Sisyphus returns to begin the task afresh – signals a break or rupture in the relentless flow of senseless action. For Camus, 'That hour like a breathing-space which returns as surely as his suffering, that is the hour of consciousness.'[6] Here, he suggests, it becomes possible for the myth's protagonist to acknowledge critically the absurdity of the task at hand and gain a heightened (even liberating or transformative) sense of his individual predicament. Sisyphean failure thus becomes double-edged – the gap between one iterance and the next produces *pause* for thought, the space of thinking.

For the critic and writer Martin Esslin, Camus' philosophy and existential reading of the Sisyphean myth is dramatized within the Theatre of the Absurd, in the work of playwrights such as Samuel Beckett, Arthur Adamov, Eugène Ionesco, and Jean Genet whose characters frequently appear caught in hopeless situations,

locked into repetitive and meaningless actions or the (il)logic of an often nonsensical dialogue constructed of cliché and wordplay. Beckett's work, in particular, often evokes the Sisyphean loop through his presentation of interminably static 'events,' where according to Esslin 'what passes ... are not events with a definite beginning and a definite end, but types of situation that will forever repeat themselves' as narrative is evacuated in favour of an interrogation of a particular *state of being*.[7] Esslin argues that in Beckett's plays 'the sequence of events ... are different ... but these variations merely serve to emphasize the essential sameness of the situation.'[8] In *Waiting for Godot* (1952), for example, two characters – Vladimir and Estragon – endlessly wait for someone who never arrives.[9] However, Beckett's stasis is by no means a passive inaction and, counter-intuitively perhaps, it is possible to identify mobility or resistance within his moments of monotony or boredom, where characters endlessly *shift* in position between the conditions of resignation and resistance, disenchantment and desire. In *Waiting for Godot* the characters' inaction starts out as a product of their enforced waiting; that resentful limbo produced by another's failure to arrive. Their inability to act (differently) might at first signal a form of resignation, the passive and acquiescent acceptance of the seemingly inevitable. Alternatively, their failure to get up and move on could be read as a defiant gesture of protest or refusal, a tactic for persistently remaining (still) against all odds. At times, Beckett's characters seem curiously engaged in, rather than strictly resigned to their designated task. As they maintain their endless and immutable waiting game, they appear to be absurdly immersed in its loop of purposeless and relentless anticipation. They tell stories and attempt jokes, sing songs, play games, fight and embrace, curse and converse, sleep, dance, get dressed and then undress again. Here, their standstill slips towards the immobility of pleasurable interlude, a performance willingly suspended. [...]

The sense of critical inconsistency in the performance of the Sisyphean action is crucial for an affirmative reading of the myth, where the shifting of position between investment and indifference, seriousness and non-seriousness, gravity and levity serves to rupture or destabilize the authority of the rule whilst still keeping it in place. In the work of artists such as John Baldessari, Marcel Broodthaers, and Bas Jan Ader, for example, the Sisyphean rule or restriction is brought into play only to then be occupied ambivalently (even humorously at times) where the failure of the action is not only inevitable but is rather encouraged – a desirable deficit which inversely produces unexpected surplus, the residue or demonstration of wasted energy. In examples of the artists' work, 'performances' appear to oscillate or remain poised between a genuine attempt at a given task and a demonstration of its failure. Within Broodthaers' black-and-white film *La Pluie (Projet pour un text)* (1969), the logic of the Sisyphean paradigm

(of repeatedly attempting and failing) is inhabited with a kind of insouciant faux gravitas, the deadpan solemnity of slapstick. The artist is filmed seated at a low table with pen in hand, attempting to write in the rain. Each inky inscription is duly erased by the downfall; the action continues nonetheless. Over and over, the artist attempts to inscribe his thoughts onto the page, however each time he is thwarted by the relentless downpour, which washes his words away. Alternatively, in Baldessari's serial works *Trying to Photograph a Ball so that it is in the Centre of the Picture* (1972–73), *Throwing Four Balls in the Air to Get a Straight Line (Best of thirty-six attempts)* (1973), and *Throwing Three Balls in the Air to Get an Equilateral Triangle* (1972–73), each photographic sequence documents a failing permutation of an action caught at a moment of playful non-achievement. Drawing on an arbitrary system of rules within games, the title of each work establishes the unachievable and equally banal parameters within which the artist must perform. The thrown balls will never coincide with the claims made by the title; the irregular permutations captured in the thirty-six frames offer only a fragment of an activity that could in fact go on indefinitely. Baldessari's serial repetitions playfully 'make light' of their inevitable lack of success, where the loop of failure and repetition is transformed into a nonchalant or even indifferent juggle. In refusing to take the task wholly seriously, the artist deftly defies the gravitas (and, more literally, the gravity) of the Sisyphean paradigm – pathos is replaced by a knowing game-play.

Perhaps more significantly for this essay, work by Bas Jan Ader from the early 1970s explores the possibility or potential of a *sustained* demonstration of failure, where a repertory of existential tropes are put to the test (almost as a form of found instruction) within innumerable filmed performances. Here, repeated or Sisyphean failure shifts to become the central focus of a body of work where it is then repeatedly explored, demonstrated, tested out, or trialled. Ader's practice functions at the point where the language of conceptualism becomes ruptured by the presence of other histories and ideas. His inhabitation of the Sisyphean trope can be seen to oscillate between a *genuine* attempt at a given (if impossible) task, and the playing out or playing within the conventions of the action itself. Ader's series of '*falls*' certainly evoke the Greek myth of Sisyphus where over and over he is filmed as he falls over or drops from a height.[10] In multiple iterations and different versions of work, Ader appears locked into a rule or obligation that requires him to repeatedly attempt an action in the knowledge that it will fail. In *Fall 1, Los Angeles* (1970), Ader falls from a chair that is balanced precariously – if only momentarily – on the apex of a house roof; in *Fall 2, Amsterdam* (1970), he loses his balance whilst cycling along the edge of canal and plunges into the water; in *Broken Fall (geometric) Westkapelle, Holland* (1971), he collapses onto a wooden trestle situated incongruently on a brick-paved country lane, whilst in

Broken Fall (organic), Amsterdamse Bos, Holland (1971), he dangles flaccidly from a tree branch for over a minute until his body can no longer escape the pull of gravity. Inevitably he loses his grip and falls into the river below.[11] In each of his filmed performances, the artist's body follows the repeated trajectory of the Sisyphean rock, falling or indeed failing to evade a gravitational pull. In *Nightfall* (1971) the sense of the inevitable once again plays out, as Ader seems unable to resist the inherent, if unspoken challenge or rule of the situation in which he finds himself. Alone in a garage space he contemplates a 'rock' of concrete on the floor and the two fragile light bulbs either side of it, which afford the only points of illumination. Gradually he lifts the concrete into precarious balance on his outstretched palm, before the posture collapses and the 'rock' falls, extinguishing one of the lights. Unable to resist the logic of the task, he once again lifts the 'rock' and repeats the action; the scene ends in inescapable darkness. [...]

The critical inconsistencies produced by the synchronous presence of different vocabularies (conceptual and existential for example), or by the artist appearing to move between different positions – between seriousness and levity, investment and indifference, humour and despair – complicates any single reading of the Sisyphean tendency, or rather creates a field of engagement in which interpretation remains multifaceted and shifting, never fixed. For contemporary artist Vlatka Horvat, this *push/pull* dynamic within the act of performance becomes a device used for denying the possibility of any singular, coherent narrative reading for the work. Horvat's work attempts to 'embody contradiction,' articulating a sense of the artist, 'wanting and not wanting something at the same time, of wanting multiple things at once, simultaneously saying *yes* and *no*, or of saying one thing while doing the opposite'.[12] In numerous works, Horvat appears trapped within the logic of a test or trial, negotiating futile tasks or searching for solutions to undeclared problems – for ways to inhabit a given space or self-imposed rule. As with Ader's series of *Falls*, there is a sense of the artist as 'being stuck, but simultaneously amused/puzzled by (her) own predicament, allowing for the possibility that the perceived inability/obstacle might be self-imposed, raising to the surface questions of control, complicity, and agency.'[13] Horvat's actions are 'performed with wavering commitment' as moments of genuine investment 'are interchanged with periods of low or no commitment ... where the person (seems to state) ... Here, look how I pretend to do it.'[14] In the real-time video, *At the Door* (2002), Horvat tries to find the correct articulation of words to declare her intentions to open a door and leave; the work presents a catalogue of many different iterations for announcing her departure. Her initially detached, disinvested 'flagging of possibilities' eventually collapses under the *actual* frustrations and limitations within the durational performance itself, as she (the protagonist) is 'affected by real time and space, by the fact of

doing this activity for so long, uninterrupted.[15] Declarations stating her imminent departure are no longer made as though weighing up the possible options for action, but rather become automatic and evacuated of emphasis or alternatively have an insistence or urgency that exceeds the nature of the task at hand. However, the event of departure is never actualized; her desire to leave never acted upon. Horvat's frustration never reaches a climax, rather it eventually exhausts itself and her declarations regain composure or are recomposed; the cycle of iteration begins once more. [...]

This mode of refusing to perform according to teleological expectation (or of *preferring* to fail) can also be witnessed in the work of Francis Alÿs, where (like Ader and Horvat) a single protagonist often appears locked into a process of protracted action that invariably fails to produce any sense of measurable outcome. In *Paradox of Praxis 1 (Sometimes Making Something Leads to Nothing)* (1997), Alÿs himself pushes a block of ice through Mexico City for nine hours, whereby the performed gravitas of this self-imposed task refuses to diminish as the ice gradually melts away to nothing. The Sisyphean loop of failure and repetition is more explicit in video works such as *Loorιυπρ* (1990), where a young boy is filmed relentlessly kicking a bottle up a steep road, only then persistently to allow the bottle to roll back down again, or in *Rehearsal 1* (1999–2004), where a Volkswagen car is filmed as it repeatedly attempts to scale a hill in Tijuana. The action of the car is synchronized to a soundtrack of a brass band rehearsal. As the musicians play, the car begins its ascent. As the band stalls so does the car; instruments are retuned as the Volkswagen gradually rolls back down the hill. Similarly in the *Politics of Rehearsal* (2005–7) a stripper undresses and redresses in accordance with the pauses and punctuations of another's performance. As a piano is played or a woman sings the stripper removes items of clothing, whilst in the intervals and interruptions of the performance she gathers her clothes from the floor and puts them back on.

Alÿs' practice is itself notable for its endless revisions, where according to curator Russell Ferguson the artist, 'tends to reject conclusion in favour of repetition and recalibration ... completion is always potentially delayed.'[16] In this sense, the Sisyphean paradigm is stripped of its explicit relationship to existential alienation or absurdity, and used instead to reflect on what Alÿs describes as 'the struggle against the pressure of being productive.'[17] Here, the refusal to behave according to teleological expectation functions as a tactic for questioning, dismantling or even misusing the logic of the dominant system whilst refusing to leave its frame. Sisyphean failure (and repetition) could then be reclassified as a playful or ludic strategy that disrupts normative expectations and values by refusing their rules in favour of another logic. For the writer Roger Caillois (1913–78), the ludic functions as 'an occasion of pure waste'[18] where 'at the end of the

game all can and must start over again at the same point.'[19] He goes on to suggest that play 'is also uncertain activity […] The game consists of the need to find and continue at once a response *which is free within the limits set by the rule.*'[20]

While the actions *within* Alÿs' work often remain ambiguous or undetermined, his intentions *for* the work itself function as a direct comment on the resistance to 'repeated attempts to impose a Northern concept of modernity on Latin America.'[21] The myth of Sisyphus thus becomes adopted allegorically, where its structure of failure and repetition is inhabited with what Ferguson has described as a degree of insouciance or even dandyism to demonstrate a playful disregard for dominant efficiency-based models of expenditure and productivity; the work serves to expose the modernist promise of progression and success as unattainable or flawed. Failure is rarely a measure in itself but rather a vague and unstable category that is used to determine all that is errant, deficient, or beyond the logic and limitations of a particular ideology or system. At one level, failure or error inversely reflect the drives and desires of the wider systems in which they (mal)function; their inadequacies give shape to habitually unspoken and yet tacitly enforced values, expectations and criteria for success by indicating the point where an accepted line or limit has been breached. Resistance might be articulated as the iconoclastic, if individual, rejection of the homogenized rhetoric of a given ideology in favour of a new order of (potentially heterogeneous) expression. Here, in Alÿs' practice a model of performed failure or the demonstration of failure offers a dissenting mode of protest or opposition, which refuses to behave according to dominant teleological or progressive doctrines, by never getting anywhere or by forever looping back on itself.

This dynamic of *standstill* might be used productively by such artists as a way to counter the demands of restrictive or dogmatic modes of government 'where there is little porosity or space for resistance', by creating situations that remain deliberately open-ended or still incomplete.[22] Alÿs' performances remain resolutely unproductive, however, rather than reflecting on the futility of purposeless activity, the artist seems to assert a political value for endless irresolution, as a tactic for resisting the logic and authority of dominant goal-oriented or progression-driven cultural economies. Practices that deploy the act of repeated failure subvert the demands of a culture driven by performance success and productive efficiency, not because they refuse to perform, rather because they *prefer not* to aspire towards completion – they just keep on performing. Alÿs' refusal or 'preferring not' is a gesture of 'negative preference' that has the capacity to disrupt the binary relationship of either/or, or of yes/no.[23] Conceived as a model of 'preferring not to,' failure is liberated from its negative designation and allowed the opportunity of being 'preferred,' where it can be read even as a desirable condition. In Sisyphean terms, this might mean to

imagine the event of the falling rock as being 'preferred' to the possibility of the task's completion, where an ecstatic Sisyphus can be imagined taking pleasure in rolling the rock *down* the hill, as one might take pleasure in the act of *sledging*.[24]

The ludic frame and model of *preferring not* enable an affirmative exploration of the Sisyphean paradigm, for they perform a declassification that allows the notion of failure to escape its negative designation. Here, it becomes possible to recuperate Sisyphean activity as a model of resistant non-production or open-endedness, which is inhabited or *played out* at the threshold between investment and indifference, between insouciance and immersion. Rejecting completion in favour of a redeemed form of anti-climax or deferral, the endless 'fail and repeat' loop proposed within the myth of Sisyphus can be seen as a way to privilege the indeterminate or latent potential of being *not-yet-there* above the finality of closure. The rule or instruction can as easily become the rules of the game, a generative device for creating infinitely repeatable permutations and rehearsals within a given structure or self-imposed restriction, or the impetus through which to test or push the limits of a given situation in order that the rules might become malleable or redefined. In this context, the Sisyphean notion of an unresolved, incomplete or endless action – or of a failed, thwarted or reiterated gesture – can be understood as a form of inexhaustible performance, a task without telos or destination which assuages the need to perform whilst deferring the arrival of any specific goal or outcome. Within artistic practice (and also within this essay itself), the myth of Sisyphus is conjured and inhabited as a temporal site of rehearsal, as a thinking space for nascent imaginings, for repeated attempts and inevitable irresolution. The rock then rolls back down again; postures taken become pleasurably collapsed. A rule is drawn, an action required. An attempt is made. Over and over, again and again – a task is set, the task fails, and the task is repeated. *Ad infinitum.*

1 Samuel Beckett, *Worstward Ho* (John Calder, London, 1983) 7.

2 Various accounts tell of how Sisyphus tricked Death (Thanatos). Sisyphus had found out that Zeus was intending to seduce Aegina and warned her father, Aesopus. Enraged, Zeus sent Thanatos to capture Sisyphus and bring him to the nether world. Instead, Sisyphus tricked Thanatos into locking himself into chains; consequently no one on earth was able to die. Further enraged, Zeus was forced to send Ares to unbind Thanatos. Meanwhile, Sisyphus hatched a further plan to evade Death. He asked his wife to leave his body unburied and when he was taken to the nether world he complained to Hades (or Persephone in some versions) that he had been dishonoured by the lack of ceremonial burial. Hades allowed him to return to chastize his wife, but this was really a ruse by Sisyphus to return to the earth where he had no intention of ever going back to the nether world. Once again, the Gods were aggrieved, and as a consequence punished Sisyphus to his eternal task of rolling the rock up the hill only for it to roll back down

again. The story of Sisyphus can be found within classical mythology, for example in Cicero, *Tusculan Disputations* I, 5 or in Homer, *Iliad*, Book IV and the *Odyssey*, Book XI where Odysseus speaks of encountering Sisyphus in the nether world in the process of his eternal task. Sisyphus is specifically encountered in 'The Story of Athamas and Ino' (94-99) in Ovid, *Metamorphoses*, trans. Rolfe Humphries, (Bloomington, Indiana: Indiana University Press, 1955), 96.

3 There are at least four ways to fail a rule-based operation: 1) by failing to accomplish or achieve success in the task; 2) by breaking the rules; 3) by succeeding (if the intent was to fail); 4) by failing (if the intent was to fail) as the task has succeeded to fail, thus failed to a be a failure.

4 In 'Art Failure' (*Art Monthly*, no. 313, February 2008, 5–8) Lisa Le Feuvre identifies a number of exhibitions that address the idea of failure including 'The Art of Failure', Kunsthaus Baselland, (5 May – 1 July 2007); 'Fail Again, Fail Better', part of Momentum/Nordic Festival of Contemporary Art (2 September – 15 October, 2006); and the exhibition and publication, *The Success of Failure*, ed. Joel Fisher (New York; Independent Curators Inc., 1987).

5 See Albert Camus, *The Myth of Sisyphus*, trans. Justin O'Brien, (New York: Penguin, 1975). First published as *Le Mythe de Sisyphe* (Paris: Éditions Gallimard, 1942). In Chapter 1, 'An Absurd Reasoning,' Camus traces a philosophical lineage that attempts to deal with the absurd through Heidegger, Jaspers, Shestov, Kierkegaard and Husserl (See Camus, 1975: 64–89). Other traditions of absurdist thought and practice have been identified, for example, Martin Esslin traces a particular lineage of absurdist thought in *The Theatre of the Absurd* (London: Methuen, 2001) especially in the chapter 'The Tradition of the Absurd,' 327–98.

6 Camus, *The Myth of Sisyphus*, 117.

7 Martin Esslin, *The Theatre of the Absurd*, 76.

8 Ibid., 46.

9 Samuel Beckett, *Waiting for Godot* (London: Faber and Faber, 1956). *Waiting for Godot* was originally published in French as *En Attendant Godot* (Paris: Les Éditions de Minuit, 1952).

10 The notion of a fall also operates more implicitly in works such as *The boy who fell over Niagara Falls* (1972).

11 Full descriptions of Ader's works compiled by Alexandra Blättler and Rein Wolf can be found in *Bas Jan Ader: Please Don't Leave Me* (Museum Boijmans Van Beuningen, Rotterdam, 2006).

12 Vlatka Horvat, 'Flagging Possibilities: Emma Cocker in conversation with Vlatka Horvat,' *Dance Theatre Journal*, vol. 23, no. 2 (Spring/Summer 2009) 24.

13 Horvat, in unpublished artist's statements (2007–2008), unpaginated.

14 Ibid.

15 Ibid.

16 Russell Ferguson, *Francis Alÿs: Politics of Rehearsal* (Los Angeles: Hammer Museum / University of California, 2007) 12.

17 Francis Alÿs, *Diez cuadras alrededor del estudio / Walking Distance From the Studio* (Mexico City: Antiguo Colegio de San Ildefonso, 2006), 68, cited in Ferguson, *Francis Alÿs: Politics of Rehearsal*, 54.

18 Roger Caillois, *Man, Play and Games*, trans. Meyer Barash (Champaign, Illinois: University of Illinois Press, 1958 / 2001), 5.

19 Ibid.

20 Ibid., 8.

21 Ferguson, *Francis Alÿs: Politics of Rehearsal*, 54.

22 Lisa Le Feuvre, unpublished dialogue with the author in London, 2008.

23 The phrase 'prefer not to' can be attributed to the protagonist of Herman Melville's short story, 'Bartleby, the Scrivener' (1856). [see discussion of this text in the texts by Agamben and Deleuze in this volume.] Slavoj Zizek suggests that Bartleby's 'I would prefer not' should be taken literally. For him: 'It says, "I would prefer not to", not "I don't prefer (or care) to" [...] he affirms a non-predicate: he does not say that he doesn't want to do it; he say that he prefers (wants) not to do it. This is how we pass from the politics of 'resistance' or 'protestation', which parasites upon what it negates, to a politics which opens up a new space outside the hegemonic position and its negation.' See Zizek, *The Parallax View* (London: MIT Press, 2006), 381–82.

24 For Caillois, racing downhill and tobogganing (or sledging) create the conditions of *ilinx*. *Ilinx* is a category of play that relates to the experience of the fall, a space of disorder based on the pleasurable pursuit of vertigo. According to Caillois, other physical activities that produce *ilinx* include 'the tightrope, falling or being projected into space, rapid rotation, sliding, speeding and acceleration of vertilinear movement, separately or in combination with gyrating movement', Caillois, *Man, Play and Games*, 24.

Emma Cocker, extracts from 'Over and Over, Again and Again', in *Contemporary Art and Classical Myth*, ed. Isabelle Loring Wallace and Jennie Hirsh (Aldershot: Ashgate Publishing Company, 2011).

There's nothing worse in art than 'You see it and you know it'. Many artists seem to work from a theory that they invent, so to speak, and which accompanies them through life, a theory they never deviate from. That's a certainty I don't like.

...sa Genzken, In Conversation with Wolfgang Tillmans, Artf... (November 2005)

EXPERIMENT AND PROGRESS

Coosje van Bruggen
Sounddance: Bruce Nauman//1988

[...] In *Playing a Note on the Violin While I Walk around the Studio* (1968), Bruce Nauman's original intention was 'to play two notes very close together so that you could hear the beats in the harmonics ... The camera was set up near the centre of the studio facing one wall, but I walked all around the studio, so often there was no one in the picture, just the studio wall and the sound of the footsteps and the violin.'[1] The sound is fast, loud, distorted and out of sync, but is not noticeable until the end of the film. Nauman quietly walks out of the frame in the knowledge that, as John Cage put it, 'There is no such thing as an empty space or an empty time. There is always something to see, something to hear.'[2] It was again Cage who made Nauman aware of the possibilities of playing with sounds 'that are notated and those that are not'. In his book *Silence*, Cage explained that 'those that are not notated appear in the written music as silences, opening the doors of the music to the sounds that happen to be in the environment'.[3] When Nauman steps outside the frame, the viewer's sense of his own environment is heightened, while the action in the film is reduced to 'white noise', vaguely present in the background; the involvement of the spectator with the performance is nearly broken.

When he made this film, Nauman did not know how to play the violin, which he had bought only a month or two earlier. 'I play other instruments, but I never played the violin and during the period of time that I had it before the film I started diddling around with it.' A year later, during the winter of 1968–69, Nauman made the videotape *Violin Tuned D E A D*. 'One thing I was interested in was playing', Nauman stated in an interview with Willoughby Sharp. 'I wanted to set up a problem where it wouldn't matter whether I knew how to play the violin or not. What I did was to play as fast as I could on all four strings with the violin tuned D, E, A, D. I thought it would just be a lot of noise, but it turned out to be musically very interesting. It is a very tense piece.'[4]

Nauman felt strongly that the important thing in doing these performances was to 'recognize what you don't know, and what you can't do', and as an amateur never to allow himself to slip into traditional music, theatre or dance, where he would put himself in the position of being compared with professional performers in those fields. Nauman believed that if he chose the right set of circumstances and structure, was serious enough about his activities, and worked hard at it, his performance would have merit. His intentions and attitude would turn the performance into art. John Cage's *Pieces for Prepared Piano* of 1940 gave Nauman additional insight into the reinvention of how to play the violin. For this piece

Cage had changed the sound of a piano in order to produce music suitable for the dancer Syvilla Fort's performance of *Bacchanale*. First Cage had placed a pie plate on the strings, but it bounced around because of the vibrations. Nails, which he placed inside the piano as well, slipped down between the strings; however, screws and bolts worked out. In this way, Cage wrote, 'two different sounds could be produced. One was resonant and open, the other was quiet and muted'.[5]

By playing the notes D, E, A, D, on the violin as fast as he could, Nauman created a rhythmic structure and notational pattern that, because of its repetition, provided a certain monotonous continuity. Because of the frenetic tempo, the performance was very intense; Nauman's screechy manner of playing lacked any melodic inflection, and the sounds picked up by the cheap equipment gave the piece a harsh electronic character. Nauman got the idea of playing as fast as he could from the aleatoric directions in certain musical compositions by Karlheinz Stockhausen, especially his 1955–56 *Zeitmasse ('Tempi') for Woodwind Quintet*. As Peter S. Hansen has written, Stockhausen's *Quintet* 'employs various kinds of "time". Some are metronomic (in specified tempi), while others are relative. These are as fast as possible' (dependent on the technique of the players), from "very slow to approximately four times faster" and from "very fast to approximately four times slower".[6] In *Violin Tuned D E A D*, Nauman created a specific kind of environment through sound, and at the same time turned the act of playing the violin into a physical activity that is itself interesting to watch. By turning the camera on its side and his back to the camera, in a static, medium-long shot of the studio, Nauman portrayed himself as an anonymous figure floating horizontally across the screen in defiance of gravity.

The performance in *Violin Tuned D E A D* would have been a continuous activity were it not for the unintentional mistakes, accentuations and moments of faltering and tiredness that slowed the tempo from time to time. In a similar way, the sound in the film *Bouncing Two Balls between the Floor and Ceiling with Changing Rhythms* (1968), in which Nauman performs a sort of athletic version of the children's game of jacks, appears at first to be only incidental but turns out to be the focus of the piece, sustaining the structure and rhythm of the performance. In the interview with Willoughby Sharp Nauman recalls:

> At a certain point I had two balls going and I was running around all the time trying to catch them. Sometimes they would hit something on the floor or the ceiling and go off into the corner and hit together. Finally I lost track of them both. I picked up one of the balls and just threw it against the wall. I was really mad, because I was losing control of the game. I was trying to keep the rhythm going, to have the balls bounce once on the floor and once on the ceiling and then catch them, or twice on the floor and once on the ceiling. There was a rhythm going and once I lost it that

ended the film. My idea at the time was that the film should have no beginning or end; one should be able to come in at any time and nothing would change.[7]

Rather than attempting to pick up objects while the balls were bouncing (as in a real game of jacks), Nauman stressed physical force by throwing the balls as hard as he could; this made them bounce more unpredictably. He compared the effect to an incident that happened when he was paying baseball as a kid: 'Once I got hit in the face, totally without expecting it, as I was leaving the field; it knocked me down. I was interested in that kind of experience you can't anticipate – it hits you, you can't explain it intellectually.' In both his films and his videotapes Nauman starts from certain rules he has invented and then lets events take their own course. He waits for chance to come along to change those rules, and when it does he allows the unexpected to take over. As a parallel to his intuitive approach of making up rules and breaking them, he cites the African game Ngalisio, which is played by the Turkana men at any time, with a constantly varying number of players. The men dig two rows of small, shallow holes in the ground, and then place stones in each. The players gather around the holes and squat down, and then one at a time move the stones in different combinations from hole to hole. The objective seems to be for each player to gather as many stones as possible, but no player ever seems to win. The game appears to be not so much about winning as about the act of playing. New rules are made up silently and are adopted or discarded with the understanding and consent of the other players, so that there is never a consistent pattern in the way the men move the stones. In *Bouncing Two Balls between the Floor and Ceiling with Changing Rhythms*, the discontinuous noises which structure both the time of the performance and the rhythm of the film can be heard by the spectators even after they have walked away from the monitor. By using the natural noises resulting from his activities Nauman found a clever way to let sounds be themselves rather than, in Cage's words, 'vehicles for man-made theories or expressions of human sentiments'.[8] [...]

1 [footnote 13 in source] Willoughby Sharp, 'Bruce Nauman', *Avalanche*, no. 2 (Winter 1971) 29.

2 [14] From *Silence: Lectures and Writings by John Cage* (Middletown, Connecticut: Wesleyan University Press, 1976) 8.

3 [15] Ibid.

4 [16] Quoted in Sharp, 'Bruce Nauman', 29.

5 [17] Quoted in *Empty Words: Writings 1973–1978 by John Cage* (Middletown, Connecticut: Wesleyan University Press, 1981) 8.

6 [18] Quoted in Peter S. Hansen, *An Introduction to Twentieth-Century Music* (Boston: Allyn and Bacon, 1971) 391.

7 [19] Quoted in Sharp, 'Bruce Nauman', 28–9.

8 [20] Cage, *Empty Words*, 8.

Coosje van Bruggen, extract from 'Sounddance', in Coosje van Bruggen, ed., *Bruce Nauman* (New York: Rizzoli International Publications, Inc., 1988) 230–32.

Yvonne Rainer
Interview with Michaela Meise//2008

Michaela Meise I would like to revert to *RoS Indexical*, which premiered last year at Documenta 12 (2007) and was also performed at the Berlin dance festival 'Tanz im August'. *RoS Indexical* deals with the history of the ballet *Rite of Spring* and its status as an icon of Modernism. Igor Stravinsky's music and the radical choreography of Vaslav Nijinsky almost caused a riot in the audience at the premiere in 1913. I was wondering if there was an attraction you felt to Nijinsky's choreographical language. I had the impression that some elements of his version of *Rite of Spring* were almost postmodern: familiar motions, jumping up, shivering, clapping hands and some anti-ballet movements like turning in the feet, turning the head out of the body's axis. Were you interested in Nijinksy's work?

Yvonne Rainer Yes, of course. This dance was such a break, such a violent rupture with previous ballet vocabulary. It was no wonder the audience created such a fuss. Rather than getting up in the air the dancers are pushing themselves into the ground and stooping over and turning in the feet. A total abandonment of the classical tradition. I've been interested in breaks, not only in dance, but in art practices like the futurist and the Dadaist and surrealist movements. You might say that my *Rite of Spring* or *RoS Indexical* has a lot of Dada in it: the stage setting of an overstuffed sofa, words coming down from the ceiling as printed banners unfold, the refusal to dance when the dancers just stand around and talk to each other. So there are references not only to Nijinsky's break but, indirectly, also to other kinds of aesthetic ruptures. [...]

Meise Before you started with your dance education there was a time when you wanted to be an actress. But you experienced yourself as soon as unable to act. In *Feelings are Facts* you describe a situation at an Actors' Workshop as follows: 'While trying to fulfil a "sense-memory" assignment, I pantomimed walking

along a riverbank and retrieving a stone from my show. The response was "We don't believe you". I couldn't generate a proper illusion. The spectacle of someone trying to create an illusion was not, of course, interesting.' I liked this text passage a lot. Maybe we could appreciate looking at someone who's trying to create illusion.

Rainer ... or appreciate looking at a failure. A failure can be interesting. Which reminds me of Sally Silvers' solo in *AG Indexical* where she turns the video around and she's copying the male solo part in Balanchine's *Agon*. She, of course, has no ballet training whatsoever and she's imitating this very masculine, physical series of moves which, it's apparent, she can't do in the style in which it's supposed to be executed. So, it's a failure, but it's fascinating because she is so involved in it. She's doing it in her own way. I got this idea and the first time I saw her do it I said: 'OK, that's it. Don't try to make it any better. You're trying to do this thing that is impossible to do perfectly, and you have created something else.' That is exactly what my situation was in acting. In their eyes I was no good at anything I tried. They also said I was too cerebral: 'We can see you thinking'.

Meise Which reminds me of your appearances in your own movies – for example a scene in *MURDER murder* in which you're doing a monologue and you're looking at the camera. One can see that you're not an actress. Also you seem to be consciously returning the gaze into the camera whilst talking, like someone who is not able to create the illusion of an easy-going process while acting; it totally changes how you watch the movie. You feel a little uncomfortable as a spectator.

Rainer Right, because I am a little uncomfortable, too. The challenge is to convince your audience that whatever you do or make is intentional. And that includes failure, self-consciousness and discomfort, three things that are traditionally taboo in the theatre. The first decade of cinema, in the work of the Lumière brothers, for instance, has been an inspiration for me. How can I reclaim that innocence? [...]

Yvonne Rainer and Michaela Meise, extract from Michaela Meise, 'Once a Dancer Always a Dancer: An Interview with Yvonne Rainer', *Texte zur Kunst* (June 2008) 149; 150–51.

Robert Smithson
Conversation with Dennis Wheeler// 1969–70

Robert Smithson My attitude towards conceptual art is that essentially that term was first used by Sol LeWitt in a personal way and then it established a certain kind of context, and out of it seems to have developed this whole neo-idealism, kind of an escape from physicality ... I'm concerned with the physical properties of both language and material, and I don't think that they are discrete. They are both physical entities, but they have different properties, and within these properties you have these mental experiences, and it's not simply empirical facts. There are lots of things, there are lots of designations that are rather explicit, but these explicit designations tend to efface themselves and that's what gives you the abstraction, like in a nonsite/site situation there is no evasion from physical limits ... It's an exploration in terms of my individual perception, and the perceptual material is always putting the concepts in jeopardy...

Dennis Wheeler What about the *Enantiomorphic Chambers*? Is that an attempt to set up a limit where the perceptual possibilities are confined?

Smithson That's really about the eyes, and a kind of external abstraction of the eyes; it's like you're entering the field of vision. It's like a set of eyes outside my personal set, so it's a kind of depersonalization.

Wheeler How do you mean a set of eyes? You mean the reflective capacity?

Smithson Like a stereopticon kind of situation – artificial eyes – that in a sense establishes a certain kind of point of departure not so much toward the idealistic notion of perception, but all the different breakdowns within perception. So that's what I'm interested in. I'm interested in zeroing in on those aspects of mental experience that somehow coincide with the physical world.

Wheeler Can you make a distinction as to where the differentiation of the object and the concept occur?

Smithson Well, I mistrust the whole notion of concept. I think that basically implies an ideal situation, a kind of closure ... And the mediums, in art ... the maps relating to the piece are like drawings, and they relate to the piece in the same way like a study for a painting would refer to the painting. They are not the

same thing but they all refer. It's like a kind of ensemble of different mediums that are all discrete …

Wheeler Functions.

Smithson Functions, right, different mediums, but different degrees of abstraction … some are painted steel containers, and others are maps, others are photographs. And these are all different kinds of mental and physical abstractions.

Wheeler I feel the best way to describe what's going on in your art is to use a vocabulary other than an art historical, a critical, or perceptual rhetoric, to use something that has simply to do with the experience of how the thing was.

Smithson If you were to enter into this experience, and respond to it in terms of your own experience – in other words, there is no explanation as to what's right or what's wrong, because both cases are true. I can't say, yes this is right, and no this is wrong. In a certain way both exist, so I'm operating in terms of both yes and no. I can't say I'm after this thing but not this thing. There's a kind of back and forth between negative and positive, so that the kind of criticism that tries to postulate one kind of experience over another one, I find rather boring. I'm equally interested in the failures of my work, and isolating them, as I am in the successes. In many ways it becomes very fascinating to investigate one's incapabilities as well as one's capabilities. That's where the aspect of entropy would come into it.

Wheeler …The appearance of the island in the Yucatan mirror project when you were already off it is nice … There are all these words floating around … (but you would not at all want to call it serial), because that is a distorted view.

Smithson That tends to get into the same trap as conceptual art would get into. The cerebral isn't touching rock bottom; it's just a sort of pure essence that is up here somewhere. So it's going back into a kind of pseudophilosophical situation. I'm really not interested in philosophy. I'm interested completely in art. […]

Robert Smithson, extract from 'Interviews with Dennis Wheeler' (1969–70), section II, in *Robert Smithson: The Collected Writings*, ed. Jack Flam (Berkeley and Los Angeles: University of California Press, 1996) 208–9. © Estate of Robert Smithson/VAGA, New York.

Frances Stark
For nobody knows himself, if he is only himself and not also another one at the same time. On Allen Ruppersberg//2005

For nobody knows himself, if he is only himself and not also another one at the same time. – Henry Miller quotes Novalis in 'Creation' (*Sexus*)

At the time the question was posed as to whether or not I would like to contribute a text about Al Ruppersberg, I was full of promises to myself to turn down any request for writing that came my way. Presumably, saying 'no' to others might constitute saying 'yes' to oneself, or rather, I may have been thinking it might be best to dedicate myself to writing something that stemmed from my own requirements, not something that was somebody else's idea. Perhaps what lies at the bottom of such selfishness – and, incidentally, at the forefront of any discussion of Al I have the luxury of initiating – is the assumption that the aim of life is self-development. To come under the influence of someone else is to become an actor in a part that has not been written for him – an assumption adorned and articulated courtesy of Oscar Wilde's *The Picture of Dorian Gray*.

Let me first explain how I was introduced to the work of Al Ruppersberg. I was in my studio with an advisor, both provided for me by the art college I was attending at the time, and we were looking at a piece I had just made. The advisor asked: 'Have you ever seen the work of Al Ruppersberg?' And I answered 'No'. Now, the reason they asked, the reason anyone asks 'Have you ever heard of X' of any aspiring young artist, is generally because the young person, in this case me, has apparently attempted to do what X, in this case Al Ruppersberg, has already done. Now, certainly just being asked the question is not the same as some referee blowing a whistle and calling a foul. It doesn't necessarily imply you are hopelessly delusional regarding your own potential for originality. It could mean something as simple and helpful as 'Why don't you look into the similarities and see where that takes you.' Either way one hears it, the question practically forces a confrontation with the most basic problem of how to navigate one's own influences. This is especially tricky when you have to account for being influenced by something you never knew existed. What I had done was to make a copy of a book that I held in high esteem, Henry Miller's *Sexus*. What Al Ruppersberg had done was, to put it simply, transcribe Henry David Thoreau's *Walden* and Oscar Wilde's *The Picture of Dorian Gray*. What I had inadvertently copied was not his actual art but the part of his art that involved transcribing literature. Now, without delving into the implications of the layers of copying at work here, I'd like to get into the actual literature at hand. You know, just proceed as if the politics

of appropriation had nothing to do with it and Miller and Thoreau and Wilde had everything to do with it. I want to put contemporary art in a small potato category momentarily if only to broach the subject of shadows cast by potatoes of grander scale. There's a perfect phrase for this grand scale shadow casting, coined by a literary critic who's still lecturing at Yale. The perfect phrase in question is 'the anxiety of influence', and the eponymous text it derives from is best summed up by one of its author's contemporaries, the late Paul de Man: '[Harold] Bloom's essay has much to say on the encounter between latecomer and precursor as a displaced version of the paradigmatic encounter between reader and text'.[1]

Now, if Al sat for months in his studio rewriting, word for word, Thoreau's *Walden*, I have to see this as a direct engagement with every single thought and idea Thoreau put into that particular work, which was in itself an experiment in living. It's an embrace of the notion that practice is key in philosophy, even while it avoids reliving what that practice describes, namely, the critical out-of-doors/self-reliance element. I guess a lot of hippies were copying that part of *Walden* already. A writer asks a reader, 'read me', not 'be me'. Now this level of involvement in a work executed by someone else doesn't necessarily smack of anxiety, probably because it doesn't set out to contest, compete or rewrite but to just re-read. It requires utter submission to the author, leaving the readers' contestations and questions unspoken, unarticulated. It's like one huge speed-freaky underline of someone else's efforts, yet of course it is more than just a generic 'hooray for Walden'. There's a story involving anxiety and influence about Al that I have to recount. Before he began working in a conceptual vein he had been doing some shaped canvases, which led him to pay a visit to a Frank Stella exhibition. He told an interviewer: 'When I saw Stella's paintings I was stunned … I looked at these paintings and realized I knew nothing about what I was doing. I thought that here was someone who knows exactly what he wants, and that it surely belonged to him and not me. It was a history that he knew and was using better than anyone. I went home knowing I had to start all over.' I think it's interesting to consider this remark in the light of the work that would come shortly after. Wouldn't Thoreau or Oscar Wilde count as someone 'who knows exactly what he wants?' Why don't *Walden* or *The Picture of Dorian Gray* 'belong' to Thoreau or Wilde the same way a painting 'belongs' to an alive guy who might just be older and more experienced than you? Does a Stella painting really mean to say 'only I do this' the way *Walden* might be saying 'perhaps you too should try this?' It's like the Stella-induced anxiety forced Al to consider a sphere of influence of a different circumference, and so his starting over was really a starting over from total scratch.

It's funny how I so easily keep referring to him as Al, even though I have only spoken with him on a few occasions. It's a layover of the familiarity he established early on in works like *Al's Cafe, Al's Hotel, Where's Al?* This casualness, this easy

familiarity, represents the quotidian concerns of his practice. I am tempted to interpret the commonplace as a foil for the literary and philosophical themes embedded in the two copied books but, that would be wrong because both texts seem to argue for a stronger role for 'real life' in art and philosophy. In *Walden*, Thoreau writes: 'There are nowadays professors of philosophy, but not philosophers ... Yet it is admirable to profess because it was once admirable to live'. The critic Stanley Cavell, who wrote an entire book on the subject of *Walden*, though the following is not from it, suggests that Thoreau is a threat and an embarrassment to philosophy, that philosophy considers him an amateur, and, out of self-interest, represses him. 'This would imply that [Thoreau] propose[s] and embod[ies], a mode of thinking, a mode of conceptual accuracy, as thorough as anything imagined within established philosophy, but invisible to that philosophy because based on an idea of rigour foreign to its establishment.' This is from a book called *In Quest of the Ordinary: Lines of Skepticism and Romanticism*. In it there's an essay called 'The Philosopher in American Life' and as I set out to read it I started thinking that maybe there is something of the ordinary in AI's work that is too ordinary even to be deemed pop and – just given the *Walden* reference alone (not exactly a small nod) – suggests that a transcendentalist tradition is worth considering. I read Cavell:

> the sense of the ordinary that my work derives from the practice of the later Wittgenstein and from J.L. Austin, in their attention to the language of ordinary or everyday life, is underwritten by Emerson and Thoreau in their devotion to the thing they call the common, the familiar, the near, the low. The connection means that I see both developments – ordinary language philosophy and American transcendentalism – as responses to skepticism, to that anxiety about our human capacities as knowers that can be taken to open modern philosophy in Descartes, interpreted by that philosophy as our human subjection to doubt ... But look for a moment ... at the magnitude of the claim in wishing to make the incidents of common life interesting.[2]

I encountered this book in a friend of mine's office. While he was out of the country, I used his desk and books while my boyfriend watered his tomato plants. My friend went to Yale where he studied with Harold Bloom, *The Anxiety of Influence* guy, and I'm guessing he studied with Stanley Cavell as well. When I was a visiting artist at Yale for a couple of weeks last year, I thought it would be nice to sit in on one of Bloom's lectures. Some students told me I could probably just call him up and go visit him at his home, insisting he was the kind of character who wouldn't mind accommodating an inquisitive stranger if it meant he could provide ample talk to a good listener. Foolishly I did not pursue the adventure.

During that same visit back east, I also opted out of a one-on-one with a tough poet and author of a great book on one of my heroes, Emily Dickinson. That author is my friend's mother. So as I sat in his chair and tried to think about how to write about Al, I had to ask myself *what is your problem?* because not only did I miss out on meeting her and Harold Bloom, I did the same thing by avoiding a conversation with Al Ruppersberg as preparation for this writing. Heck, I could've interviewed Al and spared myself the agony of lonely rumination; we could've gotten down to brass tacks. But, really, I knew from the beginning that this had to be a one-sided affair if I wanted to probe the more awkward aspects of what de Man called the encounter between latecomer and precursor, between reader and text. I got the de Man quote from my friend's office too. I was sitting there, looking at an intimate little Lawrence Weiner piece casually collecting dust on the windowsill, thinking about how the hell could I really bring Bloom into all this – and maybe even the dusty Weiner at some point too, because I couldn't even pretend to have a grasp of whom Bloom was actually referring to (the Strong Romantic Poets), so I glanced over on the shelf, thinking my friend's sure to have some of their works, and I just turned my head and the first thing I saw was *The Anxiety of Influence* itself. So I was thinking how to borrow the notion and apply it to this idea of dealing with influence in the formative years of art making à la Al's encounter with Stella, and my encounter with Al. I also knew I just couldn't leave it at that, but probably needed cautiously to determine the link to the spirit of what Al does – you know, first with his insistence on the everyday and on into the almost anthropological circles he draws around certain presumably shared human experiences. The hopeful grope for a link either put a damper on my thoughts or just unluckily coincided with a major drop in my blood sugar and, flatlined, I had no choice but just to pick up a book and start reading. Jackpot! I started copying the following text into my notebook:

> There always is a strange fascination about the bad verse that great poets write in their youth. They often seem more receptive than any to mannerisms and clichés of their age, particularly to those that their later work will reject most forcefully. Their early work, therefore, is often a very good place to discover the conventions of a certain period and to meet its problems from the inside, as they appeared to these writers themselves.
>
> Every generation writes its own kind of bad poetry, but many young poets of today are bad in an intricate and involved way that defies description. Freer and more conscious than any of their predecessors, they seem unable to surmount passivity, which is the very opposite of freedom and awareness. They can be highly formalized, but without any real sense of decorum, extravagantly free, without enjoying their daring; minutely precious, without any true taste for

language. At best, they turn around as in a cage, all their myths exploded one by one, and keep making up the inventory of the failures they have inherited. At worst, they strike poses and mistake imitation for mask, talking endlessly and uninterestingly about themselves in elaborately borrowed references. In each case there is the feeling of being trapped, accompanied by a vague premonition that poetry alone could end the oppression, provided one could find access again to true words ...[3]

I copied on and on for several pages but that'll do for our purposes, but I should at least admit to omitting the final sentence of that particular paragraph on account of it ending on a down note and I wanted it to end on the hopeful one. OK, forget it, it ended like this: 'Meanwhile, the flow of language hardly covers up the sterile silence underneath'.

1 Paul de Man, *Blindness & Insight: Essays in the Rhetoric of Contemporary Criticism* (Minneapolis: University of Minnesota Press, 1983) 273.

2 Stanley Cavell, *In Quest of the Ordinary: Lines of Skepticism and Romanticism* (Chicago: University of Chicago Press: 1988) 4–7.

3 Paul de Man, 'The Inward Generation' (1955), in *Critical Writings 1953–1978* (Minneapolis: University of Minnesota Press, 1989) 12.

Frances Stark, 'For nobody knows himself, if he is only himself and not also another one at the same time: on Allen Ruppersberg', *Afterall*, no. 6 (Winter 2002); reprinted in Frances Stark, *Collected Writing 1993–2003* (London: Bookworks, 2003) 12–14.

Karl Popper
Unended Quest//1974

[...] It is of some interest to consider the problem of the randomness (or otherwise) of trials in a trial-and-error procedure. Take a simple arithmetical example: division by a number (say, 74856) whose multiplication table we do not know by heart is usually done by trial and error; but this does not mean that the trials are random, for we do know the multiplication tables for 7 and 8. Of course we could programme a computer to divide by a method of selecting at random one of the ten digits 0, 1, ... 9, as a trial and, in case of error, one of the remaining nine (the erroneous digit having been excluded) by the same random procedure. But this would obviously be inferior to a more systematic procedure:

at the very least we should make the computer notice whether its first trial was in error because the selected digit was too small or because it was too big, thus reducing the range of digits for the second selection.

To this example the idea of randomness is in principle applicable, because in every step in long division there is a selection to be made from a well-defined set of possibilities (the digits). But in most zoological examples of learning by trial and error the range or set of possible reactions (movements of any degree of complexity) is not given in advance; and since we do not know the elements of this range we cannot attribute probabilities to them, which we should have to do in order to speak of randomness in any clear sense.

Thus we have to reject the idea that the method of trial and error operates in general, or normally, with trials which are random, even though we may, with some ingenuity, construct highly artificial conditions (such as a maze for rats) to which the idea of randomness may be applicable. But its mere applicability does not, of course, establish that the trials are in fact random: our computer may adopt with advantage a more systematic method of selecting the digits; and a rat running a maze may also operate on principles which are not random.

On the other hand, in any case in which the method of trial and error is applied to the solution of such a problem as the problem of adaptation (to a maze, say), the trials are as a rule not determined, or not completely determined, by the problem; nor can they anticipate its (unknown) solution otherwise than by a fortunate accident. In the terminology of D.T. Campbell, we may say that the trials must be 'blind' (I should perhaps prefer to say they must be 'blind to the solution of the problem'). It is not from the trial but only from the critical method, the method of error elimination, that we find, *after* the trial – which corresponds to the dogma – whether or not it was a lucky guess; that is, whether it was sufficiently successful in solving the problem in hand to avoid being eliminated for the time being.

Yet the trials are not always quite blind to the demands of the problem: the problem often determines the range from which the trials are selected (such as the range of the digits). This is well described by David Katz: 'A hungry animal divides the environment into edible and inedible things. An animal in flight sees roads of escape and hiding places.' Moreover, the problem may change somewhat with the successive trials; for example, the range may narrow. But there may also be quite different cases, especially on the human level; cases in which everything depends upon an ability to break through the limits of the assumed range. These cases show that the selection of the range itself may be a trial (an unconscious conjecture), and that critical thinking may consist not only in a rejection of any particular trial or conjecture, but also in a rejection of what may be described as a deeper conjecture – the assumption of the range of 'all possible trials'. This, I suggest, is what happens in many cases of 'creative' thinking.

What characterizes creative thinking, apart from the intensity of the interest in the problem, seems to me often the ability to break through the limits of the range – or to vary the range – from which a less creative thinker selects his trials. This ability, which clearly is a critical ability, may be described as *critical imagination*. It is often the result of culture clash, that is, a clash between ideas, or frameworks of ideas. Such a clash may help us to break through the ordinary bounds of our imagination.

Remarks like this, however, would hardly satisfy those who seek for a psychological theory of creative thinking, and especially of scientific discovery. For what they are after is a theory of successful thinking.

I think that the demand for a theory of successful thinking cannot be satisfied, and that it is not the same as the demand for a theory of creative thinking. Success depends on many things – for example on luck. It may depend on meeting with a promising problem. It depends on not being anticipated. It depends on such things as a fortunate division of one's time between trying to keep up-to-date and concentrating on working out one's own ideas.

But it seems to me that what is essential to 'creative' or 'inventive' thinking is a combination of intense interest in some problem (and thus a readiness to try again and again) with highly critical thinking; with a readiness to attack even those presuppositions which for less critical thought determine the limits of the range from which trials (conjectures) are selected; with an imaginative freedom that allows us to see so far unsuspected sources of error: possible prejudices in need of critical examination. (It is my opinion that most investigations into the psychology of creative thought are pretty barren – or else more logical than psychological. For critical thought, or error elimination, can be better characterized in logical terms than in psychological terms.)

A 'trial' or a newly formed 'dogma' or a new 'expectation' is largely the result of inborn needs that give rise to *specific problems*. But it is also the result of the inborn need to form expectations (in certain specific fields, which in their turn are related to some other needs); and it may also be partly the result of disappointed earlier expectations. I do not of course deny that there may also be an element of personal ingenuity present in the formation of trials or dogmas, but I think that ingenuity and imagination play their main part in the *critical process of error elimination*. Most of the great theories which are among the supreme achievements of the human mind are the offspring of earlier dogmas, plus criticism. [...]

Karl Popper, extract from 'Autobiography' (1974); reprinted as Karl Popper, *Unended Quest: An Intellectual Autobiography* (London and New York: Routledge, 1992) 47–51 [footnotes not included].

Bazon Brock
Cheerful and Heroic Failure//2004

[...] All scientists learnt from Karl Popper to work successfully by means of failure. Popper named this remarkable procedure 'falsifiability': a scientist proposes hypotheses the meanings of which are only proved if there is no success in refuting them.

In the natural sciences experiments are the best way of falsifying hypotheses. If the experiment fails, we know that the hypotheses are unusable, thus the scientist was working successfully!

But in order to design experiments we need hypotheses. How can experiments disprove hypotheses if the experiments only become possible through the aforesaid hypotheses? Scientists bring experiments and hypotheses together in constructing a logic (generally formulated mathematically) that makes it possible to take account of the discrepancy between hypothetical predictions and experimental results. Therefore the falsification amounts to assessing and handling discrepancies. The experiment has been successful if it fails.

In the arts of our century failure as a form of succeeding was likewise made into a theme, and in more than one respect.

The emphasis on the fact that modern artists experiment is striking. The concepts 'experimental' and 'experimental art' are always employed to make artistic works appear interesting if they obviously show up a discrepancy between what is expected of the artists and the effective works. For a hundred years such discrepancies have been stigmatized by a section of the art public as degenerate. The campaigns against the degenerate arts aimed at admitting as successful only those works that accorded with a preordained understanding of art. Those who were reproached by others with having failed felt themselves to be confirmed as artists.

But the artists wanted to check this very understanding of art by experimenting. They brought together experiments and hypothetical concepts of art in developing a logic that was intended to make it possible to see the meaning of artistic work in the confrontation with the unknown, the incommensurable, the uncontrollable, i.e. reality. The modern artist sees the success of his oeuvre in its failure to verify a preordained understanding of art according to academic rules through works; for it would in no way be up to him as an individual if he had to confirm only normative aesthetics or art theory through his work.

In the twentieth century nobody asked the awkward question 'And is that supposed to be art?' in such radical terms as the artists themselves. In their

John Dwyer
Landlord Apocalypse

Saturday December 7, 2013
7:00 - 10:00 pm

Needles & Pens, 3253 16th Street, San Francisco, CA 94103

on display through January 30, 2014

Sketches, drafts, on masonite
looks like chalk though. details...

preoccupation with this question they went as far as to doubt that they were creating works of art at all. For a work executed according to a plan would be no more than an illustration of a hypothetical construct of art which exists even without the works.

But artists did not justify the need to experiment only through the objective of falsifying prevailing conceptions of art. They discovered that a general discrepancy between a mental construct and its objective realization in pictorial language is obviously inevitable, because for human beings it is not possible to produce identity between intuition and concept, content and form, consciousness and communication (apart from mathematical unambiguity). They learnt how to deal productively with the non-identity of art concept and artwork by exploiting the discrepancy in order to produce something new that cannot be thought out hypothetically. Therefore being innovative meant forgoing from the very start the enforced identity of normative concepts of art and their correspondence in the work. The failure of the works became the precondition for making the theme something new and unknown.

This procedure had an existential dimension for the artists. Anyone who ventures into the new, embarks on experiments, is neither recognizable nor acceptable in the traditional role as artist. Latent social stigmatization drove the artists ever further into the radicalism of experimentation. They had to accept extreme living conditions. In order to tolerate them they were inclined to be excessive in their lifestyle. The consumption of drugs of every description had an impact on the experimenters' mental condition, as a result of which they often behaved in a way that made them stand out and was regarded by the public as not merely eccentric, but also psychopathological. Ever more artists perceived the failure of their bourgeois existence as a prerequisite for their ability to experiment in a radical way.

In this respect they coincided with other deviant personalities (terrorists, criminals, prophets), e.g. with Hitler. He legitimated himself through his experience of failure as both a citizen and an artist. Again and again he emphasized that he had had to endure hunger, rejection and spiritual desolation. The need to be radical arose from the experience of failure. His heroism of deeds was rooted in this radicalism: the heroic artist's attitude which theoretically proves its worth in radical failure. With everything he did he falsified the old European world with its religious, social and artistic ideals. *Götterdämmerung* (Twilight of the Gods) was the name that had been used for this strategy of heroic failure since Wagner. Thus at the end of his days he could rightly be convinced that he had changed the world more radically with his failure than all his contemporaries had done.

Nowadays the heroism of failure is no doubt more appropriately described as aesthetic fundamentalism. It has lost nothing of its fascination. But Wagner and

Nietzsche, the protagonists of heroic and cheerful failure, have meanwhile come to interest not only artists, politicians, scientists and other saviours of the world. Youthful subcultures have long used the glory of failure for their own self-justification. An entire generation seems to be living under the impression that they will fail – economically, ecologically and socially. Hooligans, ghetto dwellers and Mafiosi vie in their radicalism with any Wagner and any Hitler. They no longer believe in the creation of works. They experiment totally and face the unknown and uncontrollable autonomous course of nature and society apparently without any fear. The attitudes of artists and politicians no longer interest them because they represent these attitudes themselves. They are heroic with postmodern cheerfulness. Laughing terror, a cynical couldn't-care-less attitude, is the basis of their everyday experience in the almost scientifically justified task of falsifying themselves.

What was once reserved solely for builders of atomic and neutron bombs, saintly suicides and profound nihilists in the arts is now practiced by Everyman. The philosophy of failure as a form of perfection became total. What a success – and as enlightenment too. For adherents of the Enlightenment knew that they could be refuted by one thing only: by their success. [...]

Bazon Brock, 'Cheerful and Heroic Failure' section from essay in Harald Szeemann, ed., *The Beauty of Failure/The Failure of Beauty* (Barcelona: Fundació Joan Miró, 2004) 30–33.

Jean-Yves Jouannais
Prometheus' Delay: Roman Signer//1995

In 1981, Roman Signer put on a performance entitled *Race* near St Gallen, Switzerland. Having stretched a cable in the air between two trees in the middle of a meadow, the artist attached a rocket to it which he then lit. Wearing a red plastic helmet that clashed with the bucolic landscape, he dashed under the flying rocket: one saw, from behind, the artist-sprinter running off, desperately struggling at a race that was lost from the start. And indeed he did lose, finishing far behind the projectile. He is late with regard to the work. Let us recall that in a famous note included in *La boîte verte* (The Green Box, 1934), Marcel Duchamp suggested using the word 'delay' in the place of 'artwork' or 'painting'. Thus the performance of Roman Signer would be simply, to paraphrase the author of *Le grand verre*, a delay in acts – the same way one speaks of a poem in prose or a silver spittoon.

The image, moreover, is also reminiscent of the old happy endings in movies, though here the happy ending is paradoxically compromised by its own failure. For what is being staged on this Swiss lawn is some kind of derisory remake of the Promethean tragedy. Often, too often perhaps, the figure of Prometheus has been used to define the position of the artist in modern human History – as stealer of fire. Prometheus is above all a precursor of Christ, a pre-Christian figure of sacrifice suffered for the love of the human race: a saviour. But the mythological version favoured by Roman Signer is that of a saviour incapable of saving, chasing after the fire that he is supposed to give to humanity, without ever being able to catch up to it. A little Sisyphean Christ running late, condemned to this lateness, a delay that saves him at once from all moralism and all academicism. His is an ironic, even cynical, point of view, which echoes the utterance of Cioran: 'Society: an inferno of saviours!'

A collection of catastrophes with necessarily imperfect results: This fairly well sums up the performances that the artist has realized since 1974, which he calls *Fast Changes,* a series of experiments within the framework of which he develops an aesthetics of the accidental, a poetry at once festive and deceptive.

I know of nothing more convincing than these works that choose fiasco, not so much as an aesthetic ambition, but as a poetic *raison d'être.* The important thing being, in this case, not that the artist lose or fail, but that he acquiesce to the idea of not achieving perfection. The works of Roman Signer tend, indeed, towards imperfection, aiming at the aleatory nature of games, favouring combustion over construction, relegating to heaviness and the forces of mechanics the concern for recreating in ephemeral fashion a few forms or ghosts of forms in space. The imperfection at stake in *Race* – vital and serene and devoid of any nihilistic or masochistic connotations – is closely related to that which Takeno Jôô and Sen no Rikyû introduced in the sixteenth century into the Tea Ceremony, which was at its apogee at the time. According to them, the ceremony was intended to prove that spiritual richness can be achieved not through luxury and perfection, but through simplicity and imperfection. At that time, Chinese woods were being replaced by Korean woods and by pottery in the Hakeme, Ido, and Komogai styles of the Yi period, objects less precious in appearance, with imprecise roundings, rougher forms, less regular colours. It was with such unpretentious objects that the *shanoyu* of the Wabi style, marked by simplicity and serenity – *wabi-cha* – was established and eventually achieved its definitive form. It's an imperfection very similar to that which Jean Cassou saw in the work of Ramon Gomez de la Serna. 'We might be tempted', he wrote, 'to call the work of Ramon a catastrophe, if we were unable to imagine that one might wish to attempt something other than what appears to us to be the highest goal of art: order, order – that's the only word that comes to our lips'.

Order, order, indeed: the 'return to order' is once again the order of the day, the programme of the reactionary waves crashing down on France since the Right's return to power. In the artistic sphere it has been encouraged by the manifesto-exhibition of Jean Clair at the centenary celebration of the Venice Biennale; in the social sphere by the new questioning of the right to abortion; in the literary sphere by the revival, in the press, forty years after the fact, of the trial of the New Novel, and so on.

It is in such a context as this that Roman Signer magnifies his own libertarian virtues. And his *Race*, obviously, is not an escape, but on the contrary is much closer to a celebration of the freely lived forms of Immaturity, that immaturity which links him across the century to Gombrowicz, Jarry, Picabia and Filliou. It is a delay on the road to the 'return to order'.

Jean-Yves Jouannais, 'Roman Signer: Prometheus' Delay', trans. Stephen Sartarelli, *Parkett*, no. 45 (Winter 1995–96) 120–21.

Inés Katzenstein
A Leap Backwards into the Future:
Paul Ramírez Jonas//2004

During what we could broadly call modernity, the notions of the inventor, the discoverer and the artist have embodied respectively the prospect of innovation, the search for the unknown, and the avant-garde. We tend to imagine these figures alone and obsessed, tirelessly pursuing exorbitant goals, yet they were emblematic of the possibility of revolutionizing our world, both materially and symbolically. This utopianism is most evident in the case of the scientific inventor, whose experiments aspire radically to modify the way we live. The scientist's achievements would mark a before and after, a concrete betterment of human life. They would feed 'Progress'.

It was from the mantle of the scientist that the modern artist inherited the idea of the experimental as the path to the new, but the efficacy of that premise was, in the case of the artist, reduced to the realm of the symbolic. Because of this fundamental limitation, Theodor Adorno maintained that the modern work of art was determined by the impossibility of utopia.

Paul Ramírez Jonas' work reclaims something of the optimism and heroic excessiveness of the experiments and discoveries of the late nineteenth and early twentieth centuries. Since the beginning of the 1990s, he has echoed the

ambitions of certain inventors and discoverers from past centuries by methodically reconstructing their prototypes or pursuing their challenges based on historical accounts. And yet, as Ramírez Jonas painstakingly re-enacts those grand moments, he simultaneously strips himself of all pride by deliberately yielding the singularity of the experience to another 'I' and to another time. In the work that he has developed in recent years, the historical role of the inventor and the discoverer collapse, and this breakdown coalesces with the artist's performed anti-heroism: his tasks are practically reduced to reading a script, reconstructing, copying, following another's footsteps. 'I am a good student of the 1980s, particularly in considering the idea that originality does not exist', Ramírez Jonas says.[1] 'The map is closed, originality dead, invention futile, progress suspect. And why should more be done? Why add to the excess? We are sitting on a rich bed of fragments, most of them unread. There are enough pre-existing texts already.'[2] Like the character in 'Pierre Menard, Author of the Quixote', a story by Jorge Luis Borges, which was a key reference for a number of appropriation artists working during Ramírez Jonas' formative years, the artist has almost defined his artistic practice through the impossible ambition of replicating other people's achievements. His is a paradoxical gesture that aims to produce a signature through different exercises of the capitulation of the 'I'.

For *Men on the Moon*, a work begun in 1990, Ramírez Jonas reconstructed the phonograph designed by Thomas Edison in 1877, the first machine that could record and emit sounds. Edison's phonograph had two diaphragm-and-needle units, one for recording the sound vibrations onto a metal cylinder covered with tin foil and one for playing the sound back. Edison's new phonograph, which operated with wax cylinders instead of tin-foil surfaces, was praised as a paramount innovation. But it had a serious limitation that soon made it obsolete and forgotten (this limitation was one of the main attractions for Ramírez Jonas). These cylinders are able to store 60 seconds of sound for a (supposedly) endless period of time. However, when the sound is released, it is erased: to listen to the sound once stored on the cylinder is to lose it.

When Ramírez Jonas first heard the sound playing from the old failed phonograph he had reconstructed ('reconstruction' here meaning the ability to reproduce not only the machine as object but also its performance), he immediately thought of the research he had already begun on Apollo 11's expedition to the moon. He then began a still-unfinished process of mutual infiltration of the two stories; through the phonograph designed by Edison, he re-recorded the 23 hours of radial communications that were transmitted on 20 July and 21 July, 1969, from Apollo 11 to NASA during its expedition to the moon. The installation of *Men on the Moon* includes a series of shelves that exhibit hundreds of handmade wax cylinders, the Duchampian-looking reconstruction of Edison's phonograph, and

three books made by the artist containing the transcripts of those 23 hours of sound. Relating to the conceptual work of the 1960s, the installation presents the same information in three formats: the recording of Apollo 11's expedition onto wax cylinders; a minute-by-minute literal transcription of the conversations between Apollo 11 and NASA; and the technical instrument (the phonograph reconstructed) required to listen to the cylinders' recordings.

Between 1993 and 1994, Ramírez Jonas created *Heavier than Air*, which consisted of meticulous reconstructions of nineteenth-century kites made as precursors to the aeroplane by inventors such as Samuel F. Cody, Lawrence Hargrave, Joseph Lecornu and Alexander Graham Bell. He recreated a series of 12 kites in their original sizes and materials (wood and fabric), attaching to each one a small, disposable camera. On windy days between 1993 and 1994, the artist flew the kites one at a time from a beach west of John F. Kennedy International Airport, on Long Island. Through a triggering mechanism, the cameras captured aerial shots after 15 minutes of flight. Each kite is then exhibited along with the aerial photograph taken during its flight. These photographs depict a shoreline, the kite's string that connects the device to the artist, and, in most cases, the silhouette of the artist in the distance, as small as a dot, standing on the empty beach while manoeuvering the kite. If there are two performative instances in this work (to build, to fly), these photographs absurdly document the flying moment in reverse. By portraying the artist on the ground holding the string instead of the kite in the sky, these pictures register the solitary act of a paradoxical author, thus functioning as a kind of coy signature. The object is not the kite, but the artist engaged in his performance.

Placed on the floor of a gallery, inert, rigorous and bold, the reconstructed kites have the resonance of a monument. It is through the sculptural aspect of these eccentric devices (i.e. their materiality and form) that we immediately connect them to something temporal, to the idealistic pragmatism that they were based on and that we, today, seem to have lost.

Because of the anachronism of the artefacts reproduced and the way in which the artist presents them, *Men on the Moon* and the various kite sculptures of *Heavier than Air* can be considered exercises of superimposed identification with both the history of technology as well as with certain chapters of recent art history.

When the artist makes the artefact work, there is, in his experience, a restitution of the feeling of 'revelation' inherent to the original discovery. During the re-enactment, 'you are a hostage of time', says Ramírez Jonas. And he continues, 'When the invention works, you are as happy as if you had really invented it. When you reconstruct something from scratch, you cannot be ironic about it. As I reproduce these acts, as I read the text, as I reach the summit, I have

feelings and thoughts that must sometimes overlap with the original – when that happens, who am I?'[3] For the artist, the act of building something old and making it work again confirms the pre-eminence of an immutable objectivity over the changes of the temporal. Through these acts of reconstruction and re-enactment, he proves that some things are impervious to time and that as a subject at a specific moment in history, he actually fades away.

Another way in which his practice connects with history comes from the fact that several of his works refer directly to American art from the late 1960s and early 1970s. This is evident in the fascination with display, quantification and perception of time that is characteristic of conceptual art, especially in the case of *Men on the Moon*. Another clear link to this period is Ramírez Jonas' interest in the formalism inherent in early technological inventions, an interest that seems to be directly informed by the work and writings of artist Robert Smithson: his bizarre retro futurism and particularly the kind of connections he used to make, for instance, between designs by Graham Bell and Buckminster Fuller.

An analysis of Ramírez Jonas' projects is further complicated when one considers the type of inventions that he chooses to replicate. While Edison's phonograph and the inventor's kites might have advanced the history of a given aspiration, they were not turning points in those histories. These artefacts did not revolutionize in the way that their creators had hoped. They were flawed, incomplete, or simply surpassed by later developments that made these predecessors obsolete. In an evolutionary conception of history, these technological relics – proto-recorders or proto-aeroplanes – are located in a time before the origin, they are what took place before the object achieved both the indispensable utility of the commodity and its name (the recorder; the aeroplane, etc).

The entropic mood that Smithson saw in the work of his contemporaries – in his own words, 'mistakes and dead ends often mean more to these artists than any proven problem', – also characterizes Ramírez Jonas' inclination toward failures.[4] In this sense, not only does he shake the notion of the artist as innovator by being a plagiarist, he also does so by selecting objects that are near-misses, failed innovations, almost milestones in the history of Progress. In this respect, if it is true that Ramírez Jonas identifies with the artist as handyman, and that he, like Chris Burden, insists on 'actuality, on doing something, really',[5] he does so by abolishing the idea of authorship. If Burden's fantasy while designing and putting together his ultralight B-Car (1975) was 'to add the name of Burden to the list of Ford, Honda, Bugatti [or] Citroen',[6] Ramírez Jonas has no interest in the genius of his own creations (however practical they may look to an art audience) but rather in other people's failed creations. His is a movement of double removal from genius.

Ramírez Jonas later produced a series of projects on the same premise as his reconstruction works (mainly, repeating certain things or actions) but which are

not literal reconstructions or re-enactments. Like the Apollo 11 or the invention of the aeroplane, there is another body of work by Ramírez Jonas inspired by one of the most astonishing expeditions in human history: Ferdinand Magellan's circumnavigation of the globe in 1519–22.[7] But in *Magellan's Itinerary* (1995), *Longer Day* (1997) and *Another Day* (2003), the artist addresses only Magellan's mandate to 'go west'.

Using the name Ferdinand Magellan, Ramírez Jonas called the travel agency Worldtek Travel in Connecticut to reserve a series of connecting flights that would take him as close as possible to each of the locations where Magellan landed in his expedition. Departing from Seville, Spain, on 15 February, 1995, the flight itinerary includes almost 40 airports spread across the coasts of South America, Oceania and Africa before returning to Seville on 10 April, 1995; the itinerary entails almost two months of uninterrupted travel. *Magellan's Itinerary* consists of the six printed pages of the flight itinerary as prepared by Worldtek Travel. This piece marks a crucial moment in Ramírez Jonas' career, as he decides that the actual re-enactment of the journey is not necessary. Like the sound of the Apollo 11 conversations recorded on Edison's cylinders, this piece is the pure potentiality of the trip: the idea of the heroic journey translated into the bureaucratic code of contemporary tourism.

Longer Day is another work based on Magellan's initiative of 'going west'. Ramírez Jonas woke up at dawn in New York and drove west until sunset. Just before sunset began, on a flat highway in the Midwest, he shot a video from the car's window 'rushing to meet the sun in a vain attempt at making the day last forever'. Unlike *Magellan's Itinerary*, here the challenge is not spatial, but temporal: to gain time by moving west. The profits, alas, are meagre considering the effort: In his journey westward, Ramírez Jonas shot 20 minutes of the sunset while driving and, in the process, gained one minute of sunset (had he stood still in the car park when the sun started to set, the sunset would have lasted one minute less). Even though this work takes to an extreme a romantic trope par excellence – the melancholic fixation on the scene and duration of the sunset – it actually points to an economic issue: the disproportion of the profit-effort equation implicit in an experimental practice. In a world in which 'making the most' of your time is the basis for a rational life, the artist's endeavour, i.e. his race against the inevitable sunset, is emblematic of a stubbornness, which, however revolutionary it may turn out to be, is based on a nonsensical kind of calculus.

Another Day, the third piece that departs from Magellan's idea of 'going west,' takes this opposition between romanticism and quantification to a different level by means of the conceptual strategy of addressing an absent image through an administrative language. The work consists of three video monitors that track, through an almost identical airport arrival-departure display, the moment of

sunrise in 90 cities around the world. Each monitor displays a list of cities, the one on the top indicates the location where the sun is currently rising. The other cities are lined up, waiting for sunrise. The perpetuity and pointlessness of the device becomes almost comic: a mixture of an every-day-is-another-day optimism and an exasperating reminder of the inexorable passage of time.

Is there more to this predilection for failure than a critique of a conception of history as an escalating succession of discoveries and conquests? Is it not in the failed enterprises and dead-ends that one can better perceive the exorbitance of individual obsessions and, therefore, the prospect of utopia? These works, with their insistence on old fantasies and challenges, address a contemporary lack of hope, which, not paradoxically, is transfigured onto our time's technological arrogance. As Martha Rosler recently wrote, 'Obsolescence and the obsolete, making their millionth reappearance in this period without horizons (if not dystopian fears), may represent the effort of the moment to break the hypnotic tranquility of silent assent to the internal order of things'.[8]

Adorno, in connecting this referred absence of horizons to the problem of art that these works identity, usefully writes: 'The concept of originality, which is that of the originary, implies the very old as well as that which hasn't existed yet; it is the trace of art's utopianism.'[9] If Ramírez Jonas' works seek to recover certain individual figures who were close to a moment of genius (but didn't reach it) and restitute the existence of certain almost revolutionary artefacts, they do so by suspending the impulse to invent that is intrinsic to modern artistic creation; and through that suspension, they signal the impossibility of utopia in contemporary artistic practice. He works on the artistic and technological closure of innovation and originality. And he does so with a joyful pragmatism, firm on the task of identifying himself with those who did not give up the risk of imagining something new and, at the same time, full of a sadness that comes from having only nostalgia as the path for the future.

1 Interview with the artist, New York, January 2004.

2 Email correspondence with the artist, March 2004.

3 Email correspondence with the artist, March 2004.

4 *Robert Smithson: The Collected Writings*, ed. Jack Flam (California: University of California Press: 1996) 11–12.

5 Howard Singerman, *Chris Burden: A Twenty Year Survey* (California: Newport Harbor Art Museum, 1988) 20.

6 Chris Burden and Alexis Smith, *B-Car, The Story of Chris Burden's Bicycle Car* (Los Angeles: Future Studio for CHOKE Publications, 1977).

7 Needless to say that besides its final success – discovering a channel connecting the Atlantic and the Pacific, finding an alternative route to the colonies, and proving that the Earth was round –

Ferdinand Magellan's trip had its own quota of failure. Magellan did discover the channel but died almost a year before his ship arrived back to Spain.

8 Martha Rosler, *October*, no. 100 (Spring 2002) 7–13.

9 Theodor Adorno, *Aesthetic Theory* (1970) (Buenos Aires: Ediciones Orbis, Hyspamerica, 1983). Citation is translated from Spanish to the English by the author.

Inés Katzenstein, 'A Leap Backwards into the Future', in *Paul Ramírez Jonas* (Birmingham: Ikon Gallery, 2004) 108–12.

Will Bradley
The Village//1997

Paris 1972. Things had been going badly at the studio. Optimism, which had made transforming the closed-down hospital into a cutting-edge complex of contemporary art workspaces such a collective joy, was fast evaporating. The government grant was spent. Nobody was coming to the private views, although the bus routes were clearly marked on all the invitations and a sense of futility hung in the air like bad aromatherapy. When the local junkies broke into Jean-Paul's studio they took the broken tape machine, a mug without a handle and two rolls of masking tape, but left the paintings. The public's faith in the bourgeois attributes of line, form and harmonious colour combination remained stubborn. The roof leaked.

There was a big meeting later that year. It was the second Friday in July, with the traffic outside gridlocked halfway to Belgium and the heat enough to make Marie-Joelle's wax casts of her naked body look like forensic shots of an acid-bath accident. Anything was better than this. 'Anything is better than this', said Anton, when it was his turn to speak. 'I've got an idea', said Dominique, when it was hers. Her plan was as brilliant as it was simple, and the artists adopted it immediately. It was true to the spirit of radicalism that had informed their project from the outset, and yet it promised considerable lifestyle benefits. It would be collective, but allow for individual freedom. Above all, it would represent the coming of the dream of the avant-garde – art and life merged seamlessly together.

They sold the hospital to a property developer and bought the tiny abandoned fishing hamlet of Inutile-sur-Mer. They made the long journey south in a convoy of borrowed vans, dormobiles, hand-painted 2CVs. Each of the artists had conceived a project that would contribute to the whole. Marie-Joelle installed an oven in her cottage and, using only flour, water, yeast and salt, constructed exact replicas of

loaves of bread. Henri, as a tribute to Joseph Beuys, opened a shop that sold dead hares, and also rabbits, pheasant and a range of cured meat. Anton, inspired by Tinguely, set up a small workshop in which he worked on a variety of strange machinery, but principally the old Peugeots of the local farmers. Jean-Paul painted ironic watercolours of the surrounding countryside, which he sold to tourists.

The winters were mild and passed quickly, the summers were hot and lasted forever and the tensions of metropolitan life melted into the heat haze like so many bad dreams. The days, the weeks, the months, the years went by; the project took root and nourished. The artists became skilled in their new media, but the pile of press releases, hand-set and printed on home-made paper by Dominique and Jacques in the excitement of the community's formation lay yellowing and dust-covered, unsent.

The world's ignorance of the artists' groundbreaking activities remained profound. In the local bar (motto – 'the act of drinking beer with friends is the highest form of art') the debate strayed ever further from the need to dematerialize the object and refine the aims of social sculpture, towards love affairs, problems with the harvest, roof maintenance, the poor form of form at the local football team. Marriages were celebrated with non-religious rites, personal vows or pagan rituals. Soon the first children were born.

There were hard times too, of course, but the struggle had a meaning and what resources the villagers had were shared without bitterness. The artists' ingenuity had not been dulled by their rural idyll, far from it. When things got difficult, Anton would sabotage harvesters or grain elevators on the surrounding farms and then turn up the next morning, toolbox in hand, asking whether by any chance they needed a mechanic. Angelique and Claude grew three acres of Morocco's finest on their smallholding. There was a wine festival for the tourists with the artists dressed authentically as peasants. They sold their 2CVs and got bicycles. They claimed welfare at false addresses. They got by, in fact they thrived.

One day a stranger came to the village, out of season for a tourist but dressed like a city dweller. The children laughed at him as he passed in his bright clothes, his impractical footwear. He wandered around for a whole afternoon, bought wine and cheese from the artists' little shops and picnicked down by the disused harbour. He took photographs and wrote in a spiral-bound notebook. Two weeks later he was back, looking for a room to rent.

He was, he explained, a painter. He'd been working in Paris but had just received a grant and decided to spend a few months developing some ideas in isolation. Things hadn't been going too well. He felt his work lacked relevance. He needed to examine his practice, perhaps rebuild it entirely. A room was found that easily doubled as a studio if the mattress was propped against the wall and the rent, by Parisian standards, was very reasonable. He moved in at once.

Although the years of rural life had changed the artists out of all recognition – nobody would have guessed that the village had not always been exactly as it now appeared – the passing of time had not tempered their ideals. The stranger's arrival, financially welcome as it was, stirred up old commitments, resentments, rebellious natures. They set to work on the young painter.

One by one they visited his studio, never letting slip that they were anything but honest, country folk. Subtly, over time, criticising his successes, encouraging his mistakes, applauding his failures, they destroyed the young man's work. Taking advantage of his obvious crisis of confidence, they turned him into a shambling parody of an artist and when, months later, he left again for Paris they laughed into their beer until the sun came up.

The rest, of course, is history. A few years ago, when his rise to fame was continuing, I saw his first one-person show. At the door there was a table with a book of newspaper clippings and pile of catalogues. As I paused there before leaving I was cornered by the gallerist. Standing over the visitors book, she pressed a pen into my hand. Caught off guard, I wrote my name and then in the column marked 'comments' I wrote what I always write when I don't know what to say – 'uncompromising'.

Will Bradley, 'Fables of Deconstruction', in *stopstop*, no. 1 (Glasgow, 1997); retitled as 'The Village', in *Ryan Gander: Intellectual Colours* (Paris: Dena Foundation for Contemporary Art/Milan: Silvana Editoriale, 2006) 5–11.

Simon Patterson
Manned Flight//1999–

Dear Naomi Aviv,

My work for the Ein Hod Sculpture Biennial would entail the procurement or manufacture of a large man-lifting box kite (no more than 3m long x 1.3m high x 5m wide approx.) a Cody War Kite. (The Cody War Kite was invented at the end of the last century by Col. 'Buffalo Bill' Cody who was among many other things a pioneer of aviation). The kite was intended for military use; for example a team of these kites could be used to lift an observer several thousand feet to note enemy strength and disposition.

I intend the kite to be jammed in one of the olive trees in the Olive Grove in Ein Hod so as to appear as if the kite of an oversized child had snagged in a tree.

The Ein Hod Biennial would be the starting point for the work since I intend it to tour to other appropriate locations. The kite must be photographed in each location so that this photograph can be displayed with the kite in its next new location. I hope that it will be shown over time in more and more places accumulating a 'history' in much the same way that a passport gains stamps or luggage becomes covered by baggage labels until ultimately, the more the piece is shown, the more travelled it will look until eventually it will become so battered and tattered that it will be wrecked.

The work could in theory pack into a cylindrical container 20 cm in diameter x 300 cm long, weighing no more than 20 kg, and could be sent cheaply (by post) to the Biennal where it could then be assembled by me in situ. After the end of the exhibition the work can be dismantled and easily repacked and returned to me by post.

For other works that relate to this piece, see enclosed visual material.

Simon Patterson, London, 1999

Note:

The man-lifting Cody War Kite used in the work is one that I have inherited from a friend, who was British Kite-flying champion and flew to over 2000 feet in this kite. The white ripstop material used in modern kite making is the same as that used in spinnakers on yachts. Using yacht black vinyl lettering, coincidentally supplied by Saturn Sails of Glasgow Ltd., I placed the name of the Cosmonaut Yuri Gagarin on the larger facets of the kite making it redolent of advertizing kites that were used at the beginning of this century. Yuri Gagarin (1934-68) completed the first manned space flight, orbiting the Earth in Vostok I on 12 April 1961. He died when his jet crashed on a routine training flight. In 1973 an asteroid in the constellation of Leo was named after him.

Simon Patterson, Project notes on *Manned Flight* (1999–), reproduced in *Simon Patterson: High Noon* (Edinburgh: Fruitmarket Gallery/Birmingham: Ikon Gallery, 2005) 22.

Harald Szeemann
Failure as a Poetic Dimension//2001

The nice thing about utopias is precisely that they fail. For me failure is a poetic dimension of art. I'm not talking about a protest against political relations, but about allowing a fiasco to actually take place. A good example of this, I always think, is Richard Serra's video *Hand Catching Lead* (1969). It makes no difference at all whether the hand catches the piece of lead or not. It's purely a sculptural gesture; the failure itself becomes a wonderful story. I've been interested in the idea of failure for a very long time, for example in my 'Monte Verità' exhibition about a utopia from the 1920s that was never realized. The exhibition itself, however, gave the impression that this ideal community on Monte Verità in Switzerland had actually existed. This was because we were able to show everything simultaneously: the utopia, the anarchy and everything that happened around it.

Harald Szeemann, statement from Jan Winkelmann, 'Failure as a Poetic Dimension: A Conversation with Harald Szeemann', *Metropolis M*, no. 3 (June 2001). (www.janwinkelmann.com)

Russell Ferguson
Politics of Rehearsal: Francis Alÿs//2007

We know the conventions of the masterpiece: it is a work of art that is totally resolved, that leaves nothing to be added. As Virginia Woolf put it, 'A masterpiece is something said once and for all, stated, finished, so that it's there complete in the mind.'[1] Comparably, Michael Fried has influentially argued that in a successful work of art

> at every moment the work itself is wholly manifest ... It is this continuous and entire presentness, amounting, as it were, to the perpetual creation of itself, that one experiences as a kind of instantaneousness, as though if only one were infinitely more acute, a single infinitely brief incident would be long enough to see everything, to experience the work in all its depth and fullness, to be forever convinced by it.[2]

Francis Alÿs, despite making some of the most compelling art of recent years, has an ambivalent relationship to this idea of complete resolution. He certainly wants his work to remain in the consciousness of those who see it. He seeks the clearest possible articulations of the premises that he wishes to explore. In that sense he is looking for the quality of instantaneous presentness that Fried identifies. Yet he is at the same time highly reluctant to bring any work to an unequivocal conclusion. Certain ideas and motifs are kept open, always available to 'be pushed in new directions, reconfigured for new situations. In addition, he has consistently embraced a durational element in his work. Indeed, he has explicitly described his work in these terms, as 'a sort of discursive argument composed of episodes, metaphors or parables, staging the experience of time in Latin America'.[3]

From the beginning of his career as an artist, Alÿs has adopted a way of working that tends to reject conclusions in favour of repetition and recalibration. He has, that is, put the idea of rehearsal at the heart of his practice. As the celebrated theatre director Jean-Louis Barrault put it, the rehearsal is 'the creative period. For the actor it is the specifically artistic moment. He sketches out, he effaces, he repents, he conjures up.'[4] This process means that the moment of completion is always still to come. Each completed rehearsal opens the door to a further rehearsal, one more iteration in which things can be improved, simplified, or deleted. If a work is still in rehearsal, then it can always be changed. The moment of completion is always potentially delayed. For Alÿs, then, the final work is always in some sense projected into the future, a future that is always advancing just ahead of the work. In the interim it can constantly be revisited, and its presence can be constantly shape-shifting, not just in the form of documentation through photographs or video, but also through written descriptions or oral accounts passed from person to person.

The refusal of closure is true not just of performance-based works, but also of the paintings, drawings, and sculptures in Alÿs' studio, which often remain there for years, picked up and put down again, sometimes worked on, sometimes destroyed, or sometimes used as starting points for new work. Each delay in letting them leave his hands increases the potential for them to be reconfigured in some newly productive way. His drawings in particular bear the traces of endless revision. In the end they are palimpsests of overlaid scraps of paper, held together with tape. Works that *are* performative can constantly be tested out in new situations, different countries, even. Does a premise that works in Mexico City still work in Europe? In Los Angeles? And does it work in the same way, or differently? Some turn out to work the same; others are radically changed by their context.

Alÿs' emphasis on process and response does not, then, tend towards the immaculate resolution of the masterpiece. The idea of rehearsal does, however, contain within it an ideal of what the finished work might possibly be, even if its

incarnations continue to flicker and change in the light of the fire in the Platonic cave. For Alÿs, that flickering, the movement back and forth and around an idea, is as productive as a determined path towards a fixed and identifiable goal. In some cases, there may well be no goal beyond the process, which is almost always a series of more or less tentative moves towards an idea.

Perhaps this idea is most explicit in *A Story of Deception* (2003–6). This film was shot in Patagonia, almost as the by-product of another project. Originally Alÿs went there to film the ostrich-like birds called nandus. The impetus for that project was a story that the Tehuelche people used to hunt nandus by walking after them for weeks, until the birds collapsed from exhaustion. The relationship of the role of walking to his own work was fascinating to Alÿs, but in the end he felt that his film stayed too close to a conventional nature documentary. What he did find, however, when looking at his footage were the mirages that would appear down the dusty roads along which he was travelling. In the end, the work became this footage, an endlessly shimmering mirage that is always retreating down the road just ahead of the viewer. As he has said of this work:

> Without the movement of the viewer/observer, the mirage would be nothing more than an inert stain, merely an optical vibration in the landscape. It is our advance that awakens it, our progression towards it that triggers its life. As it is the struggle that defines utopia, it is the vanity of our intent that animates the mirage, it is in the obstinacy of our intent that the mirage comes to life, and that is the space that interests me.[5]

The artist's unwillingness to bring a decisive closure to a work is evident even in his titles. Anyone who hastened to study Alÿs' oeuvre rapidly comes up against the fact that the very concept of 'title' is exceptionally fluid for him. Unsurprisingly, there are Spanish and English titles. But tittles also change over time. The same title might be given to different works. Some seem to have multiple titles. A number have formal titles, but also nicknames. Dates are also sometimes quite slippery and can be extended by a number of years, as Alÿs continues to make new interventions into apparently completed works.

Even his activity as an artist began tentatively. Only when he was in his early thirties, after he had trained and practiced as an architect and had moved from Belgium to Mexico, did he begin to experiment with art. He began, in the early 1990s, with a series of attempts to address his overwhelming experience of Mexico City. As he described it, 'The first – I wouldn't call them works – my first images or interventions were very much a reaction to Mexico City itself, a means to situate myself in this colossal urban entity.' One of the earliest consisted of three pieces of red, white and green chewed gum, stuck to a wall in the sequence of the Mexican

flag (*Flag*, 1990). For Alÿs, an increasing fascination with the various ways in which resistances to Western modernity were played out in Mexico went hand in hand with his own inclination to avoid definite conclusions. In Mexico City, the rebar that sprouts from roofs everywhere sometimes suggests a whole city in a state of rehearsal for a presentation that may or may not be completed.

The first body of his work to draw international attention, the series of paintings he made beginning in 1993 in collaboration with the sign painters (*rotulistas*) of his Mexico City neighbourhood, are predicated on a potentially endless series of revisions and recapitulations. As he described the process, 'I commissioned various sign painters to produce enlarged copies of my smaller original images. Once they had completed several versions, I produced a new "model", compiling the most significant elements of each sign painter's interpretation. This second "original" was in turn used as a model for a new generation of copies by sign painters, and so on, ad infinitum.'[6] They are an endless rehearsal, in other words, with multiple finished performances (paintings), none of them definitive, none of them truly final.

With this work, Alÿs took on board another aspect of the rehearsal process: collaboration with others. In theatrical or musical rehearsal, an essential part of practice is the degree to which the different impulses and talents of the various participants operate alongside and against those of the others. No matter how determined or dictatorial an author, director or composer may be, there is always an element of collaboration that is integral to the passage from initial rehearsal to finished work. Within a year of beginning the *rotulista* project, Alÿs could say of his collaborations with the sign painters Emilio Rivera, Enrique Huerta and Juan García that 'by now it doesn't matter whether you are looking at a model, a copy or a copy of a copy'.[7] The collaborative element was integrated into the authorship of the works themselves. At the same time, the rehearsal process remained ongoing. Each set of paintings would be complete in itself, yet the series would remain permanently incomplete.

In *Turista* (Tourist, 1994), Alÿs simultaneously included himself among the people of the capital and acknowledged that he remained an outsider. Standing alongside workers with signs advertising their availability as plumbers, electricians or painters, Alÿs offered himself as a *turista*, a tourist. A tourist, obviously would not normally be considered a worker of any kind. As Cuauhtémoc Medina has pointed out, however, there is more than self-deprecating irony at work here: 'In his attempt to pass off his work as "professional observer" of other people's everyday life as a professional activity, he is reflecting on his status as a foreigner and also on the ambiguity of the idea of his "work" as an artist.'[8] 'Tourist' is not a job. Is 'artist'? By claiming the debased title of tourist, Alÿs is also, characteristically, delaying his assumption of the role of artist. He is still just looking:

At the time I think it was about questioning or accepting the limits of my condition of outsider, of 'gringo'. How far can I belong to this place? How much can I judge it? By offering my services as a tourist, I was oscillating between leisure and work, contemplation and interference. I was testing and denouncing my own status. Where am I really standing?[9]

In one of a number of works titled *Set Theory* (1996), a tiny figure sits alone in an upturned glass of water, again an image of isolation. Later in 1996, however, just around the corner from the railings where he had advertised himself as a tourist, an unexpected incident introduced a change in Alÿs' role as observer, and the precise moment is documented. *If you are a typical spectator, what you are really doing is waiting for the accident to happen* (1996) begins with the artist in quintessential observer mode, videotaping the movements of a plastic bottle as it is blown by the wind (and occasionally kicked) around Mexico City's main square, the Zócalo. After about 10 minutes the action comes to an abrupt end when Alÿs unthinkingly follows the bottle into the street and is hit by a passing car. In a moment he goes from observer to protagonist. The endless irresoluable rolling of the bottle had in fact led to a conclusion. For once, there could be no more delay. Suddenly it seemed that all the observation had been leading up to that moment. In fact, it is not possible to observe an action without affecting it. The observer is always involved, always implicated. From here on, there would be not simply rehearsal, but also a politics of rehearsal.

To put it that way, however, suggests more of an overarching schema than Alÿs would acknowledge. Another way in which he separates himself from Woolf's completeness or Fried's instantaneous presentness is in his attraction to fragments rather than wholes. One of his avatars is certainly *The Collector* (1990–92), a little dog-like object on rubber wheels, its body magnetized, that Alÿs led through the streets to pick up metallic bits and pieces as it went. Here we can see a developing predilection for the random, for the leftovers of the city in preference to the all-encompassing modernist rationalism that had informed Alÿs' earlier training as an architect. Further, in this apparently simple piece, we can see the origins of Alÿs' future as a creator of rumours, of urban myths – the man who led a magnetic toy dog on a string through the streets of the city.

These stories, however, are themselves fragments, moments snatched *in media res*, the way they might be experienced by a passer-by. I once asked Alÿs whether he had ever considered making a conventionally structured narrative film. 'I rarely deal with more than one idea at a time', he replied. 'In that sense, paradoxically, I am not a storyteller. Except if you look at a story as a succession of episodes. But if I were to make what you call a "more complete story", I would not start at the beginning or the end. I would need to work from some middle

point, because the middle point – the "in between" – is the space where I function the best.'

Re-enactments (2000) may be the closest thing Alÿs has produced to a conventional narrative. After buying a 9 mm Beretta handgun in a downtown Mexico City gun shop, he proceeded to stroll around the streets with the loaded gun in his hand, apparently without attracting much attention, until the police finally arrested him. Alÿs' long-time collaborator Rafael Ortega filmed the walk. This narrative has a clear beginning and ending, and in between it has great suspense, as the viewer waits for the inevitable denouement. The following day, Alÿs repeated the action with a replica gun, again filmed by Ortega. This time everything was staged. Astonishingly even the policemen who had arrested Alÿs the day before agreed to re-enact their roles. While the repetition of the action might seem to imply that this work is itself a form of rehearsal – the real incident as a kind of rehearsal for the re-enactment – the clear closure of the narrative means that Alÿs sees it somewhat differently. The first performance was not a rehearsal for the second. The second was a re-enactment of the first. The difference is crucial. For Alÿs, *Re-enactments* is less about rehearsal than it is about how actions that take place in real time are always susceptible to being recuperated by their own documentation.

1 Virginia Woolf, letter, 1 January 1933, in Nigel Nicolson, ed., *The Sickle Side of the Moon: The Letters of Virginia Woolf*, vol. 5, 1932–1935 (London: Hogarth Press, 1979).

2 Michael Fried, 'Art and Objecthood' (1967), reprinted in Fried, *Art and Objecthood* (Chicago: University of Chicago Press, 1998) 167.

3 Francis Alÿs, interview with the author, Mexico City, 2005. An edited version of the interview appears in *Francis Alÿs* (London and New York: Phaidon Press, 2007). All further quotations from Alÿs are drawn from this interview unless otherwise indicated.

4 Jean-Louis Barrault, 'The Rehearsal The Performance' (1946), in *Yale French Studies*, no. 5 (1950) 3.

5 Francis Alÿs, 'Fragments of a Conversation in Buenos Aires', in *Francis Alÿs: A Story of Deception* (Frankfurt am Main: Revolver, 2006) 99.

6 Francis Alÿs, quoted by Corinne Diserens, 'La Cour des miracles', in *Francis Alÿs: Walking Distance from the Studio* (Wolfsburg: Kunstmuseum, 2004) 139.

7 Francis Alÿs, in *Francis Alÿs: The Liar, the Copy of the Liar* (Guadalajara: Arena/Garza García: Galería Ramis Barquet, 1994) 43.

8 In Alÿs, *Diez cuadras alrededor del studio/Walking Distance From the Studio* (Mexico City: Antiguo Colegio de San Ildefonso, 2006) 26.

9 Ibid.

Russell Ferguson, extract from Introductory essay, in *Francis Alÿs: Politics of Rehearsal* (Los Angeles: Armand Hammer Museum of Art/Göttingen: Steidl, 2007) 11–35.

Hans-Joachim Müller
Failure as a Form of Art//2009

Failure is eternal. Even at the beginning of all history, there is failure. Man, having just been created, fails to fulfil expectations right from the start. All has been good until then. But suddenly the findings in the paradisiacal laboratory suggest that all is not that good. That it is not good for man to be standing there alone. The anthropogenetic project may be considerably refined with the help of an extra element: woman, who is promptly delivered as an add-on – an act that may appear somewhat disconcerting in the light of the gender debate but that is seminal to the history of failure. The initial building plan of the world obviously did not achieve the desired results. Now, if a builder has to admit to himself that he has not achieved what he set out to do, his plan has failed. And neither the chance to make corrections nor a second attempt can do much to change that fact. Corrections may offer some degree of consolation but they cannot make the failure undone. And having a goal after the goal means that, in fact, the goal you failed to reach cannot have been the ultimate, perfect one. From this point of view the repair of Adam and the delayed start of Eve mark the birth of universal failure. And, judging from the further progress of things, it looks as if Creation shall never completely recover from this moment of failure.

Progressive thinking has always rejected the idea that failure may be a law of life. It has blended the exhausted construction of world things and world conditions into ever-loftier syntheses, declaring its historic transition towards ultimate success a logical necessity. Everything must aspire to achieve its consummate form in the systemic drive of the development drama and must not fail before reaching the goal of its destination. Failure has never been credited to dialectics. Failure is not a necessary hurdle on the way to success. Failure is inadmissible. Failure is the betrayal of the linear path forward that is demanded by reason, a betrayal of free, unimpeded progress and arrival. The uncertainty factor of failure has no place in the command centre of ideas imposed by metaphysics above the objects of experience. The fact that the given things appear quite chaotic, invariably spinning out of control, constantly defying every attempt at direction and guidance, and that all probability speaks against the action of a world-spirit, has failed to make it less powerful. The narrative of the world never ceases to affirm the inevitable, truth-conditioned transcending of all contradictions, the utopian arrival of history at the promised rewards of life.

But failure is always in the here and now. Failure is absolute this-worldliness. And this is its chance. The entire polemic potential inherent in failure results

from the exclusion, the release from ideal responsibility. The effrontery of failure is the most vehement rejection of the manner in which progressive thinking thinks of progress. Where thinking expects failure it has already seen through the ideology of success and has liberated itself from the obsessive pursuit of success. In terms of scientific theory such failure is governed by the principle of verification and falsification. Unlike classic metaphysics with its irrefutable truths, the exact sciences permit taxiomatic propositions, truth propositions, only if these have passed through their opposite, through negation, if they have defied refutation. Even though, as Karl Popper pointed out, statements can be completely falsified, but never completely verified. If we look at falsification as a form of calculated failure then failure is that which is possible, and the other, that which is not possible, is not failure.

Throughout its history, art has been as much interested in failure as in non-failure. An art like Constructivism that follows a building plan cannot rest content if it does not reach the planned target. Max Bill's *Surface in Space*, built like a Möbius strip, cannot fail. Those in charge of its technical realization may fail. But not the formal instructions. They are right, in the same way as a mathematical equation is right. If it is tested and passes the test, all doubt is eliminated.

Art has repeatedly declared itself competent not only for the wide, unquestioned relations of numbers, but also for other wide unquestioned relations. It willingly accepted to be regarded as a veritable paradigm of these wide unquestioned relations and to demonstrate in an exemplary way how works gradually unfold and rise, unfalteringly, to ever more perfect perfection. It is an idealist notion that, ideally, an artist's late work should surpass his early work in terms of glory, brilliance and maturity. And as a genuine instrument of intangible ideas the artist – from the perspective of a popular, persistent understanding of art – does not require any other legitimization other than the one that he is himself. He carries his laws within himself, not knowing any binding rules or higher standards by which to measure the success or failure of his art. You cannot really reckon with him. And if the artist admits to not having mustered everything he had intended to muster, then such failure is only relative too, it is merely another word for the grandiosity which such art perceives itself to be. This heroic bourgeois history has never really ended. The old dynamic lives on unfettered in the power of, and faith in, images prevalent in these years. And the insistence with which the young, much touted figurative painting demands attention is a direct continuation of the auratic tradition, of the absoluteness with which so-called 'great' art, 'ingenious' art has always asserted the unconditional unity of an image's promise and its fulfilment.

Critical modernism has always taken an ambivalent stance on this issue. As much as it has followed the idealist logic of development in its limitless fantasies,

it has adamantly opposed any call for large-scale self-empowerment. Modernism has always been both, and continues to be both even as postmodernism: an exerted, even overexerted design of far away goals as well as a delightful, sensuous pilfering in the targeted run-up to failure. For it was not the violent, disastrous experiences of the twentieth century that led to the departure from utopias. Intelligent forms of art had emerged from the shadows of an ideologically oriented modernism long before that. 'The Art of Failure' is nothing less than an artistic practice that assumes that failure is not merely an error. One could also describe it as a cultural technique, a manner of enlightened awareness that rehabilitates the aesthetic principle by the very act of freeing it from the duty of having to be an absolute principle at the same time.

Seen from this perspective, attempts to reduce an exhibition that focuses on 'The Art of Failure' to a common denominator would amount to misunderstanding the heterogeneity of artistic approaches. What we can do, though, is identify a common maxim and, what's more, a common commitment to what is unfinished, to tentative conceptuality, to the program errors and security holes in the systems. What all these works sorely lack is a passionate certainty, a steadfast, irreducible quality. What distinguishes them is their fine sense of the potential of imperfection, of the beautiful facets of risk, of demands that cannot be fulfilled. The fact that works like those of Erik Steinbrecher are constantly changing, never appearing truly tangible, foreseeable, is due much rather to the immense allure of ambiguity than to unambiguousness that has become impossible today. If we dissect failure as a conscious event we will soon find a playful core, a moment of sensuous self-liberation. It is a fun and delightful experience to evade the standards established by reason, dive away from the goals of reason and surface unexpectedly at a completely different spot.

A well-observed story from classical mythology illustrates this polarity. It centres on two completely different types of a 'modern' understanding of art, embodied by a father and his son: Daedalus and Icarus. Both are about to set out on their first flight with self-made wings that the ingenious father had invented. He advises his son on flying, issuing instructions of life-saving prudence: 'I warn you, Icarus, fly a middle course: Don't go too low, or water will weigh the wings down; Don't go too high, or the sun's fire will burn them.' Daedalus worked out the best air corridor in advance. His son would only have needed to follow him. But Icarus suddenly soars upwards.

We would misunderstand the deadly fall that followed this acrobatic stunt if we were to interpret it in terms of morals. It is not about something having to fail simply because its failure was foreseeable. It is about the experience of wonder that someone strives for, and ultimately finds, in the very act of failure. The experience of Icarus is one of transcending the self and the world, an experience

of light, of the colossal view. An experience of a high-spirited distance from the world. It aims at a point of unbridgeable separation, of the greatest possible distance. Daedalus, the modern artist, directs his entire intellectual capacity at trying to transcend the limitations of physics and demonstrate the triumph of mind over gravity in his proud artefact. While Icarus, the other modern artist, focuses all his fantasies on the sensual abundance promised by failure. Icarus embodies the more modest ego-world case where eyes that are suddenly open to the separation from the world merge with the enforced parting with it. 'Joy of flying' is the only explanation for Icarus' mysterious breaking away from the formation that Ovid, who wrote down the story, can come up with. Audacity provoked. A strange disposition, a euphoric absence of reason and grounding. And once they are without ground or reason, all instructions regarding the handling of this sensitive flying apparatus are forgotten. That lends you wings. Unable to steer for yourself, you are as much exposed to the thermal lift as you are to the pull of the abyss below.

What does failure prove? Failure proves nothing. And yet the way in which this risky high-flyer renounces the straight line of progress of the reliable far-flier could not be more radical. In Gabriela Vanga's video *What if Tom invented Jerry?*, Jerry, the Icarean mouse, is suddenly gone. Which doesn't prove anything, either. And only helps to make the delusion of the mouse-fixated Daedalus cat Tom even more delusional. Has he, with all his hunting and chasing, forgotten that he has long devoured his prey? Object-libido is the source of Tom the cat's failure, while Daedalus the father fails in his teaching. Jerry and Icarus fail because they have chosen to experience failure.

Others have no choice, 'Adiós te dice la Jeu, la asquerosa que siempre odiaste' ('Adios, she says to you, the ugly one, the disgusting one you always used to hate'): the parting words, the *Recados Póstumos* which the Mexican artist Teresa Margolles posted on the billboards of shutdown cinemas in Guadalajara, refer to the drama of failure. A person who commits suicide has no alternative, no second chance to discard his failed life in the way an artist discards a failed work in order to start a new one. Icarus might have followed the recommended flight plan. In a life that has become destabilized, who can the teenage suicide – whose legacy 'Por la constante represión que recibo de mi familia' ('I was constantly put down by my own family') remains in the Cine Estudiante – hold on to? It makes a difference whether it is life that fails, or art. And the notion of an unliveable life does not take away any of the unbearableness of failure. One can argue that failure is inevitable. But if that is the case, then failure is also tragic and connected with fear and shame. The fact that failure is eternal and has always been around, that the original life plan has not turned out as good as it ought to have, can never provide sufficient consolation for failure. 'The Art of Failure' is art that is as deeply

entangled in the event of failure as in the scandal of failure. Therefore, it does not need to rely on the arrogation of dignity and truth. The art of failure is in itself a manifestation of failure.

Hans-Joachim Müller, 'Failure as a Form of Art: A Brief Guide to "The Art of Failure"', in *The Art of Failure* (Basel: Kunsthaus Baselland, 2009) 10–16.

Edgar Schmitz
Which Way to Heaven? Phil Collins//2007

Phil Collins' *the return of the real* approaches the saturated media landscape of popular factual programming as an arena in which to explore authenticity and illusion, intimacy and inaccuracy, and the entangled dynamics of revelation and shame. So far the project has taken the form of press conferences for the national media in Turkey and Great Britain, an internet campaign in Spain, a series of hour-long interviews presented as elaborate video installations, and a production company and research office, Shady Lane Productions, established in the galleries at Tate Britain.

For Collins, the controlled expressiveness of a press conference provides one of the richest contemporary forms of artifice: faces, bodies, voices – all arranged for the portrayal of urgent immediacy, and delivered to the attention of cameras and anonymous mass audiences. Collins does not work against the awkward drama of such formats. If anything, his re-takes exceed the visual and emotional charge of the original. The stories and personalities he presents reflect this accordingly. Like the father, from the work's first instalment in Istanbul, whose son accidentally killed a neighbour's baby, going on TV for compassion and support, only to find himself silenced and arrested. Or the actress and exotic dancer using a TV show as a platform to reveal that she was raped 25 years ago by her cousin, now a famous musician. As part of his Turner Prize nomination in 2006, Collins orchestrated the British episode of the project with a suitor who found out that the woman he had been courting on a TV programme is actually a pre-op transsexual. Another contributor was a woman whose children were bullied after appearing on *Wife Swap*. And so forth, the range is wide and potentially open-ended. Set free from the programming framework they originally appeared in, the participants' testimonies are now directed at the artist's cameras (and those of the news media Collins invited to attend). Yet the

distinction between the first instance of media exposure and the supposed redemption through the vehicle of art is as precariously constructed as is the ethical differentiation between the benefit for the individuals concerned and the programme's ratings. In the process of choreographing *the return of the real* as a secondary media event, Collins furnishes the subjects' statements with the same excessive framing that determined the situation they are now trying to redeem: like in the original event, participants speak to the camera, expect to be heard by an anonymous and hopefully benevolent audience, and ultimately find themselves at the mercy of the host and interviewer whose expertise lies in manipulating this kind of exchange day-in day-out.

It is one of the extraordinary things about Collins' practice in general, and this series in particular, that people agree to take part in the first place. This very fact tells a lot about the contradictory investments that animate the genre of reality TV, if not the whole broader phenomenon of public performance in a post-celebrity culture. The bizarre mass visibility of media stagings offers the only possible shared horizon to both sets of claims: those of TV producers who argue that their programmes enable insight and therapeutic effect, and those of participants who try hard to reclaim the overdetermined condition of abusive attention as a way out of victimhood. Second time round, they insist, it must be possible to reach a different ending, to reverse the trauma suffered and redress the story. In spite of the dramatic excesses of much of *gerçegin geri dönüsü*, the initial body of work produced in Istanbul in 2005, Collins' project resonates beyond what Kutlug Ataman has described as the overall 'artificiality' of Turkish life.[1] Beyond the particular appeal of such specificity, *gerçegin geri dönüsü* draws on the way in which the allure of post-documentary media culture hovers between the explicit claims made for its empathetic potential and the actual effect of voyeuristic gratification. Collins collides the two very precisely: his set-ups are redemptive and emotionally overburdened with the tragic accounts of lives under the influence of broken media promises, but at the same time they only generate more spectacle, too. Sitting in one of Collins' installations of the work – watching the interviews, looking at the celebrity style headshots and overhearing the cacophony of overlapping testimonies – combines both the invasive and the immersive qualities of TV consumption. Collins' installations are excessive in information overload, as well as obscene in terms of the emotional and atmospheric burden they place on viewers, left in the limbo of having to define some sort of relation to the stories they are being exposed to.

In Collins' arrangements the stories serve as more or less desperate claims for attention, and help that would appear to come with it. Their aim is redemption, the delivery of which is twofold. Part of it can be performed in the very act of telling, which allows for all sorts of corrections and straightened perspectives.

The other part needs to be delivered by others, who are challenged to respond, in hope that the stories will incite them into action. But the funny thing about redemptive gestures is how they tend to produce excessive effects without ever really providing the desired relief.

Rainer Werner Fassbinder's 1975 film *Mutter Küsters' Fahrt zum Himmel* (Mother Kusters' Trip to Heaven) articulates the logic of such processes, intimately linking heightened visibility and diminishing impact that the public appeal brings. The central character is the wife of a factory worker who, in an outburst of rage apparently prompted by news of mass redundancies, kills his manager and then himself. In a mixture of melodrama and Brechtian epic theatre, the film portrays the ways in which she and her late husband become the objects of press sensationalism and all kinds of redemptive claims. While the tabloids portray her late husband as a crazed monster on a killing spree, the wife at first suffers and then tries to utilize to her own advantage the attention that the case is generating. In order to clear her husband's name, she opens up to a reporter from the local magazine who seems to be sympathetic to her story, only to publish an even more sensationalist article. As her family desert her, she joins the Communist party, who reframe her husband's death as a misguided form of direct action against capitalist exploitation, and use her as a mere pawn in a populist game for votes at the time of the general elections. When she finally gets involved with a group of disenfranchised anarchists and takes direct action to the editorial offices of the magazine, Fassbinder proposes two different endings. In the German version, Mother Küsters is shot by the police as she leaves the building with the hostages that her commando group have kidnapped, and has her photograph taken by the attending press, with her fame-hungry starlet daughter kneeling beside her. In the American ending, she hooks up with the widowed night guard who locks the magazine offices after her failed sit-in.

Redemptive gestures, it seems, create spirals with two distinct but related dynamics: one out of control leading from accident to misunderstanding, and one downwards into ever more deeply entrenched impasses. In both Fassbinder and Collins, this is almost amusing. Collins' portraits of instant TV celebrity are touching and hilarious in equal measure, and the same is true of Fassbinder's wretched characters and the way they oscillate between agitprop and tragedy. Redemption in all this remains, at best, an engine, a motivation for involvement, a trigger for action and thus, inevitably, for all kinds of disasters. Redemption is never produced as an outcome. Despite the good intentions declared over and over, no good comes out of the supposed attempts to support Mother Küsters' story – neither from the journalists' 'help' nor from her family's; neither from the champagne communists nor from the self-declared radicals. All of them redirect her case and ultimately disregard her. Whilst redemption slips further and

further away, her need for visibility, for direct utterance, for being seen and being heard, exponentially increases. At the end, in both versions of the film, the husband has long since slipped away. In the German version even Mother Küsters herself has fallen out of the frame and is present only through the on-screen titles that read like stage directions. In the American version she happily replaces her husband by getting off with the security guard protecting the same offices from which he was misportrayed so relentlessly. The former ending comes closest to a Brechtian mode of address, whilst the latter is played out as a tribute to the petit-bourgeois idea of salvation.[2] Yet in both scenarios, the original causes, her husband's death and homicide, have been erased and no longer play a part in the unfolding of events. Reduced to a rhetorical alibi, they have been superseded and effectively obliterated by her attempts to reclaim them.

Misappropriation plays out on another level too. Fassbinder's film itself is a remake of sorts, relocating *Mutter Krausens Fahrt ins Glück* (Mother Krause's Journey to Happiness), Phil Jutzi's iconic silent movie about working class struggle in 1929 Weimar, to the key capitalist hub of post-war West Germany that was Frankfurt in 1975. Significantly, Fassbinder replaces the working-class hardness with an overall exploitative scenario of mediation, once again carried out on the back of the working-class subjects but with the very notion of the working class imploding into a rhetorical trope for salon communists. This shift brings with it a series of half-accepted defeats and a fundamental acknowledgement that an overall social perspective is lost to, and in, representation.

Collins' inversions and borrowings are equally ambivalent, consciously and strategically so. Consciously because Collins knows the media well enough to understand that they have long since constituted a realm fairly immune to critical intervention (its economies of visibility and attention are paradigmatic in that sense, and have been for a long time); and strategically too because his is not a body of work about 'liberation'. At no point is Collins trying to set up an outside position from which to evade mediatic representation. On the contrary, he is deeply invested in the kind of spaces these spectacles set up, and thoroughly curious about how they become inhabited. Instead of replicating somewhat obvious critique of media realities and the overarching relevance they have to contemporary life, Collins tentatively zooms in on the minutiae of exchanges in a dedicated examination of what is being projected, and how. This is the realm in which the self is always invented, as well as projected, and the oscillation between one and the other creates a melodramatic appeal in Collins' confessional testimonies. That all of this material is made up in one way or another is not an endpoint or an insight, but a given in which Collins grounds his work. Only from this vantage point can he look at the differences that articulate themselves in relation to and within the imposed frame, rather than existing outside of it. […]

Collins' set-ups are excessive in terms of what they produce, but they also know themselves to be largely impotent as far as salvation is concerned. Still they are important as gestures that indicate impossibilities. The question, then, is what one can do with them, how can they be useful in bringing up new questions about the relationship between life and staged performance, cultural production and the culture industries, entertainment and the media. There are several traditions through which to think this. One is what we might call the tradition of Enlightenment in which art serves as a highlighting device that enables a radically critical investigation of cultural formations. (This is Theodor W. Adorno, Alexander Kluge, or even Jean-Luc Godard). Here, formal, semantic and rhetorical inconsistencies are played out as a challenge to the orthodoxy of hegemonic cultural forms in an attempt to invent a way out of the imposed homogenizing domination. Another way is Pop which engages fascinations and identifications in postmodern forms of mimicry and desire. (Think of Andy Warhol, or more recent artists like Alex Bag). A third way is melodrama which generates excessive affects from within a given template, and does so mainly through an over-explicit *mise en scène*. Collins draws on all three traditions, and elements of each are discernible in most of his works.

What is particularly interesting in the melodramatic tradition, though, is how it enacts the relationship between life and its staging, and a significant part of Collins' practice refers back to this third lineage. The uncertain quivers, falling halfway between desire and estrangement, intimacy and distanciation, are deeply involved in modes of artificiality which need to be understood, *in extremis*, as the opposite of expression, with its supposedly immediate relationship between form and content. In this sense, melodrama is machinic. Never based on the truth-content but instead relying on its own productivity, melodrama insists on the way in which its disparate components collude to create an affect. [...]

A fascination with melodrama is always focused on the lure of non-distance and the efficiency of identificatory patterns. Melodrama is not premised on resolution, *dénouement* or catastrophe (classical drama sets these out much more neatly), but engages through the tremor of an indirect involvement and an affection originating in a generalized artifice. Collins' *the return of the real* produces its own version of such an estranged sublime by presenting an instant affect, as well as the operations of estrangement through which this affect can be traced back. In Collins' ambiguous arrangements, the post-documentary *obsessional* always features both as a set of impositions *and* a series of options to be played with still. And perhaps Collins' main investment is in the involvement as such, as a shared condition and a refusal to be solicited.

1 Saul Anton, 'A thousand words: Kutlug Ataman talks about 1+1 = 1', *Artforum* (February 2003) 116–17.

2 Rather than issuing a cynical commentary on the retreat into the realm of petit-bourgeois privacy, this ending produces an awkward tribute to the Mother's own milieu. Its melancholy is equivalent to that of Giulietta Massina's infamous smile as Cabiria, the unrepentant hooker down on her luck, resurfacing from near-death into the street party crowd in the final sequence of Federico Fellini's *Le Notti di Cabiria* (Nights of Cabiria, 1957).

Edgar Schmitz, extract from 'Which Way to Heaven?', in *Phil Collins: The Return of the Real/Gerçegin Geri Dönüsü*, ed. Sinisa Mitrovic and Leire Vergana (Bilbao: Sala Rekalde, 2007) 71–8.

Lisa Lee
Make Life Beautiful! The Diabolic in the Work of Isa Genzken//2007

A total absence of illusion about the age and at the same time an unlimited commitment to it – that is its hallmark.
– Walter Benjamin, 'Experience and Poverty' (1933)

Subtle grey gradations – dove, ash, lead, silver, pewter – tinged with brown or blue, marked by wooden moulds, speckled and streaked with uneven sediment, pockmarked with air pockets: Isa Genzken's concrete sculptures of 1986–90 exploit the irregularities of the material, further exacerbating its grittiness with raw edges and uneven horizontal breaks. Titles like *Zimmer, Saal, Halle, Kirche, Hochhaus, Korridor, Welle* and *Bühne* demonstrate that Genzken's reference points are clearly architectural, though the roughly model-scaled works seldom mimic the morphology of specific architectural typologies. With the exception of a few early examples, the rectilinear structures in Genzken's works are never sealed or solid but instead roofless walls that delineate space. Breaks in the outer walls reveal dark corridors and niches partially lit by slanting rays that snag on concrete ridges. The pieces are lifted on their bases to eye level, and the viewer's wandering gaze navigates those corridors and occasionally encounters corners that cannot be turned. The pleasures of parallax are economically produced, as a walk around the sculpture opens up new lines of sight previously unmappable.

 Much like the different pourings of cement that make up the structures, or like their compositional compounds, layers of often conflicting references settle and aggregate in these concrete sculptures. The hulking masses conjure derelict

and dimly lit housing projects and bombed-out buildings. (Genzken does not shy from explicit content or associative properties.[1] She one-ups her Minimalist forebears, whose polished metal cubes and tiles look designed and hermetically sealed compared to her construction-site frankness.) Simultaneously, the concrete works rise like pseudo-romantic ruins, gaping structures that speak eloquently of a grandeur that has succumbed to the ravages of nature and time. For Robert Morris, the ruin straddled the sculptural and the architectural, a condition of liminality that aptly describes Genzken's works, the scale of which belies their palpable presence. 'But whether the gigantic voids of the Baths of Caracalla or the tight chambers and varying levels of Mesa Verde', Morris writes, 'such places occupy a zone that is neither strictly a collection of objects nor an architectural space.'[2] Genzken's concrete works exert a spatial power akin to architecture rather than to scaled models (as such, they maintain sculptural intimacy, upheld, so to speak, by her attention to their attenuated steel pedestals, which raise the sculptures to eye level. Additional conflicting meanings inhere in the sculptures' material. Sigfried Giedion's nearly alchemical view of concrete's possibilities speaks to its original promise:

> From slender iron rods, cement, sand and gravel, from an 'aggregate body', vast building complexes can suddenly crystallize into a single stone monolith that like no previously known natural material is able to resist fire and a maximum load. This is accomplished because the laboratory intelligently exploits the properties of these almost worthless materials and through their combination increases their separate capacities many times over.[3]

But even as concrete evokes early and mid-twentieth-century utopian aspirations for air- and light-filled spaces, and even as Le Corbusier's Unité d'Habitation in Marseille compellingly reimagined flexible mass housing in undisguised concrete, we have now come to know it better for its degraded manifestation in post-war low-income housing the world over. The more immediate referent in post-war Germany would be the ubiquitous prefabricated concrete slab structures built beginning in the 1960s throughout the German Democratic Republic. Once embodiments of socialist ideals of progressive housing, the large developments of GDR prefab apartments, nicknamed *die Platte* [the slab], were notorious after the fall of the Berlin Wall for their lack of infrastructure.[4] So if Genzken's sculptures cite concrete's utopian promise, their bulky masses aspiring to lightness on thin legs, they simultaneously bring home its failure to make good on that promise. Yet far from any simple melancholic reflection of failure, Genzken's project keeps the original optimism intact and in play. Utopianism in her work cannot be pried apart from its perversion. This is clear in the importance

to Genzken of Joseph Beuys, for whom an expanded notion of sculpture as social activism was bound up with a hyper-investment of his self with shamanistic power. The steel bases of Genzken's concrete sculptures pay homage to Beuys' vitrines, even as her choice of concrete stoically refuses any of the properties suggestive of transformation and energy transfer that Beuys favoured (fat, felt and beeswax).

Benjamin Buchloh writes that Genzken's sculptural work in concrete 'insists conspicuously and consistently on addressing the collective conditions of existing in architecture'.[5] She shows these collective conditions to be deeply conflicted. In Genzken's works the same stony face of concrete reads as Kantian sublimity, Brutalist *Je-m'en-foutisme*, Corbusian harmony and airiness, GDR drab, and Giedionesque technological optimism. The suggestive power of Genzken's sculptural practice is precisely a richness of reference irreducible to a single position. Furthermore, hers is an exploration of those positions and possibilities active in the present – as legacies to be reckoned with, tested against one another, deployed or transformed. More specifically, in the case of the concrete series and the *New Buildings for Berlin*, the present to be explored would be Germany's in the decades leading up to and after reunification.

Like the GDR *Platte*, the Berlin Wall – first a literal barrier and then a differently insurmountable 'wall in the mind' post-1989 – can be seen as an unavoidable point of reference for Genzken's concrete works, executed between 1986 and 1990. The works are by no means tediously editorial or merely topical, however, but complicated by myriad references and positions and by their sculptural integrity. In their fissured and ruined states, Genzken's sculptures suggest a rupture of circumscribed space and a breakdown of inside and outside, interior and exterior. The emptiness emphatically articulated by the structures and their brutal and unyielding permanence nevertheless speaks poignantly about 'existing in architecture', as Buchloh put it, and specifically that formidable piece of architecture that was the Berlin Wall.

Rapidly removed, auctioned, or chipped into memento-ready chunks, little was left of the wall by 1991. In its absence a large swath of no-man's-land cut through the centre of the city from the Brandenburg Gate to Potsdamer Platz, Leipziger Platz, and beyond.[6] But the voids, about which Andreas Huyssen has eloquently written, were destined to be patched in a rushed and uncoordinated manner, with corporate entities and private developers vying for spots in the new *Weltstadt*. Potsdamer Platz, a primary node of activity until it was devastated in World War II, was transformed from a thriving centre to a barren periphery by the erection of the Berlin Wall. The fall of the wall prompted frantic efforts to reinstate Potsdamer Platz as the symbolic centre of Berlin. Even in the months before the fall of the wall, the city government of Berlin negotiated the sale of 15

acres of Potsdamer Platz to Daimler-Benz at a fraction of their market value. The controversial sale was finalized in 1990 and site work began in 1992 in accordance with Renzo Piano's prizewinning scheme. Only around 1995 were structures seen above ground.[7] The Daimler-Benz building was finished in 1998 and the Sony headquarters in 2000, with still other buildings in progress over the next few years. Friedrichstadt Passagen, Checkpoint Charlie and Alexanderplatz were also being re-envisioned as commercial and corporate centres in these years. With considerable leeway in regard to design and materials, the first of these, Friedrichstadt Passagen, was built according to the envelope dictated by *Berlinische Architektur*, a policy of conservative and illusory historicism upheld by the Senate Building Director, Hans Stimmann. Francesca Rogier summarizes the policy thus:

> *Berlinische Architektur*, an allusion to classical convention, is a homogenization of Prussian tradition blended with the severe architecture of the Third Reich ... *Berlinische Architektur* is, in practice, a rudimentary formula of closed, squat volumes with cornice lines at 22 metres and roofs no higher than 30 metres; sober punched-window facades, restrained ornament if any, and preferably drab materials such as stucco or stone.[8]

Alexanderplatz, with little surviving 'historic fabric', was exempted from these regulations. (Its more recent history as the rebuilt centre of East Berlin was all too readily dismissed.) Against the bitter protest of community groups, big-business representatives dominating the Alexanderplatz jury rallied behind Hans Kollhoff and Helga Timmerman's winning scheme, which proposed the construction of 13 high-rises and garnered the nickname 'Little Manhattan'.[9]

Critics have described the post-wall refashioning of Berlin's image, with faux-historicism on the one hand and cookie-cutter globalism on the other, as a making of a theme park, media city and *Schaustelle* [site of viewing and spectacle]; as a sign of willed ignorance of Germany's Weimar-era legacy of advanced architecture by figures like Ludwig Mies van der Rohe, Walter Gropius and Bruno Taut; as a troubled reckoning with the Nazi past; and as a stale debate between *Berlinische Architektur* and *Kritische Rekonstruktion* – stale because both positions ultimately reduce to a fictionalized notion of a European city of uniform building structures.[10] It is against this backdrop of architecture as image and of reconstruction as theatre that we must see Genzken's series *New Buildings for Berlin*, begun in 2001 and continued in 2002 and 2004. Rectangular strips of jewel-toned, clear and textured glass, 80 cm high, lean one against another like Richard Serra prop pieces made into luminous (if precarious) skyscrapers, or like streamlined descendents of Vladimir Tatlin's *Monument to the Third International* (1919). But are these Serras made luminous or simply Serra 'lite'? After all, Serra's

meticulous architectonics of gravity and weight hold hefty slabs and plates in perfect suspension – and we feel this tension. Genzken's *New Buildings*, on the other hand, are held together with sticky tape and silicon. (She asks us to move, in other words, from heavy industry's mills to the organized rows of Home Depot – or of Bauhaus, by which I mean Germany's version of DIY heaven.) Genzken pays homage even as she travesties Serra's work, taking to task the hypermasculine tendencies and blue-collar pretensions of some of the rhetoric surrounding it. This element of travesty is characteristic of many of Genzken's works: Tatlin's *Corner Reliefs* made flaccid, jangling mobiles of mangled cake pans, rakes and other household wares, for instance. Or Genzken's *Social Façades* of 2002, compositions on panel of mirror foil in saturated colours and disco-ready finishes, which suggest gleeful perversions and amped-up iterations of abstraction's opticality. Gridded foil taunts the stoic modernist grid; the purported non-referentiality of geometric abstraction gives way to glittering façades; and sublime uplift is trumped by the specular ecstasy of the dance hall and club culture. Consider also Genzken's public sculpture for Leipzig, *Rose* – an eight-metre-tall stainless-steel, aluminium and lacquer rose, which could be read as a kitschy, banal and ludicrous literalization of Beuysian utopianism à la *Rose for Direct Democracy*, in which a fresh bloom in a graduated cylinder enlivened each of the one hundred days of Documenta 5 in 1972. Beuys writes, 'Bud and bloom are in fact green leaves transformed. So in relation to the leaves and the stem the bloom is a revolution, although it grows through organic transformation and evolution'.[11] The revolution is arrested in Genzken's *Rose*, a steely column memorializing the loss of transformative potential, a public punch line to Beuys' outsized romanticism. With sculptural intelligence and keen wit, Genzken balances her objects on the line between homage and travesty – a line she shows to be remarkably fine.

In the 2006 Phaidon monograph on Genzken, the artist included Charles Baudelaire's prose poem 'The Bad Glazier', from his collection *Petits poèmes en prose*, alongside reproductions of 2004 versions of *New Buildings for Berlin*. The poem begins: 'There exist characters, purely contemplative and completely unsuited for action, who, however, influenced by a mysterious and unknown impulse, sometimes act with a speed of which they would not have believed themselves capable'.[12] The narrator proceeds to relate instances of 'harmless dreamers' 'abruptly hurled into action by an irresistible force', finding an 'excess of courage for executing the most absurd and often even the most dangerous acts'. He ends by retelling his own brush with demonic inspiration. Flinging open his window to the grimy Parisian air, he hears the discordant cry of a glazier hawking his wares. 'Seized by a hatred for this pitiful man as sudden as it was despotic', the narrator calls the glazier up to his room, up seven flights of narrow

stairs. Examining the fragile wares, the narrator cries in disbelief, 'What? You have no coloured panes?' No pink panes, no red no blue, no magic panes, no panes of paradise? You are shameless! You dare walk though poor neighbourhoods, and you don't even have panes which make life beautiful!' Having wrestled his wares back onto the street, the disgruntled glazier is knocked on his back by a falling flowerpot, his precious cargo crushed. The narrator, perpetrator of senseless violence, recalls, 'drunk with my madness, I shouted at him furiously, 'Make life beautiful! Make life beautiful!' Whether or not Baudelaire's poem directly proposed the terms for *New Buildings for Berlin*, it describes an aesthetic attitude critical for understanding Genzken's work, and particularly its development into the twenty-first century. Baudelaire deftly illustrates that the call for beauty and for life's betterment is implicated in violence, irrationality and intoxication [*ivresse*]; that the dystopian inheres in its more idealistic opposite; and that advocacy may erupt in antagonism. [...]

1 See 'Diedrich Diederichsen in conversation with Isa Genzken', in Alex Farquharson et al., *Isa Genzken* (London and New York: Phaidon Press, 2006) 15.

2 Robert Morris, 'The Present Tense of Space', in *Continuous Project Altered Daily* (Cambridge, Massachussets: The MIT Press, 1993) 193.

3 Sigfried Giedion, *Building in France, Building in Iron, Building in Ferro-Concrete* (1928; Santa Monica, California: Getty Research Institute, 1995) 150.

4 Paul Sigel, 'The Future of the Slab', Goethe Institut USA, July 2003, http://www.goethe.de/ins/us/lp/kue/arc/en51834.htm.

5 Benjamin H.D. Buchloh, 'Isa Genzken: The Fragment as Model', in *Isa Genzken: Jeder braucht mindestens ein Fenster* (Cologne: Walther König, 1992) 141.

6 Andreas Huyssen, 'The Voids of Berlin', *Critical Inquiry*, vol. 24, no. 1 (Autumn 1997) 65.

7 Francesca Rogier, 'Growing Pains: From the Opening of the Wall to the Wrapping of the Reichstag', *Assemblage*, no. 29 (April 1996) 49

8 Ibid., 48.

9 Ibid., 55-57.

10 Ibid., 48.

11 Quoted in Caroline Tisdall, *Joseph Beuys* (New York: Solomon R. Guggenheim Museum, 1979) 273.

12 All excerpts taken from Charles Baudelaire, 'The Bad Glazier', in *The Parisian Prowler: Le Spleen de Paris, Petits Poèmes en prose*, trans. Edward K. Kaplan (Athens: University of Georgia Press, 1989) 13–15 (a different translation from the one published in the Phaidon monograph).

Lisa Lee, extract from 'Make Life Beautiful! The Diabolic in the Work of Isa Genzken (A Tour through Berlin, Paris and New York)', *October*, no. 122 (Fall 2007) 53–9.

Eduardo Abaroa, Sam Durant, Gabriela Jauregui, Yoshua Okon, William Pope L.
Thoughts on Failure, Idealism and Art//2008

Gabriela Jauregui [...] So what about failure? What is the relationship between failure and progress? Could we say that the birth of modernism and that the idea of progress (and positivism and humanism, and so on) go hand-in-hand? If so, what are we to do today? After the collapse of the Berlin Wall, Stalin's dystopia and Henry Kissinger's crimes against humanity, could we say that we've survived an era of failure? Is the twentieth century a century of failure?

Unlike the idea of progress, which can be measured abstractly in numbers and curves rising to the heavens in a series of ever-enlightening lines to salvation, failure brings with it one certainty after all: that of failure itself, that of the very measureable sense of having failed and that of imminent failure as well. Perhaps (the oft-maligned) Gertrude Stein was right when she wrote that 'a real failure does not need an excuse. It is an end in itself.' The end of all ends Could we then say that perhaps artists – not as the opposite of scientists but rather as the inheritors of a different type of discourse and preoccupations – are more adept – like Stein, like Cyrano de Bergerac who failed in everything, even in death – to speak of failure?

In an era obsessed with individual Genius, with its ensuing tragic success stories of artists like Basquiat, what kind of relationships do artists have vis-à-vis failure and progress? In fact, how do artists deal with so-called progress (whose progress and at what cost?) or lack thereof, not only philosophically and in the world that surrounds them, but also in their own work? As the title of artist Francis Alÿs' piece reveals: *Sometimes Doing Something Leads to Nothing.* So, how is progress and a so-called progressive stance reflected in artists' work? Is there such a thing as progressive art? Or should we instead think of artists today, in a market-driven planet, as failure-artists? What about art made collectively (again opposing the notion of the unique genius and of *the* success story...)? If a company measures success in terms of capital, how can artists think of personal success: Does an artist achieve success – and therefore perhaps eventual progress – when s/he reaches though to a spectator? Or is artistic success measured in terms of marketability or amount of money earned per year based on sales? Perhaps artistic success (and failure) is a much more insubstantial, esoteric and flimsy thing that cannot be measured or quantified or which cannot even be related to progress ... Is failure the artist's success? Can artists fail successfully?

Based on these mental wanderings we've come up with certain questions that we hope address these matters and we've asked them to a group of artists

whose works we believe deal in different ways with issues of individualism, power and success; progress, humanism and utopia; and whose oeuvre as a whole can be read as response to whether failure can be the spectre that haunts us all in the twenty-first century, whether failure can be the antidote to certain kinds of humanism and utopia, whether failure is something for those who are interested in process rather than progress, whether failure is something for those who have a haunted way of looking at the world …

Audience question There has always been an element of 'progress' to modernism (and modernity in general), whereby we 'learn' from failures, grow and move on. Is it possible to let go of this idea of progress without also losing this relationship to failure? How do you have a relationship to history that isn't about progress?

Sam Durant I agree in general with your idea of modernism as progress, I think it is central to the Euro-American definition. However, I also think modernity can be something different outside the 'West', in the Second and Third Worlds. But to answer your question of how one moves out of a relationship to history as progress (or as Benjamin says an endless progression of catastrophe and death): I'm particularly influenced by the Fourth World, or, rather, *Indigenism*, as Ward Churchill defines it. Looking to Indigenous people for a new way (for us) to live in harmony with the earth and with each other (and by extension 'History'). Churchill among others (the Zapatistas!) have been laying out arguments for practices that have been for the most part almost completely destroyed by the 'West' in the very name of modernity. Churchill's essay 'False Promises: An Indigenist Examination of Marxist Theory and Practice' is an argument against western modernity where he contends that capitalism and Marxism are two sides of the same coin. They both view the earth as a supplier of resources to be exploited by people (usually in the name of progress) – the only difference is in how best to exploit those resources. I think we in the First World will either learn from Indigenous people or we will perish.

Yoshua Okòn The absurd idea that we can master our destiny (and environment) and will eventually go beyond the limits that frame the lives of other animals, is precisely what has inhibited us from embracing failure in a creative way.

I think that we can let go of the modern myth of progress – the grandiose meta-narrative of humanity gradually marching towards a better world; 'the progress of mankind' – and maintain a relationship to failure, just as long as we don't understand failure in the same absolute terms. In other words, we can maintain a relationship to failure just as long as 'failure' loses its negative connotations and is viewed as an integral (and inevitable) part of the process of

being alive. So, in a way, I think that not only can we relate to failure by eliminating the myth of progress but I would argue that abandoning the idea to the progress of humankind is a prerequisite to establishing a more creative and organic relationship to failure (and history in general).

William Pope L. It is difficult today to separate the notion of progress from notions of advancement or imagining a future. We, earth-folk, have this tribal belief, not based on logic (at least not deductive logic) that if we succeed at something on Tuesday, this success has something to do with possible outcomes for Wednesday. Science is even more dependent on progress-beliefs than the Arts. I can imagine an art based on failure; however, it is very difficult, if not impossible, to imagine contemporary science practice without some sense of progress or, even in the most limited case, failure as a building block for non-failure. The progress-fable that science tells is very compelling because the magic it speaks is made concrete in quantitative, practical terms. Qualitative terms is another matter. For example, will gene-editing better my relationships with people or will it only help me to avoid sickness and prolong my life? What if I live longer and, perhaps because I live longer, my relationships sicken and die? In this case, has science bettered my life? Perhaps I am confusing my terms here? Can we imagine a progress that is not marked by psychology, history or sociology? Can we imagine a progress that is defined only by the next forward step (like a series of prime numbers) and not the next choice? In the series 1, 3, 5, 7 – there is only one possibility for 'next choice'. If progress operated like the series of prime numbers, would we call it progress any longer? Perhaps progress is not about advancement … Or perhaps the notion of advancement must be rethought …

Audience question Do you relate to utopianism in your art (e.g. the modernist city, the social state, the avant-garde, collectives and/or communes, techno-cultural utopianism, 'counterculture', socialism, ideologically driven revolution and social change)? If so, how?

Eduardo Abaroa Utopianism includes a very specific sense of human life, one that implies a negation of some of its characteristics, including pain, suffering, chaos, strife, domination, submission, etc. I think that from the perspective of the Third World, the USA and Europe are very close to being utopias (that is why so many people try to move there.) Utopianism is a European trait and a cultural tradition. It is not at all positive. It has been a colonial and destructive force in many cases, including the destruction of the pre-Hispanic civilizations in America. The main impulse behind contemporary societies of control is utopian. The utopian writer is usually a miniature paranoid king.

Counter-culture is a more recent term. It is better than 'utopian', even if it only means a recycling of the different cultural practices with each generation. I think it is important because it usually attacks the inertia of economic systems and social strata.

Socialism (and Capitalism) have been the core of many failed programmes of progress in Latin America and other countries. In the Third World (a term I do like) one has to approach any ideological position with greater caution and one issue at a time. There is much more at stake than choosing one or the other and fight in that direction.

In my work I try to deal with these issues in a peripheral way, sometimes not even noticeable at first sight. It is not yelled at the viewer, she or he has to figure it out. Usually I point at a certain conflict that remains unsolved. Few people read it.

If anything, my work is dystopian. One has to fight against boredom, injustice, stupidity and death every day, and I would hate a utopia which finally eliminated such battles. Such a promise is a cancer of the world. One has to love the world with the suffering included, that's the tricky part.

William Pope L. I don't know nothing 'bout no utopia. I believe in bumbling ... bumbling collective human action. This belief is leavened by the vicissitudes of collaboration, which is a process, not clean and well defined.

So what is the goal of collective human action? The welfare of the collective. How is the welfare of the collective decided and who decides? Hmmm.

Again: What is the goat of collective human action? Disarray. How is this decided? Everything at once. Who decides? Everyone at once. A sense of this is true – but the preceding also suggests that all people are social and economic equals and have equal access to power. Even disarray is not evenly distributed. True, there is a natural impulse for people to collectivize. To collectivize is to create a structure, a pattern. This impulse implies a struggle and conflict. Humans are natural pattern-makers. Our minds constantly design and re-design possibility. Indeed there are an infinite number of patterns in the universe but we return to the same basic pattern-themes over and over again.

Collective human action and individual social relationships seem hard-wired into a basic menu. Within this limited menu is a profusion of interactions and scenarios. But again within a certain 'way-things-are'. And how *are* things? Well, how have they been? For example. Are you us or them? Is it yours or mine? Are you with me or against me? If yours is mine and mine is yours then who am I? If I am you and you are me and we are all together then who is she?

The most progressive movements to which I have related were the Black Civil Rights movement of the 1950s and 1960s, and the Black Power and Anti-War movements of the 1960s and 1970s. I was very young. During my

last year of high school, Nixon officially 'ended' American involvement in the Vietnam War.

So many events of significance seemed to have occurred during my childhood that I mistook that period for an anomaly. I did not realize that the notion of what is a significant event is a complex ever-changing notion.

Even so, in my naïvety I figured that after the war was over the historical nightmare was over. Great! Now I don't have to worry anymore. Now I can focus on staying in art school and getting a job doing commercial art or something ...

It was much more difficult to stay in art school than I had thought and I never went into commercial art. Progressive politics was a part of my growing up but it had occurred as if in a dream in someone else's head. That period was a very disturbing and romantic time. I had yet to begin making my own dreams and I was already overwhelmed by the possibilities ...

Since that time I have by turns been sympathetic to and taken limited part in pro-choice rallies and anti-war demonstrations. For the last six years I've been working on a project called 'The Black Factory' (BF). The function of the work is to tour the US (and at one time I was hoping to include Canada ...) in order to stir up more than conversation concerning community, race and difference using a platform, a jumping off point that begins with blackness. The problem with this work is at least twofold: I have been either too specific or not specific enough concerning the goal of the BF. My vacillation is 'a kind' of cheating. What I mean is: I do not waver intentionally. In fact, whenever I waver I believe I am struggling in earnest, following my natural process. As I write this, I feel a tiny bit exposed. This text will be printed for public consumption and perhaps, for some, undermine their belief in me as a political artist, but it is important to examine what is in the dungeon. Face it. Communicate it. Anyhow, perhaps it is more important to be human than a political artist ...

I have always harboured doubts about collective action, while revelling in it. My doubt comes out of a fear and ignorance, and a disappointment. I fear ultimately that counter-culture will succeed, and then what will we do? This is a lack of confidence and it needs a reality check. Ambivalence can be a cop out. All political or social interventions begin with a set of ideals. In the muck of battle, these ideals are bound to be tested, stomped on and muddied. And with the water, the earth and the entrails comes the sobering realization that ideals are fine but it is struggle that gets you through the darkness that is in the daylight. [...]

The Black Factory (handwritten margin note)

Gabriela Jauregui, extract from Introduction, and Eduardo Abaroa, Sam Durant, Gabriela Jauregui, Yoshua Okon, William Pope L., extracts from dialogue in *Failure: Experiments in Aesthetic and Social Practices*, ed. Nicole Antebi, Colin Dickey, Robby Herbst (Los Angeles: Journal of Aesthetic Protest Press, 2008) 57–65.

Liam Gillick
Transcript from *Three Perspectives and a Short Scenario*//2008

AS THE SNOW STARTED TO FALL. THREE PEOPLE WERE SEEN. THEY WALKED ONE BEHIND THE OTHER. IT HAS BEEN COLDER. TODAY THERE WAS THE SENSE THAT A THAW WAS COMING, IN THE DISTANCE WAS A LARGE BUILDING. LIGHT COULD BE SEEN FROM GAPS IN THE STRUCTURE. YOU COULDN'T DESCRIBE THE GAPS AS WINDOWS. THE PRIOR CLARITY OF THE STRUCTURE HAD BEEN DISTURBED, BY NEW OPENINGS CUT AT IRREGULAR INTERVALS ACROSS EACH FACE OF THE BUILDING. THE TRUE SCALE OF THE STRUCTURE WAS HARD TO READ. UNTIL YOU CAME CLOSE THE BUILDING WAS HARD TO DEFINE. THE SURROUNDING LANDSCAPE HELD NO MARKERS. NOTHING EXISTED IN ORDER TO JUDGE SCALE OR SIZE. THE THREE PEOPLE KEPT WALKING. THERE WAS NOTHING TO TALK ABOUT DURING THIS LONG TREK. WE FOLLOW THEM AS THEY WALK. AND OVER TIME THEY PROVIDE A SENSE OF SCALE. THE TRUE MASS OF THE BUILDING SOON REVEALED ITSELF. THE SIZE OF THE CUTS IN ITS FACADE NOW TROUBLING AND EXCESSIVE. GREAT TEARS AND RAW HOLES BREAKING THROUGH. YET THE STRUCTURE REMAINED. PERFORATED IN HASTE. REVEALING NOW PEOPLE MOVING SLOWLY INSIDE. NO-ONE REACTING TO THE APPROACH OF THE THREE. EVERYONE USED TO THE IDEA OF SOME NEW ARRIVALS. WALKING SLOWLY THROUGH THE SNOW. NOW INSIDE THE BUILDING. THERE ARE TRACES OF A PRODUCTION LINE. THE PEOPLE MOVING AROUND THE SPACE ARE HARD AT WORK. YET RATHER THAN USING THE PLACE AS A SITE OF PRODUCTION, THEY ARE METHODICALLY DISMANTLING EVERYTHING. NEAT PILES OF MACHINE PARTS. STACKS OF PIPING AND CONDUIT. BARRELS OF COOLANT, LUBRICANT AND MACHINE OIL. IN THE CENTRE NOW THERE WAS A CLEAR SPACE. SEATING HAD BEEN IMPROVISED. ALONG WITH LARGE TABLES. AND LOW SLUNG LIGHTING. SURROUNDING THIS AREA, LARGE SCREENS HAD BEEN ERECTED. ON THESE SCREENS, A MASS OF TEXT AND NOTATION AND PLANS. A COMPLETE EXPLANATION OF WHAT MIGHT BE DONE. AN IMPROVISED ANALYSIS OF THE POTENTIAL OF FUTURE PRODUCTION. ATTEMPTS TO RESOLVE ALL MATERIAL RELATIONSHIPS. SUCH AN EFFORT. SUCH PRECISE CALCULATION. AN INVENTORY OF PREVIOUS PRODUCTION. MANY HOURS HAD BEEN SPENT REGRETTING THE EARLY BONFIRE, THAT HAD BEEN FUELLED BY NOTES AND COMMENTS FROM EARLIER TIMES. THEY USED TO WORK IN TEAMS. NOW THEY WORK IN A LARGE GROUP. AT TIMES THEY WORK ALONE. TRYING TO CREATE AN ARCHIVE OF ALL PREVIOUS WORKING METHODS. AT TIMES THIS WORK IS PUNCTUATED BY THE SOUNDS OF IMPROVISED TOOLS TEARING AT THE WALL. EVERYONE STOPS

WHAT THEY ARE DOING. ASSUMING THAT THEY WERE DOING SOMETHING IN THE FIRST PLACE. AND MANY ARE LYING ON THE GROUND. FOR AT ANY GIVEN MOMENT, MANY APPEAR TO BE RESTING IN THE SHADOWS. THOSE THAT WERE RESTING NOW SPRING INTO ACTION. GRABBING STICKS AND RODS AND PIECES OF OLD MACHINERY. EVERYONE GOES TO THE ALREADY PUNCTURED WALLS. AND BEGIN TO HACK NEW GAPS INTO THE EXTERIOR OF THE FORMER FACTORY. SOME ARE BETTER THAN OTHERS. SO SOME PEOPLE HELP BY BENDING AND FOLDING THE TORN ALUMINIUM IN AN ATTEMPT TO PULL IT FREE. THE FACTORY CLOSED A LONG TIME AGO. OR MAYBE IT WAS A COUPLE OF MONTHS AGO. THERE WERE NO AIMS AT THE OUTSET. MERELY A DESIRE TO RETURN AND REOCCUPY. AS WE KNOW EVERYONE HAD BEEN WELL LOOKED AFTER. BUT THE POTENTIAL OF THE SPACE REMAINED APPEALING. IN ORDER TO PREVENT IT FROM BEING REUSED, PEOPLE HAD BEGUN TO USE THE PLACE AGAIN. AT FIRST MERELY HANGING AROUND AND TALKING ABOUT HOW THINGS HAD GONE WRONG. AFTER A WHILE THEY STARTED TO DRAW OUT NEW OPENINGS ON THE WALLS. THE DISMANTLING OF THE MACHINERY ONLY CAME LATER ONCE PEOPLE HAD STOPPED GOING HOME. AT NIGHT ANYONE PASSING BY WOULD HEAR PEOPLE WORKING LATE INTO THE NIGHT. WHILE THEY BELIEVED THAT THINGS WERE BEING MADE, THIS WAS CLEARLY NOT THE CASE. MERELY THE SOUND OF ACTION. OFTEN, EARLY IN THE MORNING, THE PLACE WOULD BE QUIET. YET PEOPLE RARELY LEFT THESE DAYS. FOOD WAS BEING PRODUCED IN SMALL GARDENS. WATER COULD BE SOURCED FROM A PUMP. A GREAT DEAL OF TIME AND CARE WAS PUT INTO THE GARDENS. BUT THE PRIMARY EFFORT WENT INTO CALCULATION. EVERY AVAILABLE SURFACE HAD BEEN MARKED. EVERY TABLE COVERED IN DIAGRAMS. THERE WERE LISTS OF MATERIALS. AND LISTS OF PROCESSES. THERE WERE SHIPPING ROUTES. AND ESTIMATES OF PRODUCTION TIMES. AS THE FORMER FACTORY WAS NEATLY DISMANTLED. A NEW VIRTUAL PRODUCTION LINE TOOK ITS PLACE. BUT THIS ONE WAS NOT LIMITED TO ONE LOCATION. INSTEAD IT INCLUDED ALL PLACES ON EARTH. THE CALCULATIONS ATTEMPTED TO EXPLAIN. ALL OF THE RELATIONS OF PRODUCTION. NOW, IT SOUNDS AS IF THIS MIGHT BE SOME KIND OF DEVASTATED NEAR FUTURE. OR A CORRUPTED COMMUNE. BUT THESE WERE THE NORMAL EX-WORKERS. THE PEOPLE WHO USED TO ARRIVE AT THE FACTORY EVERY DAY. MANY OF THEM HAD KNOWN EACH OTHER FOR YEARS. AT FIRST THEY HAD PEOPLED THE PRODUCTION LINE. AFTER A WHILE THEY HAD WON THE RIGHT TO ORGANIZE THEMSELVES. AT FIRST THIS HAD GONE EXTREMELY WELL. ALL PREDICTIONS OF COLLAPSE AND LOW PRODUCTION HAD BEEN UNFOUNDED. AS SOON AS THIS SELF-ORGANIZATION HAD TAKEN ROOT IT WAS TAKEN AWAY. EVERYONE HAD TO GO BACK TO THE LINE OR LEAVE. THERE WAS NO EXPLANATION AND NO LOGIC TO THIS. BUT EVEN A SHORT STRIKE COULDN'T CHANGE THE DECISION.

SOME DECIDED TO LEAVE. OTHERS DECIDED TO STAY. WITHIN WEEKS THE FACTORY FELL SILENT AND CLOSED. AT FIRST PEOPLE WERE DRAWN TO THE FACTORY OUT OF BOREDOM. AND A DEGREE OF FRUSTRATION THAT AN INCOMPLETE PROJECT HAS BEEN ABANDONED SO SOON. INITIALLY PEOPLE WOULD FUNCTION IN PARALLEL TO EACH OTHER. MANY MERELY CHOOSING THIS PLACE AS A LOCATION TO PASS THE TIME. CALCULATION BECAME THE COMMON LANGUAGE. SHARING NOTES AND SPECULATIVE MODELS. THE DECISION HAD BEEN MADE, TO AVOID ANECDOTAL PLAY. INSTEAD TO MOVE FOCUS AWAY FROM PEOPLE AND ONTO OBJECTS. A DESIRE TO ACCOUNT FOR EVERYTHING. A NEED TO CREATE A SERIES OF EQUATIONS THAT COULD PROVIDE A NEW BALANCE. A DESIRE TO QUANTIFY RELATIONSHIPS. GREAT LISTS OF MATERIALS WERE CREATED. ROUTES AND MODES OF TRANSPORTATION DISCUSSED. EVERYTHING WAS TIED TO EVERYTHING ELSE IN A DESPERATE SEARCH FOR BALANCE. PEOPLE FOUND A WAY TO AMUSE AND OCCUPY EACH OTHER WITH THIS GLOBAL ACCOUNTING. IT DREW THEM ALL TOGETHER AND TRANSCENDED ALL DIFFERENCE. SOME MORNINGS, NEW PEOPLE WOULD ARRIVE AND MARVEL AT THE INCREDIBLE QUANTITY OF WORK THAT HAD TAKEN PLACE. AN INVERSE PRODUCTIVITY. OVER MANY YEARS THE WORK CONTINUED. IT INITIALLY BROUGHT CURIOUS OUTSIDERS TO THE FORMER FACTORY. AFTER A WHILE THE VISITORS STOPPED COMING. AND LEFT THE MAIN GROUP TO CONTINUE THEIR WORK. THE MACHINERY, BY THIS POINT WAS UNRECOGNIZABLE. ALL OF IT HAD BEEN BROKEN BACK DOWN INTO ITS COMPONENT PARTS. ONE PART OF THE GROUP NOW SPECIALIZED IN TURNING THESE PARTS BACK INTO ELEMENTS. NOT REPROCESSING FOR THE PRODUCTION OF NEW THINGS BUT THE COMPLETE BREAKDOWN OF FORMER PARTS. THE EFFORT PUT INTO THIS REVERSE PRODUCTION WAS AS EXTREME AS THE EARLY DYNAMIC OF CAPITALISM. THE CORE GROUP WORKED HARD ON THEIR PROJECT AT TIMES WHEN THEY WERE NOT INVOLVED IN REFINING THEIR CALCULATIONS. THERE WAS AN INCREASING SENSE THAT A MOMENT WAS BEING REACHED. A CERTAIN LEVEL OF RESOLUTION BEING ACHIEVED. THE BORDERS OF THE BUILDING WERE NOW COMPLETELY POROUS. GARDENS EXTENDED INSIDE THE BUILDING. AND PILES OF MATERIAL WERE NOW STACKED JUST OUTSIDE THE FACTORY WALLS. SOME CHILDREN WERE BORN. SOME PEOPLE LEFT. SOME PEOPLE DIED. A FEW WERE MAIMED IN ACCIDENTS. THE OLD WORKED ALONGSIDE THE YOUNG. THERE WAS NO OBLIGATION TO DO ANYTHING. THE TEXTS AND CALCULATIONS FORMED AN ENORMOUS ARCHIVE. A MASSIVE LOG OF ALL POTENTIAL EXCHANGES. AN EXHAUSTED BUT HAPPY GROUP. WITH A PERFECT EXCHANGE TOOL. THE BASIS OF IT DERIVED FROM EXPERIENCE. A NEAR COMPLETE DISMANTLING. OVER TIME THE BUILDING NO LONGER RESEMBLED A FACTORY. IT HAD BEEN ABSORBED INTO THE LANDSCAPE. THE

RIGOUR OF THE ORIGINAL STRUCTURE HAD BEEN LOST. EVERY REMAINING SURFACE WAS DENTED AND BENT. THE ROOF WAS MISSING IN PLACES. AT NIGHT PEOPLE SLEPT IN THE FORMER OFFICES. SAFELY LOCATED IN THE BASEMENT OF THE STRUCTURE. IN GOOD WEATHER THEY SLEPT IN THE MAIN SPACE. OR ON PLATFORMS SUSPENDED ABOVE THE FLOOR. THE FEW REMAINING WALLS WERE SO HEAVILY MARKED WITH CALCULATIONS THAT THEY PROVIDED A REASSURING PATTERN. EVEN THOUGH SOME PEOPLE NO LONGER REMEMBERED WHAT THIS WORK HAD BEEN FOR. SPECIAL DAYS HAD DEVELOPED OVER TIME. CELEBRATING MARKERS IN THE HISTORY OF THE PLACE. MOMENTS WHEN ORES AND FUELS HAD BEEN RESOLVED. ALCOHOL AND FOOD HAD BEEN ACCOUNTED FOR. THERE WAS THE GENERAL FEELING THAT THINGS WERE WORKING OUT. A SENSE THAT ALL RELATIONSHIPS IN THE WORLD HAD BEEN ACCOUNTED FOR. YET ANY CASUAL VISITOR, HAD THEY STILL BOTHERED TO PASS BY, WOULD NOTICE SOME STRANGE THINGS. WHAT FELT LIKE HARD WORK IN THE FORMER FACTORY WOULD LOOK LIKE ALMOST NOTHING TO SOMEONE USED TO THE DYNAMIC OF CAPITALISM. THE LEVEL OF WORK TAKING PLACE WAS ALMOST IMPOSSIBLE TO SENSE. A GROUP OF SHY, NEARLY SILENT PEOPLE MOVING SLOWLY OR LYING ON THE GROUND. BUT IN THEIR MINDS THEY WERE STILL RESOLVING GREAT RELATIONSHIPS. BREAKING DOWN STRUCTURES AND ACCOUNTING FOR EVERYTHING. THE GENERAL HEALTH OF THE FACTORY POPULATION WAS POOR. THEIR SUPERFICIAL HEALTH AND APPEARANCE EVEN WORSE. DENTISTRY HAD NEVER TAKEN OFF. PODIATRY UNKNOWN. POSTURE WAS HUNCHED. AND MIRRORS COMPLETELY ABSENT. NEW STANDARDS HAD EMERGED. CONNECTED TO THE ABILITY TO RESOLVE. YET ANY ATTEMPT TO PROVIDE AN OBJECTIVE READING OF THIS WORK WAS NOW BOUND TO FAIL. THE TRUE EFFORT OF THE PLACE MAINLY WENT INTO GARDENING. AND EVEN THAT WAS BARELY MAINTAINED. YET THERE WAS A SENSE THAT THIS WAS A BETTER WAY. FREE FROM THE CONSTRAINTS OF PRODUCTION AND THE OBLIGATION TO IMPROVISE. A TRUE PARALLEL HAD BEEN CREATED. THAT OFFERED A TRUE ILLUSION OF IMPORTANT WORK. ONE WINTER, AS THE WEATHER GREW COLD. A SMALL GROUP OF PEOPLE GREW RESTLESS. THE ARRIVAL OF THE THREE PEOPLE HAD RECENTLY TAKEN PLACE. THEY CLAIMED TO HAVE COME FROM A SIMILAR PLACE. AND NOBODY STILL LIVED WHO COULD VERIFY THEIR CLAIM. THEIR STORY SOUNDED REAL ENOUGH. AND THEIR EXPERIENCES EXTREMELY FAMILIAR. THEY TOO HAD BEEN PART OF AN IMPROVISED COMMUNITY. A LONG WAY FROM HERE. FOR A WHILE EVEN THE MOST LANGUID ATTEMPTS AT WORK WERE STOPPED. MANY NIGHTS WERE NOW SPENT COMPARING RESEARCH. THE FACTORY SPACE WAS CLEANED UP. AND LAYERS OF WRITING EXPOSED IN ORDER TO EXPLAIN, IN REVERSE, THE WORKING OF THIS PLACE. GARDENING STOPPED LEADING TO SEVERE

MALNOURISHMENT. UNTIL ONE OF THE NEWCOMERS OFFERED TO TAKE OVER, INTRODUCING AN 'EFFICIENT' NEW TECHNIQUE. KILLING ANIMALS HAD NEVER OCCURRED TO THE FACTORY DWELLERS. BUT A TASTE FOR COOKED MEAT LIFTED MANY FROM THE FLOOR AND THEY TOO EAGERLY JOINED IN THE PROCESS OF EXPLANATION. SOME PARTS OF THE FORMER WALLS WERE NOW RESTORED. AND A SMALL GENERATOR COAXED BACK INTO LIFE. IT WAS NECESSARY TO SHOW THE VISITORS EVERYTHING. REVEAL SLOWLY HOW THE RESOLUTION OF ALL MATERIAL RELATIONSHIPS HAD BEEN ACHIEVED. LAYERS OF TEXT WERE CAREFULLY CLEANED FROM THE WALLS. EACH REMOVAL REVEALING A HIDDEN LAYER BENEATH. PAPERS WERE STACKED AND ARCHIVED. CAREFULLY CONSTRUCTED INDEXES WERE PRODUCED. EVERYONE WAS OPEN AND GENEROUS. THE VISITORS WOULD SOMETIMES BE FOUND SEARCHING THROUGH THE SHADOWS. INITIALLY THIS WAS OF NO CONCERN. BUT ONE OR TWO WERE SUSPICIOUS. YET COULDN'T FIND ANY FOCUS FOR THEIR CONCERNS. AFTER TWO OR THREE MONTHS WORK BEGAN ON RECONSTRUCTING A COMPUTER CONTROLLED WELDING MACHINE. THIS NOW JOINED THE PAINT SHOP THAT HAD BEEN COMPLETED A FEW WEEKS EARLIER. ONE COMPLETE WALL OF THE FORMER FACTORY HAD ALSO BEEN RESTORED. AT GREAT EFFORT THE FACADE HAD BEEN RECREATED. THE EFFORT TOOK ITS TOLL. AND PEOPLE DIED PREMATURELY. OTHERS WERE WEAK. BUT THE COLLECTIVE DESIRE TO SHOW THE WORK ACHIEVED LED TO RENEWED EFFORTS. A NEW SIMPLE HIGH FAT AND HIGH CARBOHYDRATE DIET WAS INTRODUCED. LEAVING THE WORKERS HAPPY FOR A WHILE. WEIGHT INCREASED. AND SO DID THE PACE OF RECONSTRUCTION. PEOPLE WERE NOW ENCOURAGED TO ACCOUNT FOR THEIR WORK. COMPLEX RELATIONSHIPS WERE FORGOTTEN. EVERYTHING NOW HAD A RATIONAL AIM. DEATH WAS INCREASINGLY COMMON. THE RATE OF RECONSTRUCTION INCREASED. THE ARCHIVE WAS LOST IN A FIRE. THE PROCESS OF EXPLANATION ABANDONED. THE WORK WAS NEARLY COMPLETE. THE THREE SURVEYED THE WORK. THEY WERE HAPPY WITH THE REINSTATED PLANT. CLEAN AND CLEAR. EARLY ON THE LAST EVENING. THE LAST OF THE FEW. WERE LINED UP BY THE SMELTER. AND NO LONGER KNOWING WHAT TO DO... SLIPPED INTO THE MELT.

Liam Gillick, transcript from the installation *Three Perspectives and a Short Scenario* (2008); exhibited at Witte de With, Rotterdam; Kunsthalle Zürich; Kunstverein München; Museum of Contemporary Art, Chicago, 2008–9.

Ludwig Wittgenstein
Tractatus Logico-Philosophicus//1921

4 A thought is a proposition with a sense.

4.001 The totality of propositions is language.

4.002 Man possesses the ability to construct languages capable of expressing
 every sense, without having any idea how each word has meaning or
 what its meaning is – just as people speak without knowing how the
 individual sounds are produced.
 Everyday language is a part of the human organism and is no less
 complicated than it.
 It is not humanly possible to gather immediately from it what the
 logic of language is.
 Language disguises thought. So much so, that from the outward form
 of the clothing it is impossible to infer the form of the thought beneath it,
 because the outward form of the clothing is not designed to reveal the
 form of the body, but for entirely different purposes.
 The tacit conventions on which the understanding of everyday
 language depends are enormously complicated.

4.003 Most of the propositions and questions to be found in philosophical works
 are not false but nonsensical. Consequently we cannot give any answer to
 questions of this kind, but can only point out that they are nonsensical.
 Most of the propositions and questions of philosophers arise from our
 failure to understand the logic of our language.
 (They belong to the same class as the question whether the good is
 more or less identical than the beautiful.)
 And it is not surprising that the deepest problems are in fact not
 problems at all.

Ludwig Wittgenstein, extract from 'Tractatus Logico-Philosophicus', *Annalen der Naturphilosophie*,
no. 14 (1921); trans. D.F. Pears and B.F. McGuiness, *Tractatus Logico-Philosophicus* (London: Routledge
& Kegan Paul, 1961; revised edition 1974) 22–3.

Biographical Notes

Eduardo Abaroa is a Mexico-based artist. He founded and worked in the artist-run space Temistocles 44 and has exhibited in Mexico, Los Angeles, New York, Argentina, Canada and Germany.

Giorgio Agamben is an Italian philosopher who teaches at the Universities of Venice and Paris. His books include *The Coming Community* (1990), *Homo Sacer: Sovereign Power and Bare Life* (1995), and *State of Exception* (2003).

Paul Barolsky is Commonwealth Professor of the History of Art at the University of Virginia. His books include *Why Mona Lisa Smiles and Other Tales from Vasari* (1991) and *A Brief History of the Artist from God to Picasso* (2010).

Larry Bell is an American artist based in New Mexico whose glass cubes from the early 1960s onwards are among the key works associated with Minimalism. His work is surveyed in detail in *A Minimal Future? Art as Object 1958–1968* (The Museum of Contemporary Art, Los Angeles, 2004).

John Berger is a British writer, artist and art critic whose books include *A Painter of Our Time* (1958), *Ways of Seeing* (1972), *A Seventh Man* (1975), *About Looking* (1980), *Another Way of Telling* (1982) and *Here is Where We Meet* (2005).

Daniel Birnbaum has since 2001 been Rector of the Städelschule and curator of Portikus, Frankfurt-am-Main, and was Curator of the 2009 Venice Biennale. He is a regular contributor to *Artforum*, *frieze* and *Parkett*. His books include *Chronology* (2007).

Heike Bollig is a German artist and writer based in Berlin. Her online project *Errors in Production* is an ongoing collection of a variety of products with individual manufacturing errors (www. errors-in-production (www.errors-in-production.info/)

Will Bradley is a writer and curator, and co-founder of The Modern Institute, Glasgow.

Bazon Brock is Professor of Aesthetics and Communication Design at the University of Wuppertal. Since the mid 1960s he has been a leading theoretician of contemporary art and performance. In 1968 he initiated the visitors' schools at Documenta.

Barbara Buchmaier is an art historian, curator and critic based in Berlin. She is a regular contributor to *Texte zur Kunst*, *Spike* and *Von Hundert*.

Chris Burden is an American artist based in Los Angeles whose performances and live art have been influential since the early 1970s. Retrospectives include Orange County Museum of Art, Newport Beach, California (1988)

Johanna Burton is an art historian and critic who teaches at the Center for Curatorial Studies, Bard College, and the School of the Arts, Columbia University, New York. She is the author of *Cindy Sherman* (2006) and a regular contributor to journals such as *Artforum* and *Grand Street*.

John Cage (1912–92) was an American experimental composer, artist and writer, and a leading figure in the post-1945 American avant-garde and international Fluxus movement. His books include *Silence: Lectures and Writings* (1961/1973).

Tacita Dean is a British artist based in Berlin. Solo exhibitions include Witte de With, Rotterdam (1997), ARC Musée d'art moderne de la Ville de Paris (2003), Solomon R. Guggenheim Museum, New York (2007) and Dia: Beacon, Riggio Galleries, Beacon, New York (2008).

Gilles Deleuze (1925–95) was a French philosopher influential for his work on historical philosophers such as Nietzsche, Leibniz and Spinoza, his co-authored studies with Félix Guattari on contemporary philosophical and psycho-social conditions, and his studies of the cinematic image.

Emma Dexter is a curator and writer on art and Director of Exhibitions at the Timothy Taylor Gallery, London. From 2000 to 2007 she was Senior Curator of Contemporary Art at Tate Modern, London.

Brian Dillon is a writer, art critic and scholar who is UK editor of *Cabinet* and a regular contributor to journals including *New Statesman, London Review of Books, Granta* and *Art Review*. His books include *In the Dark Room* (2005) and *Tormented Hope: Nine Hypochondriac Lives* (2009).

Sam Durant is an American artist based in California. He was included in the 2003 Venice Biennale and the 2004 Whitney Biennial. Solo exhibitions include The Museum of Contemporary Art, Los Angeles (2002) and Stedelijk Museum voor Aktuelle Kunst, Ghent (2004).

Russell Ferguson is Chair of the Department of Art, University of California at Los Angeles. Formerly Associate Curator at The Museum of Contemporary Art, Los Angeles, he has written, edited and curated extensively in the field of contemporary art since the late 1980s.

Peter Fischli and David Weiss are Zurich-born artists who have collaborated since 1979. Major solo shows include Centre Georges Pompidou, Paris (1992), Walker Art Center, Minneapolis (1996, touring) and retrospective, Tate Modern, London (2006–8, touring).

Joel Fisher is an American-born artist and writer based in Paris and Newcastle, England. Major solo exhibitions have included the Staditsches Museum, Monchengladbach (1975), Stedelijk Museum, Amsterdam (1978) and Kunstmuseum, Lucerne (1984).

Liam Gillick is a British artist whose projects include the ongoing series *What If Scenarios* and *Discussion Islands*. Solo exhibitions include Whitechapel Gallery, London (2002), The Museum of Modern Art, New York (2003) and the German Pavilion, Venice Biennale (2009).

Clive Gillman is an artist and curator, and Director of Dundee Contemporary Arts. Since the late 1980s he has contributed extensively to initiatives for new media culture, arts and regeneration, and media literacy.

Renée Green, Dean of Graduate Studies at the San Francisco Art Institute, is an artist, filmmaker and writer. Solo exhibitions include The Museum of Contemporary Art, Los Angeles (1993), Fundació Antoni Tàpies, Barcelona (2000) and the National Maritime Museum, Greenwich (2009).

Jörg Heiser is an art critic and curator who lives and works in Berlin. He is Associate Editor of *frieze* and a regular contributor to *Süddeutsche Zeitung*. He is the author of *All of a Sudden: Things that Matter in Contemporary Art* (2008).

Jennifer Higgie is an Australian art critic, novelist and screenwriter, and Co-Editor of *frieze*. She is the editor of *The Artist's Joke* (2007) and author of the script for the film *I Really Hate My Job* (2007).

Richard Hylton is a curator and art critic whose curatorial projects include 'Imagined Communities' (1996) and 'Landscape Trauma in the Age of Scopophilia' (2000). His publications include *The Nature of the Beast* (2007).

International Necronautical Society is an artist-centred critical collective whose members include Tom McCarthy, Anthony Auerbach, Melissa McCarthy, Simon Critchley, Laura Hopkins, Francis Upritchard, Isabel Rocomora and Alexander Hamilton (www.necronauts.org).

Gabriela Jauregui is a writer, poet and critic based on Los Angeles and Mexico City. Her books include *Controlled Decay* (2008).

Ray Johnson (1927–1995) was an American artist whose works of the 1950s were among the precursors of Pop art. He was also a pioneer of mail art, which became his principal practice. Retrospectives include Whitney Museum of American Art, New York (1999).

Jean-Yves Jouannais is a curator, art critic and scholar. He was the editor of the periodical *art press* for nine years and co-founded the *Revue Perpendiculaire* in 1995.

Inés Katzenstein is an art historian and critic, and Curator at the MALBA–Colección Costantini, Buenos Aires, Argentina. She was the co-editor of *Listen, Here, Now! Argentine Art in the 1960s* (The Museum of Modern Art, New York, 2004).

Søren Kierkegaard (1813–55) was a Danish philosopher, psychologist and writer. His works include *On the Concept of Irony* (1841), *Repetition* (1843) and *The Concept of Anxiety* (1844).

Joseph Kosuth is an American artist based in New York, centrally associated with the emergence of Conceptual art. He is the author of *Art After Philosophy and After: Collected Writings 1966–1990* (1991). In 1989 he curated the exhibition 'The Play of the Unsayable: Wittgenstein and the Art of the Twentieth Century' (Wiener Secession, Vienna).

Christy Lange is a Berlin-based writer and art critic and Associate Editor of *frieze*, who has published numerous essays on contemporary art in exhibition catalogues, monographs and art journals.

Lisa Lee is an American art historian and critic who has lectured and published essays on artists such as Isa Genzken and Roni Horn.

Lotte Møller is a Berlin based curator. Exhibitions she has organized include 'Radical Adults', The Forgotten Bar, Berlin (2010)

Stuart Morgan (1948–2002) was an acclaimed British writer on art, whose work first became known through the magazine *Artscribe*, of which he was briefly editor (1988–89). His writings are collected in *What the Butler Saw* (1996) and *Inclinations* (2007).

Hans-Joachim Müller is an art historian and critic who has contributed to numerous exhibition catalogues. He is the editor of *Harald Szeemann: Exhibition Maker* (2006).

Yoshua Okon is a Mexican artist who lives and works in Mexico City. Solo exhibitions include Sala de Arte Publico Siqueiros, Mexico City (2004), Städtische Kunsthalle, Munich (2006) and (with Raymond Pettibon) Armory Center for the Arts, Los Angeles (2009).

Simon Patterson is a British artist who first exhibited in 'Freeze', curated by Damien Hirst in 1988. Solo exhibitions include Museum of Contemporary Art, Chicago (1996), Kunsthaus Zurich (1997), Fruitmarket Gallery, Edinburgh, and Ikon Gallery, Birmingham (both 2005).

William Pope L. is an American visual and live artist. His retrospective 'William Pope L: eRacism' toured to Institute of Contemporary Art at Maine College of Art, Diverse Works Art Space, Houston, Portland Institute for Contemporary Art, Oregon, and Artists Space, New York (2003).

Karl Popper (1902–94) was an Austrian born philosopher of science, society and politics, who lived and taught in New Zealand (1937–46) and thence onwards in England. His works include *The Open Society and Its Enemies* (1945), *The Open Universe: An Argument for Indeterminism* (1956–57/1982) and *The Future is Open* (1985).

Mark Prince is a British artist and writer on art who has published essays in art journals including *Art Monthly* and *Artforum*.

Yvonne Rainer is an American choreographer, dancer (from 1957) and filmmaker (from 1968 onwards), who moved exclusively to film in 1975. Her writings are collected in *A Woman Who ... Essays, Interviews Scripts* (1999).

Paul Ricoeur (1913–2005) was a French philosopher and theorist of hermeneutics, the study of the foundations of interpretation. His works include *Freud and Philosophy: Essays on Interpretation* (1965), *Time and Narrative* (1984–88) and *Memory, History, Forgetting* (2000).

Dieter Roth (or Diter Rot, 1930–98) was a Swiss-German artist who moved from concrete poetry to works with fluxus and nouveau réaliste affinities but with more radical and diverse explorations of entropy and decay. Retrospectives include The Museum of Modern Art, New York (2004).

Scott A. Sandage is Associate Professor in the Department of History at Carnegie Mellon University. A cultural historian, he is the author of *Born Losers: A History of Failure in America* (2005).

Edgar Schmitz is a London-based artist working on the politics of confusion and ambient attitudes. He teaches at Goldsmiths, University of London, and Sotheby's Art Institute, London. He is a regular contributor to *Kunstforum International* and *Texte zur Kunst*.

Julian Schnabel is an American artist known for his neo expressionist works of the late 1970s and 1980s, and latterly a film director whose films include *Basquiat* (1996), *Before Night Falls* (2000) and *The Diving Bell and the Butterfly* (2007).

Robert Smithson (1938–73) was an American artist whose work intersected with conceptual art, Land art and Minimalism, and whose wide-ranging writings made a significant contribution to art discourse in the late 1960s and early 1970s. Retrospectives include Museée d'art moderne de la Ville de Paris (1982) and Centro Julio González, Valencia (1993).

Abigail Solomon-Godeau is an art historian, critic, curator and feminist theorist. In addition to her books, her influential essays have appeared in *Artforum*, *The Art Journal*, *Afterimage*, *Camera Obscura*, *October* and *Screen*. She is Professor of History of Art, University of California at Santa Barbara.

Frances Stark is a Californian artist whose work includes painting, installation and writing. Major solo exhibitions include Hammer Museum, Los Angeles (2002). She is Assistant Professor of Painting and Drawing at San Francisco State University.

Harald Szeemann (1933–2005) was a key figure in the European avant-garde from the 1960s onwards and a pioneer of new independent forms of curating. His exhibitions include 'When Attitudes Become Form' (1969) and 'Der Hang zum Gesamtkunstwerk' (1983).

Sarah Thornton is a writer and broadcaster on contemporary art and art critic for *The Economist*. She is the author of *Seven Days in the Art World* (2008).

Coosje van Bruggen (1942–2009) was an artist, art historian and critic. As well as texts on her partner Claes Oldenburg she published essays on other contemporaries including Richard Artschwager, Hanne Darboven, Bruce Nauman, Gerhard Richter, and the architect Frank Gehry.

Marcus Verhagen is a writer on nineteenth-century and contemporary art and a lecturer at Sotheby's Art Institute, London. He is a regular contributor to *Representations*, *Third Text* and *New Left Review* and also contributes to magazines such as *Art Monthly*, *Modern Painters* and *frieze*.

Paul Watzlawick (1921–2007) was an Austrian-American philosopher and psychologist. His works include *Pragmatics of Human Communication* (1967), *The Situation is Hopeless but Not Serious* (1983) and *Ultra-Solutions, or How to Fail Most Succesfully* (1988).

William Wegman is a West Coast American artist of the conceptual art generation, who began collaborating with his first Weimaraner dog, Man Ray, in the early 1970s. Retrospectives include the Brooklyn Museum, New York and Wexner Center for the Arts, Columbus, Ohio (2006).

Michael Wilson is an artist, curator and critic based in New York. He has written on contemporary artists for exhibition catalogues and magazines including *Artforum* and *artforum.com*, *frieze*, *Art Monthly*, *Untitled*, *Modern Painters*, *The Wire* and *Blueprint*.

Ludwig Wittgenstein (1889–1951) was an Austrian-born philosopher who studied and wrote primarily in Cambridge, England, and Skjolden, Norway. His published works include *Tractatus Logico-Philosophicus* (1921), the posthumously edited *Philosophical Investigations* (1953) and the volumes of the complete manuscripts edited by Michael Nedo (1993 to the present).

Bibliography

This section comprises selected further reading and does not repeat the bibliographic references for writings included in the anthology. For these please see the citations at the end of each text.

Altshuler, Bruce, ed., *Salon to Biennial: Exhibitions that Made Art History. Volume 1: 1863–1959* (London and New York: Phaidon Press, 2009) 'Salon des Refusés' section.

Auster, Paul, *Hand to Mouth: A Chronicle of Early Failures* (London: Faber & Faber, 1997)

Balzac, Honoré de, 'Le Chef d'oeuvre inconnu' (1845); trans. Richard Howard, with introduction by Arthur C. Danto, *The Unknown Masterpiece* (New York: New York Review Books, 2001)

Beckett, Samuel and Duthuit, Georges, 'Three Dialogues with Georges Duthuit', *transition*, no. 48 (1949); reprinted in Samuel Beckett, *Proust & Three Dialogues with Georges Duthuit* (London: John Calder, 1965)

Beenker, Erik, 'The Man Who Wanted to Look beyond the Horizon', in *Bas Jan Ader* (Rotterdam: Museum Boijmans Van Beuningen, 2006)

Benjamin, Walter, 'The Image of Proust' (1929), in Benjamin, *Illuminations*, ed. Hannah Arendt, trans. Harry Zohn (New York: Schocken Books, 1969)

Bersani, Leo, and Dutoit, Ulysse, *Arts of Impoverishment. Beckett, Rothko, Resnais* (Cambridge, Massachusetts: Harvard University Press, 1993)

Birnbaum, Daniel, 'Secret Sharer: Michael Krebber', *Artforum* (October 2005)

Bloch, Ernst, Geist der Utopie (1918; revised edition 1923); trans. Anthony A. Nassar, *The Spirit of Utopia* (Stanford: Stanford University Press, 2000)

Borges, Jorge Luis, 'Funes el memorioso', in *Ficciones* (1944); trans. Anthony Kerrigan, *Fictions* (New York: Grove Press, 1962)

Bradley, Will, 'Pay No Attention to that Man behind the Curtain', in *Adam Chodzko: Plans and Spells* (London: Film and Video Umbrella, 2002)

Camus, Albert, *Le Mythe de sisyphe* (1942), trans. Justin O'Brien, *The Myth of Sisyphus* (London: Hamish Hamilton, 1955)

Chevalier, Catherine, 'Événement/non-événement: Merlin Carpenter à Galerie Dépendance', *Mai*, no. 2 (Paris, 2009)

Crimp, Douglas, *On the Museum's Ruins* (Cambridge, Massachusetts: The MIT Press, 1993)

Debord, Guy, *La Planète malade* (1971); trans. Donald Nicholson-Smith, *A Sick Planet* (London: Seagull Books, 2008)

Fitzgerald, F. Scott, 'A Man in the Way' (first published in *Esquire* magazine, February 1940), in Fitzgerald, *The Pat Hobby Stories* (New York: Scribner, 1995)

Giacometti, Alberto, 'My Artistic Intentions'/Response to Peter Selz', in Peter Selz, *New Images of Man* (New York: The Museum of Modern Art, 1959)

Gilbert, Chris, 'Herbie Goes Bananas', in *Work Ethic*, ed. Helen Molesworth (Baltimore: Baltimore Museum of Art/University Park, Pennsylvania: Pennsylvania State University Press, 2003)

Goldstein, Ann, 'The Problem Perspective', in Goldstein, ed., *Martin Kippenberger: The Problem Perspective* (Los Angeles: The Museum of Contemporary Art, 2008)

Groys, Boris, 'The Mimesis of Thinking', in Donna De Salvo, ed., *Open Systems: Rethinking Art c.1970* (London: Tate Publishing, 2005)

Hobsbawm, Eric, 'Towards the Millenium', *The Age of Extremes* (London: Abacus, 2007)

Holert, Tom, 'Surviving Surveillance? Failure as Technology', *Printed Project*, no. 6 (Dublin, 2007)

Hughes, Robert, 'The Decline and Fall of the Avant-Garde', *Time* (New York, 18 December 1972); reprinted in Gregory Battcock, ed., *Idea Art* (New York: Dutton, 1973)

Ionesco, Eugène, Les Chaises (1952); in Ionesco, *Rhinoceros/The Chairs/The Lesson*, trans. Donald Watson (Harmondsworth: Penguin Books, 1962)

Kelley, Mike, 'Death and Transfiguration: A Letter from America', in *Paul Thek: Artist's Artist*, ed. Peter Weibel and Harald Falckenberg (Cambridge, Massachusetts: The MIT Press, 2009)

Kent, Rachel, 'Cumulus: Pun to Paradox. Bas Jan Ader Revisited', *Parkett*, no. 75 (Winter 2005–6)

Levine, Les, 'Les Levine Replies' [to Robert Hughes' 'The Decline and Fall of the Avant Garde', 1972], in Gregory Battcock, ed., *Idea Art* (New York: Dutton, 1973)

McInerney, Jay, *Brightness Falls* (London: Bloomsbury, 1992)

Melville, Herman, *Bartleby, the Scrivener: A Story of Wall Street* (1853); reprinted in Melville, Bartleby and Benito Cereno (New York: Dover, 1990)

Reust, Hans Rudolf, 'The Pursuit: Luc Tuymans 1996–2003', in *Luc Tuymans* (revised edition) (London and New York: Phaidon Press, 2003)

Rugoff, Ralph, *Just Pathetic* (Los Angeles: Rosamund Felsen Gallery, 1990)

Siedell, Daniel A., 'Art and Failure', *The Journal of Aesthetic Education*, vol. 40, no. 2 (Urbana-Champaign: University of Illinois Press, Summer 2006)

Sillars, Laurence, *Joyous Machines: Michael Landy and Jean Tinguely* (London: Tate Publishing, 2009)

Virno, Paolo, 'The Ambivalence of Disenchantment', in Virno and Michael Hardt, eds, *Radical Thought in Italy: A Potential Politics* (Minneapolis: University of Minnesota Press, 1996)

Index

ACKNOWLEDGEMENTS

Editor's acknowledgements

Thanks to Iwona Blazwick and to Ian Farr, Hannah Vaughan and colleagues for realizing this publication; Elea Himmelsbach for research support; James Porter, Edgar Schmitz and Uta Kogelsberger for many conversations on the possibilities of productive failure.

Publisher's acknowledgements

Whitechapel Gallery is grateful to all those who gave their generous permission to reproduce the listed material. Every effort has been made to secure all permissions and we apologize for any inadvertent errors or omissions. If notified, we will endeavour to correct these at the earliest opportunity. We would like to express our thanks to all who contributed to the making of this volume, especially: Giorgio Agamben, Paul Barolsky, Larry Bell, John Berger, Daniel Birnbaum, Heike Bollig, Will Bradley, Bazon Brock, Barbara Buchmaier, Chris Burden, Johanna Burton, Emma Cocker, Tacita Dean, Emma Dexter, Brian Dillon, Sam Durant, Russell Ferguson, Joel Fisher, Fischli & Weiss, Liam Gillick, Clive Gillman, Renée Green, Jörg Heiser, Jennifer Higgie, Richard Hylton, International Necronautical Society, Gabriela Jauregui, Estate of Ray Johnson, Jean-Yves Jouannais, Inès Katzenstein, Joseph Kosuth, Christy Lange, Lisa Lee, Michaela Meise, Lotte Møller, Estate of Stuart Morgan, Hans Joachim Müller, Sina Najafi, Yoshua Okon, Simon Patterson, Mark Prince, Yvonne Rainer, David Serlin, Abigail Solomon-Godeau, Estate of Dieter Roth, Scott Sandage, Edgar Schmitz, Julian Schnabel, Estate of Robert Smithson, Annika Ström, Sarah Thornton, Felicitas Thun, Marcus Verhagen, Estate of Paul Watzlawick, William Wegman, Dennis Wheeler, Mike Wilson, Jan Winkelmann. We also gratefully acknowledge the cooperation of: Armand Hammer Museum of Art; Art Monthly; Artforum; Autograph ABP; Bookworks; Faber & Faber; Flash Art International; frieze; Frith Street Gallery; Fruitmarket Gallery; Gagosian Gallery, Los Angeles; Granta Books; Greene Naftali Gallery; Hammer Museum, UCLA; Ikon Gallery; International Necronautical Society; Journal of Aesthetic Protest Press; Lux; The Museum of Contemporary Art, Los Angeles; Parkett; Pennsylvania State University Press; Princeton University Press; Richard L. Feigen & Co; Rizzoli International Publications; Sprueth Magers; Stanford University Press; TATE ETC; Tate Publishing; Taylor & Francis Books (UK); University of Chicago Press; University of Klagenfurt; Karl Popper Library; University of Minnesota Press; Verso; W.W Norton; Wesleyan University Press.

Whitechapel Gallery

www.whitechapelgallery.com

Whitechapel Gallery is supported by
Arts Council England